A DELEUZIAN CENTURY? Edited by Ian Buchanan

DUKE UNIVERSITY PRESS Durham and London 1999

© 1999 Duke University Press
All rights reserved
Printed in the United States of America on acid-free paper ∞
Typeset in Scala
Library of Congress Cataloging-in Publication Data appear
on the last printed page of this book

The text of this book originally was published without the index
as volume 96, number 3 of the *South Atlantic Quarterly*.

DUKE

UNIVERSITY
PRESS · PUBLICITY

BOX 90660

DURHAM, NC

27708-0660

Michael Taeckens
PUBLICITY

(919) 687-3639
TELEPHONE

(919) 688-4391
FAX

taeckens@acpub.duke.edu
EMAIL

REVIEW COPY

A DELEUZIAN CENTURY?

Ian Buchanan, editor, ed.

Price:
Paper (0-8223-2392-3) $18.95
Unjacketed cloth (0-8223-2359-1) $54.95

*(Please note that unjacketed cloth editions are primarily for library use.
Non-library reviewers should quote the paperback price.)*

Publication Date: October 7, 1999

**Please send two copies of the published review.*

Contents

Introduction Ian Buchanan

The time is coming when it will hardly be possible to write a book of philosophy as it has been done for so long: "Ah! the old style. . . ." The search for new means of philosophical expression was begun by Nietzsche and must be pursued today in relation to the renewal of certain other arts, such as the theatre or the cinema. In this context, we can now raise the question of the utilization of the history of philosophy. It seems to us that the history of philosophy should play a role roughly analogous to that of *collage* in painting.—Gilles Deleuze, *Difference and Repetition*

 It is doubtful now that we'll ever learn whether Foucault meant anything besides mischief in prophesying that perhaps this century would one day be known as Deleuzian. Deleuze, for his part, apparently took it to mean just that. Hasn't it occurred to you, he reproached Michel Cresole—and by implication all those who cite it as proof of his importance —"that his little remark's a joke meant to make people who like us laugh, and make everyone else livid?"[1] By the same token, it is equally doubtful whether any of us alive today will live long enough to confirm the accuracy of Foucault's prophecy. It can already be seen just how influential this re-

mark has become. I suspect, however, that the joke has gone far enough. The risk is that we will substitute hagiography for philosophy. And, as de Certeau reminds us, hagiographies serve only to glorify their authors, not their subjects.[2] Deifying Deleuze may promote book sales, but philosophy, as Deleuze himself warned, cannot survive in such a self-serving atmosphere. Now is probably the time for a bit of sobriety not to reflect on what has been, nor to contemplate what remains, but to allow a friendship to blossom.

Sometimes, when a friend dies you need to paint his picture, Deleuze said of Foucault.[3] I think this is the stage we are at now, and there are a number of problems which need to be addressed before we can move on to a more properly philosophical stage. The most urgent of these, and the one that I think will decide, finally, the extent to which this century becomes known as Deleuzian, is the one posed by posterity itself. How best do we follow in the footsteps of great philosophers? "Is it to repeat what they said or *to do what they did*, that is, create concepts for problems that necessarily change?"[4] Given Deleuze's definition of philosophy as the need to invent new concepts, there is no prize for guessing the correct answer. However, there is a prize for devising a way out of the paradox implied by the answer, namely, that to be Deleuzian one must abandon Deleuze. Unless one wishes to write hagiography, one is compelled to choose between two things, both of which result in a turning away: either one must bring other philosophical systems to bear on his corpus and enter into the very critical practice he so loathed or, if this faithlessness reviles, one must take to heart Deleuze and Guattari's axiom that philosophy progresses only by succession.[5] Deleuze's work must then be treated as an arrow that has hit *its* target and now waits to be fired once more from a newly strung bow. To this end, we might begin with a portrait.

Deleuze always maintained that interviews are an essential component of Foucault's work, just one of the many ways Foucault conducted his interventions into the history of the present (the others being, besides his books, protest marches, letters, lists, etc.). Yet, strangely, Deleuze never allowed that his own work could be conducted in that way and, for the most part, derided the very idea of the interview. When he did agree to an interview, he usually attempted to turn it into something else—a quasi-Socratic dialogue (*Dialogues*), a guerrilla's battle cry (*Negotiations*). Doubtless what Deleuze recoiled from is the inescapable reality that interviews,

whatever their supposed subject matter (a new book, for instance), invariably end up being about the interviewee. Of course, neither the fact that Deleuze never enjoyed interviews nor that they are more revealing of the person interviewed than of the interview topic itself will surprise anyone very much, since the former is common knowledge and the latter is obvious. What does seem surprising, though, is that Deleuze's interviews have been so little exploited by Deleuze scholars. Consequently, there has been no systematic attempt to construct a "picture of Deleuze" (as he himself might have put it) on the basis of what he has said about himself. This represents a serious gap in Deleuze scholarship, one that means we are not yet Deleuzian. As his interviews make clear, constructing a picture of a great artist or philosopher is one of the things Deleuze did.

It may be objected that too much can be made of ostensibly casual remarks, but given how regularly Deleuze said that interviews are a waste of time, that too much talk is distracting, and that discussing ideas is pointless, such remarks must be seen as calculated or else deceitful.[6] The question therefore is, what was Deleuze trying to do in his interviews? To reply that he was "self-fashioning" or "stylizing" would be inaccurate because these are not the terms Deleuze would choose for himself, but they would at least put us on the right path by emphasizing style. Style is certainly the key, but an enigmatic one about which Deleuze said precious little; its importance, though, cannot be overstated. Style is what every great philosopher has, according to Deleuze, and it "is always a style of life too, not anything at all personal, but inventing a possibility of life, a way of existing."[7] It is through style, as the enfolding of life and work, that the philosopher becomes imperceptible, a persona (or mediator) rather than a person. My speculation is that Deleuze's interviews are best understood as an attempt to fashion himself as (what he called) a conceptual persona.[8]

Therefore, if we can disentangle the features of Deleuze's style—style being the advertisement, as it were, that a philosophical operation is taking place[9]—we will better understand his philosophy. In other words, painting Deleuze's portrait is not merely desirable—the fond wish of a nostalgic—but a necessary move in the larger game of penetrating Deleuze's thought. Because of its very newness his philosophical praxis prevents us from utilizing preexisting philosophical methods, a fact which obviously inhibits the exegetical process. What I want to contrast here, then, are the key features of Deleuze's methodology and those elements of a possible

Deleuzian criticism which belong to an outside not of his devising. My purpose is not to close off discussion, however, but, on the contrary, to open it up. The problematic I want to broach is one that I think will become central to Deleuze scholarship: How can one follow the teaching of Deleuze and remain rigorous where that would mean employing methods and questions from elsewhere? If it is true that Deleuze's interviews fold his life and work into one, then perhaps what he does reveal about himself can be taken as part and parcel of how he wants philosophy to think of him and with him.[10] In effect, what I am looking for is a set of Deleuzian principles for reading Deleuze.

That style was a significant feature of Deleuze's philosophical praxis may be adduced from, among other things, his repeated objections to travel. ("You shouldn't move around too much, or you'll stifle becomings."[11]) What it demonstrates is a commitment to a certain stylized way of life, which should not be misunderstood as meaning either pretentious or affected. (I have no sympathy with Michel Cressole's comments on Deleuze's idiosyncrasies of deportment and dress, such as his long fingernails and peasant's coat.) Most importantly, Deleuze's unwillingness to travel is not only perfectly consistent with his view of nomads as the ones who do not move ("travel aspires to a nomadic ideal, but it's a ridiculous aspiration, because nomads are in fact people who don't move on"), but also fits with the view that the most interesting aspect of any activity is its abstract form, that part of it which can be experienced on its own and by other means: "If I stick where I am, if I don't travel around, like anyone else I make my inner journeys that I can only measure by my emotions, and express very obliquely and circuitously in what I write."[12] In effect, what Deleuze is claiming here—and this is why it is so important a clue to understanding his work overall—is that it is possible to comprehend, and therefore to write about, travel without ever having actually traveled, except on the inside.

We are alerted here to a general principle: "What's to stop me talking about drugs without being an addict," he inquires, "if I talk about them like a little bird?"[13] Deleuze's response to criticisms from Cressole, among others, that he should not write about drugs or homosexuality or schizophrenia because he himself was not a junkie or gay or schizophrenic is not simply, or at least not only, a calculated provocation, for it entails one of the central pillars of his thought, the genealogy of which can be traced right

back to his very first book on Hume, namely, the concept of the *transversal relation*. Hume said relations are external to their terms. Therefore, according to Deleuze's reading, relations are also independent of their terms, or transversal, which means they cut across both subjects and objects and have their own movement and necessity.[14] The central claim that follows from this is that "any effects produced in some particular way (through homosexuality, drugs, and so on) *can always be produced by other means.*"[15] Hence Deleuze's fascination with Henry Miller's great experiment to test whether it is possible to get drunk on pure water; if it is, then one of the most intransigent obstacles to philosophy's investigations—experience as the guarantor of identity—is eliminated.[16] Drugs may well produce *délire*, but if that state is attainable by other means, then one does not have to be an addict to interrogate drugs.

The latter point is crucial, especially in this day and age, because it enables Deleuze to sidestep the whole issue of identity politics. This does not mean he has no sympathy with the more urgent humanitarian aims of what is broadly covered by that term, only that he does not agree with the philosophy it implies. "We have to counter people," he says, "who think 'I'm this, I'm that.'" Deleuze's position is that arguments based on "one's own privileged experience are bad and reactionary arguments."[17] Not only does the insistence on personal experience deny other speakers the right to their say, it also severely limits what philosophy itself can talk about. The real philosophical problem, therefore, is not the determination of who can or should speak (a matter best left to the police, Deleuze says), but rather the fabrication of a set of conditions that would enable everyone to speak.[18] "So how can we manage to speak without giving orders, without claiming to represent something or someone, how can we get people without the right to speak, to speak?"[19] The short answer is, through philosophy. For, as Deleuze shows, these two political points depend upon two philosophical presuppositions which, in light of his extension of the concept of the transversal relation, *hecceity*, are not simply untenable but completely unthinkable.

Identity politics assumes, first of all, that experience *is* in fact a personal matter and, second, that the person whose experience it is can be adduced. Deleuze disputes both these assumptions. "Félix and I, and many others like us, don't feel we're persons exactly. Our individuality is rather that of events, which isn't making any grand claim, given that hecceities can be

modest and microscopic."[20] In other words, those experiences which are normally regarded as the special property of an individual, such as one's treasured memories, are here treated in much the same way as they are in *Blade Runner*, that is, as the very matter from which the individual is actually constituted. (Cognizance of this literally abysmal "truth" is at once the source of the razor-sharp irony of cyberpunk—and its academic associate cyborgology—and, as Jameson has pointed out, its deep utopian potential.[21]) This is probably the simplest explanation that can be given for Deleuze's version of "constructivism," which is how he came to describe his philosophy.[22] The personal is composed of—or, in Deleuze's terms, passively synthesized from—experiences and therefore cannot be separated from them. To put it another way, "there is no theoretical subjectivity," that is, a subjectivity somehow transcendental to the subject itself; there is "only a practical subject."[23] (Or, as Guattari put it, "Logical operations are physical operations too."[24]) Experience, then, is not something that a person has, or even has happen to one; it is, rather, what one is made of. This means, of course, that experience itself cannot be personal but must be nonpersonal, which, in turn, demands that the very notion of experience be rethought. If it is not the property of an individual, then what is it? Following Duns Scotus, Spinoza, and Hume, Deleuze redefines experience in terms of effects and relations, or better, hecceities, which for Deleuze means that experience is *individuating*.[25]

So, what is a hecceity? Simply put, it is a nonpersonal mode of individuation. For our purposes, though, probably the best way to think of it is in terms of style. In philosophy, Deleuze says, style is at once the *movement* of concepts and its *individuating* logic, that which sets one philosophy apart from philosophy in general. This logic, in effect a philosopher's own unique syntax,[26] is not a matter of the particular syntactical choices an author makes in the effort to express him- or herself, however, but the system of connections governing what is written that emerges in the expression itself. So it is "more like a volcanic chain than a stable system close to equilibrium." Syntax has its own necessity, in Deleuze's view, and cannot be adopted at will or on a whim. Crucially, for reasons I will explain in a moment, it is through the apprehension of a philosopher's style that his or her work can be taken "as a whole" without turning it into an oeuvre or, what amounts to the same thing, a dead letter. Style, as the "movement of concepts," is a vital substance, and it is precisely the vitality of philosophy that most interests Deleuze.[27] The importance of style to his philosophy,

and the fact that style is indeed a hecceity, can be most clearly seen in Deleuze's comments on the strengths and weaknesses of Foucault:

> When you admire someone you don't pick and choose; you may like this or that book better than some other one, but you nevertheless take them *as a whole*, because you see that some element that seems less convincing than others is an absolutely essential step in his exploration, his alchemy, and that he wouldn't have reached the new revelation you find so astonishing if he hadn't followed the path on which you hadn't initially seen the need for this or that detour.[28]

Taking an author's work "as a whole" is undoubtedly the most crucial feature of Deleuze's philosophical praxis. "You have to take the work as a whole, to try and follow rather than judge it, see where it branches out in different directions, where it gets bogged down, moves forward, makes a breakthrough; you have to accept it, welcome it, as a whole." Deleuze is quite unequivocal on this point. Unless you take the work as a whole, he says, "you just won't understand it at all."[29] Naturally, this principle informs every monograph he wrote.[30] It also informs all his more eclectic works, such as his books on cinema and his collaborations with Guattari, where it can be seen in their very texture. The cinema books, for instance, use monographs as their basic unit (their building blocks, as it were) in the compilation of what Deleuze called his "natural history." Any "analysis of images and signs," he stipulates, "has to include monographs on major *auteurs*." And, tellingly, he explains the gaps in *Cinema 1* (notably, the absence of detailed discussions of Welles and Renoir—monographs which, perhaps by rights, should have been there) by saying that he could not deal with their work as a whole in that volume, whereas he could discuss Naturalism that way, and so postponed treatment of those auteurs until *Cinema 2*. What Deleuze endeavors to specify in these various monographs is precisely each auteur's style, which, he argues, is most insistent in the types of connections between images that they construct—their syntax, in other words.[31] And, what is more, it is only by taking their work as a whole that this syntax can be rendered visible. Strangely, though, despite the obvious importance he attached to this principle and the fact that, as he quite candidly stated, he detested people who, in contrast to his own practice, would "pick and choose," Deleuze's own work has seldom been accorded this same treatment.[32]

In most instances, though, particularly with the better Deleuze scholars,

it is not bad faith that leads Deleuzians down blind alleys but something like a failure of imagination. It is hard work being Deleuzian, for although Deleuze has left us a book on what he thinks philosophy is—and repeatedly speaks of himself as doing philosophy—he did not write anything with the specific intent of instructing us on how to do philosophy. As a result, we have to content ourselves with comments made on the run, which is why I have turned to his interviews, where at least the "do nots" are spelled out. "There are some," Deleuze rather crankily snipes (at Derrida?), "who can only feel intelligent by discovering 'contradictions' in a great thinker." Such an approach to doing philosophy is sterile, in Deleuze's view, because it does not involve any creativity, and philosophy is for him nothing but the creation of new concepts.³³ He reserves the label "the plague of philosophy" for those critics corrupt enough to "criticize without creating."³⁴ But far from advocating an anything-goes type of philosophy, which it might appear philosophy would become were it ever freed from the vigilant vituperations of critics, Deleuze is actually promulgating a quite ruthless philosophical regime. Concepts, he argues, if they are good and rigorous enough, simply supplant one another when new problems and conditions emerge that can no longer be articulated by the existing apparatus, thereby eliminating the need for criticism altogether. This process is utterly pitiless—and Deleuze would not have it differently. "The idea of a Western democratic conversation between friends has never produced a single concept."³⁵ What the philosopher must therefore do is create new concepts.

This applies even in the apparently exceptional case of monographs, which on the face of it would seem to demand that creativity be restrained lest it interfere with the mimetic process of capturing a likeness. Yet nothing could be further from the truth: "The history of philosophy, rather than repeating what a philosopher says, has to say what he must have taken for granted, what he didn't say but is nonetheless present in what he did say."³⁶ This involves, Deleuze thought, a kind of philosophical buggery, or what (in his view) amounts to the same thing, an immaculate conception, whereby he took the author from behind and gave him a child "that would be his own offspring, yet monstrous." Because the philosopher really said everything Deleuze had him say, he was genuinely his child. "But the child was bound to be monstrous too, because it resulted from all sorts of shifting, slipping, dislocations, and hidden emissions." In all likelihood, it is the very monstrousness of Deleuze's monographs that has lately brought

such avid attention to his work. Of course, it is also this very monstrousness that has caused philosophers, especially those in the analytic tradition, to shy away from it. Now, though, the spirit of the times seems to have caught up with Deleuze, who, some forty years ago, felt worn down by a philosophical praxis built of prohibitions: "You can't read this until you've read that!"[37] Still, given that Deleuze does not advocate a free-for-all, but rather insists on a calculated form of creativity, there remains the question of how to do his philosophy.

It is this aspect of Deleuze's work that has yet to be fully understood. Unlike Derrida, for instance, Deleuze does not operate in a way that can be readily emulated once the principles are understood. Cultivating joy is nowhere near as straightforward a practical exercise as exposing metaphysical assumptions and unstated, a priori postulates. Even if it is true that Derrida cannot be followed so easily either, and doubtless we are right to be suspicious of any such claim, an army of adherents clearly thinks otherwise. None of this means, however, that it is impossible to be Deleuzian, only that we have not yet become so (making it doubtful that this century will be known as Deleuzian). One reason for this (one among many, I am sure) is, as I have suggested, that the significance of the emphasis Deleuze places on style has not yet been recognized. Insofar as Deleuze's work is concerned, then, the great organizing unsaid that every philosopher is said to possess is his style, implying, of course, that this is what must be grasped in order to read Deleuze. How we might go about doing so in something like a Deleuzian fashion may be gleaned, I believe, from Deleuze's treatment of other philosophers, most notably Foucault, for whom Deleuze reserved such a special place that his expatiation is self-reflexive.

According to Deleuze, Foucault was a "great stylist." If this statement plays no organizing role in Deleuze's account of Foucault, then it should be dismissed as an aside. But this is not the case. As the always novel syntax a philosopher constructs to systematically connect his or her ideas, thoughts, and images, style is an author's consistency: "There's style when the words produce sparks leaping between them, even over great distances."[38] Consistency is not, for all that, a postulate of unity and thus a cunningly disguised substitute for the classical author, which Foucault, among others, did so much to reveal as having passed into disuse. On the contrary, in Deleuze's philosophy, consistency—what he looks for in a series, or a pack—replaces unity as the criterion by which the collective is defined. Thus with Fou-

cault he set out to find the logic of his thought, not its place in the canon. "A thought's logic is like a wind blowing on us, a series of gusts and jolts." Moreover, it is the philosopher's double—"a repetition, another layer, the return of the same, a catching on something else, an imperceptible difference, a coming apart and ineluctable tearing open." [39] It is this "ghost" that Deleuze dedicated himself to finding in his book on Foucault. He thus hoped to draw his friend's picture—but not as a memorial—and to draw out that picture's inner dynamism, whatever it is that drives it from one level to another. [40] This collection could have no finer aim.

≡≡≡≡≡

Acknowledgments. This volume came about as a result of "Deleuze: A Symposium," held at the University of Western Australia in December 1996, and although it is not in any sense a "proceedings," it nevertheless owes much to that great and memorable event. I would therefore like to thank all the delegates for their participation and support. In the same spirit, I would like to thank the Department of English at the University of Western Australia, particularly Bob White, Sue Lewis, and Denise Hill, and the English and Comparative Literature Program at Murdoch University, especially Horst Ruthrof and Claire Colebrook, for making the conference possible. Finally, I would like to thank Fredric Jameson for his inspiring kindness and friendship, and Candice Ward for her humor, patience, and good honest know-how.

Notes

1 Gilles Deleuze, *Negotiations, 1972–1990*, trans. Martin Joughin (New York, 1995 [1990]), 4.

2 See Michel de Certeau, *The Writing of History*, trans. Tom Conley (New York, 1988 [1975]), 269–83.

3 Deleuze, *Negotiations*, 102.

4 Gilles Deleuze and Félix Guattari, *What is Philosophy?*, trans. Hugh Tomlinson and Graham Burchell (New York, 1994 [1991]), 28.

5 Ibid., 203.

6 See Deleuze, *Negotiations*, 130.

7 Ibid., 100.

8 Ibid., 125; for a description and explanation of "conceptual personae," see Deleuze and Guattari, *What is Philosophy?*, 61–83.

9 See Fredric Jameson, *The Prison-House of Language: A Critical Account of Structuralism and Russian Formalism* (Princeton, 1972), 154.

10 For Deleuze, philosophy should always be a matter of "thinking with," not "thinking through." Similarly, his pedagogic ideal was "doing with," not "doing as one is told." See Gilles Deleuze, *Proust and Signs*, trans. Richard Howard (New York, 1972 [1964]), 22; and *Difference and Repetition*, trans. Paul Patton (New York, 1994 [1968]), 23.

11 Deleuze, *Negotiations*, 138.

12 Ibid., 77, 11.

13 Ibid., 11–12.

14 See Gilles Deleuze, *Empiricism and Subjectivity: An Essay on Hume's Theory of Human Nature*, trans. Constantin V. Boundas (New York, 1991 [1953]), 101.

15 Deleuze, *Negotiations*, 11.

16 See Gilles Deleuze and Félix Guattari, *A Thousand Plateaus: Capitalism and Schizophrenia*, trans. Brian Massumi (Minneapolis, 1987 [1980]), 166.

17 Deleuze, *Negotiations*, 11, 12.

18 Ibid., 24. Foucault made a similar retort to questions concerning his right to write what he liked; see Michel Foucault, *The Archaeology of Knowledge*, trans. A. M. Sheridan Smith (London, 1972 [1969]), 17.

19 Deleuze, *Negotiations*, 41.

20 Ibid., 141.

21 See Fredric Jameson, *The Seeds of Time* (New York, 1994), 150–59.

22 See Deleuze and Guattari, *What Is Philosophy?*, 7.

23 Deleuze, *Empiricism and Subjectivity*, 104.

24 Quoted in Deleuze, *Negotiations*, 15.

25 The most detailed explanation of hecceities is in Deleuze and Guattari, *A Thousand Plateaus*, 260–65.

26 Deleuze, *Negotiations*, 140, 131.

27 Ibid., 84, 85, 143.

28 Ibid., 85; my emphasis.

29 Ibid., 85.

30 In his book on Nietzsche, which is generally regarded as a watershed in Deleuze's career, he writes: "Conceptual analyses are indispensable and Nietzsche takes them further than anyone else. But they will always be ineffective if the reader grasps them in an atmosphere which is not that of Nietzsche"; Gilles Deleuze, *Nietzsche and Philosophy*, trans. Hugh Tomlinson (New York, 1983 [1962]), xii.

31 Deleuze, *Negotiations*, 49, 50, 52.

32 Ibid., 85.

33 Ibid., 90, 32.

34 Deleuze and Guattari, *What Is Philosophy?*, 28.

35 Ibid., 6.

36 Deleuze, *Negotiations*, 136.

37 Ibid., 6, 5.

38 Ibid., 101, 141.

39 Ibid., 94, 84.

40 Ibid., 84.

Marxism and Dualism in Deleuze Fredric Jameson

We begin, as one so often does, without necessarily wanting to, with Hegel (heaven only knows if we will also end up in the same place). The motto will be Hegel's prescient analysis of the situation of thought in modern times, which he contrasts to the situation of nascent philosophy in ancient Greece:

> The manner of study in ancient times differed from that of the modern age in that the former was the proper and complete formation of the natural consciousness. Putting itself to the test at every point of its existence, and philosophizing about everything it came across, it made itself into a universality that was active through and through. In modern times, however, the individual finds the abstract form ready-made; the effort to grasp and appropriate it is more the direct driving forth of what is within and the truncated generation of the universal than it is the emergence of the latter from the concrete variety of existence. Hence the task nowadays consists not so much in purging the individual of an immediate, sensuous mode of apprehension, and

making him into a substance that is an object of thought and that thinks, but rather in just the opposite, in freeing determinate thoughts from their fixity so as to give actuality to the universal, and impart to it spiritual life. But it is far harder to bring fixed thoughts into a fluid state than to do so with sensuous existence.[1]

So here, astonishingly, at the opening of the *Phenomenology of Spirit*, we find a mature and subtle reflection on reification: reification not only in the world of everyday life, but in thinking as well, and in our intercourse with already existing concepts, with free-floating thoughts named and signed like so many books or paintings. The ancient Greeks had the task, Hegel suggests, of wresting abstract ideas ("universals") from the flux of the sensory: of transforming *pensée sauvage* into systems of abstractions, of reclaiming Reason (or the ego, Freud might say) from the morass of the immediate. This is henceforth achieved, and thinkers in the modern period are then suffocated by the proliferation of just such abstractions, in which we swim as in an autonomous element, which suffuse our individual consciousnesses with abstract categories, concepts, and information of all kinds. What to reclaim or reconquer from this new morass, which is rather different from what confronted the Greeks in their "blooming, buzzing confusion"? And who does not see that this holds a thousand times more true for ourselves in postmodernity and late capitalism, in the society of the spectacle and the realm of the cybernetic, than in Hegel's still relatively information-poor life-world? If the Greeks transformed their sensory immediacy into universals, into what can universals themselves be transformed? Hegel's answer is generally interpreted to be reflexivity, self-consciousness, the dialectic and its distance from the concepts it wields and inhabits: that's probably not wrong, but also not very usable under present circumstances (but his own word was "actuality"). Marx had a better formula: bourgeois thought, he said (which we may also read as Greek philosophy), sought to rise from the particular to the universal; our task is now to rise (note the persistence of the verb)—to rise from the universal to the concrete.[2]

The greatness of Gilles Deleuze—or at least one of his many claims on greatness—was to have confronted omnivorously the immense field of everything that was thought and published. No one can read the two volumes of *Capitalisme et schizophrénie* (or, in a different way, those of *Cinéma*)

without being stunned by the ceaseless flood of references that tirelessly nourish these texts, and which are processed into content and organized into dualisms. This is the sense in which one can speak of Deleuze as a thinker of synthesis, one who masters the immense proliferation of thoughts and concepts by way of assimilation and appropriation. (If you like dualisms, indeed, and great cosmic or metaphysical oppositions, then you can say that Derrida is his opposite in this respect, tirelessly dissolving all the reified thoughts he encounters in the tradition back into the first impossibilities and antinomies from which they sprang.) This is why it seems to me misguided to search for a system or a central idea in Deleuze: in fact, there are many of those. It seems preferable to observe the extraordinary process whereby his intelligence rewrites and transcodes its overpopulated conceptual environment, and organizes it into force fields. But that organization, often so luminously schematic, does not aim to give us the truth, but rather a series of extraordinary representations: it is a fictive mapping which utilizes as its representational language great mythic dualisms such as the Schizophrenic and the molar or Paranoid, the Nomad and the State, space and time.

I want to look further into that organizational process, but I want to come at it from a specific question. The attacks on Freud that run through *Capitalisme et schizophrénie* (particularly the first volume) have been more notorious than the defense and deployment of Marx, which is an equally persistent feature. But we know that Deleuze planned a work on Marx in his final years, and we may also suspect that Marx is a good deal more pervasive than the lengthy chapter on that part of the *Grundrisse* sometimes entitled "Precapitalist Economic Formations," which occupies so central a space in *L'Anti-Oedipe*. I think that Deleuze is alone among the great thinkers of so-called poststructuralism in having accorded Marx an absolutely fundamental role in his philosophy—in having found in the encounter with Marx the most energizing event for his later work.

Let's first examine, as it were, the sequence of events in that vast Marx chapter of *L'Anti-Oedipe*, which nonetheless and despite its energy and coherence may be taken as a set of notes on Marxism rather than some new philosophy of the latter, or some ideologically innovative reading. The chapter is itself a subdivision of a larger one, something like the philosophy of history of the Deleuze/Guattari operation, strangely entitled "Sauvages, barbares, civilisés," a classification that has more ancient roots (in

Adam Ferguson, for example), but which springs in recent times (with the enthusiastic approval of Marx himself) from Lewis Henry Morgan's *Ancient Society* of 1877. I must say something more about this fascinating figure, whom Lévi-Strauss called the inventor of the kinship system and the founder of modern anthropology; but I will limit myself to the extraordinary way in which, with Morgan, all theories of the modern and of modernity meet their supplement and their hidden truth. The "modern" is of course here "civilization"; but whoever says so immediately posits an Other and a preceding stage of premodernity or precapitalism. That can simply, for most theoreticians of the modern, be the traditional and its benighted ignorance, while for others it can offer the libidinal investment of a golden age, that of the Noble Savage and the state of Nature. What is unique about Morgan is that he takes both positions simultaneously—as a supporter of the Paris Commune and an adoptive clan member of the Iroquois tribe, a lifelong admirer of the Native American mode of social organization called, from its equivalents in antiquity, the *gens*. "Barbarian" thus has no negative connotations in Morgan: it is a proud affront to the dehumanization and alienation of "civilized" industrial capitalism, a badge worn in honor and defiance. But the energy necessary to break with the modernizing social order in this way must itself be paid for; so it is that Morgan's negation of civilization generates a negation of the negation—a second, supplementary Other in the form of the Savage—something like the remainder or waste product, the convenient result of an operation of "splitting" whereby everything unpleasantly uncivilized about the Iroquois can be separated off and attributed to "truly" primitive or tribal peoples. Morgan's libidinal horror at the "savage" can be sensed in his own expression, "the stupendous system of promiscuity," by which is meant not only unbridled sexuality before the incest taboo but also a generalized system of flux: no writing, no fixed domicile, no organized individuality, no collective memory or history, no customs to be passed down—the imagined list by which this absolute disorder can be designated is endless. Clearly, in the Deleuze/Guattari system, the valences on all this are changed: savagery becomes as close as we can get to the idyllic liberation of schizophrenia, while the already implicit hierarchies of the gens are, on their account of barbarism, deployed and developed into the Ur-state, primal despotism, the sway of the Emperor and of the signifier itself.

This grand narrative of history will then clearly reinvent the classic prob-

lem of the transition from feudalism to capitalism and will tend to emphasize the survivals of both earlier stages, and their possible recurrence, more than is the case in most Marxian accounts. The central position of power in the account of barbarism—the sacred body of the king or emperor replacing the body of the earth, the emphasis on hierarchy and the State as a historical force—will swell into the alternating terms of the great dualism of *Mille plateaux*. Contrary to first impressions, this emphasis on power (unlike what happens in Foucault) does not here assert itself as an alternative to Marxian economic analysis; rather, the latter is itself generalized throughout the Deleuze/Guattari historical narrative in such a way that the determination by the economic is argued more fully and persuasively for the primitive (or "savage") mode than in most Marxian discussions. Indeed, here, alongside the primal value given to the "code" and to inscription, which would seem to offer a still relatively "structuralist" interpretation of primitive society, it is the tension between filiation and alliance that perpetually reinserts the "economic," in the Marxian sense, and persists all the way up to capitalism, where it becomes the internal opposition between the two uses of money itself: as capital and as purchasing power, as power of investment and as measure of exchange.

But it is to the question of the code that we need to return in order to grasp the originality of the Deleuze/Guattari account of capitalism. The latter is, indeed, seen by them as organized by an *axiomatic*, which is very different from the *code* of the earlier moments, raising the suspicion that, as with money itself, one of the functions of the very concept of "code" in the first place is to set off this radical difference with the axiomatic, while the other function is to secure its own identity from within as a concept, described (rather than defined) as follows: "A flux is coded inasmuch as detachments of the chain and preselections of the flux operate in correspondence, embrace and marry each other."[3] The figure is that of Louis Hjelmslev's glossematics, so highly praised here owing to the relative indifference of the content of each of its planes, along with the absolute requirement of a formal coordination between the two planes (what another system describes as the double inscription).

It would not be appropriate to mark this distinction by describing the "code" as meaningful and the "axiom" as meaningless or arbitrary, since the very concept of meaning in its traditional sense is something Deleuze aims to do away with and to replace. We might just as well say that the

property of a code is to be indifferently replaceable by another code, which will look equally "meaningful" or organic after a certain time; whereas with an axiom, you're stuck—you can't change it, at best you can add another one, until the axiomatic resembles those legal systems in which enormous quantities of precedents and old rulings can be found in the stacks somewhere. In mathematics, as I understand it, the axiom is the starting point, which cannot itself be grounded or justified, but rather serves as the ground or justification for all the other steps and propositions: "The choice of axioms involves a choice of basic technical terms to be left undefined, since the attempt to define all terms would lead to endless regression."[4] It is my understanding that modern discussions of axiomatics turn essentially on this matter of presupposition and arbitrary starting points. At any rate, it is precisely as an axiomatic that Deleuze and Guattari begin their discussion of capital. Let me risk the following characterization: Codes have a momentary self-sufficiency about them, whether they subsist in the form of decorations (bodily tattoos, for example) or in the form of custom and myth, and even though they are prone to transformation into other codes in the immense slippage of history. Axioms, on the other hand, are operational; they do not offer anything for commentary or exegesis, but rather are merely a set of rules to be put into effect. And this is the sense in which capitalism repairs itself and surmounts its contradictions by adding new axioms: you are supposed to believe in a pure market system, that is to say, a rather simple axiomatic positing undisturbed exchanges. But when there is a crisis in free trade or the gold standard, you add the more complex axioms of Keynesianism: those do not modify the axiomatic of capitalism but merely complicate the operations that make it up. There can be no return here to any simpler axiomatic or purer form of capitalism; only the addition of ever more rules and qualifications (rules against rules, for example, a dismantling of Keynesianism that has to use the latter's structures and institutions in order to fulfill itself). At any rate, this enigmatic but central term must, I think, be grasped in terms of what might be called a Deleuzian semiotics, and indeed, we here urgently need something like a semiotics of the axiom, provided we have already equipped ourselves with a satisfactory semiotics of the code as such. Even so, the question lingers as to the originality of the distinction: Does it do much more than restate the old opposition between the mechanical and the organic, between *Gemeinschaft* and *Gesellschaft*, in new and novel terminology?

The answer given by *L'Anti-Oedipe* itself is resolutely "textual": codes are inscribed—at the outer limit inscribed on the body itself (tattoos, scars, face painting)—when not on the body of the world. But the axiomatic is not a writing and leaves no traces of that kind. If you prefer the distinction to be staged the other way round, we may say "that a code is never economic and can never be,"[5] an observation that slowly leads us back to Marx's own account of precapitalist formations, which, although "ultimately" organized around a specific type of economic production in them—but unlike what holds for capitalism—are secured by an "extra-economic instance": "religion for the Middle Ages, politics for the ancient city–state," to which, after Morgan, the tradition has added "kinship for tribal society or primitive communism." This separation of power from production in noncapitalist societies was then theorized by the Althusserians as the distinction between the determinant—always a form of the economic—and the dominant, which in the social formations mentioned is extra-economic: only in capitalism do the two then coincide. (One of the crucial theoretical arguments about socialism today surely turns on this distinction as well, i.e., on whether socialism and other proposed alternatives to capitalism, such as Islamic fundamentalism, do not also require some "extra-economic" motivation.)

The argument about the code, then, is one of the three principal features of this subchapter. The remarkable pages on kinship, which reorganize this concept into a tension between filiation and alliance, furnish the theme of a second development, turning on the reappearance of this tension within capital itself as the two functions of money. The final discussion on the Oedipus complex happens to interest me much less, but it posits a specific and unique form of representation and the production and function of images in axiomatic society (or capitalism), of which the primal scene and the Oedipal family become the first form and the exemplar. Meanwhile, from time to time, the authors remember their initial project and ask themselves how desire can be invested in such systems; they invoke and reinterpret the "falling rate of profit"; most significantly for any political reading, they theorize the tendencies of the system: in a remarkable passage they assert that capitalism's deterritorializations are always accompanied by reterritorializations, or at least by the impulse and temptation to reterritorialize.[6] Such tendencies, to reinvent the private garden or the religious enclave, to practice the sacred after hours like a hobby, or to try

to libidinalize money into an exciting game—in other words, to attempt to transform bits of the axiomatic back into so many codes—is obviously at one with the way in which the various forms of precapitalism (coding and overcoding, the despotic state, the kinship system) survive in capitalism in forms that resemble their traditional counterparts, but that have in reality completely different functions. This incapacity of the axiomatic, or of capitalism, to offer intrinsic libidinal investments to its subjects—its urgent internal need to reinvent older forms of coding to supplement its impoverished structures—is surely one of the most interesting and promising lines of investigation opened up by the "Marxism" of *L'Anti-Oedipe*.

Alongside this argument, however, is the other line proposed by the overall title of the two-volume work, *Capitalisme et schizophrénie*, which affirms that, despite the homologies between the two terms of the slogan, ideal schizophrenia constitutes an alternative to capitalism and stands as its external limit. I prefer to come at this from a somewhat lower level of theorization, by way of the more empirical discussions of class. For here the assertions are more revealing: "From the point of view of the capitalist axiomatic, there is only one class with a universalist vocation, and that is the bourgeoisie."[7] Deleuze and Guattari endorse the unhappy conclusion into which Sartre argued himself in the *Critique of Dialectical Reason*, namely, that social classes have only a serial being and that only group unities present a radically different and active principle. In that case, the proletariat cannot really have a historical vocation of radical systemic transformation, and indeed it is to the *hors-classe* (potentially the ideal schizophrenic) that a true guerrilla potential belongs.[8]

Those reflections are then continued in the chapter of *Mille plateaux* devoted to the State, "Appareil de capture" (particularly in Proposition 14), where the notion and consequences of the axiomatic are further developed and explored. The interrelationship between an increase in constant capital (machines, technology, automation, and the axiomatic itself) and the falling rate of profit is usefully appealed to here for a further elaboration of the internal contradictions of capitalism.[9] But the most interesting features of this chapter for us are clearly those in which Deleuze and Guattari elaborate on the notion of the "hors-classe," and, basing themselves on contemporary Italian political thought, wish to develop the idea of a revolutionary movement completely outside the State itself. This is the point at which we get the most vivid sense of the empirical value of

that Deleuzian terminology which might otherwise seem merely poetic or speculative: "decoding," "deterritorialization," the replacement of the older codes by the new capitalist axiomatic that triggers and releases "fluxions" of all kinds (translated as *flows* by Brian Massumi, but the older word is perhaps more usefully medical). These have hitherto seemed to be relatively structural; now, however, we get the real thing. "In proportion, as ever more decoded flows enter a central axiomatic, they tend ever more to escape the periphery [i.e., the third world] and to raise problems the axiomatic is incapable of controlling, let alone resolving (even with those special extra axioms that have been added to deal with the periphery). . . . The four principal flows that torment the representatives of the world economy or of the axiomatic are the following: the flux of energy–matter [i.e., oil and other such goods], flux of population, flux of food products, flux of the urban." [10] Meanwhile, the problem of the location of the working class remains central:

> As long as the working class remains defined by an acquired status, or even by a State which it has itself theoretically conquered, it still only appears as "capital," as part of capital (variable capital) and does not escape the *plane* of capital as such. That plane at best becomes bureaucratic [i.e., as in the Socialist countries]. Yet it is precisely by leaving the plane of capital, by ceaselessly exiting from it, that a mass becomes fully revolutionary and destroys the dominant equilibrium of denumerable ensembles. [11]

However uncertainly poised this estimation leaves the politics of *L'Anti-Oedipe* in its Cold War situation of 1972, the analysis is prescient and prophetic in the light of the current situation, notably, the immense structural unemployment and the recent emergence of a host of social subjects who cannot be expected to take on the political role hitherto assigned to the industrial working classes, with their strategic control of the "levers" of production. When we search for the political relevance of Deleuze and Guattari's books today, it is surely in just such insights and appreciations that it must be sought. The same is true of the concomitant discussions of money and finance and banking, with the resurgence today of a novel form of "finance capital" clearly confirming the agenda of this twenty-five-year-old work: "It is the bank which governs the whole system, including the investment of desire." [12] These are then the two directions opened up

by this prodigious analysis of the decoding and deterritorialization of the capitalist axiomatic: on the one hand, the impoverishment of subjectivity and the extinction of the older subject itself (to use a non-Deleuzian terminology); on the other, the immense power now granted to money itself and the logic of finance, as that paradoxical and contradictory form taken by the axiomatic in the everyday life and functioning of capitalism as a system.

Thus, theoretical problems arise, not so much with the descriptions of capitalism in the Deleuze/Guattari corpus as in the positing of its Other, whether the latter is to be considered the industrial working class (as is traditional) or the sub- and underclasses, the unemployed or minorities, and outside of capital and society altogether. In other words, do we face a genuine dualism in which capitalism and the State are confronted with what is absolutely not themselves, what is radically other to and outside of them? Or is this a more dialectical opposition in which the other, the working class, is also somehow a part of, and thereby itself subordinate to, the State and to capital, a position which would seem to end up in a monism whereby there exists ultimately only the State, only capital? We will return to these issues shortly.

At this point, I want to pause to clarify my position on the exercise we have just been conducting. It is not a question, I feel, of deciding whether Deleuze (or that hybrid subject Deleuze/Guattari) is or is not a Marxist. The various Marxisms are, no doubt, ideologies and are susceptible to analysis like other ideologies. Marxism as a body of thought, however— I hesitate to mention the word "science"—is something I prefer to call a problematic. What seems far more important to me in the present context is to determine to what degree the thought of Deleuze moves within and endorses that problematic; or, the other way round, to what degree the problematic of Deleuze includes the Marxian problematic and endorses Marxian problems and questions as urgent ones within its own field of inquiry. The current return to classical liberalism—and the return of traditional disciplines such as ethics, aesthetics, and political philosophy, which also characterizes the present intellectual climate—has tended to regress to pre-Marxian positions and problems by way of the assurance that the Marxian problematic is no longer valid for late capitalism. The crucial feature of this diagnosis lies not in the absence of the whole range of different

Marxist answers and solutions to those problems, but rather in the repression of the problems themselves and the disappearance of inquiries that seek to position the logic of social life today (commodification) and the novel operation of a globalizing finance capital within the descriptions we are called upon to make of aesthetic production, the functioning of ideology, and the role of intellectuals and their conceptual innovations.

But, in my opinion, the work of Deleuze gives no aid and comfort to such regressive efforts; indeed, the whole function of this work has been not to seal off the academic disciplines from the social, the political, and the economic, but rather to open them up precisely to that larger force field. Rather than attempting to contain those realities, in other words, and to send them back to the sterilized compartments of the appropriately specialized disciplines, Deleuzian analysis displays a realm of prodigious polymorphous coding in which desire restlessly invests across the boundaries; indeed, in which the libidinal cannot be confined to the narrower realm that bourgeois thought calls subjectivity or psychology (or even psychoanalysis), but shows how the social is also a tissue of fantasms, and the narrowly libidinal itself a web of social and political representations. This breaking down of the barriers between the subjective—narrow concepts of desire and libido, even of sexuality—and the allegedly objective—the social, the political, and the economic—is one of Deleuze's most important achievements, it being understood that there are other ways of doing so. (Certain contemporary developments of Lacanian thought—I think above all of the now monumental work of Slavoj Žižek—seek to achieve this end by other means and in other forms.) As far as Deleuze and Guattari are concerned, however, let me read into the record one of the more striking moments in *L'Anti-Oedipe*, when the convulsive effort to tear down those traditional walls between the subjective and the objective can be witnessed:

> How does a delirium begin? Perhaps the cinema is able to capture the movement of madness, precisely because it is not analytical and regressive, but explores a global field of coexistence. Witness a film by Nicholas Ray, supposedly representing the formation of a cortisone delirium: an overworked father, a high-school teacher who works overtime for a radio-taxi service and is being treated for heart trouble. He begins to rave about the educational system *in general*, the need to restore a pure *race*, the salvation of the social and moral *order*, then

he passes to *religion*, the timeliness of a return to the Bible, Abraham. But what in fact did Abraham do? Well now, he killed or wanted to kill his son, and perhaps God's only error lies in having stayed his hand. But doesn't this man, the film's protagonist, have a son of his own? Hmm... What the film shows so well, to the shame of psychiatrists, is that every delirium is first of all the investment of a field that is social, economic, political, cultural, racial and racist, pedagogical, and religious: the delirious person applies a delirium to his family and his son that overreaches them on all sides.[13]

And what is dramatic and narratively foregrounded in the case of delirium is also at work in the microscopic operation of desire itself, and in general, on a daily basis. This is no longer one of those Freudo-Marxisms in which each side kept its own party structures (as in some Popular Front government of the mind) and cooperated on disputed terrains, sending groups of experts to consult with each other. Rather, it underscores the will to monism in Deleuze (a matter to which I will return shortly) and the way in which that multiplicity of disciplines implied in our opening observation by Hegel is overcome by a prodigious movement of de-differentiation: one that no doubt derives much of its force from the establishment and institutionalization of the disciplines and specializations in an earlier historical moment, but marks a new will to reestablish multiple connections among all those separated things. This is the spirit of synthesis in Deleuze I evoked, and it therefore comes as no surprise that the other face of that monism of desire we have been considering offers precisely that multiplicity of references, that ceaseless incorporation of texts of all kinds and research from any number of fields which must astonish any reader and which is even more dramatic in *Mille plateaux* than in *L'Anti-Oedipe*: linguistics, economics, military strategy, the building of the cathedrals, mathematics, modern art, kinship systems, technology and engineering, the history of the great classical empires, optics, evolutionary theory, revolutionary praxis, musical modes, the structure of crystals, fascism, sexuality, the modern novel—everything is grist for a mill that is no longer a simple and mechanical establishment of homologies, but rather the setting in motion and the systemic rotation of an unimaginably multidimensional reality.

All of which returns us to the central issue of philosophical representa-

tion, to which we must now, however, add a new problem: what is called the critique of ideology (or *Ideologiekritik*) in the Marxian tradition, for which a Deleuzian alternative suddenly seems to open up in *Mille plateaux*, in the form of what the authors call *noology*, or as they put it, "the study of the images of thought and of their historicity."[14] The program for noological analysis—as a mode of distinguishing and implicitly judging texts on the basis of the Deleuze/Guattari ideological dualism (Nomads versus the State)—seems to me to have more content than the more formal distinction between the *rhizomatic* and the *arborescent* (the growing out in all directions as opposed to the hierarchical) which has become so well-known, but which seems to present a more abstract and more purely philosophical set of discursive features. For, as the opening chapter of *Mille plateaux*, "Rhizome" (also published separately) has something of the dogmatic force of a manifesto; the unveiling of the "noological" method—in the very thicket of the content of later chapters—is more concrete and argued from the opposition between "royal science" and "minor science" (on which we will touch in a moment). Whether the new coordinates do not mark a slippage of the work of Deleuze and Guattari from the economic— the modes of production that dominated *L'Anti-Oedipe*—to a conception of the political in which judgments and the taking of sides are more facile must be the open question with which we approach the new material.

At first, noology is organized around a simple checklist, and it is the characteristic originality of the authors to derive it not directly from philosophical thought but from various kinds of engineering: the building of the great cathedrals by journeymen, as opposed to the codification of building methods and engineering standards imposed later on by the State; the former is indeed characterized as an *"anexact yet rigorous"* method, one that is "inexact by essence and not by chance."[15] But what is thereby derived is a way of judging thought according to its conformity "with a model borrowed from the State apparatus": "The classic image of thought, and the *striage* of mental space that it effectuates, lays a claim to universality. In effect, it operates with two 'universals,' the totality as the ultimate foundation of being or as an all-encompassing horizon; and the Subject as the principle which converts being into a being-for-us . . . [a] double point of view of Being the Subject, placed under the direction of a 'universal method.'"[16] I think that this kind of classification has become something of a doxa in our period, where the reaction against Marxism has produced

any number of reborn anarchisms. On my view, the most welcome result of this noology is not so much its conclusion about State-oriented thought as its passionate qualification of the nomadic thinking that is its opposite— a dualism if ever there was—and that runs the risk of an association with all kinds of racisms owing to the terms in which nomadic situationality is celebrated: race, tribe, nationalism. But here the authors have a magnificent thing to say: "The tribe-race only exists at the level of an oppressed race, and of the oppression it undergoes; there are only inferior races, minority races, there is no dominant race, a race is not defined by its purity but rather by the impurity conferred on it by a system of domination"; and so on, to the obligatory climactic quotation from the Rimbaud of *A Season in Hell.*[17] This everyone can subscribe to, it seems to me; as always the deeper truth of Deleuze and Guattari is to be found on this side of the opposition, in the remarkable intuition of the minor which emerges from their thought (and which has found something of its own codification in the now classic—the now unfortunately classic—thoughts on minor literature and inner subversive language in the Kafka book,[18] something of a lost chapter to this one, a stray plateau to be added in here).

It is thus in the analysis of nomadic texts and micrological war machines that we will expect to find the most interesting pages. (As far as the State is concerned, as the title of the corresponding chapter suggests, it is rather the operation of "capture," of appropriation and annexation, exerted by the State over its satellites, its accompanying nomad or guerrilla groups, which will make up the interest of the corresponding analyses.) It is in the magnificent set piece on blacksmiths and metallurgy that we find the demonstration of a Deleuzian ideological analysis, one based on the dualisms of Hjelmslev's linguistics and which finds its strength in the insistence by Deleuze and Guattari on exteriority. For not only is the war machine "exterior" to the State; in a sense everything theorized in *Mille plateaux* is a phenomenon of exteriority, since the language of interiority, subjectivity, identity, the warm night in which "all cows are gray," is itself one of the polemic targets of Deleuzian thinking. But exteriority, now suddenly meaning relationship, opens a given phenomenon up to the outside. This then relates the individual phenomenon—whether it be a text of some sort, or this or that social individuality—to larger external forces.

The traditional vocabulary of ideological analysis is, to be sure, a relatively limited one, in which for any such individual phenomenon—a text,

an idea, or even a social class—equivalents are sought, and a correlation is meant to be established between this or that aspect of the superstructure and conditions in the base or infrastructure. The doctrine of externality usefully transcodes all this and gives us a more supple provisional way of dealing with the operation of transcoding, in which it is no longer a question of establishing some simple one-to-one correlation between two already existing entities (such as literature and society, for instance), but rather of showing how any given text knows lines of flight out beyond itself, being apparently autonomous yet in its very structure carrying a kind of referentiality, a kind of movement out of itself to something else.

Hjelmslev's linguistics is a more suitable model for this process than such widely accepted forms of semiotic or linguistic analysis as Saussure's because its two planes include four terms and are related to each other only by exteriority, by a specific or contingent intersection, rather than by some deeper, preestablished harmony. Thus the two planes of content and expression are themselves each organized into oppositions between sub-stance and form: already the old distinction between form and content is defamiliarized and renewed by this violent reassignment of each to different zones within the linguistic phenomenon. Content now has its own logic and inner dynamic, just as expression does: there is a form and sub-stance of content, just as there is a form and substance of expression. The coordination of the two planes yields a model in which the Deleuzian flux (the content) can now be punctually articulated in a given code (the expres-sion), yet in such a way that these can be analyzed separately as distinct moments which find their combination historically, as an event rather than a structure. Deleuze indeed insists strongly on a significant distinction be-tween *connexion* and *conjugaison* (conjunction): the latter term belongs to the side of the State, and foretells a kind of organic capture in which the autonomy of the two planes is finally lost; "connexion," however, would designate the provisionality of the meeting and the way in which each plane continues to remain exterior to the other, despite the productive interaction between them.[19]

It is a complex model, which is best conveyed by illustration and ex-ample, particularly this striking one of metallurgy, in which for the first and only time in the work a properly Hjelmslevian table is reproduced.[20] For the question turns on the nature of the relationship between the gen-eral form of the nomadic war machine (which can be found in types of

science and art fully as much as in Genghis Khan's social institutions) and the specific phenomenon of the blacksmith in traditional society. Oddly enough, it is the social reality of the blacksmith which is designated as the plane of content, and the war machine that of expression, perhaps because the war machine articulates the form which governs the organization of the specific social reality of metallurgic production.

Yet how can blacksmiths and metallurgy—presumably a sedentary mé-tier like those of modern society and unlike the activity, say, of hunters—be characterized as nomadic? We have to look at the material relations im-plied in this peculiar type of matter, whose extraction, unlike that of other elements such as wood or stone, requires the linkage of fields, mountains, forest, and desert. It is this unique specificity of the raw material that both gives it a relational privilege over other natural elements and also confers a social privilege on the smiths who work it. Indeed, these pages include a remarkable "praise" of metal itself as "what raises to consciousness some-thing only hidden or buried in other raw materials and other operations."[21] Metal is thus seen as matter par excellence, the *machinic phylum* itself, the very source of Wilhelm Wörringer's idea of a *nonorganic life* (which will also play a significant role in the first *Cinéma* book[22]). Metalworking is necessarily something more than a technique; it is a relationship to the singularities, the contingent "events" of raw material. And the blacksmith must somehow "follow" those contingencies—it is in that sense that he is more nomadic than other kinds of workers. Nomadism, in other words, is the process of following contingencies, events of matter, *haecceities* (to use the medieval expression), which Deleuze glosses at some length across the body of the earth: the blacksmith's work is thus the specific equivalent or *analogon* of this more general process, whence his magical power and prestige in tribal societies of all kinds.

But the Hjelmslev model intervenes precisely here, in the fact that both the work of the blacksmith and the functioning of the nomadic war ma-chine have their specific externality; that is to say, both are defined in an essential relationship to an element, a raw material, a geographical context. Thus while each is the form-term of their specific planes of content and ex-pression, each also has a substance-term. The substance pole of the metal-lurgist lies, then, in metal itself, as the very epitome of the phylum, the flux of matter as such; the substance-term of the war machine is smooth space as such (extrapolated then into desert or ocean, and governed by a move-

ment distinct from movement from point to point, which Deleuze characterizes as turbulence—vortices, whirlpools, eddies—a swirling which is an event and not a line drawn from place to place). These pages, rich with detail, are among the most exciting moments in *Mille plateaux* and should be analyzed at greater length; I have merely wanted to show what the operation of ideological coordination between social form and specific social institutions looks like in Deleuze, and how this particular analysis, on the side of nomadry, is a good deal more complex and interesting than the corresponding noological reading of forms associated with the State.

Now I want to move from the narrower question of the relationship to Marx to the broader question of the relationship to History, it being understood that the test of such a relationship will come with the capacity of the Deleuzian conceptual apparatus to register (and in this case, since we are dealing with texts dating from 1972 and 1980, to *predict*) the novel structures of late capitalism—or, in other words, our own actuality. The noological inquiry, however, will pass through questions of representation not in the sense in which some very eminent contemporary studies of history have interrogated historical texts for their deeper narrative paradigms, but rather for the larger non-narrative structures that make a Deleuzian metahistory possible in the first place. You will already have suspected that chief among such non-narrative structures is that of dualism itself, or duality: it was already implicit in *L'Anti-Oedipe* in the form of the great opposition between revolution and fascism which constituted one of that book's starting points and one of its basic conceptual dilemmas. But *L'Anti-Oedipe*'s machinery complexifies this particular opposition and adds new terms at every step, denying it the status of a mythic or cosmological antithesis that the great opposition in *Mille plateaux* between the Nomad and the State seems everywhere on the point of asserting. But is the tension between the desiring-machines and the body without organs of that cosmological type? It can seem so when we retranslate it into the terms of the great opposition between the molecular and the molar. And what of the figure of the schizophrenic (in *L'Anti-Oedipe*)? As a zero degree, it does not really seem opposed to anything in that dualistic way, not even to its political opposite number, the paranoid.

Indeed, I believe that it is the unifying will of *Capitalisme et schizophrénie*,

its drive toward monism, which is paradoxically the source of the later dualisms. For the principle of desire itself would be a monism: everything is libidinal investment, everything is desire; there is nothing which is not desire, nothing outside of desire. This means, of course, that fascism is a desire (something we now know well, but which was a more scandalous assertion at the time), that bureaucracy is desire, the State is desire, capitalism preeminently desire, even the much maligned Oedipus complex has to correspond to a certain desire in order to take on its inveterate authority.

But how does dualism emerge from monism, when it would seem that the very vocation of monism lay in the rebuking of all those traditional dualisms and in their replacement by a single principle? It is a numerological question, finally, and Deleuzian numerology, or at least the return of the numerological throughout these pages, may afford an answer. If the mission of the One lies in subordinating illusory pairs, doubles, oppositions of all kinds, then it turns out that we are still in dualism, for the task is conceived as the working through of the opposition—the dualism—between dualism and monism. The One may overcome the Two, but it also produces it: it may then counterattack from the other end of the series and seek to undermine the Dual by the Multiple, or by Multiplicity itself—many multiplicities (one, two, three . . . many Vietnams) as opposed to the One of the Multiple itself.[23] Indeed, the whole dialectic becomes intensified if we go even further (as our authors do in *Mille plateaux*) and suggest that Number itself has its opposite in the nondenumerable. This is their remarkable solution to the question of minorities within capitalism, it being understood that the solution also bears on that even more fundamental antithesis developed throughout *Mille plateaux* between major and minor (royal science versus minor science, for example) and which is, as I've said, best known programmatically from the formulation of a minor literature and a minor language in the Kafka book. Here is the fundamental statement:

> What defines a minority is thus not number, it is the relationships within number. A minority may be numerous or even infinite: just like a majority. What distinguishes the two is that the relationship within number constitutes an ensemble in the case of the majority, a completed or an infinite ensemble but one that can always be denumerated or counted; whereas a minority is defined as a nondenumerable ensemble, whatever the actual number of its elements. What characterizes the nondenumerable is neither ensemble nor ele-

ments: it is *connection* [which, as I have already said, Deleuze now wishes to distinguish sharply from conjunction], the "and" that is produced between the elements, between the ensembles, and that belongs to neither of them, which escapes them and constitutes a line of flight. . . . The role of the minority is to bring out the power of the nondenumerable even when it consists in only one member.[24]

It is an ingenious solution, which reinforces and theorizes the priority of what is outside the system (minorities, hors-classe) over and against what is still inside it (the working class); as such, it is perhaps more congenial to the current climate of identity politics at the same time that it clings to an older political value of subversion and contestation in order to rewrite it and give it a new theoretical justification — "the emergence of a foreign language within language itself,"[25] as another formulation of the minor puts it. But who does not see at the same time that this dialectical emergence of something other from out of the vexed system of number (one, dual, multiple, many multiplicities) also reinstates the dualism of number as such, by positing the new opposition of Number and the Nondenumerable?

I want now to make a few final remarks about *Mille plateaux* in the light of these issues, which are certainly not clarified by the extraordinarily complex and abstract, lapidary and formal conclusions to that book, where the theoretical materials (strata, assemblages, rhizomes, the body without organs, deterritorialization, the abstract machine) are laid out in such a way as to make the question of monism and dualism quite undecidable. I do want to correct the impression that the opposition between the State and the Nomads is the dominant dualism here: certainly, it is the most dramatic and the most mythic (if I can put it that way, meaning thereby also the most susceptible to narration). I also suspect that, being more accessible, these chapters are perhaps more widely read and influential than the others. But even here the issue is complicated by a terminological slippage which sometimes replaces "nomadism" with "war machine," despite the desperate and strenuously argued qualification that the aim and telos of this war machine is not at all "war" in the conventional sense.

But this may furnish the occasion for saying why the emergence of this or that dualism should be a cause for complaint or critique in the first place. Dualism is, I believe, the strong form of ideology as such, which may of course disguise its dual structure under any number of complicated substitutions. This is so, I want to assert, because it is the ultimate form of the

ethical binary, which is thus always secretly at work with ideology. Thus one can say, with Nietzsche, that the opposition between Good and Evil (itself derived from that between Self and Other) is always noxious and to be eradicated at the source by way of transcendence into another mode of thinking, "beyond good and evil." This does not mean, as the fainthearted or the bourgeois liberals believe, that morals in general are to be done away with and that henceforth everything is permitted, but rather that the very idea of the Other—always transmitted through concepts of evil—is to be done away with (perhaps along with the very idea of the Self, as so many religions have taught). In passing, one can then even more strongly deplore the revival of disciplines such as ethics today, after the ebbing of that modern period in which such disciplines had proved utterly contradictory and sterile, academic in the bad sense.

What the ethical binary now means for other kinds of dualism is that it always tempts us to reinsert the good/evil axis into conceptual areas supposed to be free of it, and to call for judgment where none is appropriate. Nowhere is this more obvious than in the dualisms of Deleuze and Guattari, where the reader feels perpetually solicited to take sides with the Schizo against the Paranoid (or the body without organs) and with the Nomads against the State. But the example of the war machine may demonstrate how misguided such identification would be. The Deleuzian argument indeed turns on the reassurance that the nomadic war machine does not have war as its ultimate end or content, a proposition drawn from Paul Virilio's analysis of the contemporary "military–industrial complex," where the latter plausibly suggests the insertion of military technology—constant capital—as a new axiom, so to speak, of contemporary capitalism that now requires its incorporation as an economic function and no longer as a means of defense.[26] It is the argument with which we have grown familiar, namely, that military spending in and of itself (and not for any actual use or warlike purpose) turned out to be one of the principal post-Keynesian ways of solving the Great Depression. But on the level of judgment, or even libidinal investment, this merit of the late-capitalist war machine to solve economic crises rather than to flourish by way of new wars is probably not the same kind of endorsement as what we are asked to accord the Nomads when we decipher their hidden mission as a resistance against the State rather than as the "scourge of God" and the source of bloody raids for their own sake. To what level of icy historical contem-

plation the move beyond dualism, the move "beyond good and evil," raises us must be an open question; but the example shows at the very least the way in which the ethical solicitations of dualism persist, even within the most complicated continua between various phenomena.

Still, the dualism we have been looking at here—Nomads against the State—is a very late theme of this book, emerging only after some 400 pages on other matters (less dualistic those and impossible to summarize, let alone to examine, here). Much of this material turns on the various forms of reterritorialization provoked by the capitalist axiomatic, and, after a long doctrinal opening about the central Hjelmslev linguistic system on which the book is based, takes the form of various accounts of the production of intensities, the capacity of the properties of phenomena to know transformation, and so forth; intensities and transformations are indeed something like that "foreign language" within our own language which mysteriously passes across the surface (like a minority, like a war machine) and then disappears again. I think that the ultimate appearance of the great, mythic State/Nomad opposition is a way of recontaining all this complex and heterogeneous material: something like a narrative and even, as I've suggested, an ideological frame that allows us to reorder it into simpler patterns. Whether that reordering is possible conceptually I am uncertain: the dense pages with which the book concludes give no particular confidence that the task could ever be carried to any satisfying conclusion. And this is why I think the work includes its own methodological clues, of what I hesitate to call an aesthetic nature. (But we should note that Deleuze and Guattari themselves conclude *Mille plateaux* with something like an aesthetic slow movement in the chapter on the *lisse* and the *strié*.) The clue here lies in the complex discussion of music, based on Pierre Boulez's theories, in which a dualism of slowness and speed emerges as a kind of pattern in its own right, and which can minimally authorize us to see the whole book as an immense musical score, whose alternative dualisms and monisms must also be apprehended as a pulsation of this text, and a vast interplay of modes of writing, as they recommend for reading Nietzsche, where

> the problem is not so much that of a writing of fragmentation. It is rather that of swiftnesses and decelerations: not writing slowly or swiftly, but rather such that writing itself, and everything else, should be the production of velocities and slownesses between particles. No

form can resist it, no character or subject can survive in it. Zarathustra knows only fast or slow tempi, and the eternal return, the life of the eternal return is the first great concrete liberation of nonpulsed time.[27]

It is a rehearsal of the distinction between the two great forms of time, the Aion and the Chronos,[28] which will recur so productively in the *Cinéma* books.

But one might also conclude in another way, with the other post-ideological form of dualism as such. The latter has been argued to be omnipresent in Deleuze, not least in these materialist collaborations with Guattari, which some have set against, in a properly dualistic opposition, the more Bergsonian and idealistic tendencies of the works signed by Deleuze as an individual philosopher. In that case, a certain dualism might be the pretext and the occasion for the very "overcoming" of Deleuzian thought itself and its transformation into something else, something both profoundly related and profoundly different, as in Hegel's transcendence of what he took to be the dualism in Kant.

Yet there is another way of grasping just such dualisms which has not been mentioned until now, and that is the form of the production of great prophecy. When indeed the ideological is lifted out of its everyday dualistic and ethical space and generalized into the cosmos, it undergoes a dialectical transformation and the unaccustomed voice of great prophecy emerges, in which ethics and ideology, along with dualism itself, are transfigured. Perhaps it is best to read the opposition between the Nomads and the State in that way: as reterritorialization by way of the archaic, and as the distant thunder, in the age of the axiomatic and global capitalism, of the return of myth and the call of utopian transfiguration.

Notes

1 G. W. F. Hegel, *Phenomenology of Spirit*, trans. A. V. Miller (Oxford, 1977 [1807]), 19–20.

2 Karl Marx, *Grundrisse*, Vol. 28 of *Marx–Engels Collected Works* (New York, 1986), 38.

3 Gilles Deleuze and Félix Guattari, *L'Anti-Oedipe* (Paris, 1972), 174; my translation here and elsewhere unless otherwise indicated. See also *Anti-Oedipus: Capitalism and Schizophrenia*, trans. Robert Hurley, Mark Seem, and Helen R. Lane (Minneapolis, 1983), 149.

4 *Harper Encyclopedia of Science*, ed. James R. Newman (New York, 1963), 1: 128. And see Gilles Deleuze and Félix Guattari, *Mille plateaux*, Vol. 2 of *Capitalisme et schizophrénie* (Paris, 1980):

> The axioms of capitalism are obviously not theoretical propositions or ideological formulas, but rather operatory statements which make up the semiological form of

Capital, and which form constituent parts of the assemblages [*agencements*] of production, circulation, and consumption. The axioms are primary statements, which neither derive from nor depend on any other. In a way, a given flux can be the object of one or several axioms at the same time (the ensemble of such axioms constituting the conjugation of the flux); but it can also lack any axioms of its own, so that its treatment is simply the consequence of other axioms; finally, it can remain outside altogether, and evolve without limits, remaining in the state of "free" variation [*sauvage*] in the system. There is in capitalism a constant tendency to add more axioms. (577)

See also *A Thousand Plateaus: Capitalism and Schizophrenia*, trans. Brian Massumi (Minneapolis, 1987), 461–62. The source for this doctrine of the axiomatic would seem to be Robert Blanché, *L'Axiomatique* (Paris, 1959).

5 Deleuze and Guattari, *L'Anti-Oedipe*, 294; *Anti-Oedipus*, 247.
6 "What [modern societies] deterritorialize on the one hand, they reterritorialize on the other" (*L'Anti-Oedipe*, 306–7; *Anti-Oedipus*, 257).
7 *L'Anti-Oedipe*, 301; *Anti-Oedipus*, 253.
8 See *L'Anti-Oedipe*, 304 and 303; *Anti-Oedipus*, 255.
9 See, especially, Deleuze and Guattari, *Mille plateaux*, 579; *A Thousand Plateaus*, 463.
10 *Mille plateaux*, 585; *A Thousand Plateaus*, 468.
11 *Mille plateaux*, 589; *A Thousand Plateaus*, 472 (the reference is to work by Tronti and Negri).
12 Deleuze and Guattari, *L'Anti-Oedipe*, 272; *Anti-Oedipus*, 230.
13 *Anti-Oedipus*, 274; *L'Anti-Oedipe*, 326.
14 Deleuze and Guattari, *Mille plateaux*, 466; *A Thousand Plateaus*, 376.
15 *Mille plateaux*, 454; *A Thousand Plateaus*, 367.
16 *Mille plateaux*, 464, 469; *A Thousand Plateaus*, 374, 379.
17 *Mille plateaux*, 470; *A Thousand Plateaus*, 379. The quotation—"Il m'est bien évident que j'ai toujours été race inférieure"—is from Arthur Rimbaud, "Mauvais sang," *Une saison en enfer*, in *Oeuvres complètes* (Paris, 1963), 220.
18 Gilles Deleuze and Félix Guattari, *Kafka: Pour une littérature mineure* (Paris, 1975).
19 See Deleuze and Guattari, *Mille plateaux*, 636; *A Thousand Plateaus*, 510.
20 This table appears on page 518 of *Mille plateaux* (see also *A Thousand Plateaus*, 416):

	CONTENU	EXPRESSION
Substance	Espace troué (phylum machinique ou matière-flux)	Espace lisse
Forme	Métallurgie itinérante	Machine de guerre nomade

21 *Mille plateaux*, 511; *A Thousand Plateaus*, 410.
22 See Gilles Deleuze, *Cinéma 1: L'Image-Mouvement* (Paris, 1983), 75–76.

23 But we also need to register Deleuze's dissent from such formulas, as in *Foucault* (Paris, 1986):

> The essential feature of this notion lies in the fact that the construction of a substantive like "multiple" ceases to be a predicate in opposition to the one, or attributable to a subject identifiable as One. Multiplicity must be utterly indifferent to the traditional problems of the many and the one. . . . There is no one and no multiple or many. . . . There are only the rare multiplicities, with their singular points, their empty places for whoever comes briefly to function as a subject within them. . . . Multiplicity is neither axiomatic nor typological but topological. (23)

Would it be impertinent after that to suggest that the "opposite" of this new kind of multiplicity might well turn out to be the dualism?

24 Deleuze and Guattari, *Mille plateaux*, 587, 588 (and, on the English "and," see 124, n. 26); *A Thousand Plateaus*, 469, 470.

25 *Mille plateaux*, 638; *A Thousand Plateaus*, 512.

26 See *Mille plateaux*, 583–84; *A Thousand Plateaus*, 467–68, and, on Virilio, 571 n. 64.

27 *Mille plateaux*, 329; *A Thousand Plateaus*, 269.

28 See *Mille plateaux*, 320; *A Thousand Plateaus*, 262.

The Memory of Resistance D. N. Rodowick

What must I be, I who think and who am my thought, in order to be what I do not think, in order for my thought to be what I am not? . . . How can it be that being, which could so easily be characterized by the fact that "it has thoughts" and is possibly alone in having them, has an ineradicable and fundamental relation to the unthought? —Michel Foucault, *The Order of Things*

In *Cinema 1: The Movement-Image* and *Cinema 2: The Time-Image*, Gilles Deleuze recapitulates a number of important ideas and arguments that are worked through more completely in *A Thousand Plateaus*, *Foucault*, and *What Is Philosophy?* while anticipating his extraordinary book on Leibniz, *The Fold*. Philosophically, the two *Cinema* books also represent a retrospective look. Deleuze's meditation on cinema recomprises many of the ideas and arguments in *Difference and Repetition* concerning the importance of Bergson, Kant, and Nietzsche for his philosophy of difference. The first volume is a fascinating extension of Deleuze's Bergsonism as a theory of image and movement, while the second volume testifies to the importance of a Nietzschean

perspective for both books. From the first volume to the second, Deleuze works through the vicissitudes of movement as concept: from the chronological succession of spatial intervals to absolute movement as universal variation (*physis* as flux, multiplicity of forces, and universal becoming), then to the force of time as change or eternal recurrence. Finally, *The Time-Image* presents a Nietzschean meditation on thought as experimentation, where truth is to be created rather than discovered.

In this manner, Deleuze identifies in the time-image what he calls an "original will to art," which is simulacral. The time-image and, through its own will to power, the movement-image are paradoxical entities that throw thought off balance. They are "unreasonable" images since, unlike reason or the dogmatic image of thought, they do not adhere to a logic of representation, identity, or the return of the Same. But this is only half of the encounter. For once thrown off-balance, or confronted with the simulacral unthought-in-thought, we need to become philosophers. In the name of the time-image, Deleuze asks that we the spectators pursue a philosophical activity inspired by the Heideggerian question: What calls for thinking? That is, what power is expressed in the time-image when it awakens the idea that "we are not yet thinking"? This power is a thought from the outside—and this idea is undoubtedly the most complex and elusive one in *The Time-Image*. Deleuze adopts his presentation of "the outside" from Maurice Blanchot.[1] But throughout the second half of *The Time-Image*, this concept varies subtly, depending on the context. The outside has as many definitions as time itself, including "life" as universal variation (where matter = image) and change as creative evolution. The most fundamental force of the outside undoubtedly derives from time's passive syntheses, including the impersonal form of time that divides the ego from the I and difference in itself expressed as eternal recurrence. In the *Cinema* books, then, "the outside" refers to three distinct planes of immanence: universal variation; virtuality as the force of time as change; and virtuality as an absolute memory, the memory of resistance, which expresses the powers of the outside.

Logically, the outside is posited through any two incommensurable terms that come into contact independent of space. This is the logic of the "irrational interval" [*coupure irrationnelle*], which is not a spatial figure since it neither belongs to any set nor can be incorporated as part of a whole. By contrast, in the movement-image the outside is the referent: a space with which the image has both iconic and indexical relations and against which

it measures itself. The value of the interval is measured by a spatial commensurability where the whole is the open — a web unfolding horizontally through relations of contiguity and continuity and vertically through relations of differentiation followed by integration. Here the world is constituted as image, since the image can expand to encompass any world with all the subjects and objects in it. However, the time-image does not represent in this sense, neither presenting us with an imaginary world complete unto itself in which we are asked to believe nor giving us a transcendent perspective from which we are expected to judge the world as false or true, lacking or full. The outside is not space or the actual, but rather the virtual, which acts "from the outside" — on another plane or in another dimension — as force or differentiation. Rational connections present spatial intervals, namely, the indirect image of time as a succession of sets or segmentations of space. But irrational intervals are not spatial, nor are they images in the usual sense. They open onto what is outside of space yet immanent to it: the anteriority of time to space, or virtuality, becoming, the fact of returning for that which differs. Virtuality, or difference in itself as force, defines time as the Outside. This force opens a line of variation in any image, sign, idea, or concept that attempts to express it. Only on this basis can the cinema found, in Deleuze's terms, "a theory of thought without image."[2]

The outside must not be confused with exteriority. Otherwise, the powers unleashed by the irrational interval and the series of time cannot be understood. Exteriority always concerns *form* and relations between forms. It is spatial and territorial. Two forms identical to themselves but different from each other are external to each other. However, the outside fundamentally concerns *force* and relations of forces. From Deleuze's Nietzschean perspective, force is primarily in relation with other forces. This implies an irreducible outside through which a force acts or is acted upon by another force. As Deleuze explains in *Foucault*, the becoming of forces must not be confused with the history of forms because forces operate in another dimension: *"an outside which is farther away* than any external world and even any form of exteriority, which henceforth becomes infinitely closer."[3] Forces operate at a site and in a dimension other than those of forms — not the space of extensiveness, the actual, and perception but the dimension of the Outside, the virtual, which is not so much "space" as "becoming" or emergence. This is why the relation between history and memory is incommensurable. Forces of the outside do not constitute a historical

transformation, or succession of composed events. They are, rather, "composing" forces, reacting to or with other forces from the outside. Becoming, emergence, and change involve composing forces, not composed forms.

In this respect, *The Time-Image* suggests a political philosophy as well as a logic and an aesthetic. Evaluating the political consequences of the time-image requires understanding that force is not equivalent to power. Rather, the great lesson of Foucault is that a historical meditation on force enables us to consider the relation between power and resistance as thought from the outside, or the unthought-in-thought of new ways of thinking and new modes of existence. Simulacra, including direct images of time, have no other function. Thought from the outside, this unthought-in-thought, is always the thought of resistance. If, as Foucault implied, the last word of power is that *"resistance comes first,"* it is not because resistance blocks power or slows it by friction.[4] Rather, that which resists is mobile, diffuse, nomadic, and deterritorializing. Fueled by its sensitivity to the virtual, that which comes from the outside is a power in Spinoza's sense—the capacity of a body or thought to affect, and be affected by, change.

Power in this sense has a special relation to the audiovisuality of contemporary culture, that is, how our culture is defined by its particular stratifications of the space of visibility with that of utterability.[5] Deleuze asks that we consider the two sides of power as understood by Foucault: on the one hand, that which oppresses and occludes; on the other, that which can be affected by, and in turn affect, change. The division of the subject by time exemplifies a fundamental dualism—the difference between a force that acts and one that is acted upon—which Deleuze maps onto other domains, including those of the visible and the utterable in their relation to knowledge, power, and subject formation. This division between the affecting and the affected is productive of a multiplicity that can never be represented wholly or singly because it is divided from itself by the form of time. This is why the series of time is always a rhizome and never a line, a set of mutations and never a dialectical unity, the incommunicable and never an act of communication or information. Whatever is divided by time cannot resolve into a unity. Rather, it mutates, multiplies, and differentiates itself.[6]

The audiovisuality of modern cinema has a special relation to power and resistance as expressed in contemporary culture. As Deleuze explains in *Foucault*, power neither sees nor speaks. Neither form nor force, it maps or diagrams. Power organizes the horizons of seeing and the limits of say-

ing. The visible and the utterable, in fact the whole audiovisual regime, are caught up in relations of power that they suppose and render actual as diagrams or abstract machines. Power does not repress; it produces. And what it produces are spiritual automata or images of thought that are expressed in art and cinema no less than in philosophy. The variable combinations of the visible and the utterable constitute a historically formed stratigraphic space where power is immanent in relations of forces that are nonformal and nonstratified. Power is "diagrammatic," but it is not formal. The diagram or abstract machine of a given era is suprasensible. Like the relation of the plane of immanence to concepts, it should not be confused with audiovisual formations. Rather, it is the historical a priori that audiovisual formations suppose.

Here the logic of the outside takes a peculiar yet fundamental turn. Immanent to every historical formation are relations of forces as its "outside." Relations of forces are mobile and diffuse. They express an absolute or infinite movement. These movements are not external to the stratifications of audiovisual space; they are *the* outside, more distant than any exteriority that could be represented, deeper than any interiority that could be thought. Forces are a continuous becoming, a becoming of forces or the virtual that doubles history as the actual succession of events. Power is not formal. Yet one might say that it "formalizes": it composes, limits, stratifies, and territorializes. But force is nonformal. And while it is immanent to relations of power and constructions of audiovisual space, it is equally outside them, in time, as the "opening of a future, with which nothing ends since nothing has become, but everything transforms."[7] Power and resistance are therefore coupled in a complementary yet incommensurable relation. Power anchors itself in relations of forces to the extent that it must territorialize or map them in an abstract machine; but resistance is necessarily in a direct relationship with the outside, the fluidity and multiplicity of future-oriented forces from which power has tried to stabilize itself.

What is thinking, then, in relation to power? Thinking or thought is defined not by what we know but by the virtual, or what is unthought. To think, Deleuze argues, is not to interpret or to reflect, but to experiment and to create. Thought is always in contact with the new and the emergent, with what is in the midst of making itself, and thus supposes a distinction between knowledge and thought. Knowledge is defined by formed relations—the construction of an audiovisual space as what can actually

be seen and said in a given historical era. Power is the relation of forces expressed as a diagram or abstract machine. And, finally, there is "the outside," virtuality or an absolute relation that is in fact a nonrelation—the unthought-in-thought. Foucault's description of a microphysics of power has a particular significance here. That singular point where life is the most intense, where its energies are most concentrated, is the struggle with power or the marshaling of forces to evade the snares of power. Power and resistance present two sides of force as a reciprocal inside and outside. Power cannot operate, cannot form an abstract machine, without calling on points of resistance, which are in fact primary. And power cannot target life without simultaneously revealing a life that resists power by sustaining a force of the outside which never ceases to shake and overturn abstract machines, awakening what is unthought in them.

Another way of understanding the force of the outside and its relation to the unthought is through the distinction between a *theorem* and a *problem*. The theorem follows an axiomatic logic that "develops internal relationships from principle to consequences."[8] This is a self-contained, deductive logic-world not unlike the automata of action-images (mental relations). Alternatively, the problem confronts thought as an obstacle or outside. This outside should not be confused with either the exteriority of the physical world or the interiority of a mental one, at least in the context of the direct time-image. The movement-image has its own spiritual automata, of course, founded on a dialectical relation between the outside and the inside. Here the outside is the physical world as external "real," which measures the accuracy of cinematic description and governs the logic of the image as the unfolding of sensorimotor situations. The inside, for its part, marks the interiority of thought as a projection in images. In this way, the language of cinema in the movement-image is organized as internal monologue or is regulated by the mental or linguistic "laws" of metaphor and metonymy, association and contiguity. Between the two is a dialectical expansiveness wherein world, image, and concept achieve the unity of creator and spectator in an organic image. A problem often informs or motivates a theorem as the question to which it longs to respond, but this is not a dialectical relation. A theorem may incorporate a problem whose resistance to a deductive whole it attempts to master. A problem may slip into a theorem, setting its deductive unfolding onto unforeseen roads. However, the two will never meet in a dialectical unity. Rather than

deriving from an axiom, the problematic deduction arises because "I am haunted by a question to which I cannot reply." This is a very different image of thought, Nietzschean in inspiration, in that it tears belief from faith to restore it to thought. Far from restoring knowledge to thought, or providing thought with the internal consistency and certainty it longs for, "the problematic deduction puts the unthought within thought, because it does away with all interiority by hollowing it out with an outside, an irreducible exergue [*envers*], which devours its substance. Thought finds itself carried away by a 'conviction' [*croyance*], outside any interiority of a mode of knowledge."[9] The problem contains its own principle of uncertainty. Rather than resolving itself in a method or model of knowledge, or freezing itself in a proof, thought is pitched into movement, without finality or resolution, by an unanswered question.[10] All simulacra are problematic in this sense. But to call the time-image "problematic" is also to identify it with a Nietzchean existential ethics.

Thus the formulation of a problem is inseparable from choice. Indeed, one of film's highest aspirations is "the identity of thought with choice as determination of the indeterminable. . . . This is a cinema of modes of existence, of confrontation of these modes, and of their relation to an outside on which both the world and the ego depend." In this respect,

> choice no longer concerns a particular term, but the mode of existence of the one who chooses. . . . In short, choice covered as great an area as thought, because it went from non-choice to choice, and was itself formed between choosing and not choosing. Kierkegaard drew all the consequences of this: choice being posed between choice and non-choice (and all their variants) sends us back to an absolute relation with the outside, beyond the inward psychological consciousness, but equally beyond the relative external world, and finds that it alone is capable of restoring the world and the ego to us. . . . It is not simply a question of a film-content: it is cinema-form . . . which is capable of revealing to us this higher determination of thought, choice, this point deeper than any link with the world.[11]

The time-image asks us to believe again in the world in which we live, in time and changing, and to believe again in the inventiveness of time where it is possible to think and to choose other modes of existence. This is the utopian aspect of the time-image, which also transforms memory

in relation to time. Memory is no longer habitual or attentive as a faculty for recollecting or for regathering images from the past. In positing the coexistence of nonchronological layers and incommensurable points, the orders of time figure memory as a membrane joining two sides, a recto and a verso divided by the pure and empty form of time. Here, sheets of past emanate from a pure virtuality (an unreachable interiority where the I divides from the ego), while the actual or perception recedes from us as an absolute horizon (an outside yet to come—an indeterminate future or a world, people, or thought that is not yet).

Spiritual automata are thus the expression of a power. And this is why Deleuze and Guattari suggest, "It is possible that the problem now concerns the one who believes in the world, and not even in the existence of the world but in its possibilities of movements and intensities, so as once again to give birth to new modes of existence. . . . It may be that believing in this world, in this life, becomes our most difficult task, or the task of a mode of existence still to be discovered on our plane of immanence today."[12] That thinker within me that is the unthought of my thought is also a power of transformation, indeed the power to transform life by revealing new lines of variation in our current ways of thinking and modes of existence.

How are we to become what we do not yet think, in order to think what we have not yet become? To believe again in life is to believe again in the transformative powers of life. And what is life if not this capacity of resistance in a will to power that acknowledges change and becoming as forces, or the force of time as change? Nietzsche's *Übermensch* is not a better or superior "man" but what must be overcome in us for humanity to change. Resistance should be understood, then, as an awakening of forces of life that are more active, more affirmative, richer in possibilities than the life we now have.

For Foucault, the stakes of a bio-power mean that life must be liberated in us because it is in us that life is imprisoned and unresponsive to becoming-other. Our contemporary struggle for new modes of existence is defined against two forms of subjectivation. One is an individuation obliged by a power whose command is "you will be One." The other consists of marking the individual, once and for all, with a known and recognizable identity—you will be White or Black, masculine or feminine, straight or gay, colonizer or colonized, and so on. Alternatively, resistance means the struggle for new modes of existence. It is therefore a battle for difference,

variation, and metamorphosis, for the creation of new modes of existence. However, we could neither invent nor choose new modes of existence if the force of time as eternal recurrence, becoming or change, did not undermine identity with difference. Differentiation maintains an opening to the future, from which we derive our powers to affect life and to be affected by it. The goal of the direct time-image and other forms of art, whether successful or not, is to awaken these powers in us. To become-other we need an image to wake the other in us as what yet remains unthought.

That difference returns and so unfolds identity, Deleuze argues, is presented throughout Foucault's work by the theme of the double. The double is not a projected interior, but rather an interiorization of the outside; not a redoubling of the One but of the Other, as a folding of the unthought within the subject. The double is simulacral. If the spiritual automaton awakens the unthought thinker in us, this is not a reproduction of the Same but a repetition of the Different. "It is not the emanation of an 'I,'" Deleuze explains, "but something that places in immanence an always other or a Non-self. It is never the other who is a double in the doubling process, it is a self that lives me as the double of the other: I do not encounter myself on the outside, I find the other in me."[13]

The other in me is the unthought within thought, or the spiritual automaton that lives in me. This redoubling constitutes an absolute memory, a memory of the outside that should not be confused with an archival or commemorative memory. This absolute memory is the "real name" of the affection of self by self. Time is the form through which the mind [*l'esprit*] affects itself, while space is the form through which the mind is affected by something else. Time as subjectivation, division of the temporal I from the spatial self, is Memory in this absolute sense: a splitting of time where Memory "doubles the present and the outside and is one with forgetting, since it is endlessly forgotten and reconstituted. . . . Time becomes a subject because it is the folding of the outside and, as such, forces every present into forgetting, but preserves the whole of the past within memory: forgetting is the impossibility of return, and memory is the necessity of renewal."[14]

Therefore, to think is not to recall or reconsider the past, but rather to invent the future. The time-image is like Ernst Bloch's concept of *Vor-Schein*, or anticipatory illumination. It is anterior to or ahead of history. It does not represent either the real or the imaginary; it is the harbinger of a new

reality which must yet be invented. What calls for thinking, then, has the most complex and profound relationship to time. According to Deleuze,

> To think the past against the present, to resist the present, not for a return but "in favor, I hope, of a time to come" (Nietzsche): this means making the past active and present to the outside, in order, finally, for something new to happen, and for thinking always to happen in thought [*pour qu'arrive enfin quelque chose de nouveau, pour que penser, toujours, arrive à la pensée*]. Thought thinks its own history (the past), but in order to free itself from what it thinks (the present), and to be able, finally, to "think otherwise" (the future).[15]

Deleuze argues in *Difference and Repetition* that the only aesthetic problem of concern to philosophy is the relation of art to everyday life. Because our contemporary everyday life is immersed in an audiovisual and information culture, cinema's ways of working through the relations of image and concept have become particularly significant to our strategies for seeing and saying. This is not because cinema is the most popular art. Television and video games now arguably have a far greater economic and "aesthetic" impact. However, cinema's history of images and signs is nonetheless both the progenitor of audiovisual culture and perhaps the source of its unfounding as a simulacral art. To think otherwise, from the outside, or to find the subtle way out, means thinking through the history of the audiovisual. To this end, art must appeal not to a transcendent world but to the world here and now in which we live. Art must extract from the habitual repetition of the everyday "a little time in a pure state," an event or virtuality in the passing present, deeper than any interior, farther than any exterior. Like every art form, the original will to art of the time-image consists of extracting difference from repetition by "revers[ing] copies into simulacra." Art neither represents nor imitates, because it repeats: "It repeats all the repetitions, by virtue of an internal power (an imitation is a copy, but art is simulation, it reverses copies into simulacra)."[16] Everyday life is characterized by repetition as the return of the same, primarily in the standardized production of commodities and the proliferation of information. Art is not opposed to this mechanical, stereotyped, and habitual repetition. Instead, it embraces it, or rather incorporates it, the better to expose its limits and to extract what is differential and virtual within it. The task of a work of art, then, is to open a line of flight that passes from the

actual to the virtual by interrupting repetition with difference. And gradually, repetition is transformed from the return of the same to creation from difference: first the habitual series (repetition without difference) and the chronological series (repetition as a succession of instants in space), but then the fragmentation of the present, the displacements of nonchronological memory, and the fact of returning for that which differs.

Simulacra do not represent. Thought cannot confirm itself in an initiating image there. Rather, it forces us to think, if we are able, through the construction of Events.[17] We can calculate and rationalize the passing of time as the succession of so many segments in space. This is a passing of the virtual into the actual, where thought recognizes itself in its own image. But the "event" is what happens in between—an *entre-temps* between segments that disjoins thought from itself. Time can only appear for itself in the fissures opened by irrational intervals. In the cinema, events and their corresponding powers emerge only when the force of time returns as difference, unhinging the chronological unfolding of space with seriality, interrupting repetition by relinking series on irrational intervals. The force attached to thinking is neither the exercise of an innate faculty nor the acquisition of a knowledge preconstituted in an external world. Should we then characterize the outside as an aleatory force? The formation of series shows that this is not precisely the case. What the irrational interval determines in direct images of time is analogous to the logic of Markov chains, a sequence of partial relinkings where what comes after is partially determined by what comes before. The outside is a line of variation determined not by continuous and chronological succession, but rather in a relinking on irrational intervals that mixes contingent and dependent forces. Thinking here is organized in new figures: an extraction and relinking of singularities, as well as the organization of singularities into series. What is common to singularities is that they all come from the outside: "Singularities of power, caught in relations of forces; singularities of resistance, which prepare mutations; and even *savage* singularities which rest suspended outside, without entering into relations or letting themselves be integrated (only here does the 'savage' take its meaning, not as an experience, but as what has not yet entered experience)."[18] In other words, where time is rendered incommensurable with space, the virtual opens a vast territory of potentialities in every present that passes. Through events, virtuality unfolds as a vast reserve of future acts, each of which is equally

possible in itself, yet incompossible with all the others. Thus the event "is pure immanence of what is not actualized or of what remains indifferent to actualization, since its reality does not depend upon it. The event is immaterial, incorporeal, unlivable: pure *reserve*. . . . It is no longer time that exists between two instants; it is the event that is a meanwhile [*un entretemps*]: the meanwhile is not part of the eternal, but neither is it part of time—it belongs to becoming."[19] Events are immanent to every moment of time's passing yet remain both outside and in between the passage of time. Simulacra are better understood as heterocosmic forces than as utopian worlds. Between each measure of time is an infinite movement, so many possible worlds and immanent modes of existence that we must recover from time's passing.

The noosigns of the time-image are time's concepts in this respect. Time's direct image is not time in itself, but rather the force of virtuality and becoming, or what remains outside of, yet in reserve and immanent to, our contemporary modes of existence. The irrational interval does not signify or represent; it resists. And it restores a belief in the virtual as a site where choice has yet to be determined, a reservoir of unthought yet immanent possibilities and modes of existence. In this respect, the utopian aspect of philosophy and art is the perpetuation of a memory of resistance. This is a resistance to habitual repetition—a time that is calculated, rationalized, and reified. But it is also resistance to all commerce or exchange, whether in the form of communication or of commodities.

Now, the memory of resistance is not a historical memory even though the history of capitalism is conjoined with the history of philosophy and art in complex ways. If this were not the case, neither art nor philosophy could hold in reserve or express the immanence of the memory of resistance. Capitalism no doubt has produced its own "image of thought."[20] Indeed, Deleuze and Guattari's complaint is that, in the information era, thought has been reduced to commerce, with the concept as its commodity and conversation or common sense its form of exchange. By the same token, philosophy does not have exclusive rights to the forces of deterritorialization. Capital produces its own diabolical forces—what Deleuze and Guattari call its relative deterritorializations—in the forms of imperialism and multinationalism. These and other forces uproot individuals from their land and alienate them from their work and their thought. Deterritorialization can also mean the transfer of wealth out of the earth and the labor

of individuals and into the hands of capital, without respect for borders. Capital has its own concepts and forms of immanence. Marx's great analysis and critique has not lost its force in this respect; it still testifies to the necessity of a critical encounter between philosophy and capitalism.

Therefore, the audiovisual and information era has its own philosophy of communication, consensus, and universal values, but this is not a philosophy of resistance. It is capitalism's own philosophy or image of thought, where it seeks to recognize itself and to affirm its powers. The special task of the simulacral arts and a philosophy of resistance is to interpret and evaluate, as well as to invent alternative ways of thinking and modes of existence immanent in, yet alternative to, late capitalism and liberal democracies. This is why Deleuze and Guattari find it necessary to argue that philosophy *creates* concepts rather than "reflecting on" or "communicating" notions. What is lacking is neither communication nor information; rather, we suffer from too much of both. We lack for neither truth nor knowledge. What we lack is creation and the will to experiment. "*We lack resistance to the present*," they insist. "The creation of concepts in itself calls for a future form, for a new earth and people that do not yet exist. . . . Art and philosophy converge at this point: the constitution of an earth and a people that are lacking as the correlate of creation." [21]

Memory and history are as incommensurable as time and space or the virtual and the actual. History in the sense of commemoration, an affirmative and institutional history, cannot express becoming. Commemorative history is always the history of the victors, as Walter Benjamin so forcefully argued, and a power that inhibits the becoming of subjected peoples. [22] Whatever its forces and resources may be, history works to preserve the values, will to power, and modes of existence of the victors and to inhibit and derail any immanent mode of existence that runs counter to or challenges their powers.

Alternatively, memory is not what is recalled, but rather that which returns. This is what Deleuze calls an absolute memory, deeper perhaps than Bergson's pure memory, as difference in itself or eternal recurrence as the force of returning for that which differs. The relation of history and memory is equivalent to that of power and resistance. The memory of resistance is not a "human memory," although its forces can be marshaled for all kinds of mobilizing narratives: alternative histories, or popular memory and counter-memory in the Foucaldian sense. This memory is absolute

because it is the barrier that thought comes up against—forcing thought to call upon an absolute or infinite movement, the force of time as change, and to recognize the immanence or becomings that resist capitalism and restore life to modes of existence deadened by capitalism.

This becoming, this absolute memory of resistance that founds all acts of resistance, is minoritarian. The principal quality of the minor voice—in art or philosophy—is that of double-becoming. The author and the philosopher can neither represent the people nor speak for or in place of the people. Their power is that of an anterior time, or time as anteriority. They speak "before" as the expression of a becoming or the immanence of an alternate mode of existence. The quality of becoming establishes a zone of exchange between the minor author and the people. The author/philosopher can only anticipate a new mode of existence if the people's becoming is immanent to her thought, just as her thinking is internal to the people's becoming.

> The artist or philosopher is quite incapable of creating a people, each can only summon it with all his strength. A people can only be created in abominable sufferings, and it cannot be concerned any more with art or philosophy. But books of philosophy and works of art also contain their sum of unimaginable sufferings that forewarn of the advent of a people. They have resistance in common—their resistance to death, to servitude, to the intolerable, to shame, and to the present.[23]

Abstract though it may be, philosophy has a place in the resistance to capitalism, and not just by opposing the force of its deterritorializations. For Deleuze and Guattari, the critical and utopian force of philosophy resembles Adorno's negative dialectic in some respects. Rather than simply objecting to the relative deterritorializations of capital, philosophy pursues its lures and contradictions toward an absolute horizon: it makes capitalism "pass over the plane of immanence as movement of the infinite and suppresses it as internal limit, *turns it back against itself so as to summon forth a new earth, a new people.* But in this way it arrives at the nonpropositional form of the concept in which communication, exchange, consensus, and opinion vanish entirely."[24] The nonpropositional form of the concept is not silence, but what readies itself to speak; not speechlessness, but an absolute resistance to what is, in favor of what must come to be and has not yet been thought. The idea of utopia conjoins philosophy with its his-

torical epoch, that of late capitalism, as resistance and critique rather than consensus and collusion.

Philosophy is the caretaker of utopia for a given epoch, forging its concepts and sustaining its forces. It sustains the qualities of infinite movement and so achieves a political and critical force. In this way the concept of utopia forms its own time-image. The time-image of utopia is drawn from Samuel Butler's concept of "Erewhon": both no-where and now-here.[25] Deleuze and Guattari note that, etymologically, utopia "stands for absolute deterritorialization but always at the critical point at which it is connected with the present relative milieu, and especially with the forces stifled by this milieu." The concept of utopia is risky, for there are as many or more affirmative, transcendent, and authoritarian utopias as there are utopias of contestation, immanence, and liberation. The direct time-image, however, is one expression, like revolution, of a utopia of immanence. Utopia is not dream or fantasy here, or the unrealized and unrealizable hope that consoles. "On the contrary," Deleuze and Guattari argue, "it is to posit revolution as plane of immanence, infinite movement and absolute survey, but to the extent that these features connect up with what is real here and now in the struggle against capitalism, relaunching new struggles whenever the earlier one is betrayed. The word utopia therefore designates *that conjunction of philosophy, or of the concept, with the present milieu*—political philosophy."[26]

Does this mean that the cinema of the time-image is a revolutionary and political cinema? Not necessarily, and if so, only in limited cases. As acts or events, art and philosophy are not inherently political in the sense of organized forces capable in themselves of transforming social relations. However, in their anteriority or virtuality they can call forth or solicit political acts and events, and this may be the best definition of utopia. Philosophy's relation to infinite movement is not that of a contemplation of the eternal, nor is it a reflection on the *longues durées* of history. As Nietzsche argued, philosophy interprets and evaluates. In this respect, the philosopher is the physician of culture whose tasks are the diagnosis of becomings in every passing present and the invention of new and unforeseen modes of existence.

To present a direct image of time as the force of change: this is the highest point of thought where cinema and philosophy converge. The utopian force of cinema, like any simulacral art, is that of Nietzsche's untimely

meditation. "Acting counter to the past, and therefore on the present, for the benefit, let us hope, of a future—but the future is not a historical future, not even a utopian history, it is the infinite Now, the *Nun* that Plato already distinguished from every present: the Intensive or Untimely, not an instant but a becoming."[27] This becoming is "outside" history and thus distinguishes a creative force that only philosophy or art can express. Perhaps utopia is not the best concept in this respect because it is not outside history but opposed to it. Thus it is a historical concept—an ideal or motive force housed within history. Alternatively,

> becoming is the concept itself. It is born in History, and falls back into it, but is not of it. In itself it has neither beginning nor end but only a milieu. . . . To create is to resist: pure becomings, pure events on a plane of immanence. What History grasps of the event is its effectuation in states of affairs or in lived experience, but the event in its becoming, in its specific consistency, in its self-positing as concept, escapes History. . . . To think is to experiment, but experimentation is always that which is in the process of coming about—the new, remarkable, and interesting that replace the appearance of truth and are more demanding than it is. What is in the process of coming about is no more what ends than what begins. History is not experimentation, it is only the set of almost negative conditions that make possible the experimentation of something that escapes history. Without history experimentation would remain indeterminate and unconditioned, but experimentation is not historical. It is philosophical.[28]

Foucault expresses a similar idea in his distinction between the "actual" and the present. From a Bergsonian perspective, one might be tempted to see the actual as the completion of the virtual. Foucault's actuality, however, is the continuous becoming of virtuality. The actual and the present are two sides of the passing present, and between these two sides the untimeliness of the passing present as the Now of becoming is what actuality portends. The present is what we are, and therefore what we are already ceasing to be. But Foucault's actual is not what we are now, but rather what we are now becoming, "what we are in the process of becoming—that is to say, the Other, our becoming-other. . . . It is not that the actual is the utopian prefiguration of a future that is still part of our history. Rather, it is the now of our becoming."[29]

The creation of concepts proper to cinema does not recall; it calls forth. It summons or solicits the relations of forces or will to power that express the immanence of new modes of existence. As avatars of becoming, art and philosophy have a special relation to the virtual. They do not actualize a virtual event; they incorporate or embody it. They do not represent or communicate, nor do they recall, commemorate, or celebrate the past. Rather, the task of art is to confide

> to the ear of the future the persistent sensations that embody the event: the constantly renewed suffering of men and women, their re-created protestations, their constantly resumed struggle. Will this all be in vain because suffering is eternal and revolutions do not survive their victory? But the success of a revolution resides only in itself, precisely in the vibrations, clinches, and openings it gave to men and women at the moment of its making and that composes in itself a monument that is always in the process of becoming, like those tumuli to which each new traveler adds a stone. The victory of a revolution is immanent and consists in the new bonds it installs between people, even if these bonds last no longer than the revolution's fused material and quickly give way to division and betrayal.[30]

Like every simulacrum, the cinema of the time-image and the philosophy of resistance share an arduous task: "beyond all the codes of past, present, and future, to transmit something that does not and will not allow itself to be codified. To transmit it to a new body, to invent a body that can receive it and spill it forth; a body that would be our own, the earth's, or even something written."[31] From the cinema of the body to the cinema of the brain, the time-image forges a special relation to both subjectivity and thought. Organized by irrational intervals, the time-image continually interrupts the virtual–actual circuit. This accounts, perhaps, for the difficulty, the boredom, and the miscomprehension inspired by modern cinema. But these difficulties must also be understood as missed opportunities. Our relation to the image is neither determined nor dialectical. With the circuit interrupted, we lose a present perception wherein we can harbor ourselves in the calm waters of attentive recollection. Breaking the circuit is also interrupting the force of repetition we call habit. It is in this sense that virtuality acts as a force from the outside. Deleuze and Guattari call this the supreme act of philosophy: "not so much to think *THE* plane

of immanence as to show that it is there, unthought in every plane, and to think it in this way as the outside and inside of thought, as the not-external outside and the not-internal inside—that which cannot be thought and yet must be thought." [32]

This is not the sublime. Rather, it is the pure and impersonal form of time that divides us from ourselves in identity and in thought. What is personal and human is what we continually actualize in our bodies and brains to cement our identity and render it impervious to movement and change. What Deleuze sees in the time-image is the opportunity to confront these constraints with an inhuman potential that is outside us as the pure form of time. Yet it is also the interiority where we live and think. This is neither an identity nor a thought to which we aspire. It is confronting the virtual as an Other we have not yet become that pitches us into becoming, and as an Idea that in escaping us demonstrates we are not yet thinking—an encounter without finality.

Notes

1 For Deleuze, the most important texts treating the theme of the outside are Maurice Blanchot's *L'entretien infini* (Paris, 1969), especially the chapter entitled "Parler, ce n'est pas voir"; and Michel Foucault's essay on Blanchot, "The Thought from Outside," trans. Brian Massumi, in *Foucault/Blanchot* (New York, 1989), 7–58.

2 The problem of thinking thus returns us to Kant's critique of Descartes; see Gilles Deleuze, *Difference and Repetition*, trans. Paul Patton (New York, 1994 [1968]). For only the empty form of time, furrowing between the I and the self, can explain the engendering of thought. "The subject of the Cartesian Cogito," Deleuze argues, "does not think":

> It only has the possibility of thinking, and remains stupid at the heart of that possibility. It lacks the form of the determinable: not a specificity, not a specific form informing a matter, not a memory informing the present, but the pure and empty form of time. It is the empty form of time which introduces and constitutes Difference in thought, on the basis of which it thinks, in the form of the difference between the indeterminate and the determination. It is this form of time which distributes throughout itself an I fractured by the abstract line, a passive self produced by a groundlessness that it contemplates. It is this which engenders thought within thought, for thought thinks only by means of difference, around this point of ungrounding. It is difference or the form of the determinable which causes thought to function—in other words, the entire machine of determination and the indeterminate. The theory of thought is like painting: it needs that revolution which took art from representation to abstraction. This is the aim of a theory of thought without image. (Ibid., 276)

3 Gilles Deleuze, *Foucault*, trans. Seán Hand (Minneapolis, 1988 [1986]), 86.

4 Ibid., 89.

5 I write as if the audiovisual were only a media space (cinematic, televisual, or informatic). However, Deleuze argues that stratigraphic constructions of the visible and the utterable inform in different ways every historical formation as variable relations among knowledge, power, and subjectivation. This is the larger argument of *Foucault*. See D. N. Rodowick, "Reading the Figural," *Camera Obscura* 24 (1991): 11–44; and http://www.rochester.edu/College/FS/Publications/Figural.

6 And this is also why the force of the outside is nothing other than the force of eternal recurrence, which produces simulacra in whatever is divided from itself by the pure and empty form of time. "What is this content which is affected or 'modified' by the eternal return?" Deleuze asks.

> We have tried to show that it is a question of simulacra, and simulacra alone. The power of simulacra is such that they essentially implicate at once the object = x in the unconscious, the word = x in language, and the action = x in history. Simulacra are those systems in which different relates to different *by means of* difference itself. What is essential is that we find in these systems no *prior identity*, no *internal resemblance*. It is all a matter of difference in the series, and of differences of difference in the communication between series. What is displaced and disguised in the series cannot and must not be identified, but exists and acts as the differenciator of difference. (*Difference and Repetition*, 299–300)

7 Deleuze, *Foucault*, 89; translation modified.

8 Gilles Deleuze, *Cinema 2: The Time-Image*, trans. Hugh Tomlinson and Robert Galeta (Minneapolis, 1989 [1985]), 174.

9 Ibid., 175; translation modified.

10 The problem in this sense is expressive of a will to power that pitches the individual into a Dionysian world or state of intensity. Thus Deleuze argues that

> the individual in intensity finds its psychic image neither in the organisation of the self nor in the determination of species of the I, but rather in the fractured I and the dissolved self, and in the correlation of the fractured I with the dissolved self. This correlation seems clear, like that of the thinker and the thought, or that of the clear–confused thinker with distinct–obscure Ideas (the Dionysian thinker). It is Ideas which lead us from the fractured I to the dissolved Self. As we have seen, what swarms around the edges of the fracture are Ideas in the form of problems— in other words, in the form of multiplicities made up of differential relations and variations of relations, distinctive points and transformations of points. (*Difference and Repetition*, 259)

11 Deleuze, *The Time-Image*, 177, 177–78.

12 Gilles Deleuze and Félix Guattari, *What Is Philosophy?*, trans. Hugh Tomlinson and Graham Burchell (New York, 1994 [1991]), 74–75.

13 Deleuze, *Foucault*, 98.

14 Ibid., 107–8.

15 Ibid., 119; translation modified.

16 Deleuze, *Difference and Repetition*, 293. Deleuze continues this thought in a striking passage:

> The more our daily life appears standardised, stereotyped and subject to an accelerated reproduction of objects of consumption, the more art must be injected into it in order to extract from it that little difference which plays simultaneously between other levels of repetition. . . . Art aesthetically reproduces the illusions and mystifications which make up the real essence of this civilisation, in order that Difference may at last be expressed with a force of anger which is itself repetitive and capable of introducing the strangest selection, even if this is only a contraction here and there—in other words, a freedom for the end of the world. Each art has its interrelated techniques or repetitions, the critical and revolutionary power of which may attain the highest degree and lead us from the sad repetitions of habit to the profound repetitions of memory, and then to the ultimate repetitions of death in which our freedom is played out. (Ibid.)

17 See Gilles Deleuze, *The Logic of Sense*, trans. Mark Lester, with Charles Stivale; ed. Constantin V. Boundas (New York, 1990 [1969]), which is, of course, Deleuze's deepest meditation on the nature of events; see also his "What Is an Event?," in *The Fold: Leibniz and the Baroque*, trans. Tom Conley (Minneapolis, 1993 [1988]), 76–82. On cinematic "events," see Tom Conley, "Evénement-cinéma," *Iris*, No. 23 (1997): 75–86.

18 Deleuze, *Foucault*, 117; translation modified.

19 Deleuze and Guattari, *What Is Philosophy?*, 156, 158.

20 In an implicit jab, I believe, at Richard Rorty, Deleuze and Guattari describe this as an image that capitalizes philosophy "as an agreeable commerce of the mind, which, with the concept, would have its own commodity, or rather its exchange value—which, from the point of view of a lively, disinterested sociability of Western democratic conversation, is able to generate a consensus of opinion and provide communication with an ethic, as art would provide it with an aesthetic" (ibid., 99).

21 Ibid., 108.

22 In section 7 of his "Theses on the Philosophy of History," Benjamin argues that historicism always produces empathy with the victors. This is why "there is no document of civilization which is not at the same time a document of barbarism. And just as a document is not free of barbarism, barbarism taints also the manner in which it was transmitted from one owner to another. A historical materialist therefore dissociates himself from it as far as possible. He regards it as his task to brush history against the grain"; Walter Benjamin, *Illuminations*, ed. Hannah Arendt, trans. Harry Zohn (Glasgow, 1973), 258–59.

23 Deleuze and Guattari, *What Is Philosophy?*, 110.

24 Ibid., 99.

25 Samuel Butler has an equally significant place in Deleuze's *Difference and Repetition*; see, for example, his Preface (xx–xxi).

26 Deleuze and Guattari, *What Is Philosophy?*, 100.

27 Ibid., 112.

28 Ibid., 110–11.

29 Ibid., 112.

30 Ibid., 176–77.

31 Gilles Deleuze, "Nomad Thought" (1973), trans. David B. Allison, in *The New Nietzsche: Contemporary Styles of Interpretation*, ed. David B. Allison (Cambridge, MA, 1985), 142–49; quotation from 142.

32 Deleuze and Guattari, *What Is Philosophy?*, 59–60.

Deleuze and Materialism: One or Several Matters?

John Mullarkey

Deleuze is generally regarded as a materialist, but what type of materialism does his thought express? Many believe that its definitive philosophical position stems from his work on Spinoza, which advances a mechanistic materialism of efficient causality. In fact, this image of Deleuze has in part motivated the application of his ideas in terms of the seemingly reductive materialisms of cybernetics, artificial intelligence (AI), and body-centered sociology, among others. Yet a host of different notions of materialism—reductive and nonreductive—are current across the breadth of Deleuze's philosophy. There are also other, nonmaterialist claims on his thought, empiricism and vitalism being the two outstanding contenders. As Deleuze is still a relatively unknown quantity outside France, it remains easy enough to misappropriate his ideas. I am referring here primarily to cybernetics theorists, whose advocacy of Deleuzian philosophy might seem to be that philosophy's main hope for a return to the heights of avant-garde fashion that it enjoyed in the 1970s. If he was a good materialist, Deleuze is surely unconcerned now with the posthumous standing of his work. But the

critical fate of that work is clearly a concern for us, and to attribute to Deleuze the belief that we are all mere machines, for example, would be as simplistic as the early interpretation of Jacques Derrida as a man who believes that nothing exists beyond the written word.

What follows, then, is a corrective analysis of Deleuze's materialism as well as an introduction to that aspect of his work which will be central to his reception by an Anglo-American philosophy whose twentieth-century orientation has been primarily materialist. Deleuze's work in this area mounts an extraordinary challenge to orthodox materialist philosophy, and, its own weaknesses notwithstanding, the degree of original analysis and insight it brings to this school of thought can hardly be overestimated.

Mapping the variations internal to Deleuze's materialism should enable us to situate it, at least implicitly, in the terms set by contemporary materialist thinking in the Anglo-American tradition, especially with regard to the ongoing contest between reductionists and anti-reductionists. Indeed, as we will see, this contest is also waged within Deleuze's thought, although in a very different vocabulary than that found in Donald Davidson or Thomas Nagel. Where analytic philosophers write about "reducibility," Deleuze uses the terminological dyad "molar–molecular" to express a relation between two strata, with the molecular most often appearing to have the upper hand as the medium to which molar phenomena—subjectivity, identity, and form—are reduced within a microscopic material realm. But inevitably, things are a bit more complicated than that.

In his later work at least, Deleuze does indeed materialize molar phenomena but in a genuinely nonreductive manner. In other words, subjectivity, identity, and form are materialized but not eliminated in favor of molecular substitutes. The ontological integrity of these and all other such strata is retained. His unique approach consists in what he confusingly calls "universal machinism," a strategy which is anything but mechanistic, however: neither eliminating nor reducing molar phenomena, it preserves them as material elements in larger composites called, again misleadingly, "abstract machines." Deleuze's abstract machine is a device by which to capture surface, large-scale entities as parts of even larger material processes. But the key word here is "abstract," not "machine." Deleuze's constant complaint against philosophers is that their thought is not abstract enough, that it pitches its level of abstraction too low and consequently forfeits the virtues of abstraction.[1] A more abstract theory is one that gener-

alizes from a larger (i.e., multiple) sample, taking not only human but also animal, inorganic, and other nonhuman beings into account. An abstract machine, then, operates at a level that captures human and nonhuman forms alike in its material process.

Yet it must be admitted that Deleuze's use of materialist and antimolar language often invites the type of microreductionism that underscores work in cybernetics and thereby leads to a great misunderstanding of his work on machinic desire. Examples of this, small and large, are ubiquitous. Charles Stivale, for instance, has attempted a "rapprochement" between elements of science-fictional cybernetics and *Capitalism and Schizophrenia*. A "collective assemblage" is read in terms of "flows of information," while the anomalous figures found in *A Thousand Plateaus* are explained through the idea of "cyborgs, or, more often, of the interface with cyberspace."[2] In a similar vein, there have been active debates on the Deleuze Internet site concerning whether the World Wide Web is or is not equivalent to one of Deleuze and Guattari's smooth spaces.[3] Of course, the most concrete example of cybernetic materialism comes with the image of the cyborg, or "*cy*bernetic *org*anism," attendant to the belief that "cybernetics [is] the language common to the organic and the mechanical."[4] Significantly, some have been tempted to connect the cyborg with Deleuze's desiring-machines.[5] The cyborg is said to blur the boundaries between the natural and the artificial, the vital and the mechanical, in a manner wholly identifiable with its supposed Deleuzian equivalents.

Now, the contemporary significance of the cyborg is founded on the great ease with which one can become such an entity these days (needing only to have a pacemaker or an artificial limb, or to be dependent on a dialysis machine or respirator),[6] but this is problematic when linked to Deleuze's theorization of desiring-machines, which has never depended on any human technological innovation. The misleading picture of Richard Lindner's *Boy with Machine* as the frontispiece to *Anti-Oedipus* notwithstanding, all living entities (and few things are *not* alive in Deleuze's universe) have *always* been at once machinic and vital. Their cross-categorial status never arose by virtue of mechanical innovation. If there are Deleuzian cyborgs, they are not peculiar to either our age or our species, as some have asserted.[7] Where mechanistic anorganicism is found in Deleuze's work, it is only made possible by an ulterior ontological anorganicism such as is seen, to cite just one instance, in the art of Francis

Bacon, whose Figures escape their representational and organic boundaries by the mouth, by sensation, or by natural prosthesis, but never by technology.[8] Whatever they are in themselves, then, desiring-machines are not so much the creatures of man as the creators of men, other animals, their societies, and everything else besides; to think otherwise betrays a humanistic idolization of contemporary technology.

Another point where cybernetics fails to map onto Deleuzian themes concerns the cognitivist paradigm which underpins it. Cybernetics was originally posited by Norbert Weiner in terms of organic and machinic processes as information systems, in tandem with the then-prevalent use of information theory and cognitivist language to describe both brains and computers.[9] Indeed, "cyberculture" in general, it is said, depends on and reflects the ever-increasing encroachment of "new telecommunications technologies."[10] Of course, it would be all too easy here to outline what Deleuze has to say against the representationalist biases not only of information theory but of most thinking in general.[11] Telecommunications itself can be either digital or analogical, that is, based on *either* the epistemic value of representation *or* the epistemic value of resemblance. And the early cyberneticists—Weiner himself and Gregory Bateson, among them—could be read as Deleuzian forebears in that they prioritized analogical forms of communication over digital ones.[12] What remains true of both approaches to cybernetics, however, is that they are *reductionist*. From Paul Churchland's eliminative materialism to AI (in both its classical and its connectionist implementation), cyberculture sees the living brain and the mechanical computer equally as syntactic engines, whether purely formal or somehow tied to formed matter.[13] Everything is reduced to the single stratum of syntax. Yet Deleuze is eager to preserve the integrity of each stratum of reality without prioritizing any one, purely formal or not: "The system of the strata . . . has nothing to do with signifier and signified, base and superstructure, mind and matter. All of these are ways of reducing the strata to a single stratum."[14] Deleuze also rejects the syntactic view implicit in this variety of reductionism, as is quite clear from his determined attempt to approach cinema outside of the usual linguistic/semiological tradition: "[Cinema] is a plastic mass," he insists, "an a-signifying and a-syntaxic material, a material not formed linguistically even though it is not amorphous and is formed semiotically, aesthetically, and pragmatically."[15] More overtly still, information theory is chastised for relying on "a homo-

geneous set of ready-made *signifying* messages that are already functioning as elements in biunivocal relationships."[16] Syntax is inadequate, then, for it commits the double crime of being both explicitly formal and homogeneous and implicitly signifying and bifurcating.

In sum, whether for reasons to do with its technophilia, representationalism, reductionism, or "syntaxics," a cybernetics reading of Deleuze does not look promising. Yet references to information theory, cybernetics, and cyborgology with respect to Deleuze continue apace.[17] Where does this tendency originate? Certainly, there are ambiguities in Deleuze's *Foucault*, especially in its concluding prophecy of a third generation of machines uniting inert silicon and organic carbon. Likewise, in that same text, Deleuze seems to link cybernetics and information technology positively to the eternal return, when humanity will become the cyborg–overman now in charge of both the animate and the inanimate.[18] Is this the age of the Anti-Oedipus made flesh? Perhaps. But on this score the chances are at least even that Deleuze sees the coming age in a darker light. After all, he also depicts cybernetic machines and computers as emblems of control societies, which are hardly admirable in themselves.[19] Elsewhere, he likens Hitlerian Germany to a "cybernetic race," with control not in the hands of one "leader" but "diluted in an information network."[20] The final passages of *Foucault* are hardly typical, therefore, and may well be one of Deleuze's jokes, this time at the expense of Michel Foucault.

However, this is all somewhat irrelevant in any case, for my suspicion is that the cybernetics misappropriation of Deleuze has less to do with his ambiguous gestures toward the computer age than with the aforementioned terminological ambiguity of molarity/molecularity and his constant prevarication between materialism and empiricism. So it is to these two issues that I'll now turn. In addition to taking a closer look at how each position operates in Deleuze's thought, his understanding of material force in *Nietzsche and Philosophy* needs to be assessed, as do his treatment of bodily affect in his two Spinoza books and the notion of the "body without organs" (BwO) found in *Capitalism and Schizophrenia*. Over the course of these works, as we will see, an intriguingly politicized form of materialism emerges. Furthermore, some potentially deceptive aspects of mechanistic materialism *and* vitalism running through Deleuze's oeuvre remained largely untackled until his work on Leibniz in *The Fold* allowed the issue of reducibility to be substantially resolved. I say "substantially" because,

while *The Fold* does succeed in showing how subjectivity, identity, and form can be given nonreductive materialist analyses, it fails to indicate how we might coherently materialize a fourth aspect of molar existence hitherto unmentioned, *value*. Yet value realms such as ethics and politics are central to Deleuze's project and recur throughout his work on forces, affects, and bodies. Nevertheless, value also poses the ultimate obstacle to Deleuzian thinking simply because the dualism of empirical fact and normative value remains indomitable in the face of every type of monism, Deleuze's materialism included.

The primary source of confusion over Deleuze's molar/molecular dichotomy concerns the implication of scale and dimension, yet this distinction is said to have nothing to do with scale: "The molar and the molecular are not distinguished by size, scale, or dimension, but by the nature of the system of reference envisioned."[21] By "system of reference" here, Deleuze means a particular mode of composition, organization, or consistency among the same elements: sedentary, biunivocal, arborescent, linear, striated, static, extensive, and divisible on the molar side; nomadic, polyvocal, rhizomatic, transversal, smooth, processive, intensive, and indivisible on the molecular side. Deleuze also insists that no dualism is implied here, for the two types of organization are always intermixed in any concrete manifestation (although, of course, a de facto combination of two elements does not preclude the possibility of a de jure dualism). Yet despite such assertions, both Deleuze and Guattari tend to use language suggestive of scale: majority, major, massive, big, mass, collective, whole, global, macro-, super-, over-, and molar itself, on the one hand; partial objects, part organs, larval selves, minority, minor, local, part, component, small, miniaturization, sub-, micro-, and molecular itself, on the other. Sometimes the molar is equated with statistical accumulations, with references to "large scale," "large number," and "large aggregates."[22] That the molar and the molecular have been taken to imply a difference in scale is not surprising, then, nor is the consequent implication of micromaterialism.[23]

Another misunderstanding, which stems from this one of scale, also tempts many to interpret Deleuze's analyses as reductionist, to wit, that there is an *ontological* hierarchy between molarity and molecularity, with the molar thereby unreal and everything genuinely molecular.[24] Any per-

ceived molarity must be an illusion or imposition to be dismantled or reduced. Certainly, the trenchant attacks in *Anti-Oedipus* on self, family, and state as molar representations that tyrannize and stifle our individual "becomings" might lead one in that direction. But in works prior and subsequent to that book, Deleuze most often posits a multiplicity of tyrannies —human and nonhuman, organic and inorganic, molar and molecular— microfascist as well as macrofascist. The only aspect of molar representation that is consistently rejected is its supposedly singular and anthropocentric form, as handed down through the tradition beginning with Kant.

Nevertheless, the misimpression that Deleuze would dissolve molar beings into anonymous molecular flows has brought him much criticism from at least one quarter, namely, feminist philosophy. Indeed, when Deleuze wrote that what he termed a molar entity was, "for example, the woman as defined by her form, endowed with organs and functions and assigned as a subject,"[25] and espoused the idea of "becoming-woman," whereby these molar women would seemingly disperse into imperceptible atoms, it caused considerable controversy. Luce Irigaray, for one, asserted that the Deleuzian emphasis on the machinic and the consequent loss of the organic self were all-too-familiar male responses to female bodily form.[26] Elizabeth Grosz has recently echoed this sentiment. By invoking "the notion of 'becoming woman' in place of a concept of 'being women,'" she charges, "Deleuze and Guattari participate in the subordination, or possibly even the obliteration, of women's struggles for autonomy, identity, and self-determination, an erasure of a certain, very concrete and real set of political struggles."[27] Admittedly, Deleuze did respond, saying that he would categorically allow women their "molar politics," but that their real goal should be to "become-woman in order that the man also becomes- or can become-woman." But this run-in with feminist philosophy highlights a more general problem in the reception of Deleuze's work: often, his categories are mistaken for those of more orthodox theorists, as can be seen here in the context of Deleuze's "atoms of womanhood" that would comprise any becoming-woman.[28] Such a notion is clearly a cross-categorial concept, mixing a molecular process (atoms) with molar, phenomenal behavior (womanhood). And similar examples abound in Deleuze's work; the idea of a bird, for instance, is not derived from its genus or species but from "the composition of its postures, colors, and songs."[29] Most significant here is Deleuze's treatment of the brain. Much of his work on the cinema (but

also on concepts and even on philosophy itself) was inspired by the micro-
biology of the brain rather than the more usual paradigms of psychoanaly-
sis or linguistics; crucially, however, his use of the brain, despite appear-
ances, is never reductive. Deleuze sees cinema as operating at the molar
level to shock the brain into forming new synapses, connections, and path-
ways.[30] His treatment of the brain in *What Is Philosophy?* goes even further:

> If the mental objects of philosophy, art, and science (that is to say,
> vital ideas) have a place, it will be in the deepest of the synaptic fis-
> sures, in the hiatuses, intervals, and meantimes of a nonobjectifiable
> brain. . . . According to phenomenology, thought depends on man's
> relations with the world . . . but this ascent of phenomenology be-
> yond the brain toward a Being in the world . . . hardly gets us out of
> the sphere of opinions. . . . Will the turning point not be elsewhere,
> in the place where the brain is "subject," where it becomes subject?[31]

Here we see Deleuze's enterprise in its true colors, as an attempted es-
cape from the traditional philosophical impasse of a singular, irreducible
human life-world in opposition to an anonymous, lifeless realm of pure
matter in motion. His own categories of the molar and the molecular sig-
nify much more than that.

However, the problems of his interpreters do have some real basis in
Deleuze's work—and not merely because of the confusing language he
sometimes employs. Some of the ideas themselves are barely adequate to
the task of creating a nonreductive molar/molecular materialism, simply
asserting rather than justifying the ontological integrity of these categories.
A case in point is Deleuze's ethical and political deployment of naturalis-
tic concepts (to which I will return in discussing his treatment of force,
bodily affect, and the BwO). Even more disturbing, though, is the impres-
sion Deleuze gives of not being a materialist at all, but rather an empiricist
with an attendant view of nature that utterly diverges from the type of
naturalism one would expect to find within a materialist position.

＝＝＝＝＝

At first glance Deleuze seems unquestionably materialist, even physicalist,
citing as he does the Stoics' belief that physics is at the heart of philoso-
phy.[32] Beyond the arguments themselves, his language is full of physical
imagery: points and lines, surfaces, strata, machinic and biologic pro-

cesses. Almost the entire sociological dimension of *A Thousand Plateaus*, for instance, revolves around a distinction between nomadic and sedentary society which itself turns on a dualism of smooth and striated space. Yet none of these physical images is intended as a metaphor, but rather as a subtle point about the nature of material reality.

This is what makes Deleuze's version of a philosophy of difference quite unique, for he seeks the principle of difference not just in language and signs but even more so in applied mathematics (differential calculus), biology (epigenetic "differenciation"), and physics (differential energy, potential, and temperature). Specifically, his materialist analyses of difference focus on four areas: universal machinism, psychiatry and the unconscious, language, and time. The first of these, of course, remains the best-known instance of Deleuzian materialism: "Everything is a machine," we are told in *Anti-Oedipus*, "producing-machines, desiring-machines everywhere." Hardly less important in that work, however, is its proposal of a "materialistic psychiatry." In the heyday of family-based theories of psychosis, Deleuze and Guattari stood out as advocates of "a biochemistry of schizophrenia."[33] (It is noteworthy here that Deleuze's approach returns to the more physically oriented perspective of Melanie Klein's object relations theory rather than maintaining the linguistic turn Lacan took with her ideas, which was so influential in France.) Likewise for language and time, with incorporeal events on the surfaces of bodies, fields of force, and crystal-images, among other Baroque depictions, forming the core of Deleuze's physicalist approach. In another philosopher's hands (Bergson's or Whitehead's, for example), time might have been deemed a nonmaterial entity, yet in Deleuze's treatment, including his use of Bergson's and Whitehead's process philosophy, matter retains its primacy. The event is seemingly hypostatized as a "haecceity," a thisness or principle of individuation among incorporeal but nonetheless bodily transformations.

Although Spinoza is purportedly Deleuze's inspiration here, his reading interprets Spinoza's materialism only as a corrective to the view that mind is superior to body: "Spinozian" materialism denies "any primacy of the one over the other," Deleuze asserts; indeed, it is not so much that thought is devalued in relation to the body as that consciousness is devalued relative to thought.[34] In this light, Deleuze appears to be a property pluralist of some sort, affirming the attributes not only of thought and extension but of infinite others as well.[35] Thus we ought not to be surprised that—

instances of monism and materialism in Deleuzian thought notwithstand-
ing—he can also proclaim himself a pluralist and an empiricist (in fact,
he equates these two positions).[36] His first published book was, after all, a
sympathetic study of David Hume, although it is the 1968 *Difference and
Repetition* that must count as the manifesto for Deleuzian thought, giving
his system its grand title of "transcendental empiricism."

Once again, however, we have to be careful with terms. First, Deleuze's
empiricism is not dogmatic about the origins of knowledge but concerned
with "the concrete richness of the sensible."[37] Second, its peculiar claim to
be transcendental is not understood as a demarcation or calculation of all
possible experience, for that, he contends, would simply be to project the
mundane onto a transcendental ground. The transcendental cannot be "in-
duced" or "traced" from the ordinary empirical forms of common sense.
The being of the transcendentally sensible is what can only be (involun-
tarily) sensed.[38] In fact, Deleuze proposes to reinstate a doctrine of the
faculties—of thought, of memory, and of sensibility—each with its own ex-
clusive transcendental object.[39] Far from being otherworldly, though, this
doctrine of the faculties purports to be fully immanent. Yet it would seem
to fall far short of being so for an orthodox materialist, as can be seen if we
delve a little into Deleuze's picture of nature as a whole. For him, "physics
is Naturalism from the speculative point of view."[40] But despite such proc-
lamations, if Deleuze's naturalism were compared with that of, say, David
Papineau's recent work,[41] much would be found that fundamentally sepa-
rates them. Papineau aims to defend the view that humans are material
objects living in a material world; this is the meaning of his naturalism,
which is connected to the position that all reality boils down or reduces to
mass/energy. As a label, of course, naturalism once denoted the belief that
everything could be explained through the human and natural sciences
without any recourse to supernatural entities; now it means that even the
human is reducible to the natural realm—or, rather, that it is reducible to
the scientific and materialist view of the natural realm.

Deleuze could not be called a naturalist on this score. At one level he
clearly does want to see "the unity of human beings and Nature," though
not at any price.[42] In contrast to scientific materialism, Deleuze's project
of "a new 'naturalism'" refuses to "devaluate Nature by taking away from
it any virtuality or potentiality, any immanent power, any inherent being."
To this extent, he sees himself in that anti-Cartesian line of naturalists

running from Spinoza through Nietzsche and down to present-day philosophers. And it is in fact through his analyses of Nietzsche's desire to naturalize humanity in terms of a newly redeemed nature and Spinoza's tempering of Cartesian mechanism with "a dynamic theory of the capacity to be affected" that Deleuze's own naturalist program is pursued.[43]

It is widely remarked that of the many philosophers Deleuze has worked on, the most important for him is Nietzsche.[44] Over the course of *Nietzsche and Philosophy*, he develops a theory of difference based on a physics of force or, more precisely, on the quantitative difference between forces. But this work also pursues an *ethics* of force quite alien to normal materialist discourse, a contrast between active and reactive force that many commentators have found problematic. Deleuze describes reactive force as separating "active force from what it can do," while "active force . . . goes to the limit of what it can do."[45] Significantly, the separation of a force from what it can do is Deleuze's definition of slave morality. Out of this ethics of force Deleuze formulates a "paralogism of *ressentiment*," or *"the fiction of a force separated from what it can do"*:

> Reactive forces "project" an abstract and neutralised image of force; such a force separated from its effects will be *blameworthy* if it acts, *deserving*, on the contrary, if it does not. . . . Although force is not separated from its manifestation, the manifestation is turned into an effect which is referred to the force as if it were a distinct and separated cause. . . . Force, which has been divided in this way, is projected into a substrate, into a subject which is free to manifest it or not. . . . The force thus neutralised is moralised.[46]

The problem with all this is that the moralization of force actually does succeed, according to Deleuze's own account, in separating it from what it can do. The very "fiction" of the repressibility of force truly does help to repress force. But surely it is a fallacy of retrospection to talk of forces not doing what they can, could, or even ought to do. "Can do" means overcoming any possible obstacle; hence, if something didn't do so, then it couldn't. To speak of forces that should not do what they can do is, of course, moralistic, but so too is speaking of them as being *allowed* to do what they can; if they can do it they will, if they can't they won't.[47]

Vincent Descombes has chastised Deleuze for this, namely, for "measuring *that which is* according to the standard of *that which is not*, but *which ought to be*."[48] But perhaps Descombes and I are both missing the point. With reference to Spinoza, Deleuze writes in a similar fashion about "*a body* [that] *always goes as far as it can, in passion as in action*; and what it can do is its right." It is our right, he adds, to fulfill our bodily potential simply because it is possible not to do so; we can easily be "cut off, in a way, from our essence or our degree of power, cut off from what we can do."[49] The art of avoiding such inhibitions to our power constitutes the ethical aspect of Spinoza's naturalism, which—far from perpetrating any fallacy by deriving an "ought" from an "is"—understands the body, power, and nature in general as sites of simultaneously physical and ethico-political forces. In fact, Spinoza's influence, as well as Nietzsche's, pervades Deleuzian thought, as confirmed by Deleuze himself when he stated that he considered himself a Spinozist throughout his career.[50] This influence manifests itself most clearly in terms of Spinoza's treatment of the body and its capacity for action, about which Deleuze says, "A thing has the greater reality or perfection, the greater number of ways in which it can be affected."[51] In other words, what a body can or cannot do is of central importance, but what it can and cannot do is not at all self-evident and requires scrupulous investigation. An empirical study of bodies is thus needed to ascertain the nature of their interrelations, that is, which relations are productive of sad passions, which of joyful ones, and which of free and active affects.[52] Knowing which is which is part and parcel of any realistic ethico-political manual— precisely what Spinoza's *Ethics* is intended to be.

This examination of the relative compatibility of bodies therefore amounts to a Spinozian physics that forms the cornerstone of his ethics as well.[53] One's *natural rights* (emphasis on both terms) are defined by one's *conatus*.[54] Such a fusion of the physical and the political in Deleuze's work on Spinoza was further developed, in collaboration with Guattari, in the concept of the body without organs,[55] the politics of which emerges in the BwO's subjection to the stratagems of any society predicated upon its opposite: the individuated organism. Society is a codifying machine or policing mechanism designed to enforce its own code vis-à-vis the otherwise chaotic incarnation of each individual desiring-subject; hence even facial tics, for instance, are not just (about) muscle spasms—they are political, or geopolitical.[56] Indeed, the face itself is just another mechanism, at

once political and physical, by which otherwise vital forces are repressed or codified. This politicization of the factual realm, physical or metaphysical, continues even in Deleuze's own process philosophy. The concept of process in *Anti-Oedipus* comprehends different types of *production* — recording production, consuming production, and so on — no doubt as a lingering influence of orthodox Marxian thought, but in *Kafka* too the term "process" is politicized by the play on its simultaneous metaphysical and juridical meanings ("change" as well as "due process").[57]

More broadly, a general question can be raised over the entire political and ethical valorization of process which is the hallmark of Deleuze's thinking. Why is change, creativity, novelty, or becoming to be commended? Surely not from a simple dogmatic assertion of liberal values, and even less from the anthropocentric criterion that it simply makes us happy. If, on the other hand, creativity is a value just because the universe itself is a process, then this fallacy of deriving an "ought" from an "is" leaves us wondering why a fact about the universe must be a value — our value — as well.

Turning now to the way in which Deleuze's composite use of physical categories alongside political and ethical ones reflects on the wider issue of his materialism, what we find throughout his work is an even starker blend, this time at the metaphysical level, of materialism and vitalism as such. Like other aspects of Deleuzian thought, this one is best approached from several angles: automatism, vitalism, and the problem of Deleuze's internalism.

Earlier, we looked at the claim in *Anti-Oedipus* that everything is machinic and that the universe we inhabit is nothing less than a vast "mechanosphere." Deleuze is careful to remind us, however, that these machines are not mechanical or technical: "Mechanics is a system of closer and closer connections between dependent terms. The machine by contrast is a [noncontiguous] 'proximity' grouping between independent and heterogeneous terms."[58] Oddly enough, though, the writing machines found in *Kafka*, for example, are evoked with a great deal of mechanical imagery, including gears, motor parts, cogs, piston rods, and the engineers who maintain them.[59] And elsewhere, machines with "tractable gears" that need to be "greased" can be encountered,[60] slips that may explain some of the technocentric reductions of Deleuze we have already seen. Neverthe-

less, this distinction between the machinic and the mechanical is carried further in Deleuze's two *Cinema* books, where different sorts of automata are described. The inspiration for this endeavor is Deleuze's initial picture of cinema as a type of spiritual automaton, that is, as an automatic movement; cinema is "psychomechanical," a machine which communicates to the mind–brain directly.[61] This is no different from the spiritual automaton as Spinoza would have defined it, except for its working here on a physical plane in accordance with the laws of neurology rather than on a mental plane and in accordance with the laws of thought.[62]

Besides the basic spiritual automaton, the *Cinema* books also refer to a panoply of other types of automata and related phenomena (many of them characters in films), including a "dialectical automaton," "automatic writing," the "experimental dummy," and the "mechanical man," among others.[63] Significantly, however, a class of automata far less benign is added to the earlier set: "the dummy of every kind of propaganda," "the spiritual automaton [become] fascist man," "the Mummy," "a marionette" giving rise to "material automatism," and, most importantly, the "psychological automaton . . . dispossessed of his own thought . . . the somnambulist."[64] Here, too, we are told that "machines can take hold so fully on man that it awakens the most ancient powers, and the moving machine becomes one with the psychological automaton pure and simple, at the service of a frightening new order." This is the cinema as propaganda machine, or "the Hitlerian automaton in the German soul," which coincides with the "automatization of the masses."[65] Accompanying this newfound caution in the face of universal automatism is a concern about "cretinization" through the ubiquity of the clichéd image: physical, optical, and auditory clichés are everywhere, all around us and inside us, thinking for us, making of us a cliché, a bad film, an urban cancer.[66] The task facing the cinema of the future is to create a genuine image in spite of the stifling omnipresence of the cliché. Cinema today, sadly, "reflects mental deficiency rather than any invention of cerebral circuits . . . organized mindlessness."[67]

But it is what underlies this condemnation of automata and the cliché which is significant for us, namely, the vitalist tendency in Deleuze's thought. For running alongside his physical and spatial imagery is a host of organic and vitalist images: eggs, rhizomes, becoming-animal, vegetal cinema versus animal cinema, and so on. "Everything I've written is vitalistic," he announced in 1988.[68] No surprise again, then, that many consider Deleuze a vitalist, albeit of a "high-tech brand."[69] Like Nietzsche and Berg-

son before him, Deleuze often wrote "Life" with a capital L to accentuate the difference between this metaphysical category and any mere living organism whose health could actually be disturbed when in the grip of a Life too great for it to embody adequately.[70] But that this vitalism should be pursued in tandem with materialism demands a proper explanation of how these categories are to be fused. While Deleuze states that he prefers nonorganic life to organic life and that it is the molecular lines of life and not molar animals which are the positive object of his thought, this sounds as problematic as preferring the idea of becoming-woman to real molar women themselves. Something more needs to be said.

And more might have been said in *Anti-Oedipus*, which aspires to surmount the impasse of vitalism and mechanism. The solution given there is not so much a genuine rapprochement, however, as a sidestepping of the entire issue. Mechanism is said to invoke a structural unity to explain the organism's functioning, vitalism to invoke an individual unity rendering the organism autonomous and subordinating any mechanisms connected to it; but both unities are spurious, as they are molar aggregates. Mechanism and vitalism are equally inadequate, failing to account for the nature of desire and its role in machinic production. In the end, "it becomes immaterial whether one says that machines are organs, or organs, machines. The two definitions are exact equivalents: man as a 'vertebro-machinate mammal,' or as an 'aphidian parasite of machines.' . . . In a word, the real difference is not between the living and the machine, vitalism and mechanism, but between two states of the machine that are two states of the living as well."[71] Along with these statements concerning the monolithic nature of the object of inquiry in *Anti-Oedipus* comes a declaration of the identical nature of the different disciplines investigating it in *Difference and Repetition*, where "universal physics, universal psychology and universal sociology" are said to form one and the same enterprise.[72] So, life and matter are just states of something else, according to Deleuze, but rather than explaining precisely what this third element is, Deleuze often just continues to describe it with language fusing biological and physical terms. The rationale for this alloy of concepts is missing.

What remains to do now is to wrap up some of the loose ends connected to Deleuze's materialism: its ambiguous relationship with his empiricism; the problematic use of "force" and physics in general in an avowedly

ethico-political discourse; and, finally, the dogmatic identification between the vital and mechanical spheres in *Anti-Oedipus* and other works. My attempted synthesis (of sorts) hinges on the question of Deleuze's internalism, that is, his continual use of intensive physicalist terms: those we've already encountered—*affect, conatus, force*—and others such as *implication, virtuality,* and *spatium*. Most of these belong to a dyad (intensive/extensive, implication/explication, virtual/actual, *spatium/extensio*) in which the first element is deemed the properly physical component, while the second is but a shadow of the same, reflected in a merely empirical state of affairs. Now this is surely an odd way of going about one's materialism or one's empiricism, although, admittedly, it gives Deleuze the ability to amalgamate concepts and thereby inflate his so-called materialism to such a degree that molar phenomena can apparently be materialized without being reduced. What it loses him, however, is, first, any real connection with the physical sciences apart from a dogmatic assertion that his analyses simply are materialist and, second, any consistency with one of his own empiricist principles.

This last transgression concerns the basic internal/external dyad that underlies all the other pairs. Yet it was clearly Hume's empiricism which taught Deleuze, at the very start of his career, that "the given is not in space; the space is in the given. . . . Extension, therefore, is only the quality of certain perceptions."[73] Like Leibniz and Berkeley before him, Hume dissolves the notion of extension and, with that, the opposition between inside and outside. Deleuze repeats this basic tenet at numerous points: "Exterior and interior are relative."[74] "The inside and the outside, the container and the contained, no longer have a precise limit"; or, "the internal and the external, depth and height, have biological value only through this topological surface of contact. Thus, even biologically, it is necessary to understand that 'the deepest is the skin.'"[75] But even such a deconstruction, wrought by his own hand, of one of modern philosophy's classic dualisms fails to stop Deleuze from continuing to invoke an internalist logic in his materialist thought. *Why* he should do so has already been specified, namely, that it facilitates the expansion of his materialism to allow a nonreductive comprehension of molar phenomena. But *how* he should be able to pursue such a strategy is never adequately explained within a properly materialist or even empiricist framework. Not, that is, until he gets to his study of Leibniz, when the notion of the fold takes over much of the role previously filled by an internalist vocabulary.[76]

It is interesting that one of the last books penned by Deleuze should mark a return to the type of history of philosophy he pursued before supposedly finding his own philosophical voice in such works as *Difference and Repetition, The Logic of Sense,* and, most spectacularly, *Anti-Oedipus.* The curiosity value is heightened by the fact that this later work is on Leibniz, toward whom Deleuze had always been ambivalent. While Leibniz's perspectivism ought to attract a thinker in the Nietzschean tradition such as Deleuze, for the most part he had rejected the perspectivism of the *Monadologie* on account of its basis in representation, compounded by the tendency of Leibnizian perspective toward a totalizing view of reality—the monads being points of view that converge on one and the same world.

Now, in effect, Deleuze's return to Leibniz was motivated by a desire to rehabilitate representation in general through a materialist analysis of Leibnizian representation in particular. The instrument Deleuze employs throughout this revaluation is the Baroque concept of the fold and its cognate processes of enfolding and unfolding. As a bonus, however, the reconstruction of Leibniz has a second string to its bow, for it provides Deleuze with an understanding of molar unity which is simultaneously molar and material, only this time with the means for such a nonreductive materialism clearly demonstrated rather than simply assumed. Hence the spurious molar unity rejected by *Anti-Oedipus* in its failed attempt to surmount the vitalism/mechanism problematic finally acquires a cogent materialist equivalent that can also do justice to the ontological integrity of the molar realm. The importance of *The Fold* to the Deleuze corpus, then, should not be underestimated.

To look at these ideas in more detail, one must begin with representation, long an anathema to most philosophers of difference, and Deleuze is no exception in that regard. But Leibnizian rationalism distinguishes itself from most of the tradition by attempting to go beyond organic representation and render it infinite, a strategy that might make it less unattractive to the egalitarian thinking of a typical poststructuralist. Prior to *The Fold,* Deleuze had found both of the conventional means by which representation has been raised to infinity—that is, by contradiction in Hegelian thought and by infinitesimals in Leibniz—entirely wanting, with each failing to "get beyond the element of representation, since the double exigency of the Same and the Similar is retained." Moreover, Leibniz also proves inadequate as regards the form of cognition, retaining a subject-centered position, with "monads, and points of view, and *Selves* in the manner of

Leibniz" being no real advance over the Kantian "I."[77] Consequently, the *Monadologie* crashes on the rocks of subjectivity and identity at the same time: the subjectivity of the monad qua apprehending ego, and the identity of the world that the monad supposedly mirrors.

The Fold tackles the first of these failings plainly enough: Baroque perspectivism, Deleuze now claims, "does not mean a dependence in respect to a pregiven or defined subject; to the contrary, a subject will be what comes to the point of view, or rather what remains in the point of view."[78] Leibnizian perspective is now deemed a purely physical affair: "A soul always includes what it apprehends from *its* point of view, in other words, inflection. . . . Thus the soul is what folds and is full of folds. . . . Microperceptions or representatives of the world are these little folds that unravel in every direction. . . . And these are minute, obscure, confused perceptions that make up [by unfolding] our macroperceptions."[79] The related issue of identity is thornier and turns on the distinction between the convergent perspectivism of Leibniz and the divergent perspectivism of neo-Leibnizians like Whitehead. The latter perspectivism is immediately more acceptable to the philosopher of difference, for it posits a set of many diverging worlds rather than one actual world. Here, at least, Leibniz himself (as opposed to the line of thinking he inspired) proves irredeemably traditional.[80]

But that still leaves us with the last and most pertinent problem to be resolved, that of molar unity, or, in a Leibnizian framework, the substantial unity of any cluster of monads possessing a dominant monad. Here, once more, Deleuze finds a material correlate by which to render the dominant organic unity in physicalist terms: a *vinculum*, or membrane, which "works as a sort of grid filtering the monads that it receives as terms." Unity is in the skin. What makes this filtering mechanism sufficient to ground the unity of the organism as a molar whole is its own peculiar surface structure. For this "vinculum" is no ordinary type of fold but an infinite one—a torsion of the world that exteriorizes or unfolds as a wall, surface, or membrane its own interior folding of the world; in short, it is a fractal surface, limited yet infinite. Such an infinite surface can more than accommodate a molar entity without recourse to any reductive molecular substrate. Indeed, mechanism is now chastised "for not being mechanical enough, for not being adequately machined," that is, for not being "infinitely machined."[81] In *Foucault*, subjectification was described as an inside

constituted from a folding of the outside; in *The Fold*, all molar forms are presented as monadological foldings.

The first special feature of the fold, therefore, is that it enfolds the outside and the inside, reconciling them through a harmonics of space—a wave theory, if you like—rather than by any direct efficient action between two substances or within one substance. So, while the Deleuzian language of implication, virtuality, and intensity is retained even in *The Fold*, its basis in a strictly dichotomous logic of inside and outside has been made redundant. The second contribution of the fold is that it enables Deleuze to do justice at last to the full phenomenality of the molar stratum within a materialist discourse; as a topological concept, the fold is a complication of surfaces that offsets any temptation to step beyond the wholly immanent plane. It is a Baroque conception of matter that inflates it not into a universal machinism but into a universal texturology.[82]

Now, one notion that can do so much work must be quite special indeed, possibly too good to be true. So what exactly is a fold? Deleuze develops his analysis at a number of points in this work, with folds exemplified by the dermal surfaces of the embryonic body, harmonics, domestic architecture, fabrics, draperies, and costumes. What these myriad cases of folds ultimately uncover is an abstract folding process that comprehends physical, psychological, and cultural phenomena at all levels.

I do not believe, however, that the idea of the fold can resolve all the dichotomies we have looked at here. While adequate to the task of deconstructing the opposition between molarity and molecularity, the internal and the external, and the machinic and the vital, fact and value still seem recalcitrantly opposed; after all, even if the universe already has certain values irreducibly enfolded into its very texture, a metatheoretical gap remains between that fact and the altogether different idea that we ought, therefore, to pursue those values ourselves (assuming we were free to do so anyhow). Before we can justify the Deleuzian principle that "politics precedes being,"[83] we will have to go much further in reformulating our notion of value.

We can translate this last development in Deleuze's thought into a distinction between the two theories of expression advanced by Spinoza and Leibniz, respectively. Spinoza's modal essences are not to be confused with Leibniz's monads, as they are not microcosms; their expressivity is very different and passes from infinite (quality) to finite (quantity). Leibnizian

monads express themselves, on the contrary, in the opposite direction: their finite expression is of the infinite world. In Deleuze's turn to Leibniz, therefore, we see a switch of philosophical orientation from a "bottom-up" materialism predicated on a monism of substructural matter or plane of immanence (Spinoza's infinite substance, in other words) to a "top-down" view that nonreductively materializes the dominant unity of each individual form on account of the enfolded intricacy of its material content.[84]

As for cybernetics, then, some final words need to be said. Much of contemporary materialism is (without using the term) "molecular," whether cast in reductive, eliminative, or magically supervenient terms. Deleuze, in ultimately materializing the molar sphere without reducing it to the scale of the molecular, bypasses the false dualism of either irreducible representation (space, for example, understood in terms of its meaning for our being-in-the-world) or reductive naturalism (seeing our phenomenal existence as either an illusion or an epiphenomenon of molecular matter). While reductionists and anti-reductionists both believe matter to be essentially impoverished, the former applaud that, whereas the latter, fearing the reductionists may be right, try to offset the claims of material nature by positing certain rights, powers, or faculties as exclusive to humanity. Neither camp makes any serious reappraisal of the original estimation of matter. For Deleuze, on the other hand, matter has an inorganic life and a *Dasein* of its own; it is far from being the worldless category that Heidegger, for one, thought it to be.

Could a nonreductive cybernetics interpretation of Deleuze thus appropriate his ideas without losing what is unique about his rethinking of matter? Yes, if cybernetics were divested of all links with cyborgology and AI, that is, viewed purely in terms of isomorphic structures, all of which would be open, self-organizing, and operating beyond equilibrium. Cybernetics, understood in the wholly abstract framework of a general system theory, would thereby shed its reductivism. But then we would be faced with the host of associated problems at the heart of any system theory. As a mode of structuralist thought, such a cybernetics would have been rejected by Deleuze for thinking of itself as formal and systematic rather than in terms of the empirical and chaotic reality which typifies Deleuzian thinking.[85]

Notes

I would like to thank the following people for insights that have either directly or indirectly influenced the development of this paper: Ian Buchanan, Philip Goodchild, John Marks, Brian Massumi, and all those who attended the seminar at University College, Dublin, in October 1996, where these ideas were first aired.

1 See, for example, Gilles Deleuze and Claire Parnet, *Dialogues*, trans. Hugh Tomlinson and Barbara Habberjam (New York, 1987 [1977]), 115.

2 Charles J. Stivale, "Mille/Punks/Cyber/Plateaus: Science Fiction and Deleuzo-Guattarian 'Becomings,'" *SubStance* 66 (1991): 66–84; quotations from 66–68.

3 See http://www.dc.peachnet.edu/~mnunes/smooth.html. Hakim Bey's work on "Temporary Autonomous Zones"—oases of anarchic self-expression found in a range of sites from the Internet to dinner parties—draws explicit parallels with the ideas of nomadism, micro-politics, smooth spaces, and imperceptibility that Deleuze and Guattari utilize in their philosophy; see http://www.c2.org/~mark/lib/zone.html#tnatw, 3–5, 7. (I should note that here I often conflate the significance of the collaborative work done by Deleuze and Félix Guattari with Deleuze's individual studies, which is admittedly a dubious, though at present unavoidable, scholarly move.)

4 Chris Hables Gray, Steven Mentor, and Heidi J. Figueroa-Sarriera, "Cyborgology: Constructing the Knowledge of Cybernetic Organisms," in *The Cyborg Handbook*, ed. Chris Hables Gray, with Heidi J. Figueroa-Sarriera and Steven Mentor (New York and London, 1995), 1–14; quotation from 4.

5 See Sandy Stone, "Split Subjects, Not Atoms; Or, How I Fell in Love with My Prosthesis," in Gray et al., eds., *Cyborg Handbook*, 393–406; quotation from 398.

6 Manfred Clynes—who, along with Nathan Kline, coined the term in 1960—points to the existence of cyborgs as far back as the Middle Ages, when spectacles first came into use; see Chris Hables Gray's interview with Manfred Clynes in Gray et al., eds., *Cyborg Handbook*, 43–53; quotation from 49.

7 See Gray, Mentor, and Figueroa-Sarriera, "Cyborgology," 6.

8 See Gilles Deleuze, *Francis Bacon: Logique de la Sensation*, 2 vols. (Paris, 1981), 1: 17.

9 See Gray, Mentor, and Figueroa-Sarriera, "Cyborgology," 5.

10 Ibid., 7.

11 Deleuze's entire corpus could be cited to this end, but the locus classicus for his antirepresentationalism probably remains the third chapter of *Difference and Repetition*, trans. Paul Patton (New York, 1994 [1968]).

12 Deleuze explicitly valorizes analogy in *Francis Bacon*. The digital, subordinating the hand to the eye, forms a striated space (99). Nevertheless, analogy is reread here as an active production of resemblance utilizing nonrepresentational means; it is in no way a reproduction of some prior reality (75).

13 There is an ongoing debate between connectionists within the AI fraternity and antireductionists over the significance of an artificial neural network: Does its power emanate from its formal properties or from its material content? If the former, then a neural network remains a syntactic engine, while the latter would start it down the slippery slope to vitalism (certain material substances having special vital powers). The second

possibility is not a viable option for any science working within the paradigm of mechanism.

14 Gilles Deleuze and Félix Guattari, *A Thousand Plateaus: Capitalism and Schizophrenia*, trans. Brian Massumi (Minneapolis, 1987 [1980]), 71; see also Deleuze and Parnet, *Dialogues*: "No assemblage can be characterized by one flux exclusively" (101).

15 Gilles Deleuze, *Cinema 2: The Time-Image*, trans. Hugh Tomlinson and Robert Galeta (Minneapolis, 1989 [1985]), 29.

16 Deleuze and Guattari, *A Thousand Plateaus*, 179.

17 Michael Hardt, for example, says that Deleuze's approach to ontology is "as new as the infinitely plastic universe of cyborgs and as old as the tradition of materialistic philosophy," in *Gilles Deleuze: An Apprenticeship in Philosophy* (Minneapolis, 1993), xiv. Ronald Bogue claims that Deleuze and Guattari talk of flows of "information," among other things, "in a very loosely cybernetic sense," in *Deleuze and Guattari* (London and New York, 1989), 91; see also Bogue's claim that "Deleuze and Guattari propose . . . a cybernetics" (92).

18 Gilles Deleuze, *Foucault*, trans. Seán Hand (Minneapolis, 1988 [1986]), 131–32.

19 See Gilles Deleuze, *Negotiations, 1972–1990*, trans. Martin Joughin (New York, 1995 [1990]), 175, 180.

20 Deleuze, *The Time-Image*, 264–65.

21 Deleuze and Guattari, *A Thousand Plateaus*, 217.

22 Gilles Deleuze and Félix Guattari, *Anti-Oedipus: Capitalism and Schizophrenia*, trans. Robert Hurley, Mark Seem, and Helen R. Lane (Minneapolis, 1983 [1972]), 70, 280, 342.

23 Not that all reductionism is a demotion solely in scale—economic reductionism, Platonist reductionism, and structuralist reductionism would be obvious counterexamples; Deleuze's materialist language and sporadic antimolar analyses, however, do invite the type of microreductionism prevalent in materialist cyberculture.

24 See, for example, Deleuze and Guattari, *Anti-Oedipus*, 42–43; and *A Thousand Plateaus*, 33; see also Deleuze, *Foucault*, 84.

25 Deleuze and Guattari, *A Thousand Plateaus*, 275.

26 See Luce Irigaray, *This Sex Which Is Not One*, trans. Catherine Porter, with Carolyn Burke (Ithaca, 1985).

27 Elizabeth Grosz, "A Thousand Tiny Sexes: Feminism and Rhizomatics," in *Gilles Deleuze and the Theatre of Philosophy*, ed. Constantin V. Boundas and Dorothea Olkowski (London and New York, 1994), 187–210; quotation from 189. Deleuze and Guattari's attraction to such writers as D. H. Lawrence and Henry Miller cannot have helped their cause with feminists—nor, for that matter, would their reading of anorexia as a positive act of becoming a body without organs; see Deleuze and Parnet, *Dialogues*, 43, 90, and 110.

28 Deleuze and Guattari, *A Thousand Plateaus*, 275–76, 276.

29 Gilles Deleuze and Félix Guattari, *What Is Philosophy?*, trans. Hugh Tomlinson and Graham Burchell (New York, 1994 [1991]), 20.

30 See Deleuze, *Negotiations*, 149.

31 Deleuze and Guattari, *What Is Philosophy?*, 209–10.

32 Gilles Deleuze, *The Logic of Sense*, trans. Mark Lester, with Charles Stivale; ed. Constantin V. Boundas (New York, 1990 [1969]), 142.

33 Deleuze and Guattari, *Anti-Oedipus*, 2, 84.

34 Gilles Deleuze, *Spinoza: Practical Philosophy*, trans. Robert Hurley (San Francisco, 1988 [1981]), 17–19.

35 Remember that Spinozian substance has an infinite number of attributes, only two of which—thought and extension—are directly known; see *Ethics*, pt. 1, def. 6 and prop. 15, proof and scholium.

36 See Deleuze and Parnet, *Dialogues*, vii.

37 Ibid., 54.

38 Cf. Deleuze, *Difference and Repetition*, 143–44; and Gilles Deleuze, *Proust and Signs*, trans. Richard Howard (New York, 1972 [1964]), 164.

39 See Deleuze, *Difference and Repetition*, 140ff.

40 Deleuze, *Logic of Sense*, 272.

41 See David Papineau, *Philosophical Naturalism* (Oxford, 1993).

42 Deleuze and Guattari, *A Thousand Plateaus*, 406.

43 Gilles Deleuze, *Expressionism in Philosophy: Spinoza*, trans. Martin Joughin (New York, 1990 [1968]), 227, 229.

44 See, for instance, Bogue, *Deleuze and Guattari*, 2.

45 Gilles Deleuze, *Nietzsche and Philosophy*, trans. Hugh Tomlinson (New York, 1983 [1962]), 61.

46 Ibid., 123, 124.

47 Of course, Deleuze is not alone in utilizing this type of language; talk of potential forces or energies, natures, dispositions, and powers is perfectly respectable in science. But Deleuze is supposedly a Humean empiricist espousing the radical *externality* of relations: the future is completely open and undetermined; hence possibility, potentiality, and so on are only retrospective illusions of the present reality projected into futures already past (a point that Bergson frequently makes, as Deleuze would know).

48 Vincent Descombes, *Modern French Philosophy* (Cambridge and New York, 1980), 180.

49 Deleuze, *Expressionism in Philosophy*, 258, 225.

50 Ibid., 11.

51 Ibid., 94. The capacity for being affected is both a power of acting, qua active affections, and a power of being acted upon, qua passions (see Deleuze, *Spinoza*, 27).

52 See Deleuze, *Spinoza*, 28.

53 Before consigning Deleuze's reading of Spinoza to the same problematic as that of his reading of Nietzsche (making power or force a rightful potential), it ought to be noted that Deleuze describes *potentia* as "act, active, actual" (ibid., 97), but he then depicts action itself, immediately thereafter, as a "capacity for being affected . . . constantly and necessarily filled by affections that realize it"; hence "potentia" has simply been replaced by the equally offending "capacity." These problems might be resolved, at least for Spinoza, by recognizing that his notion of substance does not stand alone, separate from its modes, in that the expressed and the expression are one and the same; thus the action and what is activated are not distinct. Still, some sort of difference between the two, and a further difference between the expressed (or what is activated) and substance itself, does remain. As a result, this Spinozian substance-metaphysics of expression will have to be rejected for a Leibnizian model.

54 Ibid., 102.

55 "After all," asks Deleuze, "is not Spinoza's *Ethics* the great book of the BwO?" (Deleuze and Guattari, *A Thousand Plateaus*, 153).

56 Ibid., 188.

57 See Gilles Deleuze and Félix Guattari, *Kafka: Toward a Minor Literature*, trans. Dana Polan (Minneapolis, 1986 [1975]), 48.

58 Deleuze and Parnet, *Dialogues*, 104. Sometimes the machinic is defined simply as a "synthesis of heterogeneities" (Deleuze and Guattari, *A Thousand Plateaus*, 330).

59 See Deleuze and Guattari, *Kafka*, 29, 39, 40, 45, 57, and 82. Of course, as they nearly always do, Deleuze and Guattari draw a cautionary distinction between these machines and the merely technical components of larger machinic assemblages (ibid., 57).

60 See Deleuze and Guattari, *Anti-Oedipus*, 109.

61 Deleuze, *The Time-Image*, 156.

62 Yet in Deleuze's earlier analysis of spiritual automata (see *Spinoza*, 86), on Spinozian principles a *bodily* automaton has to be seen as the other aspect of the spiritual automaton, operating in the attribute of extension rather than being identified with the spiritual automaton as such.

63 Deleuze, *The Time-Image*, 161, 165, 169.

64 Ibid., 157, 164, 166, 178, 179.

65 Ibid., 263, 264.

66 See Gilles Deleuze, *Cinema 1: The Movement-Image*, trans. Hugh Tomlinson and Barbara Habberjam (Minneapolis, 1986 [1983]), 208–9, 212.

67 Deleuze, *Negotiations*, 60.

68 Ibid., 143.

69 Rosi Braidotti, "Discontinuous Becomings: Deleuze on the Becoming-Woman of Philosophy," *Journal of the British Society for Phenomenology* 24 (1993): 44–55; quotation from 44.

70 Cf. Deleuze, *Spinoza*, 12; and Deleuze and Parnet, *Dialogues*, 5, 15.

71 Deleuze and Guattari, *Anti-Oedipus*, 284–86, 44, 285–86.

72 Deleuze, *Difference and Repetition*, 190.

73 Gilles Deleuze, *Empiricism and Subjectivity: An Essay on Hume's Theory of Human Nature*, trans. Constantin V. Boundas (New York, 1991 [1953]), 91.

74 Deleuze and Guattari, *A Thousand Plateaus*, 49.

75 Deleuze, *Logic of Sense*, 87, 103.

76 Michael Hardt (*Gilles Deleuze*, 5–6) tries admirably to rehabilitate this internal/external dualism in terms of necessary versus contingent causality, but the relationship between these two dyads seems itself rather tenuous.

77 Deleuze, *Logic of Sense*, 259, 99.

78 Gilles Deleuze, *The Fold: Leibniz and the Baroque*, trans. Tom Conley (Minneapolis, 1993 [1988]), 19.

79 Ibid., 22, 86.

80 Ibid., 79–82.

81 Ibid., 112, 8.

82 Ibid., 115.

83 Deleuze and Guattari, *A Thousand Plateaus*, 203.

84 This is not to conclude that the views upheld in *The Fold* emerged from Deleuze's thought without any precedents. They can be traced back to ideas in *A Thousand Plateaus*, which in turn can be said to relativize many of the ideas of *Anti-Oedipus* at the same time as it generalizes them. Hence, in the second volume of *Capitalism and Schizophrenia*, deterritorialization and reterritorialization are always complementary, relative, and intertwined rather than opposed, as previously, and the same can be said of the increasingly relative and complementary status of molarity and molecularity (see Deleuze and Guattari, *A Thousand Plateaus*, 54). Additionally, the move from the first volume to the second marks a shift in a more physicalist and less psychosocial direction: ethology replaces ethnology, rhizomatics replaces schizoanalysis (ibid., 328). Schizophrenia is eventually seen to express rhizomatics only at the level of pathos and not universally (ibid., 506). Yet *A Thousand Plateaus* is also more organicist and less machinic than *Anti-Oedipus*, and not just because it is more detailed or generalized, but because it involves a more subtle view of matter. That is why the vocabulary of "desiring-machines" is replaced by the terminology of "assemblages" ("no assemblage can be characterized by one flux exclusively").

85 See Ludwig von Bertalanffy, *General System Theory: Foundations, Development, Application* (New York, 1968), who describes the theory as a general science of "wholeness": "In elaborate form it would be a mathematical discipline in itself purely formal but applicable to the various empirical sciences" (36). Deleuze himself favored productive resemblance or repetition over isomorphism or bare repetition (see *Francis Bacon*, 75; and the introduction to *Difference and Repetition*).

Art and Territory Ronald Bogue

According to the composer Olivier Messiaen, birds are probably "the greatest musicians existing on our planet."[1] To a certain extent, one might regard the eleventh plateau of *A Thousand Plateaus*, "1837: Of the Refrain," as Gilles Deleuze and Félix Guattari's extended meditation on the significance of this remark. The conjunction of birds and music points in one direction toward a conceptualization of human music as a cosmic art, one that is directly in touch with the differential rhythms of the natural world. Throughout his life, Messiaen was enamored of birdsong, which he incorporated into a number of his works. His compositional practice aptly illustrates Deleuze and Guattari's concept of "becoming-animal," and his transformative manipulations of bird motifs provide perhaps the clearest instance of music as "a creative, active operation that consists in deterritorializing the refrain."[2] But Messiaen's remark also points in another direction, toward a biological contextualization of art. Are birds musicians? Do animals have art? If so, what is the relationship between human art and the art of other creatures? These are some of the questions Deleuze and Guattari explore in Plateau

II, the guiding thread of their discussion being the concept of "territoriality." My concern here is to show how this discussion affects our understanding of ethology, developmental biology, and evolutionary theory, and how we might begin to relate aesthetics to these sciences.

The concepts of territorialization, deterritorialization, and reterritorialization play an important role in the thought of Deleuze and Guattari. As early as 1966, Guattari made use of these concepts in discussions of group psychology, speaking of mass identification with a charismatic leader as "an imaginary territorialization, a fantasmatic group corporalization that incarnates subjectivity," and of capitalism as a force that " 'decodes,' 'deterritorializes' according to its *tendency*." [3] Guattari's effort here is to extend to the domain of the social Lacan's essentially psychological use of "territorialization," that is, as the process whereby parental caregiving invests the infant's libido in specific body regions, with the infant's initially free-floating "polymorphous perversity" giving way through parental care (feeding, cleaning) to a "territorialized," or fixed and localized, organization of the body into erogenous and nonerogenous zones. Guattari's broadly social application of the Lacanian concept is developed further in *Anti-Oedipus*, where "deterritorialization" and "reterritorialization" figure prominently in tandem with the concepts of "decoding" and "recoding," the first pair largely relating to bodies and physical investments of energy, the second pertaining to symbolic representations and mental investments of energy. [4] As Eugene Holland has pointed out, in *A Thousand Plateaus* decoding and recoding tend to recede in importance, whereas deterritorialization and reterritorialization become increasingly significant concepts, their relatively circumscribed function in *Anti-Oedipus* of describing material investments in human desiring-production being extended in *A Thousand Plateaus* to characterize phenomena ranging from geologic formations to DNA strands and interspecies relations. [5] It is only at this juncture of their work that Deleuze and Guattari turn to what biologists call "territoriality."

Observers since Aristotle and Pliny have noted that certain animals defend their domains against intruders, but the formal concept of territoriality has been slow in taking shape. Henry Eliot Howard is often credited with first developing the biological concept of territory in his 1920 *Territory in Bird Life*, although Ernst Mayr points out that many of Howard's findings were anticipated in Bernard Altum's 1868 *Der Vogel und sein Leben*, a work that has remained untranslated and generally unknown in the English-speaking world. [6] Allen Stokes notes as well that the concept of territoriality

may be found in C. B. Moffat's largely ignored 1903 essay "The Spring Rivalry of Birds."[7] In the 1930s and 1940s, J. S. Huxley, Nikolaas Tinbergen, Konrad Lorenz, and others extended these analyses of territoriality in birds to other animals, and gradually the concept became established as a basic notion in ethology. From the earliest studies by Altum, Moffat, and Howard, the idea of territoriality has been related to aggression. In a 1956 survey of the literature on territoriality in birds, R. A. Hinde reviewed a number of definitions of the concept and concluded that G. K. Noble's 1939 characterization of territory as "any defended area" could serve as a standard, minimal formulation of territoriality.[8] Several functions have been attributed to territorial behavior: limitation of population density, facilitation of pair formation and maintenance of the pair, reduction of interference with reproductive activities, defense of the nest, defense of food supplies, reduction of losses to predators, reduction of time spent in aggression, prevention of epidemics, and prevention of inbreeding and crossbreeding.[9] But the predominant view is that territoriality is a mode of social organization whereby the strongest males (generally) secure mates and desirable habitats, establishing through various aggressive communicative actions with conspecifics an equilibrium of population density across a given area.

Perhaps the best-known and most fully developed study of aggression and territoriality is Lorenz's *On Aggression*, a 1963 work that articulates with particular clarity the assumptions predominant in the field. Lorenz sees hunger, sex, fear, and aggression as the four great biological drives. Intraspecies fighting has Darwinian survival value in that "it is always favorable to the future of a species if the stronger of two rivals takes possession either of the territory or of the desired female."[10] Territorial aggression ensures that the resources of a region will not be exhausted through overcrowding, that the strongest will obtain the most desirable mates, and that progeny will be sheltered within the defended domain: "The environment is divided between the members of the species in such a way that, within the potentialities offered, everyone can exist. The best father, the best mother are chosen for the benefit of the progeny. The children are protected."[11] Various territorial signals—the "bright poster-like color patterns" of certain tropical fish,[12] the songs of numerous birds, the olfactory markings of deer, rabbits, or dogs, diverse ritual-behavior patterns such as the zigzag dance of the stickleback—serve as substitutes for fighting, hence as derivative means of establishing and maintaining distance between rivals.

According to this familiar mechanistic, stimulus–response model, ter-

ritoriality is simply a random outgrowth of the primary drives that has proven to possess survival value. Birdsong, far from being an animal art form, is merely an instinctual communicative signal at the service of the drives of sex and aggression. Lorenz's influential thesis, in Deleuze and Guattari's judgment, "seems . . . to have little foundation."[13] They do not deny the connection between aggression and territoriality, but they do question the primacy accorded to aggression as territoriality's explanatory cause. Aggression is organized differently in a territorial species than in a nonterritorial one, just as other functions (mating, rearing, food-gathering, etc.) are differently configured, or in some cases newly created (such as in various forms of dwelling construction). But no function explains territoriality; rather, it is territoriality that explains the reorganization of functions: "These functions are organized or created only because they are *territorialized*, and not the other way around. The T factor, the territorializing factor, must be sought elsewhere: precisely in the becoming-expressive of rhythm or melody, in other words, in the emergence of proper qualities (color, odor, sound, silhouette). . . . There is a self-movement of expressive qualities," which "are auto-objective, in other words, find an objectivity in the territory they draw." They express the relation of the territory to internal and external milieus, but this expressiveness is not the result of an impulse triggering an action: "To express is not to depend upon; there is an autonomy of expression."[14] Deleuze and Guattari's response to Lorenz may seem to be no response at all, in that they claim "the T factor," the "becoming-expressive of rhythm or melody," as its own explanation. In fact, what they are proposing is an alternative conception of nature, one that is expressive rather than mechanistic and that builds especially on the work of the pioneering ethologist Jakob von Uexküll and the philosopher Raymond Ruyer.

Deleuze and Guattari cite von Uexküll as the author of "an admirable theory of transcodings," one that treats milieu components "as melodies in counterpoint, each of which serves as a motif for another: Nature as music."[15] The work in which the nature–music connection is most evident is von Uexküll's 1940 study *Bedeutungslehre*, which appeared in French translation in 1956 as *Théorie de la signification*.[16] Living beings are not mechanical objects regulated merely by cause-and-effect forces, according to von Uexküll, but subjects inhabiting worlds of meaning. When von Uexküll meets a furiously barking dog on his daily walk and throws a pavingstone toward it to scare it away, the stone does not change its physical proper-

ties, but its *meaning* for the dog does change. What had been an object functioning in the human world as a support for the steps of pedestrians (and probably as an indifferent feature of the ground for the dog) has been converted into a menacing projectile in the dog's world, into a bearer of meaning: "It is only by way of a relation that the object is changed into a bearer of meaning, meaning which is conferred on it by the subject." Von Uexküll distinguishes between plants, which are immediately embedded in their habitat, and animals, which occupy a milieu (*Umwelt*); but "on one point the planes of organization of animals and plants coincide: both effect a precise choice among the events of the external world that concern them." An animal milieu "constitutes a unity closed in on itself; each part of it is determined by the significance it receives for the subject of this milieu."[17] Perhaps von Uexküll's best-known example of this concept is the tick, whose milieu is constituted by a very limited number of factors. It climbs to the top of a branch or stalk and drops onto a passing mammal, whose blood it then sucks. The tick has no eyes, so only the general sensitivity of its skin to sunlight orients it on its upward climb. Its olfactory sense perceives a single odor, that of butyric acid, a secretion given off by the sebaceous follicles of all mammals. When the tick senses a warm object below, it drops on its prey and searches out a patch of hair, then pierces the host's soft skin and sucks its blood. The tick's milieu is made up of those elements that have meaning for it: sunlight, the smell of butyric acid, the tactile sense of mammalian heat, hair, and soft skin, and the taste of blood. Its milieu is a closed world of elements outside of which nothing else exists. Although animals all seem to inhabit the same universe, each lives in a different, subjectively determined milieu. Hence the stem of a wildflower is a different object for the tick that climbs it, the girl who plucks it, the locust larva that pierces it and extracts its sap, and the cow that eats it: "The same components, which in the stem of the flower belong to a precise plane of organization, separate into four milieus and with the same precision join four totally different planes of organization."[18]

From a behaviorist's perspective, this is simply to say that animals respond to different stimuli. Von Uexküll insists, however, that the passage from perception to action is to be understood not as the induction of an electrical current through a wire, but as "the induction which passes from one sound to another in the unfolding of a melody,"[19] that is, as a unifying theme that expresses a meaning. Furthermore, such melodies,

uniting perceptions and actions, are inextricable from the developmental melody that guides the gestation and maturation of each living being, "a melody of growth or an imperative of growth that regulates the individual tonalities of the germinative cells." Hence von Uexküll can refer to gastrulation as "the simple melody with which every superior animal's life begins."[20] To emphasize the interconnection of biological beings and their habitats/milieus, von Uexküll speaks of the relationship between an interpreter and a bearer of meaning as a contrapuntal relation, that is, as a harmonious concurrence of two or more melodies. For an oak tree, rain is a bearer of meaning that it utilizes as nourishment. The oak's leaves, fashioned with gutterlike veins, are spread like the tiles of a roof to form a melodic point in harmony with the counterpoint of the rain. In a similar fashion, the octopus's muscular pocket, which it contracts in order to swim, is a developmental melody that, in counterpoint with the incompressibility of water, makes such hydraulic locomotion possible.

More complex are the contrapuntal relations between species, such as between bats and certain nocturnal butterflies. The chief predator of such butterflies is the bat, which uses sound for a variety of purposes; the butterfly, equipped with a very limited sonic apparatus, is capable of recognizing only a narrow band of frequencies, but it is one that corresponds precisely to the cry of the bat. The same sound emitted by the bat has different meanings for the two species. "Given that the range of perceptive signals of the bat is extended, the sharp sound it perceives is only one tone among others. By contrast, the range of perceptive signals of the nocturnal butterfly is very limited, for its milieu contains only one sound: that of its enemy." How is it that the structure of the butterfly contains an apparatus suited to perceiving its enemy? "The rule of development of butterflies contains from the beginning instructions for forming an auditory organ attuned to the cry of the bat."[21] Clearly, the butterfly's behavioral melody of perception and action presumes a developmental melody, both butterfly melodies being constituted in counterpoint with the melody of the bat. And it is meaning that is the guiding concept in this analysis, "not the miserable rule of causality which can see no further than one step in front or one step behind, and remains blind to broad structural relations."[22]

The same determinative role of meaning in relation to development may be seen in the spider. Its web is ideal for capturing flies, with a tensile strength sufficient to withstand the fly's struggles and gaps in the mesh

proportioned to the fly's dimensions. The web's radial filaments are more solid than its circular arcs, hence well suited for conveying vibrations and guiding the spider to the site of a disturbance; the finer circular strands, unlike the radial spokes, have a sticky glue for imprisoning the fly, and all the threads of the web are fine enough to be invisible to the fly. What is most surprising is that the spider "weaves its web before even having encountered a real fly. Its web, consequently, cannot be the copy of a physical fly, but represents its archetype, which is not given physically."[23]

Von Uexküll regards a territory simply as a specialized milieu, but one that clearly reveals the subjective nature of all milieus. Although a fly may have a dwelling, the space it traverses does not comprise a territory. The spider, by contrast, has both dwelling and territory in its web. The mole also has a dwelling and a territory in its central nest and radiating network of tunnels, which occupy and control a given region like an underground spiderweb. What one sees more clearly in the mole's territory than in the spider's, however, is that a territory is "a pure active space,"[24] the tunnels marking the repeated and familiar movements whereby the animal constructs its milieu in accordance with its particular array of senses. In the case of territorial birds and fish, dwelling and territory are distinct. Such territories may be marked in various ways, but they tend to be more abstract and less visible than those of the spider and mole; like the mole's burrow—and more obviously so—they are pure active spaces created through patterns of movement that define an extended milieu.

While Deleuze and Guattari do not adopt all aspects of von Uexküll's analysis of nature as music, they are in sympathy with much of it. Von Uexküll's stress on "meaning" is rephrased in terms of "affects" and "bodies," the tick aptly illustrating the thesis that a body may be defined by its power of affecting and being affected by other bodies.[25] But this shift in terminology merely reinforces von Uexküll's basic point that milieus are inextricable from the creatures that create and inhabit them. Deleuze and Guattari, like von Uexküll, speak of milieu components as "melodies," thereby emphasizing the organization of pragmatic and developmental patterns as temporal unfoldings that possess a thematic coherence. But they stress as well the role of differential rhythms and periodic metrical repetitions in the construction of milieus; hence isolating the characteristic common to sonic and nonsonic motifs—the temporal disposition of their elements—enables these authors to speak of milieu components literally rather than figura-

tively as musical motifs. Von Uexküll's analyses of such contrapuntal rela-
tions as those between bats and butterflies, and spiders and flies, merely
reinforce Deleuze and Guattari's contention that milieus must be consid-
ered as relational concepts. And although their differentiation of milieu
and territory varies somewhat from von Uexküll's—the spider, for example,
is not territorial, according to Deleuze and Guattari[26]—they all regard ter-
ritory as a specialized rhythmic organization of milieu components.

Von Uexküll recognizes the importance of developmental melodies in
the symphony of nature, but for a detailed elaboration of this notion one
must turn to Raymond Ruyer, a philosopher whom Deleuze and Guattari
cite with some frequency.[27] In a series of books, including *La Conscience
et le corps* (1937), *Eléments de psycho-biologie* (1946), *Néo-finalisme* (1952),
and *La Genèse des formes vivantes* (1958), Ruyer articulates a philosophy of
biology centered on the formative activity of all living beings. His control-
ling insight is that the morphogenesis of a living entity can never be ex-
plained on the basis of a mechanistic causality-through-contiguity model,
but must presume the existence of a formative theme or melody guiding
its development. Following Whitehead, Ruyer distinguishes between living
forms—self-shaping, self-sustaining, and self-enjoying entities—and ag-
gregates—quantitative collections of entities whose forms are determined
by external forces and hence explicable in terms of mechanistic causal
relations. Examples of aggregates are clouds, ocean currents, geologic for-
mations, and human crowds. Living forms extend from the smallest self-
sustaining subatomic particles through viruses and bacteria to the most
complex multicellular organisms.

A living form is a process, an ongoing formative activity that Ruyer
equates with consciousness: "Consciousness *is* every active process of for-
mation, in its absolute activity, and every process of formation *is* conscious-
ness." Ruyer is not advocating a mind–body dualism or a vitalistic dualism
of "entelechy" and organic machine. Consciousness is not a separate ingre-
dient or a spiritual substance. It is an "intelligent or instinctive act, always
in the process of organizing, according to the theme that it assumes, sub-
domains themselves in the midst of a process of organization."[28] Ruyer
also differentiates his position from panpsychism, which adopts human
consciousness as its model and then ascribes such a consciousness to other
entities; for Ruyer, however, human consciousness is a very specialized,
idiosyncratic instance of a general formative activity exhibited by all living

entities. Hence embryologists are former embryos who, in the course of their morphogenesis, have developed a most complicated and indirect cognitive tool—adult human consciousness—with which they try to learn what every embryo already knows: how to grow into a mature individual.

According to Ruyer, morphogenesis proceeds in a temporal, "horizontal" sequence but always according to a "vertical," trans-spatial and transtemporal theme, "an individualized melodic theme which can either be repeated as a whole or can be distributed in variations, in which the initial, repeated theme serves as its own 'development' (in the musical sense of the term)."[29] This organizing and regulating theme exists in a virtual, ideal domain immanent within the entity undergoing actualization. The theme, however, is not a complete blueprint or code for the construction of a living being, for Ruyer is not proposing to replace a mechanistic preformationism (which he finds in conventional explanations of morphogenesis as the implementation of genetically coded instructions) with a metaphysical version. Morphogenesis proceeds in accordance with the theme, but not as the copy of a fully formed model. "The organism forms itself with risks and perils, it is not formed. . . . The living being is at the same time agent and 'material' of its own action. . . . The living being forms itself directly according to the theme, without the theme having first to become ideaimage and represented model."[30]

The vertical melodic theme, a virtual motif immanent within the actualizing process of morphogenesis, is consciousness, which is "nothing other than form, or rather the active process of formation, in its absolute existence."[31] To emphasize the derivative, specialized nature of human consciousness, Ruyer distinguishes among three different kinds of forms. Form I is the fundamental form, the self-sustaining, auto-conducting, self-enjoying activity common to all living beings. Form II is a particular case of Form I, a reflective, representational consciousness created through the development of organs of perception and motor schematization. Form III, a subset of Form II found only among humans, "appears when utilitarian perception, which serves only as a signal or index of instinctive life in animals and in humans insofar as they lead an animal life, changes its role, and when the signal becomes a symbol, manipulable by itself, and detachable from every context of vital or immediate utility." In this sequence of forms Ruyer sees the nature of morphogenesis evinced as a conquest of space and time: "a conquest and also a creation." Form I, as exemplified

in atoms and molecules, is a structuring activity "for constituting a do-
main of space." Form II creatures, provided with faculties of perception
and schematization, gain possession of an extended space as *Umwelt*. And
with the advent of Form III, "the 'subject' or 'perceiving consciousness'
seems detached from extension and duration, as a sort of point of view."[32]
Territoriality marks a specific stage in the conquest of space and time, and
one that reveals the intimate connection between Form I and Form II. Ter-
ritoriality requires the development of a Form II consciousness, but the
inhabited territory is defined and fashioned by the body inhabiting it, that
is, by the body as actualization of the Form I process of morphogenesis.
Territory and animal constitute a single biologic field, "a morpho-genetic
theme directing at once the organic and the extra-organic, internal circuits
and external circuits, the biotope and the psychotope, that which is inside
and that which is outside the skin. . . . Organic movement includes the
milieu. The *Umwelt* is a subordinated theme in the organic form before
being differentiated into a distinct extra-organic form as territory."[33]

Ruyer does not discuss the role of birdsong, display markings, or other
indexes used to demarcate territories, but his remarks on the relation-
ship between animal and human artistic activity suggest what his analysis
would be. The display feathers of the peacock form a complex, organized
pattern, each feather developing as if it could see from the outside its posi-
tion in the overall design. The mystery of such self-decoration, however,
arises only when we analyze it from the perspective of a human artist be-
fore a canvas. Instead, we should reverse the situation and treat human art
as a subcategory of organic creativity. A man tattooing himself is essen-
tially no different from a peacock forming its ornamental display, except
that in the human being the ornamental theme appears first as an idea in
the cerebral tissues and then is executed through a complex neuromotor
circuit of eye–hand–brain activity. In the peacock, on the other hand, there
is no such specialization of functions, with the morphogenetic formative
activity of the organism operating as the equivalent of an undifferentiated
eye–hand–brain circuit. Human art, then, is merely a specialized and in-
direct manifestation of the organism's ongoing formative activity, one that
is increasingly detached from other life functions: "The expressivity of per-
ceived forms is detached from the vital situation, which permits artistic
play and the gratuitous creation of aesthetic forms . . . that live their own
life and develop as if by themselves, although they are naturally always at-

tached to possible perceptions, that is to Form II, itself always attached to the Form I of the organism."[34] Birdsongs and display markings, we may infer, are simply components of the territorial time–space system that reflect a certain level of specialization in the organism's morphogenetic formative activity and a specific degree of detachment from other life functions.

Ruyer's expressive biology, with its emphasis on the dynamic process of actualization as the expression of immanent virtual themes, clearly resonates with Deleuze and Guattari's philosophy in a fundamental way.[35] What is important to note here, however, is the continuity among living forms that Ruyer exhaustively establishes, as well as the increasing degrees of specialization and detachment he points out at various stages in the development of complex organisms. Every living form is the unfolding of a virtual melodic theme, but in the emergence of Form II from Form I and of Form III from Form II, one sees a growing autonomy in the organization of time and space, an increasing separation of subjectivity from morphogenetic formative activity and an augmenting independence of aesthetic forms from their vital context. In essence, what Ruyer is describing at such length are biological instances of de/reterritorialization, of the detachment or unfixing of elements and their reorganization within new assemblages. Ruyer's work, then, supports Deleuze and Guattari's contention that a *territory*, in the biologic sense of the term, is created through the general processes of *deterritorialization*, whereby milieu components are detached and given greater autonomy, and *reterritorialization*, through which those components acquire new functions within the newly created territory. Although Deleuze and Guattari emphasize the distinction between milieus and territories, the continuity of living forms across that divide is suggested in their concept of the refrain, which can serve as a point of organization for a milieu, can delimit the dimensional space of a territory, and can open a line of flight from a territory toward the cosmos; these three manifestations of the refrain, however, are "not three successive moments in an evolution" but "three aspects of a single thing."[36]

One might concede that Ruyer and Deleuze/Guattari have demonstrated the ubiquity of de/reterritorialization yet still question whether this is a self-explanatory phenomenon (and hence challenge the assertion that a territory emerges through the "self-movement of expressive qualities"). What remains to be seen is how von Uexküll's ethology of contrapuntal *Umwelten* and Ruyer's developmental biology of melodic living forms can

be accommodated to evolutionary biology. It is, after all, from the neo-Darwinian model that the primary explanatory power of Lorenz's account of territoriality is derived, and any alternative to that account must address the issues raised by evolutionary theory. A useful approach to the subject that embraces many of the insights of von Uexküll and Ruyer while largely according with Deleuze and Guattari's thought is the so-called Santiago theory of Humberto Maturana and Francisco Varela (to which Guattari briefly refers in *Les trois écologies* and *Chaosmose*).[37]

Maturana and Varela are among a number of researchers who have been studying self-organizing systems, or systems whose patterns of order emerge spontaneously from chaotic states. Characterizing living systems as self-organizing, self-maintaining, and self-referring, Maturana and Varela have coined the term "autopoiesis" to describe this process of auto-generation and auto-regulation. What differentiates living systems from other self-organizing ones is the manner in which they interact with the world. Not only do they act on and react to the outside world, but they specify which external perturbations will be incorporated into their circular, self-regulating organization. They engage in a "structural coupling" with selected features of their surroundings, thereby "bringing forth a world." Maturana and Varela equate this autopoietic process of structural coupling with cognition. As Maturana formulates this relation, "Living systems are cognitive systems, and living as a process is a process of cognition."[38]

In *The Embodied Mind*, Varela and his colleagues Evan Thompson and Eleanor Rosch, offering a critique of neo-Darwinism, outline an alternative approach to evolutionary theory based on the notions of autopoiesis, structural coupling, and natural drift. They point to several problems inherent to the neo-Darwinian model, especially the severe restrictions on genetic variation imposed by pleiotropy (the interdependent linkage of genes to one another) and by the complex genic interconnections that orchestrate the developmental sequence of morphogenesis; the puzzling phenomenon of genetic drift and the gratuitous existence of "junk DNA"; and the evolutionary stasis of some organisms through pronounced environmental changes over long periods of time. Neo-Darwinism presumes a fixed, given environment to which an organism must adapt, with genetic variation serving as the engine of that adaptation. Varela, Thompson, and Rosch insist, however, that living beings and their environments are mutually specified, or codetermined, and that genetic codes cannot be separated

from their material context.[39] Organisms and environments are "mutually unfolded and enfolded structures" engaged in a process of bringing forth a world, and that world is not ruled by a logic of the "survival of the fittest." Natural selection (if one must use the term) does not prescribe what life forms will exist, but simply proscribes those that are not viable. Within the broad constraints of survival and reproduction, mutually enfolded organisms and environments engage in a process of "natural drift," exploring a vast range of possible lines of development. Those possibilities do not have to be the best (survival of the *fittest*) but simply good enough. The evolutionary process, "*satisficing* (taking a suboptimal solution that is satisfactory) rather than optimizing," proceeds via "*bricolage*, the putting together of parts and items in complicated arrays, not because they fulfill some ideal design but simply because they are possible."[40]

Maturana and Varela conclude *The Tree of Knowledge* by positing love as the controlling principle of evolution, thereby stressing the cooperative values of mutual enhancement and interdependence as opposed to the competitive values of struggle and domination that reign in neo-Darwinism.[41] But what Varela, Thompson, and Rosch suggest in their notion of natural drift as "satisficing" bricolage—an assembling of parts "simply because they are possible"—is that *creation* is the primary force operating in evolution. Living systems emerge from chaotic states as loci of self-organization and, as they develop, bring forth multiple worlds, over time interchanging components in heterogeneous structural couplings, thereby fashioning new "enactive couplings" for no other reason than that they can be formed. The broad constraints of survival and reproduction allow myriad structural couplings but dictate none; new couplings continually emerge simply because living systems are inherently creative, inventive, formative processes.

What Maturana, Varela, and their colleagues provide is an evolutionary-biologic justification for the claim that the transmutations of the refrain, whose transverse, differential rhythms pass between milieus and territories and beyond, are indeed self-explanatory. Von Uexküll's contrapuntal harmonies of intertwined milieu-melodies are structural couplings, spontaneously generated codeterminations of organisms and environments. The varying degrees of deterritorialization and reterritorialization manifested in the passage from Ruyer's Form I to Form II and Form III, and from milieus to territories and other modes of spatial organization, are

evidence of no teleological design, but rather the products of a ubiquitous experimental bricolage, an inventive construction of machinic assemblages across a wide range of structural possibilities.

If we return to the question of whether animals have art, we might say in a general sense that all living beings have art, in that all are inherently creative. Following Ruyer's analysis of the relationship between the peacock's feather display and the painter's canvas, we might argue that there is a continuity between animal and human creativity, although animal invention involves Forms I and II but not the more deterritorialized Form III. Yet we may still ask whether animal creativity is an aesthetic activity—whether, for example, birdsong is really music. Ruyer would answer no, for only with Form III is the expressivity of perceived forms "detached from the vital situation, which permits artistic play and the gratuitous creation of aesthetic forms."[42] Lorenz would obviously respond in the negative as well, since for him birdsongs and other territorial markings are simply functional signals in the service of aggressive and sexual drives. Charles Hartshorne and W. H. Thorpe, both of whom have discussed the relationship of birdsong to music with particular care and insight, conclude that birds are indeed musicians since they play with sounds and appear at times to enjoy song for its own sake.[43]

All these responses assume an opposition of the functional and the aesthetic, of activities that are purposive means and of those that are self-sufficient ends. Deleuze and Guattari concur with Hartshorne and Thorpe's view that birds make music: "Art is not the privilege of human beings. Messiaen is right in saying that many birds are not only virtuosos but artists, above all in their territorial songs."[44] But their approach to the question entails a realignment of the functional and the aesthetic that allows for their mutual interpenetration in the work of art.

From the point of view of neo-Darwinism, birdsong exists only because it serves the purposes of species survival and reproduction. From the perspective of an autopoietic universe of natural drift, on the other hand, birdsong might serve any number of functions, some (possibly) ensuring survival and reproduction, others promoting different activities of the living system, including but not limited to those that we consider artistic creation and aesthetic enjoyment or contemplation. The birdsong as a territorializing refrain is a milieu component that has gained autonomy and become expressive, in the process creating a territory and concomitant re-

organization of functions.[45] As a territorialized motif, the birdsong takes on various roles within the territory, being combined with diverse functions to promote different activities. The refrain itself, however, as differential, incommensurable rhythm passing between milieus and territories, has a life of its own, a nonorganic life that functions only as a creative line of flight, an autonomous, deterritorializing transverse vector of invention.

If birdsong is a form of art, as Deleuze and Guattari assert, then the work of art is embedded in the world and enfolded in various functions. Art therefore cannot be construed in terms of a pure formalism, as a "purposiveness without purpose" divorced from the world (if we were to adopt a common narrow reading of Kant here). Those functions, however, extend over such a wide range that the concept of function as pragmatic purpose is undermined, in that there is no longer any clear criterion for distinguishing pragmatic from nonpragmatic ends. The functionalism of natural drift ultimately tends toward the functionalism of molecular desiring-production described in *Anti-Oedipus*, one in which "functioning and formation, use and assembly, product and production merge." The functional question in such desiring-production is not what it is *for* but simply whether it works: Does it make something happen? "Only what is not produced in the same way it functions has a meaning, and also a purpose, an intention. The desiring-machines on the contrary represent nothing, signify nothing, mean nothing, and are exactly what one makes of them, what is made with them, what they make in themselves."[46] And immanent within such machinic functions is the vector of the abstract, creative line of flight. The work of art, then, may participate in pragmatic, purposive activities, but its functions are also unrestricted, machinic. And to the extent that the work of art follows a vector of invention, it participates in the autonomous "purposiveness without purpose" of genuine creation.

Deleuze and Guattari differ from von Uexküll, Ruyer, and Maturana and Varela on key points. To counter the mechanistic tendency in much biologic thought, von Uexküll stresses subjects and meaning in biology, Ruyer equates living form with consciousness, and Maturana and Varela define living systems as cognitive ones. Deleuze and Guattari likewise reject mechanistic models, but they also avoid any terminology that might reintroduce the problematics of subjectivity. Von Uexküll, Ruyer, and Maturana and Varela develop theories of biology and hence concentrate on the distinction between living and nonliving systems. Deleuze and Guattari, by

contrast, recognize a nonorganic life that ignores any such distinction, even Ruyer's Whiteheadian differentiation of aggregates from self-sustaining, self-enjoying forms. Yet Deleuze and Guattari do embrace von Uexküll's vision of nature as music, integrating actual sonic music with the music of the differential rhythms of milieu components through the concept of the refrain. They also make use of Ruyer's notion of virtual developmental melodies, articulating his analysis of the differing levels of autonomy in Forms I, II, and III within a general theory of de/reterritorialization. And their approach to evolutionary biology broadly accords with Maturana and Varela's conceptualization of evolution as autopoietic natural drift. It is within the context of such a melodious, contrapuntal nature, a cosmos of inherently creative structural couplings engaged in a movement of unpredictable, open-ended natural drift, that we must place the work of art, which at times is functional in a pragmatic sense, but is always functional in a machinic sense, ever disclosing the course of an autonomous, transverse line of invention.

Notes

Generous support for this project was provided by a Senior Faculty Research Grant from the University of Georgia Research Foundation.
1 Claude Samuel, *Conversations with Olivier Messiaen*, trans. Felix Aprahamian (London, 1976), 51.
2 Gilles Deleuze and Félix Guattari, *A Thousand Plateaus: Capitalism and Schizophrenia*, trans. Brian Massumi (Minneapolis, 1987 [1980]), 300. For my own attempt to address these issues, see Ronald Bogue, "Rhizomusicosmology," *SubStance* 66 (1991): 85–101.
3 Félix Guattari, *Psychanalyse et transversalité* (Paris, 1972), 164; my translation.
4 Gilles Deleuze and Félix Guattari, *Anti-Oedipus: Capitalism and Schizophrenia*, trans. Robert Hurley, Mark Seem, and Helen R. Lane (Minneapolis, 1983 [1972]).
5 For a succinct summary of the relationship between deterritorialization/reterritorialization and decoding/recoding, see Eugene W. Holland, "Schizoanalysis and Baudelaire: Some Illustrations of Decoding at Work," in *Deleuze: A Critical Reader*, ed. Paul Patton (London, 1996), 240–56; and, for his account of the expanded role of deterritorialization/reterritorialization in *A Thousand Plateaus*, Eugene W. Holland, "Deterritorializing 'Deterritorialization'—From the *Anti-Oedipus* to *A Thousand Plateaus*," *SubStance* 66 (1991): 55–65.
6 See Henry Eliot Howard, *Territory in Bird Life* (London, 1948 [1920]); and Ernst Mayr, "Bernard Altum and the Territory Theory," *Proceedings of the Linnaean Society, New York* 45/46 (1935): 24–30.
7 See *Territory*, ed. Allen W. Stokes (Stroudsburg, PA, 1974), 4–5; and C. B. Moffatt, "The Spring Rivalry of Birds," *Irish Naturalist* 12 (1903): 152–66.

8 See R. A. Hinde, "The Biological Significance of the Territories of Birds," *Ibis* 98 (1956): 340–69. Consider, for example, Irenäus Eibl-Eibesfeldt's typical textbook definition of territory in *Ethology: The Biology of Behavior*, 2d ed., trans. Erich Klinghammer (New York, 1975 [1970]): "Ethologically a territory is defined as a space in which one animal or a group generally dominates others, which in turn may become dominant elsewhere (E. O. Willis, 1967). Domination can be achieved by diverse means, for example by fighting threat, territorial songs, and olfactory marking. By these means the territory owners usually banish those that do not belong to the group or any conspecific if it is solitary" (340).

9 See Hinde, "Biological Significance," 350–64.

10 Konrad Lorenz, *On Aggression*, trans. Marjorie Kerr Wilson (New York, 1966 [1963]), 30.

11 Ibid., 47.

12 Ibid., 18.

13 Deleuze and Guattari, *A Thousand Plateaus*, 316.

14 Ibid., 316–17.

15 Ibid., 314.

16 Jacob von Uexküll, *Mondes animaux et monde humain, suivi de Théorie de la signification*, trans. Philippe Muller (Paris, 1956 [1940]). My references to this work, which has not yet been translated into English, will be to this same French translation cited by Deleuze and Guattari in *A Thousand Plateaus*. Throughout *Théorie de la signification*, "Bedeutung" is rendered as "signification," which I translate as "meaning." The difficulties of dealing with the German terms *Bedeutung* and *Sinn*, the French *sens, signification*, and *signifiance*, and the English *sense, meaning*, and *signification* are well known and, of course, were of great concern in translating Deleuze's *Logique du sens*. They are of less moment here, however, since von Uexküll uses "Bedeutung" in a fairly straightforward fashion and does not follow Frege and others in distinguishing between "Sinn" and "Bedeutung." The French edition also contains von Uexküll's 1934 *Streifzüge durch die Umwelten von Tieren und Menschen*, translated as *Mondes animaux et monde humain*. Most of my remarks will be restricted to *Théorie de la signification*, but I shall make brief reference to *Mondes animaux et monde humain* in summarizing von Uexküll's views on territoriality.

17 Von Uexküll, *Mondes animaux*, 86, 93, 90.

18 Ibid., 89.

19 Ibid., 93.

20 Ibid., 98.

21 Ibid., 114.

22 Ibid., 106.

23 Ibid., 105.

24 Ibid., 63.

25 See Deleuze and Guattari, *A Thousand Plateaus*, 52, 257; and Gilles Deleuze, *Spinoza: Practical Philosophy*, trans. Robert Hurley (San Francisco, 1988 [1981]), 124–25.

26 See Deleuze and Guattari, *A Thousand Plateaus*, 314.

27 See especially Gilles Deleuze, *Difference and Repetition*, trans. Paul Patton (New York, 1994 [1968]), 216; Deleuze and Guattari, *Anti-Oedipus*, 286, 289; Gilles Deleuze, *The Fold: Leibniz and the Baroque*, trans. Tom Conley (Minneapolis, 1993 [1988]), 102–3;

and Gilles Deleuze and Félix Guattari, *What Is Philosophy?*, trans. Hugh Tomlinson and Graham Burchell (New York, 1994 [1991]), 210. On the importance of Ruyer and Whitehead to the thought of Deleuze and Guattari, see Eric Alliez, *La Signature du monde, ou qu'est-ce que la philosophie de Deleuze et Guattari* (Paris, 1993), 67–104.

28 Raymond Ruyer, *La Genèse des formes vivantes* (Paris, 1958), 240, 244; my translations here and elsewhere.

29 Ibid., 96.

30 Ibid., 261–62.

31 Ibid., 240.

32 Ibid., 220–21.

33 Ibid., 230.

34 Ibid., 220–21.

35 I am, of course, using the term "expressive" in the Deleuzian sense; see Gilles Deleuze, *Expressionism in Philosophy: Spinoza*, trans. Martin Joughin (New York, 1990 [1968]). Ruyer himself refers to his philosophy of biology as a neofinalism [*néo-finalisme*].

36 Deleuze and Guattari, *A Thousand Plateaus*, 312.

37 See Félix Guattari, *Les trois écologies* (Paris, 1989), 60; and *Chaosmose* (Paris, 1992), 61. For a helpful introduction to the work of Maturana and Varela and other recent developments in biology, see Fritjof Capra, *The Web of Life: A New Scientific Understanding of Living Systems* (New York, 1996), esp. 174–75 and 264–74.

38 Humberto R. Maturana and Francisco J. Varela, *Autopoiesis and Cognition* (Dordrecht, 1980), 13.

39 See Francisco J. Varela, Evan Thompson, and Eleanor Rosch, *The Embodied Mind: Cognitive Science and Human Experience* (Cambridge, MA, 1991). As Susan Oyama puts it in her extended critique of the latent determinism and dualism of current biological thinking, "What all this means is not that genes and environment are necessary for all characteristics, inherited or acquired (the usual enlightened position), but that there is no intelligible distinction between inherited (biological, genetically based) and acquired (environmentally mediated) characteristics"; see her *Ontogeny of Information: Developmental Systems and Evolution* (Cambridge and New York, 1985), 122.

40 Varela, Thompson, and Rosch, *The Embodied Mind*, 199, 196.

41 Humberto R. Maturana and Francisco J. Varela, *The Tree of Knowledge: The Biological Roots of Human Understanding* (Boston, 1987). Lynn Margulis and Dorion Sagan, in *Microcosmos* (New York, 1986), especially, have stressed the importance of cooperative values in evolution. See also Brian Goodwin, *How the Leopard Changed Its Spots: The Evolution of Complexity* (New York, 1994), 179–81; and Capra, *The Web of Life*, 232–63.

42 Ruyer, *La Genèse*, 220.

43 See Charles Hartshorne, "The Relation of Bird Song to Music," *Ibis* 100 (1958): 421–45; and W. H. Thorpe, *Bird-Song: The Biology of Vocal Communication and Expression in Birds* (Cambridge, 1961), 1–13.

44 Deleuze and Guattari, *A Thousand Plateaus*, 316–17.

45 Ibid., 320–22.

46 Deleuze and Guattari, *Anti-Oedipus*, 288.

Deleuze and Cultural Studies Ian Buchanan

No theory today escapes the marketplace. Each one is offered as a possibility among competing opinions; all are put up for a choice; all are swallowed. There are no blinders for thought to don against this, and the self-righteous conviction that my own theory is spared that fate will surely deteriorate into self-advertising. But neither need dialectics be muted by such rebuke, or by the concomitant charge of its superfluity, of being a method slapped on outwardly, at random. The name of dialectics says no more, to begin with, than that objects do not go into their concepts without leaving a remainder, that they come to contradict the traditional norm of adequacy.—Theodor Adorno, *Negative Dialectics*

Cultural studies displays a common assumption that its object is ready-made and that theory is something one simply applies.[1] But as Adorno points out, this cannot ever be the case: "The object of theory is not something immediate, of which theory might carry home a replica. Knowledge has not, like the state police, a rogue's gallery of its objects. Rather it conceives them as it conveys them; else it would be content to describe the facade."[2] Theory and its object are born together, Deleuze insists, "for, accord-

ing to the Nietzschean verdict, you will know nothing through concepts unless you have first created them—that is, constructed them in an intuition specific to them: a field, a plane, and a ground that must not be confused with them but that shelters their seeds and the personae who cultivate them."[3] One wonders, then, what a Deleuzian, that is, a transcendental empiricist, cultural studies would look like.

The problem of the formation of the subject Deleuze finds in Hume should, I believe, be at the center of any attempt to produce a Deleuzian cultural studies, not the question of which concepts can be applied to a reading of the social, as is usually the case. That problem may be stated as follows: "How can a subject transcending the given be constituted in the given?"[4] But in order to fully see what Deleuze means by *transcendental* empiricism, it is best if we begin with *empiricism* and then see how it becomes transcendental in Deleuze's work. The classical definition of empiricism is, of course, that knowledge not only begins with experience but is derived from it. This definition, proposed as it is by the Kantian tradition, foreshadows the Kantian turn to the question of how a priori synthetic judgments are formed and therefore conceals a certain tendentiousness that needs to be exposed. As Deleuze asks, "*Why* would the empiricist say that? and as the result of which question?" Deleuze has two main objections to this definition: first of all, "knowledge is not the most important thing for empiricism, but only the means to some practical activity"; and second, "experience for the empiricist, and for Hume in particular, does not have this univocal and constitutive aspect that we give it." The classical definition, which casts empiricism in experiential terms, completely ignores the role of *relations*. "[For] Kant, relations depend on the nature of things in the sense that, as phenomena, things presuppose a synthesis whose source is the same as the source of relations. This is why critical philosophy is not an empiricism." Yet for Deleuze, it is precisely the manner in which relations are derived that is decisive: "We will call 'nonempiricist' every theory according to which, *in one way or another*, relations are derived from the nature of things."[5] The empiricist catchcry that emerges is as simple as it is profound: "relations are external to their terms."[6]

We can begin to see the operational importance of relations to empiricism in Deleuze's repudiation of the experiential definition. Since neither of the two senses of experience that Deleuze attributes to Hume is constitutive, it cannot contribute to a theory or definition of empiricism; rather,

it is relations that present themselves as constitutive. In the first sense, experience, as "a collection of distinct perceptions," cannot be constitutive because relations are not derived from it. In fact, it is precisely *in* experience that relations, which "are the effect of the principles of association," constitute the subject. In the second sense of the word, denoting various conjunctions of past objects, "we should again recognize that principles do not come from experience." On the contrary, "experience itself must be understood as a principle." Our experience of the world is meaningful only insofar as we institute relations between perceptions—it is these relations that make experience cohere sufficiently to be called understanding. As such, our construction of the world is an integral aspect of our experience of it; in fact, we experience it *as* we construct it. "In short, it seems impossible to define empiricism as a theory according to which knowledge derives from experience." [7]

According to Deleuze, the determination that *relations are external to their terms* is the condition of possibility for a solution to the empiricist problem of how a subject *transcending the given can be constituted in the given*. It is this "solution," as it were, that gives rise to transcendental empiricism. Thus, in order to ascertain whether empiricist methods are going to be valuable to cultural studies, we have to determine whether the externality of relations can contribute anything to an understanding of how culture operates. To begin with, what does it mean that relations are external to their terms? It means, foremost, "that ideas do not account for the nature of the operations that we perform on them, and especially of the relations that we establish among them." In other words, the relations among ideas do not inhere in the ideas themselves but in human nature. "A collection of ideas will never explain how the same simple ideas are regularly grouped into complex ideas." [8] If the method of grouping ideas is in principle external to what it groups, then the relations among ideas that it institutes are also external. "And if they are external, the problem of the subject, as it is formulated in empiricism, follows." [9] (And cultural studies, if it can be thought in transcendental empiricist terms, will turn out to be a problem, above all, of subjectivity.) We receive here our first tantalizing glimpse of what Deleuze calls transcendental empiricism.

The problem is this: If a subject is wholly *transcendent*, then it cannot effect or be affected by the society it inhabits. A transcendent subject is, by definition, beyond the reach of such constitutive systems as psychiatry or

the judiciary.[10] Only a subject that is *given* can be shaped by the social, that is, constituted by forces external to itself. But a subject that is completely *given* and not at least partially *transcendent* cannot have any effect on the social order. The aim of cultural studies should be to provide a theory of culture that can accommodate both of these considerations. By constructing the subject dually, transcendental empiricism does in fact furnish the grounds for just such a theory, showing that the subject is the product of social mechanisms *and* that the subject is capable of manipulating those mechanisms. To see how this is possible, we have to interrogate the decisive relation between the principles of association and the subject.

According to Deleuze, association both transcends and differs from the imagination, which is to say, it affects the imagination. "We can now see the special ground of empiricism: nothing in the mind transcends human nature, because it is human nature that, in its principles, transcends the mind; nothing is ever transcendental." This is the basis of what Deleuze describes as the "coherent paradox" of Hume's philosophy: "It offers a subjectivity which transcends itself, without being any less passive."[11] The subject, in other words, is constituted in the given but also able to transcend the given. This is possible because the relation between the imagination and the principles of association operating there is dynamic.[12] Association, then, far from being a product, which would involve an unnecessary hypostatization, is in fact "a rule of the imagination and a manifestation of its free exercise." As such, association at once guides the imagination (thereby giving it uniformity) and constrains it. It is through this relation that the imagination becomes human nature: "The mind, having become nature, has acquired now a *tendency*."[13] The notion of *tendency* is anthropological and, in this sense, humanist, since it posits an individual composed of social codes (and thus available to interrogation via those codes). But it is not fully humanist: the subject it posits is a fragmented one.

Although the subject is said to have transcended itself, that does not mean it is a transcendental subject. It does not stand outside what it organizes or makes coherent; rather, organization and coherence—made possible by the principles of association—take place *in* the subject, which is why the subject is fragmented. As the site of the instance of coherence referred to as *subjectivity*, the subject is not the principle of totalization that would supply that coherence. "Empirical subjectivity is constituted in the mind under the influence of principles affecting it; the mind therefore

does not have the characteristics of a preexisting subject."[14] It transcends itself to the extent that the mind becomes a subject.[15] "In Hume's empiricism, genesis is always understood in terms of principles, and itself as a principle." The subject, therefore, can only be apprehended via its constitutive principles—which must be external in order to be apprehended in themselves—and chief among these is *habit*: "Habit is the constitutive root of the subject."[16]

The paradox of habit is that it is formed by degrees (therefore constituted, not constitutive) *and* a preformed principle of nature (therefore constitutive, not constituted). But as Deleuze shows, this implies no contradiction: the subject invents the very norms and general rules it lives by.[17] Despite appearances, habit is not the same thing as *habitus*, not as Bourdieu understands the term anyway. In his formulation, habitus is an acquired "system of generative schemes" with "an infinite capacity for generating products—thoughts, perceptions, expressions and actions—whose limits are set by the historically and socially situated conditions of its production."[18] The transcendental empirical subject, in contrast to Bourdieu's conception, is as much the product of self-invention as it is the consequence of conforming to an existing structure.

To put it another way, in the given the subject is without agency; he or she is simply one particle among many and must move and sway with the ebb and flow of the social tide. To gain agency, the subject must *transcend* the given. How the subject does this is perhaps the most vital question we can ask of Deleuze's version of empiricism. It is the process of *appropriation* that enables the passively synthesized subject to become active—to self-fashion, as it were.[19] By "appropriation" I mean precisely what Deleuze describes in reference to Artaud as the necessary effort to think. This concept of appropriation posits "uses" as creative acts. It is through the practices of everyday life—the multiplicity of "uses" to which social structures, the regulatory bodies that shape culture *and* cultural commodities, the already appropriated and about to be appropriated items that combine with desire to produce a culture, are put—that the passively formed subject becomes active. The value of this pivotal "mechanism" to cultural studies is that it is liberating, enabling the subject to particularize the universal and, as a result, to put the so-called normative institutions which ordinarily govern his or her existence to his or her own use. Appropriation is therefore a path to freedom.

Prisons provide an excellent test case for this hypothesis. If it can be shown that freedom is possible, via appropriation, in a place so purposively unfree as a prison, then we can be sure that freedom is always possible. The crucial problem for our theory is that circumstances cannot be ignored or relegated to a secondary role. There would be nothing profound in the claim that freedom is possible even in Auschwitz, say, if circumstances are totally ignored. The gas chambers, the crematoria, the electrified-wire fences, the impossibly small bunks, the desperate lack of food, the wooden clogs that permit only clumsy hobbling—none of these circumstantial elements can be discounted or dismissed.[20] But, by the same token, none can be said to be decisive either or we will be forced to conclude that freedom in this situation *is* impossible.

If the prisoner is an other, then what must be found is a means of expressing, simultaneously, otherness as an insular identity with its own sovereign power *and* otherness as a deplorable state of oppression. This is, in fact, the principal utility of appropriation as an analytic model: by not defining the Self in relation to an Other, it enables cultural studies to express the everyday as a dynamic and complex series of interlocking relations between existing forms and current uses (i.e., between passive forms and active transformations), allowing us to theorize concomitantly—despite the law of noncontradiction—oppression *and* resistance. Such a facility, in turn, enables us to apprehend the fact that an imprisoned person can simultaneously conform to an imposed "foreign" order *and* subvert that order.[21] Because the social structure defining the parameters of people's lives—oppressed or otherwise—has to be enunciated by them in order to be actualized, it is always available to appropriation. The passively formed subject is always *becoming* active. When, for example, Arthur Koestler's Rubashov (in *Darkness at Noon*) is taken into custody, the given of his everyday life is radically altered.[22] He undergoes what Deleuze and Guattari call an "incorporeal" transformation and becomes a political prisoner.[23] When Rubashov says "I" in prison, he *realizes* the potential of the prison to turn him into a prisoner. In saying "I am a prisoner," he actualizes his imprisonment as the *given* of his daily existence, but, in order to do that, he has to *appropriate* the language of incarceration. This is an uncertain enterprise: while appropriation can certainly be shown to lead to freedom, the freedom it results in is not constant; rather, it varies according to degrees of intensity, that is, there are different modalities of freedom (a problem I will return

to). In this respect, the interrogation scene that takes up much of the third section of the novel is revelatory. At this moment in his detention, Rubashov is able to regain agency by appropriating his interrogation, and subsequent confession, to his own existentially motivated purposes. What this means, in effect, is that while the prison and its regulations define the circumstances of Rubashov's existence, they do not fully determine the conditions for his freedom. It becomes possible to say, now, that one is not free in prison, but that one can nevertheless achieve freedom there.

Rubashov, like Camus's Meursault (in *The Outsider*), welcomes his death, first of all, as a release from the endless self-examination to which he subjects himself (do ends justify means?) and, second, as a passage to what he calls "oceanic sense," a purely affect-driven space. Cultural studies need not admire the fact that Rubashov faces his death with equanimity, nor suppose that he has somehow exercised his free will in choosing to view death so tranquilly. In fact, it is not with his death that cultural studies should be concerned, but rather with the way he lives. What Rubashov confronts as he stares down his own finitude is the limitlessness of death, which his (previously) limited life prevented him from accessing. Suddenly, he realizes that life is not a series of limitations, but rather, as Hume said, a problem of integration: "oceanic sense" means unrestricted integration (the opposite of atomism). Thus we have no difficulty in guessing his jailer's view of it: "The 'oceanic sense' was counter-revolutionary."[24] When Rubashov appropriates the discourse of the prison to his own ends, he includes himself in a discourse from which he was hitherto forcefully excluded. He is not supposed to enunciate the discourse of the prison as an "I"; he is not supposed to say "I" at all, and it is only on the eve of his death that he finally does say it.[25] Atomism is thus an inability to say "I." Atomism in the prison, as Foucault's analysis revealed, takes the form of an austere exteriority not only in the prisoner's relation to prison—and, more generally, to society itself—but also in his relation to his or her Self and, finally, to his or her death. The death sentence is, in this sense, the most extreme form of the negative: the imposition of finitude as the One, the Same, and the Necessary. Foucault's horror of the panopticon is due precisely to its unifying what should be particularized, its homogenizing what should be varied, its rendering inevitable what should be contingent. We may sympathize with Foucault's view, but we cannot accept his conclusions. He does not see that, as the prisoner realizes—and thus *affirms*—

the One, the Same, and the Necessary, he or she transforms them into the Multiple, the Different, and the Aleatory. Thus cultural studies could perhaps say, contra Foucault, that delinquency is not a product of the penal system but of the prisoner system, delinquency being the prisoner's own affirmation of the prison as *his/her* milieu. And, as Deleuze shows, it is precisely such affirmation that sets becoming in motion.[26]

Even in Auschwitz freedom could be attained, as Primo Levi found, and his collection of tales (pointedly titled *Moments of Reprieve*) clearly shows that he was not alone in doing so. There is the marvelous example of Leon Rappoport, who, amidst the horror, could say: "With a little initiative, even here you can find something good every so often. . . . If I meet Hitler in the other world, I'll spit in his face and I'll have every right to because he didn't get the better of me."[27] Given that freedom *is* experienced by subjects whose lack of it appears to be beyond question, we need to devise a means of apprehending that freedom. Deleuze's answer is, as we shall see, *affect*. Affect is the experience of freedom raised to the highest power, but how is that experience *experienced?* The answer to that is *appropriation*, which raises the following theoretical problem: affect, if it is to be both empirical and ethical, must be produced by appropriation *and* be inherent in the relation between a subject and his or her circumstances. Here we can see the importance of the externality of relations: if we do not wish to hypostatize the world or ontologize the subject by making either one a ground, then the relations in question must be independent of their terms.

Transcendental empiricists view freedom not as a property to be obtained but as an affective relation to be entered into. Both Spinoza and Nietzsche, two crucial thinkers in Deleuze's genealogy, advocate this position. Spinoza, Deleuze argues, regards freedom in the same light as truth: neither is given, in principle, but only appears as the result of a determined activity "through which we produce adequate ideas" and which liberates us from "the sequence of external necessity." Spinoza's inspiration, says Deleuze, is in this respect *"profoundly empiricist."*[28] For Spinoza, "one is never free through one's will and through that on which it patterns itself, but through one's essence and through that which follows from it."[29] Nietzsche realized that one's essence, though finite, is not a uniform or homogeneous substance; it is, in fact, composed of a hierarchy of forces. Essence is qualitative: "The qualities of force are called 'active' and 'reactive.'"[30] Here, "reactive" corresponds to the empiricist given, while

"active" is cognate with transcendence. Freedom is thus achieved to the extent that active forces not only dominate reactive ones but *actively* transmute them. This transmutation involves the appropriation of the given of everyday life and henceforth living it according to one's own desires.

As we have seen, appropriation is a creative process. Like Nietzsche and Spinoza, Deleuze prizes the creative.[31] He locates in creativity a special power of transformation that enables a subject to transcend the homogenizing pressures of the social and to carve an "I" from the indifferent stone of the universal. Such acts, in the event that an "I" results, are necessarily passages to freedom. In this formulation, one cannot be an unfree subject. Conversely, acts that have a deleterious effect on the subject's capacity to say "I" lead, regressively, to unfreedom and desubjectification. The subject is returned to that primordial and passive homogeneity from which he or she first emerged. Appropriation is thus a means of creating pluralism where homogeneity had previously reigned. This is true even of concentration camps, which are so overwhelmingly oppressive that heterogeneity of any sort is eradicated. As Jean Améry shows, Nazism was nothing other than a naked attempt to recreate primordial universality: "The power structure of the SS state towered up before the prisoner monstrously and indomitably, a reality that could not be escaped and that therefore finally seemed reasonable. No matter what his [sic] philosophy may have been on the outside, in this sense here he became Hegelian: in the metallic brilliance of its totality the SS state appeared as a state in which the idea was becoming reality."[32] For Améry, not even that "other" space, which we can call after Blanchot the space of literature, where death is a flickering but comforting candle, was accessible to him. He had to enunciate the camp just as he was instructed—he never managed to *appropriate* the camp:

> I recall a winter evening when after work we were dragging ourselves, out of step, from the IG-Farben site back into the camp to the accompaniment of the Kapo's unnerving "left, two, three, four," when— for God knows what reason—a flag waving in front of a half-finished building caught my eye. "The walls stand speechless and cold, the flags clank in the wind," I muttered to myself in mechanical association. Then I repeated the stanza somewhat louder, listened to the words sound, tried to track the rhythm, and expected that the emotional and mental response that for years this Hölderlin poem ["Life's

Middle"] had awakened in me would emerge. But nothing happened. The poem no longer transcended reality.[33]

It might be speculated that the reason Améry found the camps so utterly hopeless was precisely because the space of literature was so profoundly deracinated from his repertory of survival tactics.

In Primo Levi's case, it was that very space of literature which enabled him to survive. Reciting Dante's "Canto of Ulysses" on the way to the soup dispensary led to an epiphanic moment, when he saw "in a flash of intuition, perhaps the reason for our fate." He found, in this frozen, spatialized "moment," an enormous reservoir of life-affirming hope.[34] Through poetry Levi was able to enunciate the camp differently, to metaphorize it, albeit for an instant, and so, managed to escape without leaving. Although by no means free, he found freedom. The same conclusion should be reached for *The Outsider*. It is only when Meursault becomes fully cognizant of his death sentence that he realizes true freedom. Both Levi and Camus's character *appropriate* their certain deaths to their own affective purposes and thus triumph over the given:

> With death so near, Mother must have felt like someone on the brink of freedom, ready to start life all over again. No one, no one in the world had any right to weep for her. And I, too, felt ready to start life over again. It was as if that great rush of anger had washed me clean, emptied me of hope, and, gazing up at the dark sky spangled with its signs and stars, for the first time, the first, I laid my heart open to the benign indifference of the universe. To feel it so like myself, indeed so brotherly, made me realize that I'd been happy, and that I was happy still.[35]

As I have already said, transcendental empiricism does not consider unfreedom to be a sociological problem; it is a philosophical problem. Although it must be addressed in the social, it is first of all a problem of subjectivity. But it should not be thought of as something imposed by the social; on the contrary, it is the *given* of the social—a primordial universality from which the subject emerges only with difficulty and only by means of *particularization*. According to Deleuze, this is a view to which both Nietzsche and Spinoza subscribe. The essence of humanity, for Nietzsche, "is the becoming-reactive of forces, this becoming as universal be-

coming."[36] Spinoza's position is that from "the beginning of our existence we are necessarily exercised by passive affections."[37] The subject, to *become* one, must transcend the given, and thus attain subjectivity, by using a previously given set of procedures, or principles of action. Subjectivity, therefore, is incompatible with unfreedom; hence the social cannot be said to *subjectify*. To the extent that a subject *is* a subject, he or she is free. However, as I have said, this freedom is not constant but variable. Since the subject is always already free, any variation in freedom is also a variation in subjectivity. This variability I will call *modality*.

As may be seen in the example of Foucault's description of the special but silent expatiations of the mad, silence can be *affirmed* and, in its expressivity, can be a source of subjectivity. In being reduced to silence, one is certainly alienated—which is to say, othered—but in affirming one's silence, one becomes expressive. As Artaud recognized, this is as little and sometimes as much as one can hope to achieve: "No works, no language, no words, no mind, nothing. Nothing but a fine Nerve Metre."[38] The "Nerve Metre" is Artaud's access to a new mode of expressivity, one that will at last enable him to embrace the void and remake himself. What can psychiatry know of the Nerve Metre? The patient is catatonic? Nonresponsive? Silent? None of these diagnoses touch upon Artaud in the least, for in the void he is inured against them by his own lack of being. He cannot be touched. It is as though he is refusing to *actualize* the fact that he is in a mental hospital. But this would be to misconstrue as passive or reactive what is in essence active: becoming mad. What, according to Artaud, is an authentic madman? He is a man who prefers "to become mad, in the socially accepted sense of the word, rather than forfeit a certain superior idea of human honour."[39] Madness is the key to Artaud's expressivity: not our key to understanding him, however, but his key to understanding us.

Artaud, Deleuze claims, takes empiricism to a higher plane. Artaud's problem was not the difficulty of orienting his thoughts, or even the demand that he perfect the expression of his thoughts through the application of "method"; his problem, rather, was "*simply to manage to think something.*" Thought is not proof of being but a passage to it: one must think in order *to be*. Just because one *is* in discourse, as one *is* in the world, does not mean one *is* expressive. One must become expressive. This applies equally to those who would think of themselves as sovereign beings *and* to their others. Artaud, Deleuze argues, knew "that thinking is not innate, but

must be engendered in thought." The problem, therefore, "is not to direct or methodically apply a thought which pre-exists in principle and in nature, but to bring into being that which does not yet exist (there is no other work, all the rest is arbitrary, mere decoration)." Thinking *is* creation, Deleuze contends, and for him there is no other form of creation. But, as Artaud understood, "to create is first of all to engender 'thinking' in thought."[40] We thus arrive at what Deleuze calls, without irony, either superior empiricism or transcendental empiricism, and while transcendental empiricism attained its greatest refinement in Artaud, it began with Hume.

We have only to compare their respective problem positions to see how much sympathy there is between Hume and Artaud.[41] For Hume, the question was, how does the mind become a subject? His answer was, as an effect of thought—not thought as a preexisting idea, but rather as a principle of action. Acts of the mind, for Hume, do not refer to a disposition, or habitus; they do not mean that the mind *is* active, but that the mind, having been *activated*, "has become subject."[42] Transcendental empiricism, concerned with the issue of what it takes to become a subject, is in flight from any notion that subjectivity might be innate. In this respect, the exchange of letters between Jacques Rivière and Artaud is, according to Deleuze, exemplary.[43] "Words, shapes of sentences, internal directions of thought, simple reactions of the mind—I am in constant pursuit of my intellectual being."[44] His thoughts having abandoned him, he has no being. Thinking must be engendered in thought, not in its flight, if he is to have being. Artaud suffers from what he calls "a powerlessness to crystallize,"[45] which is exactly the transcendental empiricist problem: How does one become a subject? How does one "crystallize"?

A Deleuzian cultural studies would, I am sure, begin with the question of the subject, but it would not ask, what is a subject? Rather, as we have just seen, it would ask, how does one become a subject? It is only by asking "how does one become a subject?" that cultural studies can avoid *objectifying* subjects. Only by asking "how is a subject formed?" can we avoid the reductive question, "What is a subject?" So long as we persist in examining subjects in terms of an ostensive "what is," we will continue to objectify them—perception, itself, *objectifies*. This, in effect, is Foucault's charge against sociology: it names phenomena—that is, it brings them into being as objects according to the rules of representation—but does not come to grips with the concrete forces of *subjectification*. It treats the social as the

milieu in which the subject conducts his or her actions, not as the background against which the subject emerges. If we assume subjects to be always already there, to be somehow ready-made, and only attempt to map their movements, we will inevitably reduce their everyday lives to a series of points on a graph and thus neglect the event.[46] But, as I have tried to show, the subject is not ready-made. There can be no question, therefore, of charting highs and lows, or some such other quantifying procedure; it is rather a question of determining conditions of existence. What appears to be a sociological problem, calling for a certain type of quantification, is in fact, Deleuze would likely say, a philosophical one, demanding the creation of new concepts.

Notes

1 As Lawrence Grossberg puts it, cultural studies "detours" via theory on its way to its object; see his "Cultural Studies and/in New Worlds," *Critical Studies in Mass Communication* 10 (1993): 23–48.

2 Theodor Adorno, *Negative Dialectics*, trans. E. B. Ashton (London, 1973 [1966]), 206.

3 Gilles Deleuze and Félix Guattari, *What Is Philosophy?*, trans. Hugh Tomlinson and Graham Burchell (New York, 1994 [1991]), 7.

4 See Gilles Deleuze, *Empiricism and Subjectivity: An Essay on Hume's Theory of Human Nature*, trans. Constantin V. Boundas (New York, 1991 [1953]), 86.

5 Ibid., 107, 107–8, 111, 109.

6 Ibid., 101.

7 Ibid., 108.

8 Ibid., 101.

9 Ibid., 98.

10 This position is rejected by Michel de Certeau in *The Practice of Everyday Life*, trans. Steven Rendall (Berkeley, 1984 [1980]): "There is no law that is not inscribed on bodies. . . . Through all sorts of initiations (in rituals, at school, etc.), it transforms them into tables of the law, into living tableaux of rules and customs, into actors in the drama organized by a social order" (139).

11 Deleuze, *Empiricism and Subjectivity*, 24, 26.

12 "The effect of association appears in three ways. Sometimes the idea takes on a role and becomes capable of representing all these ideas with which, through resemblance, it is associated (general idea); at other times; the union of ideas brought about by the mind acquires a regularity not previously had, in which case 'nature in a manner point[s] out to every one those simple ideas, which are most proper to be united into a complex one' (substance and mode); finally, sometimes, one idea can introduce another . . . so that the essence of relations becomes precisely this easy transition" (ibid., 25).

13 Ibid., 24, 25.

14 Ibid., 29.

15 "The subject is the effect of principles in the mind, but it is the mind that becomes subject; it is the mind that, in the last analysis, transcends itself" (ibid., 126–27).

16 Ibid., 66, 92–93.

17 Ibid., 66, 86.

18 Pierre Bourdieu, *The Logic of Practice*, trans. Richard Nice (Cambridge, 1990 [1980]), 55.

19 The manner in which "appropriation" is used here should not be confused with Heidegger's usage, since my primary concern is neither understanding nor interpretation. However, it may profitably be compared with his concept of "care" in the sense that care is what produces the subject. The difference between "care" and "appropriation" (as I use them) might best be described in terms of their underlying aspirations. Heidegger says he is not interested in a "philosophy of culture," whereas that is precisely my concern; see Martin Heidegger, *Being and Time*, trans. John Macquarrie and Edward Robinson (Cambridge, 1962 [1927]), 203, 211, and 242–44.

20 This litany is excerpted from Primo Levi, *If This Is a Man*, trans. Stuart Woolf (London, 1979 [1958]), 28–43.

21 De Certeau, *Practice of Everyday Life*, xiii.

22 Arthur Koestler, *Darkness at Noon* (London, 1947).

23 "In effect, what takes place beforehand (the crime of which someone is accused), and what takes place after (the carrying out of the penalty), are actions–passions affecting bodies (the body of the property, the body of the victim, the body of the convict, the body of the prison); but the transformation of the accused into a convict is a pure instantaneous act or incorporeal attribute that is the expressed of the judge's sentence"; Gilles Deleuze and Félix Guattari, *A Thousand Plateaus: Capitalism and Schizophrenia*, trans. Brian Massumi (Minneapolis, 1987 [1980]), 80–81.

24 Koestler, *Darkness at Noon*, 205, 204.

25 Ibid., 202.

26 As Deleuze says in *Difference and Repetition*, trans. Paul Patton (New York, 1994 [1968]): "The eternal return is a force of affirmation, but it affirms everything of the multiple, everything of the different, everything of chance *except* what subordinates them to the One, to the Same, to necessity, everything *except* the One, the Same and the Necessary" (115). The One, the Same, and the Necessary cannot be affirmed, then, without transforming them into their positively charged opposites, which, of course, is the special power of affirmation.

27 Primo Levi, *Moments of Reprieve*, trans. Ruth Feldman (London, 1987 [1981]), 23–24.

28 Gilles Deleuze, *Expressionism in Philosophy: Spinoza*, trans. Martin Joughin (New York, 1990 [1968]), 149; my emphasis.

29 Gilles Deleuze, *Spinoza: Practical Philosophy*, trans. Robert Hurley (San Francisco, 1988 [1981]), 70.

30 Gilles Deleuze, *Nietzsche and Philosophy*, trans. Hugh Tomlinson (London, 1983 [1962]), 42.

31 For Nietzsche, "the power of transformation, the Dionysian power, is the primary definition of activity" (ibid.). On Spinoza, see Deleuze, *Expressionism in Philosophy*, 239–41.

32 Jean Améry, *At the Mind's Limits: Contemplations by a Survivor on Auschwitz and Its Realities*, trans. S. and S. P. Rosenfeld (New York, 1986 [1966]), 12.

33 Ibid., 7.

34 Levi, *If This Is a Man*, 121. For an extended discussion of this moment, which brings together the metaphysical and the brutally physical, see Z. Jagendorf, "Primo Levi Goes for Soup and Remembers Dante," *Raritan* 12 (1993): 31–51.

35 Albert Camus, *The Outsider*, trans. Stuart Gilbert (Harmondsworth, 1961 [1942]), 120.

36 Deleuze, *Nietzsche and Philosophy*, 169.

37 Deleuze, *Expressionism in Philosophy*, 226.

38 Antonin Artaud, "The Nerve Metre," in *Selected Writings*, ed. Susan Sontag, trans. Helen Weaver (Berkeley, 1988), 79–87; quotation from 86.

39 Antonin Artaud, "Van Gogh, the Man Suicided by Society," in Sontag, ed., *Selected Writings*, 483–512; quotation from 485.

40 Deleuze, *Difference and Repetition*, 147; my emphasis.

41 On sympathy, see Gilles Deleuze and Claire Parnet, *Dialogues*, trans. Hugh Tomlinson and Barbara Habberjam (New York, 1987 [1977]), 53.

42 Deleuze, *Empiricism and Subjectivity*, 26.

43 See Deleuze, *Difference and Repetition*, 146.

44 Antonin Artaud, "Correspondence with Jacques Rivière," in Sontag, ed., *Selected Writings*, 31–49; quotation from 31.

45 Artaud, "Nerve Metre," 82.

46 Even a notion so apparently well suited to articulating movement as trajectory is not without its problems, as de Certeau found. Its very convenience is its fault: "It transforms the *temporal* articulation of places into a *spatial* sequence of points. A graph takes the place of an operation" (*Practice of Everyday Life*, 35).

Immanence and Transcendence in the Genesis

of Form Manuel DeLanda

One constant in the history of Western philosophy seems to be a certain conception of matter as an inert receptacle for forms that come from the outside. In other words, the genesis of form and structure invariably seems to involve resources that go beyond the capabilities of the material substratum of particular forms and structures. In some cases, these resources are explicitly *transcendental,* eternal essences defining geometric forms which are imposed on compliant and infertile materials, themselves incapable of any spontaneous morphogenesis. Aristotle's distinction between material and formal causes seems to fit this pattern, as do most Platonist philosophies and, until recently, most scientific theories of matter. Yet, as Gilles Deleuze showed in his work on Spinoza, not every Western philosopher has taken that stance. In Spinoza Deleuze discovered another possibility: that the resources involved in the genesis of form are immanent to matter itself.

A simple example, one *not* used by Deleuze himself, should suffice to illustrate this point. The simplest type of immanent resource for morphogenesis seems to be the *endogenously generated stable state.* Historically, the

first such states to be discovered by scientists studying the behavior of matter (gases) were energy minima and the corresponding entropy maxima. The spherical form of a soap bubble, for instance, emerges out of the interactions among its constituent molecules as these are constrained energetically to "seek" the point at which surface tension is minimized. In this case, there is no question of an essence of "soap-bubbleness" somehow imposing itself from the outside, an ideal geometric form (a sphere) shaping an inert collection of molecules. Rather, an endogenous *topological form* (a point in the space of energetic possibilities for this molecular assemblage) governs the *collective behavior* of the individual soap molecules and results in the emergence of a spherical shape.

In his important *Difference and Repetition*, Deleuze repeatedly makes use of these "spaces of possibilities" (called *state spaces* or *phase spaces*) and of the topological forms (or *singularities*) that shape them. Through the work of mathematician Albert Lautman, Deleuze seems to have become acquainted with the potential of topological singularities for a theory of immanence and, through the work of scientist Gilbert Simondon, with the importance of immanent resources to developing an alternative model of the genesis of form, one in which form is not imposed on matter from the outside (what Simondon calls the "hylomorphic schema").[1]

However, my concern here is not with establishing the exact genealogy of Deleuze's ideas on morphogenesis but with exploring the way in which his recent work (in collaboration with Félix Guattari) extended those basic ideas, theoretically expanding the kinds of immanent resources available to matter for the creation of structures of different types—geologic, biologic, and even socioeconomic. In *A Thousand Plateaus,* in particular, Deleuze and Guattari develop theories of the genesis of two very important types of structures: *strata* and *self-consistent aggregates* (or "trees" and "rhizomes"). Basically, strata emerge from the articulation of *homogeneous* elements, whereas self-consistent aggregates (or, to use the term I prefer, *meshworks*) emerge from the articulation of *heterogeneous* elements as such.[2] Although Deleuze and Guattari often illustrate their ideas about the processes giving rise to these two types of structures with examples from the scientific literature, their choice of illustrations is not always systematic or consistent, so the task of "confronting" their ideas with those of the relevant branches of science remains to be done (beginning with my contribution here).

The dichotomy between strata and meshworks can be usefully applied

in a wide variety of contexts. For instance, animal species can be considered biologic instantiations of a stratified structure, while ecosystems can be treated as meshworks. Similarly, human institutions governed by hierarchical, centralized decision making may be seen as strata, while those which emerge from decentralized decision making may be treated as meshworks of heterogeneous elements. This raises the question of whether some (or most) applications of these terms are purely metaphoric. There is undoubtedly some element of metaphor in such applications, but, the appearance of linguistic analogy notwithstanding, I believe that a deep, objective *isomorphism* underlies the different instantiations of strata and meshworks. That isomorphism may be accounted for, in turn, by the physical processes common to the formation of actual meshworks and strata, the structure-generating processes which make all the different applications of those terms quite literal. However, these common processes cannot be captured through linguistic representations alone, so we need to move into the realm of *engineering diagrams* to specify them.

Perhaps a concrete example will help to clarify this rather crucial point. When we say (as Marxists used to) that "class struggle is the engine of history," we are using "engine" in a purely metaphoric sense. On the other hand, when we say that "a hurricane is a steam engine," we are *not* simply making a linguistic analogy; rather, we are saying that a hurricane embodies the same blueprint used by engineers in *building* steam engines, hence that it contains a reservoir of heat, that it operates via thermal differences, and that it circulates energy and matter through a (so-called) Carnot cycle. The above-mentioned phase spaces also exemplify a design and diagram of this sort. When one such space of possibilities contains a singularity in the form of a closed loop (technically, a *limit cycle* or *periodic attractor*), all of the possible physical instantiations of this diagram will display isomorphic behavior: an endogenously generated tendency to oscillate in a stable way. Whether one is dealing with a sociotechnologic structure (e.g., a radio transmitter or a radar device), a biologic one (e.g., cyclic metabolism), or a physical one (e.g., a convection cell), the same immanent resource will dictate the different oscillating behavior of each structure. And this common resource, which may be studied by means of a diagram showing the singularities embedded in the phase spaces of those structures, indicates that such structures are not merely linked metaphorically but, at a deeper, objective level, connected isomorphically. Deleuze

and Guattari refer to the common diagrams or blueprints of the morphogenetic processes that yield different physical assemblages as "abstract machines." Our question is, therefore, do abstract machines also underlie the processes that generate strata and meshworks?

Let's begin with hierarchical structures and, in particular, those of social strata. Like geologic strata (stacked layers of rocky material), social strata are, by analogy, stacked layers (classes and castes) of human material. To the extent that this is all that is claimed, "strata," as used by sociologists, is clearly a metaphor. Is it possible, however, to claim a deeper isomorphism? This would involve showing that the generative processes by which geologic and social strata are shaped can be accounted for via the same blueprint. In terms of the process that generates geologic strata or, more specifically, sedimentary rock such as sandstone or limestone, a close look at the layers of rock in an exposed mountainside reveals a striking characteristic: every layer contains additional layers, each of which is composed of small pebbles that are nearly *homogeneous* in size, shape, and chemical composition. It is these layers that are referred to as strata.

Now, given that pebbles in nature do not come in standard sizes and shapes, some kind of *sorting mechanism* seems necessary to achieve this highly improbable distribution, some specific device by which a multitude of heterogeneous pebbles is distributed and deposited in more or less uniform layers. One possibility has been suggested by the discovery that rivers act as veritable *hydraulic computers* (or at least as sorting machines). Rivers transport rocky materials from their points of origin (such as mountains undergoing erosion or weathering) to the ocean, where they then accumulate. During this process, pebbles of variable size, weight, and shape tend to be differently affected by the water transporting them, and it is these effects of moving water that sort them out, with smaller pebbles reaching the ocean sooner than larger ones. Once the raw materials have been sorted into more or less homogeneous deposits at the bottom of the sea (that is, once they have become *sedimented*), a second process occurs that transforms these loose collections of pebbles into units of a larger scale: sedimentary rock. *Cementing* is carried out by soluble substances (e.g., silica, or hematite in the case of sandstone) which penetrate the sediment through the pores between pebbles. As this percolating solution crystallizes, it *consolidates* these pebbles' temporary spatial relationship into a more or less permanent "architectonic" structure.[3]

Thus a double operation—a "double articulation"—transforms structures at one scale into structures at another scale. Deleuze and Guattari call these two operations *content* and *expression* (or alternatively, *territorialization* and *coding*), and they warn us against confusing them with the old, philosophical "substance" and "form," since each of these two articulations involves both substances and forms. Sedimentation is not just a matter of accumulating pebbles (substance) but also entails sorting them into layers (form), while consolidation not only effects new architectonic couplings between pebbles (form) but also yields a new entity, sedimentary rock (substance).[4] Moreover, these new entities may in turn accumulate and sort out (e.g., the alternating layers of schist and sandstone that compose alpine mountains), then consolidate when tectonic forces cause the accumulated layers of rock to fold and become an entity of an even larger scale—a mountain.[5]

In the Deleuze/Guattari model, these double articulations constitute an "abstract machine of stratification" that operates not only in geology but also in the organic and socioeconomic domains. According to neo-Darwinists, for example, species are formed through the gradual accumulation of genetic materials, which yield adaptive anatomic and behavioral traits when they undergo nonlinear dynamical processes (such as the interaction of cells during embryonic development). Genes, of course, are not merely distributed or deposited at random, but are sorted out by a variety of selection pressures, including climate, the actions of predators and parasites, and the effects of male or female mating choices. Thus, in a very real sense, genetic materials "sediment" as pebbles do, even if their "sorting device" is completely different. Furthermore, these loose collections of genes may, like sedimented pebbles, be lost under some drastic change of conditions (such as the onset of an ice age) unless they become consolidated. Genetic consolidation occurs as a result of *reproductive isolation*, that is, by the closure of a gene pool when a given subset of a population becomes incapable (for ecological, mechanical, behavioral, or genetic reasons) of mating and reproducing along with the rest. Reproductive isolation acts as a "ratchet mechanism" which, by conserving the accumulated adaptive traits, makes it impossible for a given population to devolve into unicellular organisms. Through this dual process of selective accumulation and isolative consolidation, a population of individual organisms comes to form an entity of a larger scale: a new species.[6]

We can also find this double articulation (and hence, this abstract machine) operating in the formation of social classes. Roughly, we speak of "social strata" whenever a given society presents a variety of differentiated roles to which not everyone has equal access and when a subset of those roles (i.e., those to which only a ruling elite has access) involves the control of key natural, material, and human resources. While social-role differentiation may be a spontaneous effect of an intensified flow of energy through a society (such as when a Big Man in a pre-State society acts as an *intensifier* of agricultural production), the sorting of those roles into ranks on a scale of prestige involves specific group dynamics. In one model, for instance, members of a group who have acquired preferential access to some roles may then begin to acquire the power to further restrict access to them, while within these dominant groups criteria for "sorting" the rest of their society into subgroups begin to crystallize. "It is from such crystallization of differential evaluation criteria and status positions that some specific manifestations of stratification and status differences—such as segregating the life-styles of different strata, the process of mobility between them, the steepness of the stratificational hierarchies, some types of stratum consciousness, as well as the degree and intensity of strata conflict—develop in different societies."[7]

Even though roles tend to "sediment" through these sorting or ranking mechanisms in most societies, ranks do not become an *autonomous dimension* of social organization in all of them. There are many societies in which the elites are not intensively differentiated (as a center around which the rest of the population forms an excluded periphery), surpluses do not accumulate (they may be destroyed in ritual feasts), and primordial relations (of kinship and local alliance) tend to prevail. Hence a second operation, beyond the mere sorting of people into ranks, is necessary for the formation of social classes or castes: the informal sorting criteria must be given a theological interpretation and a legal definition, and the elites must become the guardians and bearers of the newly institutionalized tradition, that is, the legitimators of change and delineators of the limits of innovation. In short, to transform a loose accumulation of traditional roles (and the criteria for access to them) into a social class requires its consolidation as such via theological and legal *codification*.[8]

Therefore, I can now say (literally, not metaphorically) that sedimentary rocks, species, and social classes (and other institutionalized hierar-

chies) are all historical constructions, the products of specific structure-generating processes which begin with a heterogeneous collection of raw materials (pebbles, genes, roles), homogenize them by means of a sorting operation, and then consolidate these homogeneous groups into something larger and more permanent. Hence while some aspects differ (e.g., only human institutions and, perhaps, some species develop a hierarchy of command), others, such as the articulation of homogeneous components into entities of a larger scale, remain the same for all structures.

≡≡≡≡

What about meshworks of heterogeneous elements? Deleuze and Guattari's hypothetical diagram for this type of structure entails the articulation of diversity as such, but it is not as straightforward as in their double-articulation model. This other abstract machine must be contextualized in terms of what mathematical and computer models of meshworks have revealed about their formation and behavior, from which it should then be possible to derive their "blueprint." Perhaps the best-studied type of meshwork is the autocatalytic loop, a closed chain of chemical processes in which a series of mutually stimulating pairs of substances link up to form a structure that reproduces as a whole. Basically, a product that accumulates due to the catalytic acceleration of one chemical reaction serves as the catalyst for yet another reaction which, in turn, generates a second product that catalyzes the first one. Hence the loop becomes self-sustaining and can remain so as long as its environment continues to provide enough raw materials for the chemical reactions to proceed.

Humberto Maturana and Francisco Varela, pioneers in the study of autocatalytic loops who have developed a theory of "autopoeisis," attribute two general characteristics to these closed circuits: first, they are dynamical systems which endogenously generate their own stable states (called *attractors* or *eigenstates*); and second, they grow and evolve by *drift*.[9] In the simplest autocatalytic loops only two reactions occur, each serving as the catalyst for the other. But once this basic two-node network has been established, new nodes may form and can insert themselves into the mesh if they do not jeopardize its internal consistency. Thus a new chemical reaction may occur (using previously neglected raw materials or even waste products from the original loop), which, by catalyzing one of the original pair and being catalyzed by the other, makes the loop a three-node network. The

meshwork grows, therefore, but its growth is, in effect, "unplanned." A new node (one that happens to satisfy some internal-consistency requirements) forms and the loop complexifies, yet, precisely because the only constraints are internal, that complexification does not take place *in order* for the loop as a whole to meet some external demand (such as adapting to a specific situation). The surrounding environment, as its source of raw materials, certainly constrains the growth of the meshwork, but more in a proscriptive than a prescriptive way. This is what Maturana and Varela describe as "growing by drift." [10]

The question now is whether from these and other empirical studies of meshwork behavior we can derive a structure-generating process abstract enough to generalize as a geologic, biologic, and social operation. Deleuze and Guattari's model entails a sequence of actions involving three kinds of elements. First, a set of heterogeneous elements must be brought together through an *articulation of superpositions*, that is, an interconnection among diverse but overlapping elements. (In the case of autocatalytic loops, the nodes in the circuit are joined to each other by their functional *complementarities*.) Second, a special class of operators, *intercalary elements*, is needed to effect this interlock by serving as local connections. (In our case, this role is played by catalysts inserting themselves between two other chemical substances to facilitate their interaction.) Finally, the interlocked heterogeneities must be capable of endogenously generating stable behavioral patterns, such as those occurring at regular temporal or spatial *intervals*.[11] Deleuze and Guattari's blueprint for self-consistent aggregates is much less well developed than their double-articulation model. However, the centrality to their "machinic" philosophy of a nonhomogenizing articulation of diverse elements is beyond doubt. Indeed, "what [they] term machinic is precisely this synthesis of heterogeneities as such."[12]

Is it possible to find evidence of this three-element diagram underlying radically different morphogenetic processes? Let's return to geology and that other great class of rocks exemplified by granite—igneous rocks. Granite, unlike sandstone, is not the result of sedimentation and cementation but the product of a very different construction process. Igneous rocks form directly out of cooling magma, a viscous fluid constituted by diverse molten materials. Each of these liquid components has a different threshold of crystallization, and therefore each undergoes the bifurcation toward the solid state at a different critical point in temperature. This means that

as the magma cools down its different elements separate and crystallize in sequence, with those solidifying earlier serving as containers for those that acquire a crystal form later. The result is a complex set of *interlocked* heterogeneous crystals, which is what gives granite its superior strength.[13]

In this context, intercalary elements include anything that brings about local articulations from within—"densifications, intensifications, reinforcements, injections, showerings, like so many intercalary events."[14] The reactions between liquid magma and the walls of an already crystallized component, nucleation events within the liquid which initiate the next crystallization, and even certain "defects" inside the crystals (called "dislocations") that promote growth from within are all examples of intercalary elements or events.

Finally, chemical reactions within the magma can generate endogenous stable states. Those reactions involving either autocatalysis or cross catalysis function as veritable "chemical clocks" in which an alternating accumulation of materials from the reactions occurs at *perfectly regular intervals*. This rhythmic behavior is not imposed on the system from outside but generated spontaneously from within (via an attractor). When a reaction like the one involved in chemical clocks is not stirred, these temporal intervals become spatial intervals, forming the beautiful spiral and concentric-circle patterns that can sometimes be observed in frozen form in some igneous rocks.[15] Granite may thus be regarded as an instance of a meshwork or self-consistent aggregate.

Let's turn now to some biological and cultural examples of diversity's articulation as such via self-consistency. As we saw before, a species (or, more precisely, the gene pool of a species) may be considered a prime example of an organic stratified structure. Similarly, an *ecosystem* represents a biologic realization of a self-consistent aggregate. While a species may be a highly homogeneous structure (especially if selection pressures have driven many genes to fixation), an ecosystem links a wide variety of heterogeneous elements (animals and plants of different species). These elements are articulated through their interlock, that is, by their functional complementarities. Since one of the main features of ecosystems is the circulation of energy and matter in the form of food, these particular complementarities are alimentary: prey/predator and parasite/host are two of the most common functional couplings that make up food webs. In this situation, *symbiotic relations* can act as intercalary elements, aiding the process

of building food webs by establishing local couplings. Examples include the bacteria that live in the guts of many animals, enabling them to digest their food, and the fungi and other microorganisms that form the rhizosphere, the underground food chains of interconnected roots and soil. Since food webs also display endogenously generated stable states,[16] all three operations of the Deleuze/Guattari abstract machine seem to occur in this case.

In the socioeconomic sphere, precapitalist markets may be considered examples of cultural meshworks. In many cultures weekly markets have traditionally been the meeting place of people with heterogeneous needs for goods and supplies of them. Matching complementary demands (i.e., interlocking these people on the basis of their needs and supplies) is performed automatically by the price mechanism. (Prices not only transmit information about the relative monetary value of different products, but also create incentives to buy and sell.) The price mechanism is at work when prices drop in the face of an excess supply and trigger a slowdown in the production of the relevant goods. Of course, this mechanism can only be said to work *automatically* when prices *set themselves*. Therefore, we must imagine that there is no local wholesaler who can manipulate prices by dumping (or hoarding) large quantities of a given product and no guild or other hierarchical structure which can set prices arbitrarily. In the absence of price manipulation, money (or even a primitive currency such as salt blocks or cowry shells) may be said to perform the function of an intercalary element; that is, with pure barter, two complementary demands must be matched by chance, but when money is introduced such a chance concurrence becomes unnecessary and complementary demands can be matched at a distance, so to speak. Finally, markets also seem to generate endogenous stable states, particularly when commercial centers form trading circuits, as can be seen in the cyclic behavior of their prices (such as the so-called Kondratieff cycles).[17]

An important issue must be raised at this point. As Deleuze and Guattari argue, neither meshworks nor strata occur in pure form, and more often than not we are confronted with mixtures of the two. Even the most goal-oriented hierarchical organization will display some drift in its growth and development, and even the smallest local market will involve some hierarchical element—at the very least, some bureaucracy charged with security or the enforcement of contracts. Moreover, hierarchies give rise to meshworks, and meshworks to hierarchies. Thus when several bureaucra-

cies coexist (governmental, academic, ecclesiastic) in the absence of any superstructure to coordinate their interactions, the whole set will tend to form a meshwork of hierarchies, articulated mainly through local and contingent links. Similarly, as local markets grow (such as into those gigantic fairs of the Middle Ages), they give rise to commercial hierarchies, with a money market on top, a luxury goods market below, and a grain market at the bottom.[18] A real society, then, consists of complex, changing mixtures of these two types of structures and in only a few cases will it be easy to designate a given institution as exclusively meshwork or stratum.

However, if we keep in mind the relativity of the distinction and the ubiquity of mixtures, it is still possible (and enlightening) to say that sedimentary rocks, species, and social hierarchies are all instances of strata, while igneous rocks, ecosystems, and precapitalist markets are meshworks. And if this typology (with all its underlying immanent, topological mechanisms) is correct, then many interesting philosophical consequences follow from it. At the very least, Deleuze and Guattari have shown us how to make nonmetaphoric comparisons like these, that is, how to go about identifying the roots of these deep isomorphisms. Beyond that, their conception of specific abstract machines that govern a variety of structure-generating processes blurs not only the distinction between the natural and the artificial but also that between the living and the inert. It points us toward a new kind of materialist philosophy, a neomaterialism in which raw matter–energy, through a variety of self-organizing processes and an intense, immanent power of morphogenesis, generates all the structures that surround us. Furthermore, such a neomaterialist account renders matter–energy flows, rather than the structures thereby generated, the primary reality. Let's elaborate this crucial point in more detail. There is a sense in which the thin, rocky crust that we live upon and call home is not a fundamental part of reality but simply a side effect of deeper morphogenetic processes. Indeed, if we waited long enough, if we could observe planetary dynamics at geologic time scales, we would witness the rocks and mountains that define the most stable and durable traits of our reality dissolving into the great underground lava flows which drive plate tectonics. In a sense, these geologic structures represent a local *slowing-down* in this flowing reality, a temporary *hardening* in those lava flows.

Similarly, we can say that our individual bodies and minds are mere coagulations or decelerations in the flows of biomass, genes, memes (behav-

ioral patterns established and maintained through imitation), and norms (patterns originating in and reinforced by social obligation). Here too we, as biologic and social entities, would be defined *both* by the materials we are temporarily binding or chaining into our organic bodies and cultural minds *and* by the time scale of that binding operation. With longer scales, what matters is the flow of biomass through food webs, as well as the flow of genes through generations, not the individual bodies and species that emerge from these flows. Given a long enough time scale, our languages would also become momentary slowdowns or thickenings in a flow of phonologic, semantic, and syntactic norms; standard languages would thus result from institutional interventions to slow down the flow, to rigidify a set of norms, while pidgins and creoles would emerge from accelerations in the flow, with such languages as Jamaican English and Haitian French being produced in a few generations.[19] The worldview that this "geological philosophy" generates can be encapsulated by means of some technical terminology.

First of all, the fact that meshworks and strata occur mostly in combination makes it convenient to have technical labels for these combinations. Let's call a mixture in which strata, or hierarchical components, are dominant a structure with *a high degree of stratification*, while calling its opposite, a combination dominated by meshwork components, a structure with *a low degree of stratification*. Since, as I said, hierarchies give rise to meshworks, and vice versa, we can say that these mixtures undergo processes of *destratification* as well as *restratification*. Finally, let's refer to the relatively unformed and unstructured matter–energy flows from which strata and meshworks emerge, this flowing reality animated from within by self-organizing processes constituting a cauldron of nonorganic life, the *body without organs* (BwO):

> The organism is not at all the body, the BwO; rather it is a stratum on the BwO, in other words, a phenomenon of accumulation, coagulation, and sedimentation that, in order to extract useful labor from the BwO, imposes upon it forms, functions, bonds, dominant and hierarchized organizations, organized transcendences. . . . The BwO is that glacial reality where the alluvions, sedimentations, coagulations, foldings, and recoilings that compose an organism—and also a signification and a subject—occur.[20]

We can apply the term "BwO" to these unformed, destratified flows as long as we keep in mind that what counts as destratified at any given time or space scale is entirely relative. That is, the flows of genes and biomass are "unformed" relative to any given individual organism, but they themselves have internal forms and functions. Indeed, if we expanded our planetary perspective into a truly cosmic one, we would view our entire planet (together with its flows) as a merely provisional hardening within the vast flows of plasma that permeate the universe. Deleuze and Guattari speak of bodies without organs (in the plural) when referring to locally limited processes of destratification, while they speak of *the* body without organs (or "plane of consistency") in reference to the hypothetical absolute limit of such processes. Immanent to the BwO is a set of abstract machines, the blueprints or diagrams that capture the dynamics of certain structure-generating processes, the two most general of which may be those to do with the formation of strata and self-consistent aggregates. But there are others. For instance, when the sorting device (effecting the first articulation of strata) is coupled with the ability to replicate with variation (as in the sorting of genes, memes, or norms), a new abstract machine emerges, in this case a blind probe-head, or searching device, capable of exploring a space of possible forms.[21]

These abstract machines may be viewed as if equipped with "knobs" for controlling certain parameters, which in turn define the dynamical state of the structure-generating process and hence the nature of the generated structures themselves. Key parameters include the strength and thoroughness of the sorting process and the degree of consolidation or reproductive isolation for the double-articulation machine; the degrees of temperature, pressure, volume, speed, density, and connectivity serving as parameters in the generation of stable states in meshworks; or the rates of mutation and recombination that set the speed of the probe-head, as well as the strength of biomass flow and of the coupling between coevolving species, which dictate the kind of space it explores. Therefore, using these abstract diagrams to represent what goes on in the BwO is equivalent to using a representational system in terms of *intensities*, since it is ultimately the intensity of each parameter that determines the kind of dynamic involved and hence the character of the structures generated. Indeed, one way of picturing the BwO is as that "glacial" state of matter–energy which results from turning all those knobs to zero, that is, the absolute minimum de-

gree of intensity, and thereby *bringing all production of structured form to a halt*. As Deleuze and Guattari put it:

> A BwO is made in such a way that it can be occupied, populated only by intensities. Only intensities pass and circulate. Still, the BwO is not a scene, a place, or even a support upon which something comes to pass. . . . It is not space, nor is it in space; it is matter that occupies space to a given degree—to the degree corresponding to the intensities produced. It is nonstratified, unformed, intense matter, the matrix of intensity, intensity = 0. . . . Production of the real as an intensive magnitude starting at zero.[22]

It is my belief that statements like this one become all the more intense the more literally we read them, and, as I have tried to show here, I strongly believe that such statements should be read as (at least trying to be) literally true. That is, their context is the most rigorous philosophy of physics, one that does not content itself, however, with meditating on the findings of orthodox (academic and industrial) physics, but a philosophy that dares to launch ahead, pushing its conceptual innovations to their limits. This "philosophical physics," I also believe, could be the basis for a renovated, reinvigorated materialism freed from the (essentialist and teleological) dogmas of the past. On the other hand, in order for Deleuze and Guattari's writings to be read nonmetaphorically, their ideas must be more systematically connected to current scientific theories and data. As a contribution to this task, and to the development of a coherent neomaterialism, I hope to have shown that some basic ideas in Deleuze and Guattari's later work cohere rather well with the relevant scientific findings. If this coherence does indeed hold true, then elucidating its nature and increasing its strength can only be good for philosophy as well as for science.

Notes

1 Gilles Deleuze, *Difference and Repetition*, trans. Paul Patton (New York, 1994 [1968]), 163–64 (on Lautman), 246 (on Simondon). In both cases, the question at issue is not "the genesis of form" but "the genesis of solutions" to problems, with immanence posited in terms of the objectivity not of the morphogenetic potential of matter but of the "problematic field" governing the production of solutions (the singularities of phase space which govern the behavior of specific trajectories, i.e., solutions to the equations). It seems to me that these are simply two aspects (the ontic and the epistemic) of the same question. That Deleuze is equally concerned with questions of morphogenesis in the physical

world is clear from statements such as this one: "It is no longer a question of imposing a form upon matter [i.e., the hylomorphic schema] but of elaborating an increasingly rich and consistent material, the better to tap increasingly intense forces. What makes a material increasingly rich is the same as what holds heterogeneities together without their ceasing to be heterogeneous"; Gilles Deleuze and Félix Guattari, *A Thousand Plateaus: Capitalism and Schizophrenia*, trans. Brian Massumi (Minneapolis, 1987 [1980]), 329.

2 "Stating the distinction in the most general way, we could say that it is between stratified systems or systems of stratification on the one hand, and consistent, self-consistent aggregates on the other. . . . There is a coded system of stratification whenever, horizontally, there are linear causalities between elements; and, vertically, hierarchies of order between groupings; and, holding it all together in depth, a succession of framing forms, each of which informs a substance and in turn serves as a substance for another form [e.g., the succession pebbles–sedimentary rocks–folded mountains]. . . . On the other hand, we may speak of aggregates of consistency when instead of a regulated succession of forms–substances we are presented with consolidations of very heterogeneous elements, orders that have been short-circuited or even reverse causalities, and captures between materials and forces of a different nature" (Deleuze and Guattari, *A Thousand Plateaus*, 335).

3 See Harvey Blatt, Gerard Middleton, and Raymond Murray, *Origin of Sedimentary Rocks* (Englewood Cliffs, 1972), 102 and 353.

4 See, for example, Gilles Deleuze, *Foucault*, trans. Seán Hand (Minneapolis, 1988 [1986]): "Strata are historical formations. . . . As 'sedimentary beds' they are made from things and words, from seeing and speaking, from the visible and the sayable, from bands of visibility and fields of readability, from contents and expressions. . . . The content has both a form and a substance: for example, the form is prison and the substance is those who are locked up, the prisoners. . . . The expression also has a form and a substance: for example, the form is penal law and the substance is 'delinquency' in so far as it is the object of statements" (47).

5 See Deleuze and Guattari, *A Thousand Plateaus*, 41. Actually, here they incorrectly characterize the two articulations involved in sedimentary-rock production as "sedimentation," then "folding." The correct sequence is sedimentation, cementation, and then, *at a different spatial scale*, cyclic sedimentary-rock accumulation, followed by folding (into mountain). In other words, they collapse two different double articulations (the second one using the products of the first as its raw materials). This correction does not undermine their argument, it seems to me; in fact, it is strengthened by virtue of showing that the same abstract machine can operate at two different spatial and temporal scales.

6 See Niles Eldridge, *Macroevolutionary Dynamics: Species, Niches and Adaptive Peaks* (New York, 1989), 127.

7 S. N. Eisenstadt, "Continuities and Changes in Systems of Stratification," in *Stability and Social Change*, ed. Bernard Barber and Alex Inkeles (Boston, 1971), 65–87; quotation from 65.

8 Ibid., 66–71.

9 See Humberto R. Maturana and Francisco J. Varela, *The Tree of Knowledge: The Biological Roots of Human Understanding* (Boston, 1992), 47 and 115.

10 Francisco J. Varela, "Two Principles of Self-Organization," in *Self-Organization and Management of Social Systems: Insights, Promises, Doubts, and Questions*, ed. H. Ulrich and G. J. B. Probst (Berlin and New York, 1984), 27–35; quotation from 27.

11 See Deleuze and Guattari, *A Thousand Plateaus*, 328–29. One potential source of misunderstanding should be mentioned here. Deleuze and Guattari, drawing on the work of Eugène Dupréel for their model, use his term "consolidation" for the theory of meshwork formation as a whole, while I use it for one of the two articulations of strata formation (what they call "coding").

12 Ibid., 330.

13 See *The Illustrated Encyclopedia of the Earth's Resources*, ed. Michael Bisacre (New York, 1984), 79.

14 Deleuze and Guattari, *A Thousand Plateaus*, 328.

15 See Grégoire Nicolis and Ilya Prigogine, *Exploring Complexity: An Introduction* (New York, 1989), 29.

16 D. A. Perry, M. P. Amaranthus, and J. G. Borchers, "Bootstrapping in Ecosystems," *BioScience* 39 (1989): 230–37.

17 See J. D. Sterman, "Nonlinear Dynamics in the World Economy: The Economic Long Wave," in *Structure, Coherence and Chaos in Dynamical Systems*, ed. Peter Christiansen and R. D. Parmentier (Manchester, 1989), 389–413.

18 See Fernand Braudel, *The Wheels of Commerce*, trans. Sian Reynolds (New York, 1986 [1979]), 91.

19 For an application of Deleuze and Guattari's sociolinguistic theories to the morphogenesis of Western languages (and Western-derived creoles), see Manuel DeLanda, *A Thousand Years of Nonlinear History* (New York: Zone Books, forthcoming), chap. 3.

20 Deleuze and Guattari, *A Thousand Plateaus*, 159.

21 For a description of the details of this abstract machine, see Manuel DeLanda, "Virtual Environments and the Emergence of Synthetic Reason," in *Flame Wars: The Discourse of Cyberculture*, ed. Mark Dery (Durham, 1994), 793–815.

22 Deleuze and Guattari, *A Thousand Plateaus*, 153.

Comment peut-on être deleuzien?

Pursuing a Two-Fold Thought

Charles J. Stivale

 This is a chapter about a title, or at least about an expression. No sooner had I proposed this title to Lawrence Kritzman (for one of the Twentieth-Century French Studies Division panels of the 1996 MLA convention) than I recognized the dilemma, or at least the conundrum, in the question. "Comment peut-on être deleuzien?" (How can one be Deleuzian?) is an obvious reference to Montesquieu's well-known ironic formulation in the *Lettres persanes,* "Comment peut-on être Persan?" (How can one be Persian?), which evokes at once the haughty elitism of Parisians gazing on the Oriental other and Montesquieu's self-deprecating humor in placing this question, addressed to the *Persan,* in the mouth of a Parisian. Besides occasionally feeling like this "other" in the poststructuralist critical domain of the past two decades, many commentators on Deleuze's works, written with and apart from Félix Guattari, have found themselves confronted by the second reference in my titular question, the *être deleuzien* enunciated by Michel Foucault in his

now-overexploited declaration that "un jour ce siècle sera peut-être deleuzien."[1] As rendered in an English translation—"Perhaps one day this century will be known as Deleuzian"[2]—Foucault's statement is complicated by the passive voice. For the century to "be known as Deleuzian" suggests that an assemblage of privileged knowers will somehow come to recognize the *être deleuzien* of this century and even of or among themselves.

Foucault's own explanation, now buried in his four-volume collected interviews and occasional pieces, *Dits et écrits*, was originally given during a 1978 interview published in the Japanese journal *Sekai*.[3] Opening "Theatrum philosophicum" with a wink aimed at the few Deleuzian initiates in 1970 who would read this review essay in *Critique* on *Différence et répétition* and *Logique du sens*, Foucault had implied that one day, perhaps inevitably, "le siècle" or "l'opinion commune" would come to recognize itself as "deleuzien"; eight years later, he added, "Et je dirais que ça n'empêchera pas que Deleuze est un philosophe important" (And I would say that this takes nothing away from Deleuze's being an important philosopher).[4]

If the number of recently published translations is any indicator, Deleuze's works (and Deleuze and Guattari's) have entered into just such a process of machinic assemblage and meta-modelization, to put it in Deleuzo-Guattarian. That is, despite or perhaps because of the work, at once serious and snickering, that we have undertaken in studying Deleuze and Guattari, their writings now function as cogs in the machinery of sociocultural and material interrelations and representations extending into many domains: pedagogy, university institutionalization and professionalization, and competition between academic and commercial presses, to name but a few. In short, their works are now in circulation as part of what has come to be called "cultural capital," in an oddly schizo sort of way that Deleuze and Guattari might have appreciated, or maybe not. Of course, producing this paper, with this title, in this public venue, is to participate fully in those very machinic assemblages. My hope here is to reflect briefly on certain paths that may allow me, if not to leave this "siècle deleuzien" behind, then perhaps to scramble its tracks a bit—or at least to explore my own practices and modes of apprenticeship.

As for answers to the somewhat facetious question in my title, the most obvious one comes from Guattari. When I asked him in 1985 which aspects of *Capitalism and Schizophrenia* he thought remained the most valid, he replied, "They're not valid at all! Me, I don't know, I don't care! It's not my problem! It's however you want it, whatever use you want to make of

it."[5] As tempting as it might be to accept this apparently outright rejection of the operative query, such a gesture would be tantamount to falling into what Foucault, in his preface to *Anti-Oedipus*, calls one of the main "traps" of the Deleuze/Guattari enterprise, its humor: "so many invitations to let oneself be put out, to take one's leave of the text and slam the door shut." Yet, as Foucault also maintains here, it is precisely in this use of humor and play that something essential and highly serious takes place: "the tracking down of all varieties of fascism, from the enormous ones that surround and crush us to the petty ones that constitute the tyrannical bitterness of our everyday lives."[6]

Referring to *Anti-Oedipus* (and asking Deleuze and Guattari's forgiveness for doing so) as "the first book of ethics to be written in France in quite a long time," Foucault then suggests one reason for the book's broad appeal beyond a specialist readership: "Being anti-oedipal has become a life style, a way of thinking and living." He goes on to specify a set of goals and principles that accords with this antifascist "art of living," as a "guide to everyday life": "free political action from all unitary and totalizing paranoia"; "develop action, thought, and desires by proliferation, . . . not by subdivision"; "prefer what is positive and multiple . . . over uniformity, . . . unities . . . systems, [over what is] sedentary"; avoid sadness in political militancy; "use political practice as an intensifier of thought"; "'de-individualize' by means of multiplication and displacement"; and "do not become enamored of power."[7] One understands why Foucault asked Deleuze and Guattari's forgiveness in advance: their sense of humor and their rejection of ceremony would seem to have run counter to such an exercise of "meta-modelization," however well-meant. Nevertheless, I want to elaborate Foucault's "way of thinking and living" (even at the risk of pursuing what Deleuze and Guattari would no doubt reject), namely, as a "two-fold thought" that brings into play a number of principles geared not to an *être* but to a *devenir* (becoming), or, if you will, a *devenir deleuzien/guattarien*:

> —a principle of becoming in and through constant mutation, displayed and enfolded in the profusion of multiplicities developed, for example, in Plateau 10 of *A Thousand Plateaus*;
> —a principle of becoming *à cheval*, a *chevauchement* astride the Anglo-French divide, for example, by means of the mutations of linguistic cross-fertilizations and monstrous realizations;
> —a principle of intermezzo, *dans le milieu*, intersections at once

of microrelations to ongoing processes of smooth becomings in diverse projects, however disparate, and of macrorelations, debates in a "milieu" or a "profession," in well-configured and striated domains that are nonetheless fertile possibilities for the production of becomings, circumstances permitting;
—a principle of transversality, of reciprocities, contaminations, and lines of flight out to the edge, but also of *fuites* (leakages), as in the unexpected transpositions of creativity and apparent madness so well understood by Guattari in his clinical work and political practice;
—a principle of linkages, of connectivity, the culmination of all the preceding principles, as exemplified by the cyberspatial overlaps and engagements that give rise not merely to production and creativity but to the repressions, aggressions, and abuses symptomatic of what Deleuze and Guattari call "cancerous BwOs" (bodies without organs).[8]

All of these principles underlie modes of becoming and hence inform modes of practice. Fundamental to practice (and to my notion of the "twofold thought") is a complex principle simply designated as "apprenticeship," a term employed by Michael Hardt in his book on Deleuze's early writings.[9] Yet I think apprenticeship needs to be envisaged from those perspectives that Deleuze and Guattari developed throughout their collaboration, namely, friendship, or intermezzo (working with or between each other), and a relationship with "the outside" based on *intercesseurs* (mediators). These, says Deleuze, "can be people—for a philosopher, artists or scientists; for a scientist, philosophers or artists—but things too, even plants or animals, as in Castaneda. Whether they're real or imaginary, animate or inanimate, you have to form your mediators" ("peut être des gens—pour un philosophe, des artistes ou des savants, pour un savant, des philosophes ou des artistes—mais aussi des choses, des plantes, des animaux même, comme dans Castaneda. Fictifs ou réels, animés ou inanimés, il faut fabriquer ses intercesseurs"). Calling this a relation in "a series," he adds, "If you're not in some series, even a completely imaginary one, you're lost" ("Si on ne forme pas une série, même complètement imaginaire, on est perdu").[10] Although Deleuze concludes here by saying, "Félix Guattari and I are one another's mediators," it is his reference to Carlos Castaneda that seizes my attention, for it may lead toward answering the question in my title while also elaborating the "two-fold thought."

Deleuze and Guattari's collaborative work is punctuated by crucial references to the early volumes of Castaneda's "conversations" with "Don Juan Matus," particularly *Tales of Power*.[11] Castaneda's "apprenticeship" to Don Juan appears to be a reconceptualized student/teacher relationship. As we know quite well, this relationship can entail a considerable sacrifice of time and energy, and much patience, on the part of the teacher in hopes of inducing some sort of insight that may be resisted or accepted, readily or grudgingly, by the student. Moreover, it is only as the student extends his or her horizons of understanding, or better still, recognizes new possibilities for deterritorialization (however relative and fleeting), that he or she comes to apprehend more fully the import of the gift of knowledge, and the concomitant sacrifice, proffered through the intensive pedagogical exchange. The teachings of Don Juan Matus, as recorded and later revisited in Castaneda's narrative, provide at least three perspectives on their joint trajectory toward knowledge and power that relate to the Deleuze/Guattari project.

First, the evolving phases and circumstances of Castaneda's apprenticeship described in his first four volumes bring into stark relief the inherent resistance to possible deterritorialization that complicates the sacrifices made and the gifts proffered in the master/apprentice or teacher/student relationship. At several key moments, Castaneda feels obliged to break off his apprenticeship completely, for reasons explicitly related to perceived threats to his "objectivity" and ability to maintain his preestablished, rational belief system. It is only after several years of reflection that he can resume his apprenticeship each time and reveal new details about the circumstances he had originally related in his reconceptualization of what had gone before, the better to pursue his search. These break/flows suggest the extent to which various processes of production and antiproduction and their diverse becomings can operate within a particular mode of apprenticeship, indeed as the very dynamic of the pedagogical exchange.

Second, the Castaneda/Don Juan exchange may also allow us to consider apprenticeship in terms of a "space of affect," that is, as the "thisness" of events that Deleuze and Guattari call "hecceity."[12] The hecceity's combination of relative "speed" and "feeling" corresponds here to a precipitation of the gift of knowledge as a result of both sacrifices made and concomitant resistances maintained—yet another set of break/flows that also establishes an affective rhythm within the teaching/learning process. This precipita-

tion becomes evident in the second through fourth volumes as Castaneda, having somehow resolved his fear upon reviewing his earlier experiences, hurries to resituate successively each series of field notes and recognizes the previously unappreciated (and predictably misunderstood) depth of the teachings made available to him by the sorcerer [*brujo*] Don Juan.

Third, that the *brujo* conceives of his teaching and Castaneda's apprenticeship as coterminous with the latter's acquisition of "power" (as defined by Don Juan) is quite relevant for understanding the potential of the gift of knowledge to carry the student toward a point "beyond," or better perhaps, "outside," the gift. The exchange between teacher and student is one in which the latter's understanding and applications of the gift can transform the former's sacrifice in unexpected ways, leading the student not simply to "power" (at once threatening and beneficent) but also to insight about the use of power and knowledge, that is, to wisdom. This concept of power would seem to be at odds with one of the principles elaborated by Foucault from his reading of *Anti-Oedipus*—"do not become enamored of power"— but in fact the relation to power in Don Juan's teachings is anything but a love affair. Rather, it constitutes a practical means by which to approach one's existence—relationships and circumstances—at once cautiously and efficiently, that is, out on an edge productive of the dismantlings of hierarchies, yet with a foothold maintained in a plane of consistency. In Plateau 6 of *A Thousand Plateaus*, Deleuze and Guattari ask,

> What does it mean to disarticulate, to cease to be an organism? How can we convey how easy it is, and the extent to which we do it every day? And how necessary caution is, the art of dosages, since overdose is a danger. You don't do it with a sledgehammer, you use a very fine file.
>
>
>
> Que veut dire désarticuler, cesser d'être un organisme? Comment dire à quel point c'est simple, et que nous le faisons tous les jours. Avec quelle prudence nécessaire, l'art des doses, et le danger, overdose. On n'y va pas à coups de marteau, mais avec une lime très fine.[13]

They then refer specifically to Don Juan's pedagogy, describing how Castaneda is compelled

> first to find a "place," . . . then to find "allies," and then gradually to give up interpretation, to construct flow by flow and segment by segment

lines of experimentation, becoming-animal, becoming-molecular, etc. For the BwO is all of that: necessarily a Place, necessarily a Plane, necessarily a Collectivity (assembling elements, things, plants, animals, tools, people, powers, and fragments of all of these . . .).

. . . .

d'abord à chercher un "lieu," . . . puis à trouver des "alliés," puis à renoncer progressivement à l'interprétation, à construire flux par flux et segment par segment les lignes d'expérimentation, devenir-animal, devenir-moléculaire, etc. Car le CsO est tout cela: nécessairement un Lieu, nécessairement un Plan, nécessairement un Collectif (agençant des éléments, des choses, des végétaux, des animaux, des outils, des hommes, des puissances, des fragments de tous ça . . .).[14]

This brief excursus into apprenticeship, into teaching and learning as an exchange between Don Juan and Castaneda, has given me some reference points, oriented me between the static, striated confines of an "être deleuzien" and a dynamic "devenir deleuzien/guattarien"—becoming as a process of teaching and learning, hardly undertaken and never finished but always to be recommenced. Diverse "devenirs deleuziens" participate, or at least have the potential to do so, in the dimensions and sociocultural strata opened up through various activities that we might designate as "rhizomatic" and to which Brian Massumi has recently addressed himself in an essay conveniently entitled "Becoming-deleuzian." Among a number of provocative insights, Massumi argues that the Deleuze text "challenges the reader to do something with it" and that, through this pragmatic rather than dogmatic insistence, "readers are invited to fuse with the work in order to carry one or several concepts across their zone of indiscernibility with it, into new and discernibly different circumstances."[15]

While the reference points I have sought here would seem to contradict the concept of continual "devenirs," I can formulate some questions about possible "rhizomatic activities": What concrete, actual, and pertinent examples of fusion and new modes of discernibility could clarify these "devenirs deleuziens" as intersections of strata and everyday life? What modes of teaching and learning, of apprenticeship in its many senses, could extend such "devenirs"? In what ways could these modes of apprenticeship be articulated or constructed by an individual such that they would not appear to be merely banal, anecdotal, inapplicable, or even inhospitable to one's interlocutors? As a matter of fact, nearly every recorded conver-

sation with Deleuze and/or Guattari reveals their concern with the learning/teaching process, including the role of "intercesseurs," or mediators, as a means to further their (and our) work, to extend their concepts and find new ones. These concepts are not limits to which we necessarily remain bound, but rather, to paraphrase Manuel DeLanda, serve as that little plot of land to which we can return after a hard day of deterritorializing.[16] At the same time, the process of exchange in apprenticeship can lead us out toward that edge of the world which Castaneda confronted again and again, where he learned to experiment and "to see," that is, to become a "seer" in the sense that Don Juan (and Rimbaud) understood it.

First on a panel and now in a publication devoted to "the Deleuzian century," I have been tempted to conclude that the tracks of a "siècle deleuzien" and an "être deleuzien" are all the more deeply etched through my perhaps predictable reinforcement of their assemblages and concomitant reterritorializations. Still, the "devenirs" that I have also evoked must occur outside of these pages, beyond this localized event, through reconnections, explorations, and transmissions (pedagogical, cyberspatial, or interpersonal, as one prefers). These devenirs invoked alongside Deleuze's name depend on continual *expérimentations-vie* (life-experimentations) that may somehow punctuate striated frameworks, even minimally, and thereby produce zones of mutual apprenticeship, friendship, and, with a little luck or work, *devenirs monstrueux*—becoming(s)-monstrous.

Notes

1 Michel Foucault, "Theatrum philosophicum" (1970), in *Dits et écrits*, 4 vols. (Paris, 1994), 2: 75–99; quotation from 76.
2 Michel Foucault, *Language, Counter-Memory, Practice*, trans. Donald F. Bouchard and Sherry Simon (Ithaca, 1977), 165–96; quotation from 165.
3 See Michel Foucault, "La scène de la philosophie" (1978), in *Dits et écrits*, 3: 571–95.
4 Ibid., 589.
5 Charles J. Stivale, "Pragmatic/Machinic: Discussion with Félix Guattari (19 March 1985)," *Pre/Text* 14 (1993): 215–50; quotation from 226.
6 Michel Foucault, Preface, in Gilles Deleuze and Félix Guattari, *Anti-Oedipus: Capitalism and Schizophrenia*, trans. Robert Hurley, Mark Seem, and Helen R. Lane (Minneapolis, 1983 [1972]), xi–xiv; quotations from xiv; rpt. in French in *Dits et écrits*, trans. F. Durand-Bogaert, 3: 133–36; quotations on 136.
7 Foucault, Preface, xiii; see also *Dits et écrits*, 3: 134–35.
8 On the concept of the "body without organs," see Deleuze and Guattari, *Anti-Oedipus*, chap. 1; and *A Thousand Plateaus: Capitalism and Schizophrenia*, trans. Brian Massumi

(Minneapolis, 1987 [1980]), chap. 6. For a selection of works individually authored by Félix Guattari, see *The Guattari Reader*, ed. Gary Genosko (Cambridge and London, 1996).

9 Michael Hardt, *Gilles Deleuze: An Apprenticeship in Philosophy* (Minneapolis, 1993).

10 Gilles Deleuze, *Negotiations, 1972–1990*, trans. Martin Joughin (New York, 1995), 125; *Pourparlers, 1972–1990* (Paris, 1990), 171.

11 These crucial references are to Carlos Castaneda, *The Teachings of Don Juan: A Yaqui Way of Knowledge* (New York, 1974 [1968]); *A Separate Reality: Further Conversations with Don Juan* (New York, 1971); *Journey to Ixtlan: The Lessons of Don Juan* (New York, 1972); and *Tales of Power* (New York, 1974).

12 See Deleuze and Guattari, *A Thousand Plateaus*, 260–65.

13 Ibid., 159–60; Gilles Deleuze and Félix Guattari, *Mille plateaux*, Vol. 2 of *Capitalisme et schizophrénie* (Paris, 1980), 198.

14 Deleuze and Guattari, *A Thousand Plateaus*, 161; *Mille plateaux*, 199–200. On the tonal/nagual distinction, see Castaneda, *Tales of Power*, 102–209.

15 Brian Massumi, "Becoming-deleuzian," *Society and Space* 14 (1996): 395–406; quotations from 401.

16 See Erik Davis, "De Landa Destratified," *Mondo 2000* 8 (1992): 44–48, esp. 48.

Marx and Poststructuralist Philosophies

of Difference Eugene W. Holland

One of the many misfortunes suffered recently by Marxism was the death of Gilles Deleuze before he could complete the book he was writing on Marx. This misfortune was, however, mitigated by the publication of an important book on Marx by Jacques Derrida (which appeared shortly before Deleuze's death). Together, Deleuze and Derrida had formed the philosophical backbone of French poststructuralism, putting difference on the agenda in the wake of structuralism with two major books in the late 1960s: Deleuze's *Difference and Repetition* and Derrida's *Of Grammatology*.[1] A quarter of a century later, their quite different career paths notwithstanding, both were writing books on Marx. Although Derrida's *Specters of Marx* is not the book Deleuze would have written, of course, it may by comparison reveal something of what Marx meant to Deleuze nonetheless and raise some of the issues that Deleuze's book might have addressed.[2]

The stance Derrida takes toward the legacy of Marx in this courageous book is, to say the least, a careful and complicated one.[3] The figure of the ghost or specter, insistently cast by Derrida in the plural, serves (among other things) to enable

him to choose among a plethora of Marx's ghosts, to respectfully embrace some and frankly castigate and reject others. Of course, since Althusser (at least), the idea of making uncompromising choices among different Marxes is nothing new in itself. But the figure of the ghost enables Derrida to raise the specter not just of an "early," still Hegelian Marx (as per Althusser) but of an Enlightenment Marx, a Marx who is dependent on the metaphysics of presence and is therefore afraid or suspicious of ghosts. A "hostility toward ghosts, a terrified hostility that sometimes fends off terror with a burst of laughter," Derrida suggests, "is perhaps what Marx will always have had in common with his adversaries."[4] He himself, by contrast, finds the figure of the ghost appealing and useful, since ghosts belie the binary oppositions of presence and absence, of matter and spirit, of present and past. So, understandably, those aspects of Marx's work that Derrida is most at pains to detect and reject are the very ones (the "predeconstructive ones," Derrida calls them) that would rely on presence or self-presence as grounds for his critique of ideology or capital. With regard to Marxism, a metaphysical "materialism"—a metaphysics of matter, of self-present "reality," of the "real world"—would in principle take the same form, and be just as baneful, as a metaphysical "idealism" (a metaphysics of spirit) like that of Hegel.

Much of what Derrida targets as metaphysical in Marx involves the latter's rhetoric of ideology critique: Marx himself often represents historical or economic actors as haunted by ghosts, but only in order to dispel such illusions as ideological. In this regard, Derrida suspects Marx of invoking a solidly grounded, self-present reality as a referent by which to conjure away the ghosts of ideology.[5] More importantly for our purposes here (since Deleuze himself had little use for the notion of ideology), Derrida makes the same kind of claim about the distinction between use-value and exchange-value in Marx: that use-value serves as a self-present reality which gets corrupted only ex post facto by the vagaries of exchange-value and eventually of capital itself.

This is a complicated, and potentially important, issue. It may well be that many of Marx's formulations of the relations between use- and exchange-value court metaphysics and leave ample room for, indeed even foster or imply, ontologizing interpretations. At the same time, it could be said that at least some of Marx's statements rather forcefully suggest the opposite: far from being the ground for a metaphysics of utility or an

anthropology of needs, the content of "use-value as such," he says at one point, "falls outside the sphere of investigation of political economy."[6] But the point is not to claim that Marx was always right or always wrong. As Derrida has shown, dealing with contradictory statements in a given corpus requires reading—and his book on Marx points up the need for such a reading, without ultimately performing it. For this reason, the terms of his argument turn out to be very revealing, and bear closer examination.

In discussing the relation of use- and exchange-value within the commodity-form, Derrida takes up an illustration from *Capital* in which the existence of a wooden table qua table is contrasted with its existence as a commodity: "To say that the same thing, the wooden table for example, *comes on stage* as a commodity *after* having been but an ordinary thing in its use-value is to grant an origin to the ghostly moment. Its use-value, Marx seems to imply, was intact. It was what it was, use-value, identical to itself." This kind of purity, of course, raises Derrida's suspicions:

> The phantasmagoria, like capital, would begin with exchange-value and the commodity-form. It is only then that the ghost "comes on stage." Before this, according to Marx, it was not there. Not even in order to haunt use-value. But whence comes . . . this supposed use-value, precisely, a use-value purified of everything that makes for exchange-value and the commodity-form?[7]

Where else, for Derrida, but from a metaphysical commitment to the purity or self-presence of use-value as ontological ground? "Marx continues to want to ground his critique or his exorcism of the spectral simulacrum in an ontology"[8]—a ground against which exchange-value, the commodity-form, and eventually capital itself will appear as phantasmagoria to be exorcised by a revolution that would restore use-value to its proper purity. But an opposition based on the presence of one of its terms, of course, cannot stand:

> The said use-value of the said ordinary, . . . thing, . . . the . . . wood[enness] of the wooden table concerning which Marx supposes that it has not yet begun to "dance" [i.e., appear as a commodity], its very form, . . . must . . . have . . . promised it to iterability, to substitution, to exchange, to value; it must have made a start, however minimal it may have been, on an idealization that permits one to identify it as the same throughout possible repetitions, and so forth.[9]

Note the sequence of terms used here: the table is promised to "iterability," "substitution," "exchange," and "value." For although Derrida presents them as equivalents, these terms in fact designate very different forms of what he here calls "idealization." Especially important is the distinction between substitution as a function of linguistic value—the iterability of the signifier—and substitution as a function of economic value—the exchangeability of the commodity.[10] That Derrida is not attending to this difference here becomes clear as the passage from which I quoted above continues: "Just as there is no pure use, there is no *use-value* which the possibility of exchange and commerce (by whatever name one calls it, meaning itself, value, culture, spirit, signification, the world, the relation to the other . . .) has not in advance inscribed in an *out-of-use*—an excessive signification that cannot be reduced to the useless."[11] But exchange is not "meaning itself"; commerce is not the same thing as signification—and precisely this distinction lies at the heart of Deleuze's analysis of capitalist society. For he agrees with Marx (the Marx of "all that is solid melts into air") that what makes capitalism unique—and, moreover, makes such a thing as "universal history" possible—is the predominance of economic value over linguistic value.

≡

Contrasting capitalism with other social formations in *Anti-Oedipus*, Deleuze and Guattari discuss the dominance of economic value in terms of "axiomatization." Organized on the basis of directly interpersonal (that is to say, political) relations by means of linguistic or semiotic codes of various sorts, these other formations define the value of things, persons, and behaviors according to qualitative relations of similarity and dissimilarity, as coded by a society's cultural order. Capitalism, by contrast, organizes society impersonally, by means of the market: the value of goods and labor-capacity—along with the persons and behaviors that take them to market and back—is determined by the "cash nexus," by quantitative relations embodied ultimately in the abstract, universal equivalent of money. Capitalism undermines or "decodes" all established meanings and beliefs, replacing them with sets of axioms that govern the conjunction of decoded flows—of money, labor-capacity, raw materials, skills and technologies, consumer tastes, and so forth—in the pursuit of surplus-value. This is what Deleuze and Guattari describe as the basic "cynicism" of capital-

ist axiomatization,[12] with all beliefs and meanings strictly subsidiary to the conjunction of quantified flows and continually subject to decoding as capital transforms itself in the process of self-expansion. Given this asignifying cynicism, it should be clear that capitalism itself has no need for a concept or content of "use-value." And neither does Marxism, inasmuch as Marx's critique of political economy remained internal to its dynamics rather than being imposed on it from some external, Archimedean vantage point. An immanent critique of what exchange-value enables (under certain conditions), namely, the formation and ensuing self-expansion of capital, in no way depends on assigning content to use-value as a standard by which to judge and condemn the commodity-form.

This analysis of capitalist axiomatization provides the basis for contextualizing the poststructuralist critique of representation and valorization of difference historically—for Deleuze and Derrida alike. First, however, we need to back up a bit and consider the projects informing their respective philosophies of difference. The aim of *Difference and Repetition*, arguably Deleuze's single most important contribution to poststructuralist philosophy, is to restore difference to its rightful place in relation to identity. "The primacy of identity . . . defines the world of representation. But modern thought is born of the failure of representation, of the loss of identities, and of the discovery of all the forces at work beneath the representation of the identical."[13] Extending lines of argument from Spinoza and Nietzsche, and arguing along with them against most of the Western metaphysical tradition starting with Plato, Deleuze insists that difference and multiplicity are the primary categories and that identity must henceforth be conceived as secondary and dependent on them rather than the other way around:

> Such a condition can be satisfied only at the price of a . . . general categorical reversal according to which being is said of becoming, identity of that which is different, the one of the multiple, etc. That identity not be first, that it exist as a principle but as a second principle; . . . that it revolve around the Different: such would be the nature of a Copernican revolution which opens up the possibility of difference having its own concept, rather than being maintained under the domination of a concept in general already understood as identical.[14]

This reversal in turn transforms the concept of repetition, or rather (to illustrate the process while describing it), such a reversal produces an

internal differentiation in what we understand by repetition, which is now different, now differs from itself. For it will henceforth be necessary to understand repetition as involving not identity or equivalence among terms but difference and variation. What Deleuze calls "bare" or merely mechanical repetition—repetition of the same—must be distinguished from authentic or creative repetition, that is, repetition of the different. Plato and Platonism in all its many versions are major targets throughout the book: repetition "here below"—word usage, for example—doesn't imperfectly mimic a heavenly realm of pregiven eternal, transcendent Forms; rather, repeated word use merely projects such forms as sedimented, ideal identities, which real repetitions at most approach only asymptotically (if at all).[15] For Deleuze, difference and repetition (creative repetition) are what is given; they then get betrayed and distorted by operations of mechanical repetition, which result in identity (or a sense of identity).

At the very beginning of *Difference and Repetition*, Deleuze identifies the two orders of mechanical repetition, or "generality," that suppress difference: "the qualitative order of resemblances and the quantitative order of equivalences"[16]—in other words, to revert to the terminology of *Anti-Oedipus*, codes and axioms. Capitalism, by subverting codes in the "mechanical" operations of axiomatization, unleashes difference in the process. Then, in order to profit from difference (and surplus-value is, after all, nothing but a difference—between M and M'), capital tries to recapture it by continually adding new axioms.[17] But it never completely succeeds. Difference continues to emerge "in between" decoding and axiomatization; its appearance on the agenda of poststructuralism can thus be seen as a response to the acceleration of decoding and the trials of global axiomatization during the period of intense capitalist expansion that followed World War II. Accordingly, the express aim of Deleuze's philosophy of difference would be to salvage or sustain difference, to prevent its subordination to identity by the operations of either old-fashioned resemblance in codification or—increasingly—of the newfangled equivalence embodied in capitalist axiomatization.

We are now in a position to understand Deleuze's appreciation of the notion of universal history as propounded by Marx—surely one of the more controversial aspects of the Marxian "legacy." Capitalism can open up the possibility of universal history because its mode of suppressing difference—axiomatization—is not only different from but antithetical to

all previous modes of suppression, which depended on the formation of identities based on codes. Axiomatization subverts codes, subjecting them to critique or simply dissolving them. Universal history is therefore, as Deleuze and Guattari put it (following Marx), retrospective (and thus emphatically not teleological) as well as "singular, ironic and critical." "Capitalism determines the conditions and the possibility of a universal history" inasmuch as it is absolutely unlike any other social formation and in fact undermines the principle of coherence (codification) on which all those others are based—but only to the extent that it is capable of self-criticism.[18] Axiomatization subverts codification, but must itself be brought to the point of self-criticism, in turn, to make universal history possible. Now in principle, difference would be freed from the mechanical repetition of capitalist axioms if, for example, socially necessary labor-time were no longer the abstract standard of equivalence for exchange-value—if, that is, labor-capacity were no longer sold as a commodity but invested in production via different relations of production (such as self-managed worker cooperatives). But in reality, of course, such conditions already point well beyond any capitalist horizons, about which Deleuze and Guattari are not inclined to say very much at all.[19]

If we return, then, to a comparison of Deleuze's philosophy of difference with that of Derrida, we must note that—in the early stages of his career, at least—Derrida focused primarily on the "operations of resemblance" constraining difference, on the dynamics of representation or cognition, on linguistic or semiotic rather than economic value, and on codes rather than axioms. Even the writing of the "archi-trace," which underlies both speech and graphic writing, remains a cognitive or precognitive operation, fundamentally a matter of representation and of its impossibility. (And when, later on, Derrida turns his attention to questions of "economic" rather than linguistic value, his concern is largely with the dynamics of gift and debt "beyond" exchange, as he puts it, rather than with exchange per se, as we shall see.) "Differance" for Derrida designates the sheer mobility of linguistic value, the impossibility of ever pinning down meaning—whether of a thing or an experience or a word. The initial sources and targets of deconstruction were Husserl and Saussure, and vintage deconstruction concentrated for the most part on the realms of meaning—experiential and

linguistic, respectively—that those two figures circumscribe. Given this focus on the structure and dynamics (that is, the impossibility) of "meaning itself," Derrida elected to take what might be termed a "de-ontological" stance, according to which we must avoid and disallow the ascription of determinate meaning to the pure, present Being of things and words in contempt of the way that we (now) know experience and language to actually work—that is, differentially.[20]

But Deleuze was able to avoid this dilemma. Instead of choosing between an ontology of Being and a de-ontology, he spent the early stages of his career developing what I will provisionally call an ontology of Becoming, based on his readings of Bergson and Nietzsche (as Michael Hardt has recently shown[21]). If what is given ontologically is neither Being nor nothing, but rather difference and change ("Becoming" in the old, philosophical sense), then repetition must really entail variation, differentiation, improvisation—except to the extent (the very considerable extent, alas) that persons and behaviors succumb to the identifying operations of resemblance and equivalence (in various forms of subservience, habit, economic compulsion, etc.).

Yet "Becoming" is not really the right term for Deleuzian ontology: it's too passive or contemplative, as if change and difference were something happening out there, outside us. Nature is in constant flux, on this view, despite our misguided attempts to impose notions of Being, essence, and permanence on it. Drawing on Spinoza, Deleuze refuses the subject-object polarity underlying this view of Becoming; rather, we are part of "nature," and human activity contributes as much to the development or self-differentiation of nature as nature does to our own development— hence Deleuze and Guattari's insistence in *Anti-Oedipus* that "Nature = Industry, Nature = History."[22] Deleuze's position would in this light be better termed an ontology of practice than an ontology of Becoming— provided that we understand "practice" (as its other meanings suggest) as a matter of productive repetition. The world (and we along with it) constitutes itself ontologically by continually repeating itself, but always with a difference. Whereas Derrida turns to the figure of the specter to avoid the risks of metaphysical materialism and to deconstruct the opposition of spirit and matter, past and present, Deleuze develops an ontology of productive practice (whereby Nature = Industry = History).[23]

Such an ontology, only adumbrated, perhaps, in *Difference and Repetition* (which is informed by Nietzsche, Bergson, and Freud rather than by Marx), becomes an explicit embrace of materialism in *Anti-Oedipus* (a materialism derived from Marx and Spinoza as well as from Nietzsche and Freud). Although Deleuze and Guattari never address the relation of use-value and exchange-value directly, they do attach great importance here (following Marx) to the historical emergence of abstract labor as a singular property of capitalism—the emergence, that is, of labor-power as a commodity.[24] Part of what they mean by "production" (what they call "social production") involves the "becoming-concrete" of abstract labor-power (or its "use-value"): its capacity to transform the world (and ourselves in the process). It should be clear that such "use-value" is never purely present, but always in process, undergoing transformation (on which basis, incidentally, Marx claimed that consumption, products' use-values, and "human needs" are also always in a constant state of flux or process of transformation). But the other component of "production" ("desiring-production") in *Anti-Oedipus* involves not "matter" but "spirit"—the production of reality not in the physical, but the cognitive and libidinal, sense. The other of exchange-value is thus never solely a matter of "use" for Deleuze and Guattari, but also and indistinguishably a matter of pleasure and joy. These two aspects of production, labor-power and libido-power, taken together produce the Real.[25] And the boundary between them is strictly "undecidable" (to adopt the Derridean term).[26] The Deleuzian ontology of productive practice thus involves more than just "industrial" labor practices; it also includes—and may indeed favor, insofar as they would be more likely or better able to elude axiomatization—the arts, the sciences, mathematics, philosophy, (anti-)psychiatry, and so on.[27]

Such a view of productive practice has little to do with an ontology of (fixed or pure) "use-value" and indeed seems to square with Derrida's suggestion that we should interpret Marx and his materialism "from the perspective of work and production and not from that of material substance."[28] To understand why Derrida seems not to have followed through with such an interpretation in *Specters of Marx*, we will need to consider the themes of some of his more recent work, in which he has moved beyond experience and language to take up questions of economics and justice.

We can start by returning to the passage from *Specters* quoted earlier, in which reiterability was seen to inhabit use-value even before it was transformed by exchange-value in the commodity-form; to this, Derrida adds that

> one could say as much . . . for exchange-value: it is likewise inscribed and exceeded by a promise of gift beyond exchange. In a certain way, market equivalence arrests or mechanizes the dance that it seemed to initiate. Only beyond value itself, [beyond] use-value and exchange-value, . . . is grace promised, if not given, but never *rendered* or given back to the dance.[29]

Like use-value, then, exchange-value is never pure; it can in turn be deconstructed in light of the concepts of the gift and justice, which appear markedly different from the restricted rationality of Western economics and political philosophy. Gifts and justice (or what Derrida sometimes simply calls the gift of justice) instantiate something beyond commercial exchange and legal retribution. Like Georges Bataille and Claude Lévi-Strauss before him, Derrida draws on the work of Marcel Mauss in order to question and suggest alternatives to liberal society, based as it is on exchange and contract law.[30] But what this amounts to (as is clear from Mauss's work itself) is a vision of society based on personal obligation instead of market exchange—on an ethic of responsibility (so patently lacking in liberal societies) of one person to another or to others in general.

Such a sense of responsibility (also derived by Derrida from the work of Emmanuel Levinas) is precisely the reason Derrida gives for having accepted the invitation to speak at the conference on Marxism upon which *Specters of Marx* is based: "If I take the floor at the opening of such an impressive . . . colloquium . . . it is first of all so as not to flee from a responsibility."[31] This responsibility, Derrida explains, is that of an heir—and it is not his alone: "All men and women, all over the earth, are today to a certain extent the heirs of Marx and Marxism. Whether we like it or not," he goes on,

> . . . we cannot not be its heirs. There is no inheritance without a call to responsibility. An inheritance is always the reaffirmation of a debt,

but a critical, selective, and filtering reaffirmation, which is why we distinguished several spirits [i.e., "specters" of Marx]. By inscribing in our subtitle such an equivocal expression as "the State of the debt," we wanted to announce . . . above all . . . an uneffaceable and insoluble debt toward one of the spirits inscribed in historical memory under the proper names of Marx and Marxism.[32]

Given his commitment to de-ontology, the one debt to Marx or Marxism that Derrida wants to reaffirm involves what he calls (following Walter Benjamin) the "weak messianic force," or "the messianic and emancipatory promise as promise . . . and not as onto-theological or teleo-eschatological program or design."[33] Since in his selective affirmation of the debt to Marx, Derrida categorically dismisses the whole "concrete history of . . . the worldwide labor movement" as ontological, the emancipatory promise of the labor movement is to be fulfilled instead by justice: a carefully crafted yet abstract notion of justice without concrete content, a justice never "reducible," he insists, "to laws or rights," a justice of "absolute hospitality" and openness to the future (precisely the themes of much of his recent work).[34] And so, when Derrida defines the "New International" that also appears in his subtitle, it turns out to designate not some new form of political organization but "a link of affinity, suffering, and hope," "the friendship of an alliance without institution," whose main concern is the analysis (and reform?) of international law: "For above all, above all, one would have to analyze the present state of international law and of its institutions."[35]

Deleuze, by contrast, is not concerned with reaffirming any debts—not even selective or filtered ones. Nor is he interested in reassigning personal responsibilities and obligations. And, in line with Spinoza and Nietzsche, Deleuze would almost certainly view rights and laws as the mere residue or expression of relations of force and would want to focus on transforming those relations rather than on reforming the law. But more important—and this is a fundamental distinction between Deleuze and Derrida—the "emancipatory promise" of universal history for Deleuze lies not in moving "beyond exchange," but precisely in *preserving* exchange-value and the market as the potential for freedom inherent in decoding, while at the same time expunging the power component of capitalism, which severely limits the realization of that freedom. In order to understand why this is so, and how the economic component and the power component of capi-

talism interact, in Deleuze and Guattari's view, we must return to the process of axiomatization.

≡≡≡≡

According to Deleuze, decoding constitutes the positive moment of axiomatization, inasmuch as it frees repetition from the constraints and distortions of codification. One corollary for Deleuze of the immense productivity of capitalism—so admired by Marx—is that it frees practices from fixation in established codes. But the emancipatory decoding effects that stem from this economic component of capitalist society are always accompanied by opposing recoding effects that stem from its power component, which rebind freed libidinal energy onto factitious codes so as to extract and realize privately appropriable surplus-value. This opposition between decoding and recoding derives not so much from the classical, nineteenth-century contradiction between outright owners of capital and the dispossessed as from the contradiction between the generally socialized production of surplus-value, on one hand, and its private ownership and management, on the other. On the one hand, capitalism devotes itself to production as an end in itself, developing the productivity of socialized labor to the utmost, yet on the other hand, due to private investment in the means of production, social labor and life are restricted to regimes of production and consumption that valorize only the already existing capital-stock.

In the third volume of *Capital*, Marx outlines these two moments of capital's ongoing self-expansion: First, a wave of new, more productive capital-stock transforms the preexisting apparatuses of production and consumption; this "continual revolution of the means of production" that for Marx characterizes capitalism spawns decoding throughout society. But then this progressive movement is abruptly stopped and everything is recoded, with the evolving apparatuses of production and consumption alike tied down to what is now obsolete capital-stock solely in order to valorize it and realize a profit on previous investment.[36] A wave of decoding liberates all kinds of creative energies (in consumption as well as in production) at the same time that it revolutionizes and socializes productive forces; then recoding supervenes, yoking the relations of production and consumption to the deadweight of private-surplus appropriation.

Now, the ultimate goal projected by the logic of this analysis—a *logical* projection, not a historical one, not the *telos* of a teleology but something

that would have to be brought into existence by the intersection of a number of productive practices—would be to eliminate the power component, the moment of recoding, by bringing the socialization of the *appropriation* of surplus-value into line with the already existing socialization of its *production*. Absent the power component of private appropriation, decoding would proceed without being continually counteracted by recoding and would even, in all probability, accelerate; truly free-market conjunctions of decoded flows would replace the axiomatized conjunctions imposed by private capital via the power it wields through the market (but also through its command of the political process).[37] Economic value would be determined neither by socially necessary labor-time nor according to the requirements of private capital, but by the fluid dynamics of the market, which would in effect express the creative repetitions of productive practice. So much for the ultimate goal.

In the meantime—and nothing Deleuze says suggests that such a goal would be reachable soon (on the contrary[38])—the ongoing process of capital's self-expansion is bound to continue decoding and hence providing opportunities for productive practices, whether at the behest of capital itself or for a time outside or against its grain, until such practices either peter out on their own or an axiom is invented to capitalize on them by reintegrating them into the production–realization–appropriation circuits of surplus-value. In the short to medium term, then, it may be feasible to realize some of the freedom that the market makes possible, by surfing the waves of decoding generated via continuing technological revolutions and by trying to kick out of each wave before the inevitable moment of recoding sets in. (The image of surfing, incidentally, comes from Deleuze himself.[39]) In order to maximize impact, however, these would have to be group practices of transformation rather than merely individual "lines of flight" opened up by market decoding. But that's another topic altogether.[40]

⸻

For Deleuze, then, the "greatness of Marx" (apparently the working title of his book) would have included (among other things, no doubt) the discovery of the world-historical significance of the distinction between "the qualitative order of resemblances" and the "quantitative order of equivalences" as enemies of difference in repetition (the distinction, that is, between codification and axiomatization); for it was Marx who recognized

the potential for freedom in the latter and its importance for an ironic universal history, and who then brought the process of axiomatization to the point of self-criticism. How to compose or arrange productive practices so that their combined effect is to finally liquidate capital and realize the emancipatory potential of the market would be a question—and the challenge—that Deleuze left to us.

Notes

I would like to thank Ian Buchanan for inviting me to present an early version of this essay at the University of Western Australia in December 1996, and Fredric Jameson and Horst Ruthrof for their comments and suggestions.

1 Discussions of difference appeared in earlier works by these authors, of course; I single out Gilles Deleuze, *Difference and Repetition*, trans. Paul Patton (New York, 1994 [1968]); and Jacques Derrida, *Of Grammatology*, trans. Gayatri Chakravorty Spivak (Baltimore and London, 1976 [1967]), because they are in effect programmatic works of philosophy in their own right rather than studies devoted to others' works (however tenuous such a distinction may finally be). As Paul Patton puts it in his Translator's Preface: "*Difference and Repetition* is the first book in which Deleuze begins to write on his own behalf" (xi).

2 Jacques Derrida, *Specters of Marx: The State of the Debt, the Work of Mourning, and the New International*, trans. Peggy Kamuf (New York and London, 1994 [1993]). Both Derrida and Deleuze made more or less frequent reference to Marx before the 1990s, of course.

3 Before *Specters*, Derrida treated Marx or Marxism most extensively in *Positions*, trans. Alan Bass (Chicago, 1972); Michael Sprinker, "Politics and Friendship: An Interview with J. Derrida," in *The Althusserian Legacy*, ed. E. Ann Kaplan and Michael Sprinker (London, 1993), 183–231; and Jacques Derrida, "Text Read at Louis Althusser's Funeral," in *Althusserian Legacy*, 241–45. The key study of Derrida and Marx remains Michael Ryan, *Marxism and Deconstruction: A Critical Articulation* (Baltimore, 1982); but see also Gayatri Spivak's suggestive essay, "Speculations on Reading Marx: After Reading Derrida," in *Poststructuralism and the Question of History*, ed. Derek Attridge, Geoff Bennington, and Robert Young (Cambridge, 1987), 30–62.

4 Derrida, *Specters of Marx*, 47.

5 See the detailed analysis of Marx and Max Stirner (ibid., 120–47).

6 Karl Marx, *A Contribution to the Critique of Political Economy*, trans. N. I. Stone (Chicago, 1911 [1903]), 21; see also this comment from his *Grundrisse*, trans. M. Nicolaus (New York, 1973 [1939]): "Value excludes no use-value; i.e. includes no particular kind of consumption etc., of intercourse etc. as absolute condition" (541).

7 Derrida, *Specters of Marx*, 159.

8 Ibid., 170.

9 Ibid., 160.

10 Derrida has long been interested in the relations between these two kinds of "value" and acknowledges that his work has mostly involved the former: "In fact, *in fact and ap-*

parently, I am more concerned with language than with 'economic reality' itself. . . . I am not directly concerned with what one may call 'economic reality' in the strict and scientific sense (if that exists, independently and objectively)" (quoted in Sprinker, "Politics and Friendship," in Kaplan and Sprinker, eds., *Althusserian Legacy*, 222–23).

11 Derrida, *Specters of Marx*, 160.

12 Gilles Deleuze and Félix Guattari, *Anti-Oedipus: Capitalism and Schizophrenia*, trans. Robert Hurley, Mark Seem, and Helen R. Lane (Minneapolis, 1983 [1972]), 225.

13 Deleuze, *Difference and Repetition*, xix; translation modified.

14 Ibid., 40–41.

15 Another way to think of Deleuzian repetition is in relation to chaos theory, with order in nature not a matter of strict obedience to fixed laws, but of something fragile that emerges out of chaos; see Brian Massumi, *A User's Guide to Capitalism and Schizophrenia: Deviations from Deleuze and Guattari* (Cambridge, MA, and London, 1992).

16 Deleuze, *Difference and Repetition*, 1.

17 On the specificity of capitalist surplus-value as a differential surplus of flows rather than of codes, see Deleuze and Guattari, *Anti-Oedipus*, 226–38.

18 Ibid., 140; see also 224, 277, and 299. Deleuze and Guattari may be alluding to this passage from Marx's *Grundrisse*: "The Christian religion was able to be of assistance in reaching an objective understanding of earlier mythologies only when its own self-criticism had been accomplished to a certain degree. . . . Likewise, bourgeois economics arrived at an understanding of feudal, ancient, oriental economics only after the self-criticism of bourgeois society had begun" (106); but see also 104–8.

19 What little they do say involves rather obscure references to a "new earth" as a fourth socius to follow capital (the third); see Deleuze and Guattari, *Anti-Oedipus*, 321–22 and 382. But see also this remark: "Schizoanalysis as such does not raise the problem of the nature of the socius to come out of the revolution" (380).

20 This neologistic use of "de-ontology" has nothing to do with "deontic logic" or "deontological ethics" (from *deon*, duty, and *logia*, study: the study of duty), but refers to the conviction that an ontological stance is illegitimate yet almost unavoidable and must continually be undone.

21 See Michael Hardt, *Gilles Deleuze: An Apprenticeship in Philosophy* (Minneapolis, 1993). It should be noted that the confrontation with Hegel that Deleuze studiously avoided in his early work (the focus of Hardt's indispensable book) did eventually take place in *Difference and Repetition*.

22 Deleuze and Guattari, *Anti-Oedipus*, 25.

23 Michael Ryan (in a very different context) sees such a view as already implicit in Marx, whose concept of productive labor would "radically deconstruct the binary opposition between nature and history, nature and technology, in such a way that the development of an economy can no longer be conceived as an inevitable objective mechanism" (*Marxism and Deconstruction*, 93).

24 See Deleuze and Guattari, *Anti-Oedipus*, 226–27, 258–59, and 270–71; see also Marx, *Grundrisse*, 104–8.

25 See Deleuze and Guattari, *Anti-Oedipus*, 26–27.

26 The "discovery of the decoded . . . flows is the same . . . for political economy and in social production, in the form of subjective abstract labor, and for psychoanalysis and in desiring-production, in the form of subjective abstract libido. . . . In short, the discovery of an activity of production *in general and without distinction*, as it appears in capitalism, is the identical discovery of *both* political economy *and* psychoanalysis, beyond the determinate systems of representation" (ibid., 302). Moreover, the existence of the two determinate systems of representation is materially determined, according to Deleuze and Guattari, by the historical segregation of human reproduction from social production at large in the institution of the nuclear family (see ibid., 113–22 and 302–6 et passim).

27 "Emancipatory promise," for Deleuze and Guattari, is thus located in productive practice: "The identity of desire and labor is . . . the active utopia par excellence that designates the capitalist limit to be overcome through desiring-production" (ibid., 302).

28 Quoted in Sprinker, "Politics and Friendship," in Kaplan and Sprinker, eds., *Althusserian Legacy*, 191.

29 Derrida, *Specters of Marx*, 160.

30 See Jacques Derrida, *Given Time: I. Counterfeit Money*, trans. Peggy Kamuf (Chicago, 1992 [1991]), esp. 6–80.

31 Derrida, *Specters of Marx*, 51.

32 Ibid., 91–92.

33 Ibid., 55, 75.

34 Ibid., 89, xix, 168. Without offering any explanation of why it is all ontological, Derrida bluntly dismisses the labor movement in the following terms: "The deconstruction of Marxist ontology does not go after only a theoretico-speculative layer of the Marxist corpus but everything that articulates this corpus with the most concrete history of the apparatuses and strategies of the worldwide labor movement" (ibid., 88–89).

35 Ibid., 85, 86, 83. Based as it is on combining the premodern, preliberal social model of Mauss with the neo-existentialist ethics of Levinas, would it be unfair to say that the emancipatory promise of Derrida's Marx has been reduced to the ghost of a promise, namely, that we'll all take responsibility for one another, someday?

36 See Karl Marx, *Capital*, trans. E. Untermann (New York, 1967 [1867]), 3: 249–50; see also Marx, *Grundrisse*, 618–23, especially the following statement: "In one period the process appears as altogether fluid—the period of the maximum realization of capital; in another, a reaction to the first, the other moment asserts itself all the more forcibly—the period of the maximum devaluation of capital and congestion of the production process" (623).

37 It would be worth considering the relation between Deleuze and Guattari's perspective on the market and that of Fernand Braudel (especially his notions of markets and antimarkets); see his *Capitalism and Material Life, 1400–1800*, trans. M. Kocham (New York, 1973 [1967]).

38 Deleuze seems less sanguine about the prospects for any immediate, radical social transformation in his later works. See Gilles Deleuze and Félix Guattari, *A Thousand Plateaus: Capitalism and Schizophrenia*, trans. Brian Massumi (Minneapolis, 1987 [1980]); and Gilles Deleuze, "Postscript on the Societies of Control," in *Negotiations 1972–1990*, trans. Martin Joughin (New York, 1995 [1990]), 177–82.

39 On bodysurfing, see Deleuze, *Difference and Repetition*, 23; on surfing and windsurfing, see Deleuze, "Mediators," in *Negotiations*, 121–34, esp. 121.

40 This notion may be similar to Hakim Bey's "Temporary Autonomous Zones"; see *T.A.Z.: The Temporary Autonomous Zone, Ontological Anarchy, Poetic Terrorism* (New York, 1991 [1985]). The "Temporary Autonomous Zone," however, does not necessarily require (as far as I can tell) a "material" support, such as the technology waves alluded to here.

Straining to Hear (Deleuze) Tessa Dwyer

Early in 1995, I passed a flyer advertising an upcoming
conference on "A Century of Cinema: Australian and French Connec-
tions."[1] My interest was caught by the number of papers on Gilles Deleuze
featured in the program. On attending the conference, I was interested to
note what I now regard as a particularly prevalent phenomenon within
contemporary film studies: the practice of identifying specific films as
either good or bad exemplars, that is, according to how well they "fit"
something else. In terms of Deleuze's project, one film may be considered
inspirational, while another may prove ultimately unable to realize the
radical potential of his reconceptual philosophy. Regardless of their nega-
tive or positive judgments on specific films, such analyses position film
itself as illustration, reducing the diversity of its signification to a fixed
image—static, silent, one-dimensional—a "still." Meaning is approached as
though it were a stable essence rather than an active field of contestation.

Stop. I start, instead, with a stop. My discussion here of Hong Kong (HK) action films has begun by referring to a type of theoretical practice that I am at pains to avoid—to *stop.* What I do not want to produce is a reading of HK action films on the basis of a particular theoretical model, such as that proposed by Deleuze in his two-volume *Cinema.*[2] I am interested neither in determining how Deleuze himself might have read the HK action film (by sifting through his scattered and quite general references to the "karate film" or the "third world film-maker") nor in judging how well these films fit, or may be manipulated in terms of, a Deleuzian trajectory (by claiming that certain films provide illustrations of Deleuzian concepts or meet specific Deleuzian criteria). To do so would be to assume a natural, unproblematized passage from the filmic to the theoretical, and vice versa, to posit translation as an ultimately one-way process. Such objectives run counter to the type of philosophical project under construction throughout Deleuze's two *Cinema* books.

In starting with a stopping-motion—a motion to stop certain practices in order to enable others to be activated—I immediately begin to borrow from Deleuze, to position myself within a decidedly Deleuzian framework. In professing his commitment to the interval, the gap, the "and," and the "in-between," Deleuze effectively stops film theory in its tracks. By effecting this pause, he actually produces a change in direction, a navigational maneuver. This is how I understand Deleuze: in stops and starts, through his various stagings of the stop and the start. To start with a stop is to posit the indistinguishability of these two actions, reconfiguring such modalities as interventions of the in-between, as pauses—moments of temporary stasis that are thoroughly invested in future-past scenarios of activity. Stopping does not put an end to movement, but rather causes its radicalization, its aberration. "The interval designates the point at which movement stops and in stopping gains the power to go into reverse, accelerate, slow down."[3] Approaching Deleuze in terms of such activity makes it possible to investigate his writings at the level of their production—their methodology—intervening within their space of construction.

I am interested in the way in which movement is *virtually* present within points of stasis, in how, with stopping and starting, activity becomes virtual (anticipated, implied, recalled). Movement and stasis, the actual and

Figure 1. *Strike* (1924), dir. Sergei Eisenstein.

the virtual, collide and crystallize in Deleuze's texts as he traces the radicality of such processes, configured as instances of becoming: the actual *becoming*-virtual, the virtual *becoming*-actual. Within his cinema project, the virtual image and the actual image form a circuit; they "run after each other and each is reflected in the other."[4] By both constructing and collapsing the lines of distinction between actual and virtual, movement and time, action and stasis, Deleuze seeks to engage the radically hybrid nature of film theory, identifying it as a discourse of translation that must continually traverse two unlike terms or modes: the filmic and the theoretical. But how are such operations of translation affected when the texts themselves remain "in-translation"? Where does the HK action film figure within such relations? How does it "pause" the translation of film into theory, calling for time-out, for a moment of respite in which to stop, look around, rethink one's present surroundings, and plan future directives? How is translation staged, and in what language? What gets lost in translation? How might we begin to consider translations "of or between cultures"?[5]

Figure 2. *The Killer* (1989), dir. John Woo.

Figure 1. Produced through various stopping devices, my discussion re-
volves around three stills, or pauses, the first of which introduces the par-
ticular method of film-reading that operates within the Deleuzian text.[6]
In *A Thousand Plateaus*, Deleuze and Guattari's discussion of smooth and
striated space introduces their notion of *holey space*, which, they claim,
communicates between the two. They illustrate this notion with a scene,
and a still, from a 1924 Eisenstein film: "An image from the film *Strike*
presents a holey space where a disturbing group of people are rising, each
emerging from his or her hole as if from a field mined in all directions."[7]
(The image itself is simply captioned "Holey Space.") Deleuze's *Cinema*
books, by contrast, contain no images and, in particular, no film stills. They
thereby push the notion of a film reading to its limit. The representation
of "holey space" featured in *A Thousand Plateaus*, however, may be read as
an illustration of the particular manner in which Deleuze approaches the
relationship between image and text, film and theory.

PULP DICTION

From a list of English subtitles used in films made in Hong Kong, compiled by Stefan Hammond and Mike Wilkins for their book Sex and Zen & a Bullet in the Head, *to be published in August by Fireside.*

I am damn unsatisfied to be killed in this way.

Fatty, you with your thick face have hurt my instep.

Gun wounds again?

Same old rules: no eyes, no groin.

A normal person wouldn't steal pituitaries.

Damn, I'll burn you into a BBQ chicken!

Take my advice, or I'll spank you without pants.

Who gave you the nerve to get killed here?

Quiet or I'll blow your throat up.

You always use violence. I should've ordered glutinous rice chicken.

I'll fire aimlessly if you don't come out!

You daring lousy guy.

Beat him out of recognizable shape!

I have been scared shitless too much lately.

I got knife scars more than the number of your leg's hair!

Beware! Your bones are going to be disconnected.

How can you use my intestines as a gift?

The bullets inside are very hot. Why do I feel so cold?

Figure 3. "Pulp Diction." Reprinted with permission from *Sex and Zen & A Bullet in the Head* by Stefan Hammond and Mike Wilkins. Copyright © 1996 by Stefan Hammond and Mike Wilkins. Published by Simon & Schuster Fireside, 1996. All rights reserved.

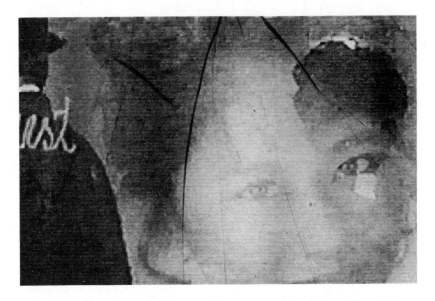

Figure 4. *The Killer* (video, 1991). Reproduced by permission of Level Four Films, Melbourne, Australia.

Figure 2. My second image—a publicity still from *The Killer*, a 1989 HK feature written and directed by John Woo—has already appeared in a recent issue of *Film Quarterly*.[8] I have also seen it reproduced on the Net and in *Sex and Zen & A Bullet in the Head*.[9] This image is instructive in terms of a prevalent methodology within contemporary film theory, that is, the use of the still as the primary means by which a film is positioned relative to text and translated within the pages of theory. With the film still posited as illustration, interpretation is projected *onto* the site of cinematic production and a certain level of filmic specificity is thereby denied.

Figures 3 and 4. Images that approach still-ness from a different angle, being at once active and static, interrupt our reading and interpretation of a film, producing moments of illiteracy and dysfunction.[10] I suggest, however, that when translated into a predominantly Western theoretical context the HK action film holds its ground through its characteristically illegible subtitles, regarded by some English-speaking viewers as offering

an occasion for "uproarious" fun.[11] The subtitle shifts the focus, directing our attention toward the bottom of the screen and forcing us to attend to distinction, differentiation, and disjunction—to the operations of translation. Similarly, the phenomenon of "films-on-video" has crucially affected the way in which the HK action film enters and entertains the West.[12] I am particularly interested in the possibilities of temporal manipulation afforded by the "pause" function of the video cassette recorder (VCR). By engaging the HK action film through the processes and practices of video recording and subtitling, we can extend Deleuze's notion of translation, specifically, in reference to this genre's Western reception and circulation.

━━━━
━━━━

Holey space. Deleuze stages his philosophical intervention into film theory with his two-volume *Cinema*, taking the integral unit of this discipline, the film reading, as both beginning and end. He inundates us with references to films, film directors, and film genres, yet Deleuze remains conventional in more than just this sense: on closer inspection, his focus becomes clearer, namely, European and American auteurs. As he himself said in reference to *The Movement-Image*, "I don't, first of all, claim to have discovered anyone, and all the *auteurs* I cite are well-known people I really admire."[13] Eisenstein, one of a long list of such admired auteurs, forms part of a canon that Deleuze's texts cannot help but perpetuate. In basing his discussion of cinema on the figure of the auteur, he constructs a particularly traditional and self-referential framework.[14] The manner in which Deleuze positions himself within the confines of a particular disciplinary domain—philosophy, psychoanalysis, literary criticism, art history, or film theory—suggests that he posits convention, structure, and staticity as modes of actualization that enter into complex relations with the radical activity of the virtual.

Deleuze's *Cinema* books expose the untenability of the notion that film can be read rather than seen, watched, or heard. He warns against the assumption that film can be subjected to modes of theoretical interpretation from other domains. "Film criticism faces twin dangers: it shouldn't just describe films but nor should it apply to them concepts taken from outside film." Linguistics, for example, "provides only concepts applicable to cinema from outside, the 'syntagm' for instance. But that immediately reduces the cinematic image to an utterance, and its essential characteristic, its motion, is left out of consideration. . . . It's not to psychoanalysis or lin-

Figure 1. *Strike* (1924), dir. Sergei Eisenstein.

guistics but to the biology of the brain that we should look for principles, because it doesn't have the drawback, like the other two disciplines, of applying ready-made concepts."[15] Deleuze's film readings thus situate (and complicate) themselves within the discourse and practice of translation. He stresses the need to register differences in language so that the authoritative voice of theory does not subsume that of film. Rather, he strives to preserve the filmic as a vital energy within his own discourse, unfettered by the staticity of the written word, by the articulation of textual fixtures and theoretical concepts, structures, or frameworks. In remaining attentive to the radical activity of film, Deleuze emphasizes the gap (or interval) between film and theory. In this sense, his *Cinema* books do not engage filmic signification, but rather interrogate conditions of nonengagement and incompatibility, thereby theorizing the specificity of that gap.

In *Bergsonism*, Deleuze suggests that actualization constitutes a process of differentiation, divergence, and creation: "The actual . . . does *not* resemble the virtuality that it embodies. It is difference that is primary in the

process of actualization."[16] The relationship between a virtual image that is in the process of being actualized and an actual image that is forming its own virtual image is, for Deleuze, the essence of the circuitous crystallizations of movement and time effected through cinematic production. The actual and the virtual enter into a relation of translation; since they do not approximate one another, they cannot be substituted for one another. Deleuze suggests the need to approach film indirectly, in terms of the virtual, not through description and definition ("filmic movement *is* . . .") but from behind, from an elsewhere, out-of-field.[17] As Roland Barthes suggests, the filmic can only be glimpsed "over the shoulder."[18] It is at its points of stasis and structure—in lighting effects, shots, and edits—that film's mobility radically persists in virtual form.

At first glance, this interpretation appears somewhat at odds with Deleuze's stated thesis regarding the essential (though inherently unstable) distinction between movement and time, for his reconfiguration of cinema seems to be premised upon the sweeping assertion that film criticism has repeatedly emphasized movement over and above time. In constructing time and movement as oppositional terms, Deleuze invests the signifier of time with connotations of stagnancy, immobility, and pause. With respect to movement, however, we might be better off looking not at what *Cinema* says but at what it *does*—the movement it intends to effect or produce. By interpreting Deleuze's texts at the level of their surface rather than their hermeneutic depth, we may find a way into the interior, where we can access the content of his thought. The path thereby traced will constitute a reassessment—a rereading and reinterpretation—of Deleuze's words as the building-blocks of his textual formations.

As an example of his reading/writing style, chapter 7 of *The Time-Image* ("Thought and Cinema") reflects Deleuze's project as a whole, specifically, the way in which his concept of the Whole is predicated upon division, not least in the twofold nature of his two-volume *Cinema*. In moving from the first volume to the second, Deleuze returns to the interstice or in-between effected through movement, circuitous progression and regression, translation.

This chapter of *The Time-Image* opens with Eisenstein, moves on to Artaud, and ends with Godard. In discussing Eisenstein's theories and techniques of montage, Deleuze emphasizes the importance of the shock, which "has an effect on the spirit, it forces it to think, and to think the

Whole." Then, shifting abruptly to Artaud's "cinema of cruelty" and introducing the notion of the "unthought," Deleuze effectively undoes Eisenstein's theory of montage without ever explicitly stating such an intention. What cinema advances for Artaud, says Deleuze, "is not the power of thought but its 'impower.'" The unthought concerns the fossilization of thought, the powerlessness to think that lies at the heart of thought. The Whole cannot simply be thought, as Eisenstein contended, but rather needs to relate to the unthought, leading Deleuze to conclude that belief in the impossible is what "makes the unthought the specific power of thought."[19] Finally, with Godard, Deleuze returns to a belief in the Whole, the same Whole that Eisenstein sought to engage through the shock effects of montage editing: "The cuts or breaks in cinema have always formed the power of the continuous." The chapter then ends with the suggestion that Godard's cinema of disjointed narrative and disrupted dialogue leaves us "with only a belief in this world."[20] Here, Deleuze has traced a circuitous route that brings him (and the reader) full circle. I interpret this redoubling as the life force that animates Deleuze's cinema project—a movement as significant as the actual words upon which it hinges.

The progression effected in the transition from *The Movement-Image* to *The Time-Image* is an uneasy and difficult one. It is not that the second volume presents a radically different or more challenging text, but rather that it *re*-presents more of the same. *The Time-Image*, as the sequel to *The Movement-Image*, claims the ending as the site of a new beginning. *The Movement-Image* ends with the words "beyond movement," and it is this very "beyond" with which *The Time-Image* is ostensibly engaged. What happens, however, when you reach the end of the sequel? As contemporary blockbuster cinema makes clear, you wait for the next installment, learning never to trust the logic that endings necessarily signify closure.[21] Having reached the end of *The Time-Image*, does one feel that Deleuze has arrived at or in any way engaged this notion of the "beyond" inscribed in *Cinema*? Perhaps not. By the time we reach the "pure direct time-image," we are far from being *beyond* movement, but are rather *within* its radical inside. We are returned to the movement-image itself. It is this space of progression and regression, of relay and return, which needs to be emphasized, precisely this staging of an interstitial movement.

The gap that opens as one closes *The Movement-Image* and turns to *The Time-Image* is the gesture upon which Deleuze's film theory rests, that is,

the stop-and-start action. In a sense, *Cinema* itself becomes the by-product of the interval between its two volumes. In *The Time-Image*, Deleuze calls for a "method of BETWEEN, 'between two images,' . . . the method of AND, 'this and then that.'"[22] Elsewhere, he refers to the "AND" as a "creative stammering, the foreign use of language."[23] His words thus become both relevant and irrelevant, productive and dysfunctional. They are invested with a new materiality and a certain wastefulness. This feeling of waste is necessary. It belongs to the materiality and life span of the structural unit which Deleuze identifies as integral to thought, language, and knowledge production. Structure depends on unnecessary production; lines of flight are predicated upon instances of stagnancy and sedentary pauses.[24]

Deleuze's film readings articulate this very translative tension between the actual and the virtual, movement and stasis, film and theory. According to my calculations, in the seventh chapter of *The Time-Image*, Deleuze cites 45 films, 36 directors, 11 philosophers, 6 theorists, 4 painters, 3 authors, and one mathematician. These 45 films are further broken down into scenes, shot sequences, and sound or lighting effects. Deleuze's readers are subjected to one film reference after another in a manner that appears quite deliberately exhausting. Even those exceptionally film-literate readers who have seen every film listed could not possibly be familiar with all the different scenes, shots, and lighting effects that Deleuze details. It is exactly in this sense that these references become significant. In becoming unreadable, that is, nonmeaningful, these citations function as punctuation rather than as text, marking pauses within the dense theoretical framework under construction. They yield a type of "holey space."

The manner in which Deleuze treats the films of various auteurs is, more often than not, frustratingly brief, cursory, unelaborated, and inaccessible. In *The Movement-Image*, he inserts bracketed film references at the end of complex theoretical discussions, thus formally rendering their disjunction from the rest of the text. Often, these brackets simply contain a list of film titles and/or directors.[25] Personally, I find these references most effective when I am unfamiliar with the film in question, when I can let Deleuze's words wash over me, momentarily relieved of the often unrewarding task of constructing meaning. To view the film reading as a punctuating interval is to engage with what it enacts as well as what it has to say. As I have already mentioned, *Cinema* contains no images, unlike other works such as *A Thousand Plateaus*.[26] This exclusion accentuates a

Figure 2. *The Killer* (1989), dir. John Woo.

thematic of illustration all the more. It constitutes a dramatic device that stages (and continues to rehearse) lines of differentiation between image and text, viewing and reading, film and theory.

Mickey Mouse and Dumbo. According to Jillian Sandell, "The final scenes of *The Killer* perfectly exemplify Steve Neale's argument concerning the importance of spectacle within male action films." Sandell reads in Woo's films nostalgia "for a time when male intimacy was a celebrated and valorized aspect of masculinity."[27] A still from *The Killer* (see Figure 2) inserted into her text functions as an illustration of an illustration and reveals how the film itself can be used to illustrate or exemplify a particular argument (in this case, both Neale's and Sandell's).[28] I regard this type of reading as the norm or dominant paradigm within contemporary film theory, which, in seeking to discover or interpret the meaning of a particular film, effectively denies its radical indeterminacy.

In this still, *The Killer*'s two central protagonists hold each other at gunpoint, eyes and arms locked in a moment of suspense, or pause. Killer

(Jeff) and cop (Inspector Li) come face to face for the first time in the apartment of the killer's blind girlfriend, Jenny. The stalemate produces a sense of hesitation, an interval in which reflection becomes possible. Killer and cop recognize themselves in one another, and, in an act of empathy and compassion, form an alliance to relieve Jenny's distress. Wishing to mask the potential danger of the situation into which they have been drawn, killer and cop create playful tags for one another. In order to convince Jenny that they are friends, they refer to each other as "Mickey Mouse" and "Dumbo." As Steve Rubio notes, these nicknames are an invention of the translator/subtitler, intended to approximate for a Western audience the cultural familiarity of the original Chinese nicknames.[29] These Disney-character names register the manner in which translation operates via various out-of-fields—virtual points of contact "behind the scenes" or "out-of-frame."

Although Rubio identifies Mickey Mouse and Dumbo merely as nicknames "which the subtitles have given to the two primary heroes," they also relate to the dubbing process. Prior to May 1994, when a subtitled version was released under the UK label "Made in Hong Kong," the only available English-language video of *The Killer* was in fact dubbed.[30] This distinction between a subtitled print and a dubbed soundtrack illustrates the effects of intercultural translation. In this case, with dubbing an audio rather than a visual technique, the effect is of translation not seen but heard. In other words, making translation audible rather than visible "silences" the subtext of the subtitle. Moreover, while the subtitle is necessarily subordinated to the image, dubbing amounts to an overlay and erasure. This is not to say, however, that dubbing and subtitling *oppose* one another; rather, their proximity establishes a relation of *apposition*. Meaning is modified and qualified. By accentuating sound, dubbing suggests the need to listen— not to what is being said but to what remains unspoken, to *disarticulation* and to *silent communication*.

According to Barthes, the essence of film is precisely that which cannot be articulated by any other means, "that in the film which cannot be described, the representation which cannot be represented."[31] For Barthes, film theory cannot engage film without *listening* to the filmic, a practice that he regards as "a veritable mutation of reading." The subtitle adds a new dimension to this listening/reading relation, further qualifying Barthes's notions of cultural differentiation and "distanciation." Tracing the subtle-

ties of translation as a discursive mode that pulls in different directions, the subtitle seems to belong to the language of both original and copy— and to neither one. In seeking to translate the foreign into the familiar, the subtitle effects a deterritorialization, one that makes the self sound other. In Deleuze and Guattari's terms, it effects the "becoming-minor" of language and the written.[32] The language of the other persists in a virtual relation with the actual language being articulated. With such lines as "I am damn unsatisfied to be killed in this way" or "It's hard for me to tolerate such bitch," difference becomes audible precisely through the unspoken, the unrepresented or unrepresentable, the virtual.[33] By analyzing the technicalities of an actual intercultural translation, we can put a film still, such as this one from *The Killer*, in motion, exposing "Mickey Mouse and Dumbo" as an image that is still "in-translation," in the process of being- (or becoming-)comprehended.

═══════

Pulp diction. By pausing on the image or text of the subtitle, this discussion has ground to a halt, rebounding from a certain, impenetrable surface quality. The surface is, I contend, the only point at which the HK action film becomes available to a Western audience. But how is such availability posited and effected? And how do certain texts become accessible despite points of untranslatability and illegibility? The surface marks an intersection for patterns of reception and patterns of production, yielding meanings that are contingent, conditioned by location and contextualization. The subtitle intimates one way in which the HK action film might begin to speak for itself, overlaying its Western theoretical interpellation. Despite their apparent user-friendliness and purported aim of enhancing a film's availability and accessibility, translated subtitles are almost always potential agents of ambiguity (see Figure 3).

HK action films expose translation as a process that is ongoing, occurring in a continuous present that never becomes the past. Their subtitles constitute a site of slippage, of error and excess, that shows how translation can go wrong, can even work to *unwork* itself. In this sense, the HK kung-fu genre resists translation, refusing to translate "well" in terms of the conventional measures of transparency and inaudibility. In stark contrast, HK action films "in translation" can be heard, felt, or otherwise noticed at every grating step. Their postproduction translations consistently produce

PULP DICTION

From a list of English subtitles used in films made in Hong Kong, compiled by Stefan Hammond and Mike Wilkins for their book Sex and Zen & a Bullet in the Head, *to be published in August by Fireside.*

I am damn unsatisfied to be killed in this way.
Fatty, you with your thick face have hurt my
 instep.
Gun wounds again?
Same old rules: no eyes, no groin.
A normal person wouldn't steal pituitaries.
Damn, I'll burn you into a BBQ chicken!
Take my advice, or I'll spank you without pants.
Who gave you the nerve to get killed here?
Quiet or I'll blow your throat up.
You always use violence. I should've ordered
 glutinous rice chicken.
I'll fire aimlessly if you don't come out!
You daring lousy guy.
Beat him out of recognizable shape!
I have been scared shitless too much lately.
I got knife scars more than the number of your
 leg's hair!
Beware! Your bones are going to be dis-
 connected.
How can you use my intestines as a gift?
The bullets inside are very hot. Why do I feel
 so cold?

Figure 3. "Pulp Diction." Reprinted with permission from *Sex and Zen & A Bullet in the Head* by Stefan Hammond and Mike Wilkins. Copyright © 1996 by Stefan Hammond and Mike Wilkins. Published by Simon & Schuster Fireside, 1996. All rights reserved.

miswording, misspelling, mistiming, and a degree of miscomprehension that amounts to misprision—all of which nonetheless suggests new opportunities for meaning construction. The "bad translation" that we find in the HK action film signals a certain untranslatability of meaning, an un(trans)mutability of difference. In this sense, as sites of unforeseen productivity, "bad translations" inscribe lines of disarticulation that need to be recognized as strategic for the reconceptual programs of both the postmodern and the postcolonial.[34]

Focusing on instances of unsuccessful translation makes us attentive to emergent gaps in meaning.[35] These voids or moments of dysfunctionality indicate differences that are being preserved rather than elided, differences that can be heard. When distinct texts and contexts are made to work against each other, their disparity becomes active, productive, effective. "Bad" subtitling linguistically registers cultural and generational differences, allowing us to hear, sense, or intuit the clashes and collisions that occur between different modes and levels of signification—between images and texts, producers and receivers—yielding messages that aren't received, images that refuse to speak, words that become unintelligible. Within such a context, "reading between the lines" assumes a renewed significance as both practical measure and subversive act.

≡≡≡

Pause. Video constitutes a sublimated genre within current film theory. Its various push-button controls (rewind, fast-forward, pause, and still-advance) perform a crucial role in the subjectification of film, that is, the process by which film is made an object of study. With the aid of video-recording technologies, the cinematic experience can be dissected, repeated in slow motion, or advanced shot by shot. In this way, video serves a largely translative function, providing filmic texts with new, "improved" formats that are practical and easy to handle, accessible and readily amenable to manipulation. Video's prevalence within academic or institutionalized film studies rarely involves an engagement with production techniques or conditions of reception. Rather, video becomes invisibly positioned *in-between* movie theater and lecture hall, library and living room.

In the case of HK action films, video technologies affect the manner in which they enter and are viewed in Western sociocultural contexts. The

Figure 4. *The Killer* (video, 1991). Reproduced by permission of Level Four Films, Melbourne, Australia.

HK action film's ready assimilation into video culture, both mainstream and marginal, is an important factor in its intercultural transportation and translation (see Figure 4).

Through the modality of the pause, the HK action film can shift contexts and be either deterritorialized or reterritorialized. The video pause function has a particular effect on the translation (temporal, technical, textual, etc.) of a film in terms of the act of reception and the various degrees of (remote) control attendant to this act. Producing a different view of the filmic, the pause remains necessarily distinct from film itself. It holds film in a moment of suspense, of isolation and analysis, whether to be reflected upon or simply to reflect, flat and surfacelike. This surface quality plays a primary role within intercultural translation, where difference is read and apprehended in terms of its face value. The shimmering, illusionary texture of the surface returns the critical gaze with a blank stare, giving nothing away.

≡≡≡≡≡

Restart. The HK action film cannot simply be read as a theoretical practice, for it effectively disorients the terms by which reading and interpretation proceed. In this investigation of video pragmatics and ineffective subtitling, film theory has been reconceived as a form of "surface-" or "speed-reading." The effort to gain a practical level of intelligibility has produced a discourse replete with holes. Deleuzian film theory accentuates the instrumentality of such a "holey space," producing problematic film readings that remain attentive to instances of incompatibility, to gaps of meaning opened up by radical differences in kind. Deleuze's *Cinema* texts do not merely speak; they listen. Straining to hear, they seek to engage a language that is neither verbal nor textual but unactualized, inarticulate. How is the filmic to be translated?

Translation constitutes a process of meaning construction that is active, on the move, presently under construction. With translation, signification remains mobile and multidirectional. In this sense, it extends beyond the realm of the actual. It cannot be pinned down or affixed to a stable point of reference, but rather occurs, or intervenes, within a space that may be termed "in-between." By stressing points of interval rather than stasis, accentuating modes of translation over interpretation, we can reconfigure the film still as pause or interruption, disarticulated and incomplete. Stopping occurs midway between action and stasis, and thus remains invested in a dynamic of movement. Press *pause* on a VCR and the image freezes. Press *pause* again and movement restarts—activity is activated.

Notes

1 Organized by the Departments of French and Italian Studies, University of Melbourne, in April 1995. Selected proceedings of this conference have recently been published as *A Century of Cinema: Australian and French Connections*, ed. Jane Warren, Colin Nettelbeck, and Kirsop Wallace (Melbourne, 1996).

2 Gilles Deleuze, *Cinema 1: The Movement-Image*, trans. Hugh Tomlinson and Barbara Habberjam (Minneapolis, 1986 [1983]); and *Cinema 2: The Time-Image*, trans. Hugh Tomlinson and Robert Galeta (Minneapolis, 1989 [1985]).

3 Deleuze, *The Movement-Image*, 83.

4 Deleuze, *The Time-Image*, 54.

5 Rey Chow, *Primitive Passions: Visuality, Sexuality, Ethnography, and Contemporary Chinese Cinema* (New York, 1995), 197.

6 Gilles Deleuze and Félix Guattari, "1227: Treatise on Nomadology—The War Machine," *A Thousand Plateaus: Capitalism and Schizophrenia*, trans. Brian Massumi (Minneapolis 1987 [1980]), 351–423; figure on 414.

7 Ibid., 413–14.

8 Jillian Sandell, "Reinventing Masculinity: The Spectacle of Male Intimacy in the Films of John Woo," *Film Quarterly* 49 (1996): 23–34; figure on 25.

9 Stefan Hammond and Mike Wilkins, *Sex and Zen & A Bullet in the Head: The Essential Guide to Hong Kong's Mind-Bending Films* (New York, 1996), 43.

10 Figure 3, a paused still from the video of *The Killer* produced and distributed in Australia by Level Four Films, was reproduced by means of Microsoft's Premier program. Figure 4 appeared in *Harper's Magazine* (June 1996): 23.

11 See, for example, John Powers, "Glimpse Eastward," *Film Comment* 24 (1988): 35–38, esp. 35.

12 The emergence of this hyphenated term has identified a hybrid viewing scenario as a subgenre in its own right; see David Ehrenstein, "Film in the Age of Video: 'Oh, We Don't Know Where We're Going But We're On Our Way,'" *Film Quarterly* 49 (1996): 38–42.

13 Gilles Deleuze, "On *The Movement-Image*," in *Negotiations, 1972–1990*, trans. Martin Joughin (New York, 1995 [1990]), 46–56; quotation from 50.

14 According to Laura U. Marks, Deleuze's "fascination with auteur cinema . . . inhibit[s] the productive line of his thought." See her detailed discussion of "experimental diasporan cinema," in which she aims to contrast autobiography and auteurism, in "A Deleuzian Politics of Hybrid Cinema," *Screen* 35 (1994): 244–64.

15 Gilles Deleuze, "On *The Time-Image*," in *Negotiations*, 57–61; quotations from 57, 59, 60.

16 Gilles Deleuze, *Bergsonism*, trans. Hugh Tomlinson and Barbara Habberjam (New York, 1988 [1966]), 97.

17 Deleuze notes in *The Time-Image* that each time "description has obliterated the object, . . . the mental image has created a different one" (46).

18 Roland Barthes, "The Third Meaning, or, Research Notes on Some Eisenstein Stills," in *Image–Music–Text*, trans. Stephen Heath (London, 1977): "If you look at the images I am discussing, you can see this meaning 'over the shoulder' or 'on the back' of articulated language" (61).

19 Deleuze, *The Time-Image*, 158, 166, 170.

20 Ibid., 181, 188.

21 I have recently heard a rumor that Deleuze completed a third volume of *Cinema*, which has yet to be released. Death poses no barrier to the self-generatory life span of the serial.

22 Deleuze, *The Time-Image*, 180.

23 Gilles Deleuze, "Three Questions about *Six fois deux*" (1976), trans. Rachel Bowlby, in *Jean-Luc Godard: Son + Image 1974–1991*, ed. Raymond Bellour and Mary Lea Bandy (New York, 1992), 35–41. "The AND not only rocks all relations, it rocks being, the verb, and so on. The AND, 'and . . . and . . . and,' is exactly the creative stammering, the foreign use of language, as opposed to its conforming and dominant use, based on the verb 'to be.' . . . The AND is diversity, multiplicity, the destruction of identities" (40).

24 As Deleuze and Guattari note in *A Thousand Plateaus*: "It would be oversimplifying to say that flight is a reaction against the order-word; rather, it is included in it, as its other face in a complex assemblage, its other component" (107).

25 See, for example, Deleuze's discussion of the French New Wave, in *The Movement-Image*, 213.

26 In an interview, Deleuze makes much of the fact that *A Thousand Plateaus* is an "illustrated book." That each of its chapter titles includes a date is, according to Deleuze, intimately related to the fact that each chapter is also headed by an image, an illustration. Together, the date, illustration, and title signify lines of actualization or events that concern immanent becomings; see Deleuze, "On *A Thousand Plateaus*," in *Negotiations*, 25–34, esp. 26.

27 Sandell, "Reinventing Masculinity," 27.

28 Sandell's emphasis on nostalgia reflects a particularly common interpretation of this genre among contemporary film critics. Cf. Rey Chow, "A Souvenir of Love," *Modern Chinese Literature* 7 (1993): 59–76; and Ackbar Abbas, "The New Hong Kong Cinema and the *Déjà Disparu*," *Discourse* 16 (1994): 65–77.

29 Steven Rubio, "The Meaning of Chow (It's In His Mouth)," *Bad Subjects*, No. 13 (April 1994); http://english-www.hss.cmu.edu/BS/13/Rubio-Sandell.html.

30 The Australian television network SBS recently screened an in-house subtitled version of *The Killer* in which "Shrimp" replaces "Mickey Mouse."

31 Barthes, "The Third Meaning," 64.

32 On the notion of "becoming-minor," see Deleuze and Guattari, *A Thousand Plateaus*; and Gilles Deleuze and Félix Guattari, *Kafka: Toward a Minor Literature*, trans. Dana Polan (Minneapolis, 1986 [1975]).

33 See Hammond and Wilkins, *Sex and Zen & A Bullet in the Head*, 196.

34 Hamid Naficy's account of various subtitling, inter-titling, and dubbing practices relative to the reception of Western films in Iran provides a particularly valuable insight into such potential; see his "Theorizing 'Third-World' Film Spectatorship," *Wide Angle* 18 (1996): 3–26.

35 Kwai-Cheung Lo, remarking on the disjointed effects produced by subtitles, says about the films of HK director Tsui Hark: "Normally people need to see his films twice, once to watch the images and once to read the subtitles and follow the story"; see his "*Once Upon A Time*: Technology Comes to Presence in China," *Modern Chinese Literature* 7 (1993): 79–96, esp. 88.

Deleuze and the Body: Eluding Kafka's
"Little Death Sentence" Horst Ruthrof

Gilles Deleuze has made a major contribution to the cri-
tique of conceptuality. Yet unlike Derrida, who treats concepts as formal
and so rejects the very notion of their fitness for describing the significatory
relations of writing, Deleuze retains part of Husserl's eidetic approach.
This places the concept in close proximity to formal definition, even if
Deleuze carefully distinguishes his concepts from propositions and so
avoids the equivocation of formal- and natural-language sense found in the
Fregean analytic tradition. Deleuze also maintains Kant's distinction be-
tween the stipulated concepts of logic and empirical concepts as well as
philosophical, speculative concepts, which, as Kant says, have no "secure
boundaries" and the "analysis" of which "is never complete."[1] Yet we can-
not help but note a certain tension between the formalism of Deleuze's
earlier works and its radical critique in the writings he coauthored with Félix
Guattari. Such antistructuralist terms as "rhizome," "becoming-animal,"
"becoming-crystalline," "desiring-machine," "minor language," "nomadism,"
"body without organs," "deterritorialization," and "order-word" paradoxi-

cally inspire our theorizing while resisting any ready reconciliation with the rigorous apparatus of Deleuze's "logic of sense" and even with certain hidden conceptual ground rules that shine through in *A Thousand Plateaus* and *What Is Philosophy?*.

Tracing some of these quasi-formal rules may enable us to liberate Deleuze's synesthetic concepts from the dominance of his syneidetic commitments. If we wish to elude Kafka's "little death sentence,"[2] as Deleuze and Guattari put it, the retention of any kind of idealized sense must prove detrimental to the sort of description of language they have in mind. Although Deleuzian scholars will be able to test my claims against their more comprehensive reading of the Deleuze/Guattari corpus, their very closeness to the "real" Deleuze also tends to produce a more homogeneous theoretical mapping than is warranted in the face of such questions as the following: How are the *mots d'ordre* able to fulfill their task in Deleuze's semantic politics, and how do they fit into his pragmatics? What is an asignifying sign, and how do signs relate to Deleuze and Guattari's "amorphous atmospheric continuum"? How does Deleuze proceed from empirical corporeality to the incorporeality and absoluteness of the concept? Does this idealization serve the triadic analysis of science, art, and philosophy?

At the center of Deleuze's semantic politics stand the *mots d'ordre*, or "order-words," a notion that deserves careful attention. In *A Thousand Plateaus* Deleuze and Guattari sharpen the already inverted relation of modality over proposition in linguistic expressions by defining modality broadly, and politically, as the imposition of power: "The compulsory education machine does not communicate information; it imposes upon the child semiotic coordinates possessing all of the dual foundations of grammar (masculine–feminine, singular–plural, noun–verb, subject of the statement–subject of enunciation, etc.)." In this view, grammar is always first "a power marker" rather than a syntactical feature. At the same time, with the inversion of the usual dominance of propositional content over modality goes the reversal of information and transmission. As Deleuze and Guattari tell us, "Information is only the strict minimum necessary for the emission, transmission, and observation of orders as commands."[3] Language "gives life orders" rather than being a part of life, achieving this dominance by way of the *mot d'ordre*, which suggests not merely a slogan, watchword, or military order, nor "a particular category of explicit statements (for example, in the imperative), but the relation of every word or

every statement to implicit presuppositions" and "every act that is linked to statements by a 'social obligation.' "[4]

If traditional descriptions of information transfer are premised on the principle of maximizing information while minimizing redundancy as a "limitative condition," for Deleuze the "redundancy of the order-word is instead primary," with information merely a limit to the exchange of *mots d'ordre* as grammaticality. It is consistent with this position that Deleuze would also be opposed to differentiating information from communication and to idealizing signification. For "signifiance" cannot be shown to occur without a "dominant signification" or subjectification outside of an "order of subjection." Here Deleuze distinguishes *subjectification* as the formation and fixing of subjectivity from *subjectivation*, or the self-positing of subjectivity. Order-words result in the former to the detriment of the latter. What we need to do in response to this situation is to try to evade Kafka's "Judgment," which is part of language and its concepts. It is obvious that this way of describing language cannot be carried out within an analytic approach, which isolates neutral sentence meanings by way of propositions, nor within a Searlean speech act theory that retains the conviction of idealized sense. This is why Deleuze and Guattari insist on a pragmatics in which language plays no more than an important role as one form of semiotic regime. Pragmatics becomes the presupposition behind all of the dimensions, and, says Deleuze, practicing his transcendental empiricism, "linguistics is nothing without a pragmatics (semiotic or political) to define the effectuation of the *condition of possibility* of language and the *usage* of linguistic elements."[5]

Importantly, Deleuzian pragmatics has two sides, a political and a purely functional one. It is the latter that is summed up, under the heading of the "abstract machine," as a "moment at which nothing but functions and matters remain." Yet "language alone does not constitute an abstract machine, whether structural or generative," a misunderstanding Deleuze finds in the history of language theory from Russell to Chomsky. Instead, Deleuze speaks of "diagrammatic functions" and "machinic assemblages" and of their "movements of deterritorialization that cut across the stratification of various systems and elude both the coordinates of language and of existence."[6] Neither logic nor syntax, but only "*a regime of signs or a semiotic machine*"[7] can serve as a ground for such relations. We are dealing here with a machinic pragmatics that has political effects. So we need to

ask how Deleuze's semantic politics can operate as a pragmatics in a significatory frame, a semiotics—a question that does not seem to have been asked in the relevant literature.

Deleuzian semiotic systems are made up of regimes of signs in which signifiers fulfill the role of the "self-redundancy" of "deterritorialized" signs in a "multiplicity" of "circles or chains" and so guarantee what Deleuze terms *signifiance*. The perpetuation of "signifiance" is secured in turn by *interpretance*, or infinite interpretation, forever feeding on earlier interpretations. In this semiotic relativism, "the ultimate signified is therefore the signifier itself, in its redundancy or 'excess.'"[8] At this point we glimpse Deleuze's *asignifying sign*: "a sign that has become a pure event, and no longer signifies anything outside of that which it is."[9] This strikes me as important, for we ought to be able to clarify the function of this concept and suggest an answer to the question of whether the asignifying sign is no more than a limit case in the large-scale evolution of human communication. Seen in evolutionary terms, the asignifying sign appears to be a necessary outcome of the change of regimes of signs from an iconic, presignifying semiotic, through a nomadic, countersignifying semiotic and the signifying regime of despotic societies characterized by the signifier as *visagéfié* (or the signifier "made face"), to the postsignifying semiotic of authoritarian subjectification.[10]

What we also note here is the trajectory of disappearing corporeality. Deleuze and Guattari distinguish sharply between such an actual "intermingling of bodies" as occurs in "eating bread and drinking wine," or "communing with Christ," and what happens when we turn this into signs (perceptual interpretation or language), or abandon all corporeality: "When knife cuts flesh, when food or poison spreads through the body, when a drop of wine falls into water, there is an *intermingling of bodies*; but the statements, 'The knife is cutting the flesh,' 'I am eating,' 'The water is turning red,' express *incorporeal transformations* of an entirely different nature (events)."[11] Such transformations are certainly different events from those involving physical social interaction. But the contrast appears to be drawn too starkly, as if we were suddenly in the realm of formal ideality. Radical incorporeality, however, is possible only in full-fledged formal systems consisting of nothing but syntax or the combination of two kinds of syntax in a formal semantics,[12] as in the work of Rudolf Carnap. By contrast, we retain traces of the body via *Vorstellung* as necessary and socially

controlled acts of fantasy in all natural-language signs on a scale of diminishing corporeality from the most concrete to the most abstract terms. Given the arbitrariness of most signifiers, *at the level of the signified we are iconic beings*—precisely what Deleuze and Guattari appear to affirm in exclaiming, "Representations are bodies too!"[13] Yet do representations play a role in linguistic signs for Deleuze and Guattari? The authors' characterization of the concept, especially Deleuze's earlier schema of concept formation, bars corporeal representations from doing so; nevertheless, it is precisely in the interest of their semantic politics for representations to play a prominent role in linguistic signs.

Strictly speaking, the only asignifying signs we have are formal signs in homosemiotic systems—pure syntax—hence signifiers that act as nothing more than placeholders for whatever variables we wish to substitute. Natural language, by contrast, always bears traces of the corporeality of the social world; natural language signs are part of a heterosemiotic and only partially linguistic system that strains under formalization. Consequently, the description of language, especially from the perspective of a politically engaged pragmatics, gains nothing from the stipulation of empty signification, such as asignifying signs. What, for Deleuze, are natural language concepts, then, and how are they able to function as order-words?

In *What Is Philosophy?* concepts are characterized as fragmentary, with an "irregular contour" that reflects the totalized assemblage of their components. Concepts, which have meaning, a pedagogy, and a history, cut out new contours in a field of problems and are forever being "reactivated and recut." In its formation a concept is in a state of *becoming* during which it enters into new relationships with other "concepts situated on the same plane." Every concept is endoconsistent and exoconsistent. Its endoconsistency, or inherent cohesion, is guaranteed by the inseparability of its heterogeneous components, which are ordered so as to meet in *voisinage*, the concept's "heterogenesis," forming "thresholds of indiscernibility." By contrast, the exoconsistency of the concept is defined by its relations with other concepts on the same plane. It accords with the formal character of such a description that the concept should be condensed to a point—"the point of coincidence"—at which its components are accumulated and surveyed. As these authors put it, "The conceptual point constantly traverses its components, rising and falling with them."[14] Accordingly, "the concept is defined *by the inseparability of a finite number of heterogeneous components*

traversed by a point of absolute survey at infinite speed." This idea is reiterated when Deleuze and Guattari speak of the concept as "an act of thought, . . . operating at infinite (although greater or lesser) speed." While the concept has meaning and intensity, it cannot have representational features since it is "incorporeal" and "anenergetic." It is "pure Event, a hecceity," yet also "an entity," a focused vibration. The formal nature of the concept is further strengthened by the observation that it is not discursive and by the contrast between the absoluteness it achieves as condensation and its relative status vis-à-vis its components and other concepts on the same plane. Put simply, "as a whole it is absolute, but insofar as it is fragmentary it is relative." [15]

At the same time, Deleuze and Guattari are at pains to distinguish concepts from propositions, which they do by insisting that only propositions have references and associated states of affairs. One might object that formal propositions do not have references either unless applied to external systems, so are closer to their notion of concepts than these authors would like, as is their picture of the genesis of the concept: "The task of philosophy when it creates concepts, entities, is always to extract an event from things and beings, to set up the new event from things and beings, always to give them a new event: space, time, matter, thought, the possible as events." [16] Once more, then, the extraction of such an event from things and beings always leaves corporeal traces in the nonlinguistic representations (*Vorstellungen*) required to conceive of anything outside formal logic. The idealization of the concept that comes through not only in *A Thousand Plateaus* and *What Is Philosophy?* but also in *The Logic of Sense* reflects a long-standing division between the body in which concepts are "incarnated" and "effectuated" and the pure concept in and of itself.

This impression of formalism has been reinforced by some of the commentary it has attracted. Brian Massumi, for example, unhesitatingly presents the Deleuzian/Guattarian concept as fully formal: "Nomad thought replaces the closed equation of representation, $x = x =$ not y ($I = I$ = not you) with an open equation: ... $+ y + z + a + $... (... $+$ arm $+$ brick $+$ window $+$...)." [17] If Massumi is right, then Deleuze and Guattari have done nothing more than replace the formal relation of identity and nonidentity with the formal relation of additive nexus. Yet since both are formal, neither captures what actually occurs in natural language and in standard, social conceptuality. In accordance with the difference between generalization and formalization, nothing in natural language is ever formal, but

rather is situated on a continuum from a high degree of corporeality up to generalized corporeality. As long as the slightest referential or deictic trace can be identified, as it can be in even the most abstract natural-language concepts, the concept will be corporeal and hence synesthetic. Only with formal signs, from which both reference and deixis have been erased (as in "let x and y relate to one another as do a and b"), where, that is, the terms are empty placeholders, can we speak of actual incorporeal semiosis at the level of the signified. I am not claiming that this is a fair reflection of *Capitalism and Schizophrenia*; however, the fact that it allows a Deleuze/Guattari convert like Massumi to sketch his logical schema the way he does in order to assist the reader suggests that the formal and corporeal tendencies in Deleuze and Guattari's picture of language are not sufficiently identified. Moreover, if concepts are to play the role they are meant to play in the system of order-words, they must in some way reflect tangible social obligations, and their full formalization prohibits this. According to Deleuze, barring philosophical counterefforts, we cannot do what we like with language: we are its victims. This is so precisely because of the social traces that remain part of the most abstract natural-language terms. However, no such condition applies to stipulated formal language. If concepts are socially controlled recipes for representation, then the links between concept and representation cannot be severed.

The formal emptiness of concepts is also conveyed—unfortunately, I think—by the "immanence" with which concepts are endowed at their organizational level. Deleuze and Guattari call "the plane of consistency" (or "the plane of immanence of concepts") the *planomenon*. Concepts as events require an "indivisible milieu," "horizon," or "reserve," which they inhabit.[18] Expressed transcendentally, the planomenon is the base condition for the thinkability of concepts. It is here that "chaotic variability" achieves "consistency" and so "reality." Hence they speak of the concept as "a chaoid state" to remind us of the transformation of chaos into "chaosmos," chaos "become Thought."[19] What seems difficult to sustain in the face of this emphasis on immanence is the social nature of concepts and the specifics of power that they impose on the speech community.

The picture of "purity" is not relieved by Deleuze's notion of "sense" either. Although sense has to be instantiated or "incarnated," as he puts it, "it has neither physical nor mental existence"; rather, "it inheres or subsists." Sense leads an in-between life, for it "*is both the expressible or the*

expressed of the proposition, and the attribute of the state of affairs."[20] Because of the double status it acquires by turning "one side toward things" and the other "toward propositions," sense cannot possibly be equated with the proposition itself; it has what Deleuze calls "an objective (*objectité*)" or, better perhaps, an object status that singles it out from propositions. This may suggest the reintroduction of corporeality beyond the level of the materiality of the signifier. Furthermore, the attributive character of sense, says Deleuze, points us to states of affairs rather than to the abstractable content of a sentence, namely, the proposition; by contrast, "the attribute of the proposition is the predicate."[21] So it is only in formal propositions that are not applied to social reality (of which physical reality is a part) that we are dealing with self-referentiality proper. Sense in natural language always directs us to our world (including ourselves).

It is therefore puzzling that Deleuze would insist on placing sense in the no-man's-land between world and full formalization: "It is exactly the boundary between propositions and things."[22] Is sense then quasi-propositional or quasi-corporeal, or both? In this no-man's-land there is a point at which sense is about to take place as event, but hasn't yet done so. It could still occur in a number of different ways. This is the aleatory point of meaning of which Humpty-Dumpty is the master. But why would Deleuze want to associate Lewis Carroll's nonsense verse so closely with the central function of sense? My tentative answer is that Deleuze's aleatory point already invites us to play with representations, many of which can be shaped into cohesive possible worlds. If this is so and we want to argue sense along the corporeal lines of fantasy, it must be defined in a less eidetic fashion than Deleuze appears to permit. Indeed, the perceptual, quasi-corporeal activity of projecting mental representations in a community-sanctioned and thus intersubjective manner could form precisely the sort of bridge between world and formally empty signification to which Deleuze appears to be pointing.

Yet this move is once more made problematic, though by no means ruled out, by the fact that Deleuze understands sense in terms of a triple relation to states of affairs, subject manifestation, and signified concepts, properties, and classes, regarding sense as neutral with respect to all three, an indirect inference,[23] or, one might say, a transcendental condition for the actuality of social signification. "Meaning is the sphere in which I must already be settled in order to perform various possible designations, and

even to think their conditions." It follows that "it must be indifferent to questions of truth or falsehood, existence or non-existence (designation); it must have no fixed and stable objects or subjects (designation and manifestation); and it must be devoid of any irreversible relations of implication, including relations of cause and effect, before and after, bigger and smaller, etc. (signification)."[24] What emerges is an entity which is difficult to imagine except as something stripped of any corporeal—hence also any representational—ingredient whatsoever: a formal formation.

In distinguishing the role of philosophy from those of both science and art, Deleuze and Guattari lead sense and the concept further down the road toward eidetic idealization. While science works with propositions and functions, art with sensations, philosophy works with and reworks concepts. As a result, "philosophy brings forth events. Art erects monuments with its sensations. Science constructs states of affairs with its functions." Deleuze and Guattari sum up this relation with a "general hypothesis" in *What Is Philosophy?*: "From sentences or their equivalent, philosophy extracts *concepts* (which must not be confused with general or abstract ideas), whereas science extracts *prospects* (propositions that must not be confused with judgments), and art extracts *percepts and affects* (which must not be confused with perceptions or feelings)," later adding that "the three thoughts intersect and intertwine but without synthesis or identification."[25] The three domains of the creative regulation of chaos—science, art, and philosophy—are characterized as separate, "irreducible" planes of immanence: the *"plane of immanence of philosophy, plane of composition of art, plane of reference or coordination of science; form of concept, force of sensation, function of knowledge; concepts and conceptual personae, sensations and aesthetic figures, figures and partial observers."*[26]

Deleuze and Guattari suggest that the achievements of these three domains are also distinct, with the "greatness of a philosophy" being measured by the kind of events its concepts produce in history. This looks attractive, except that one could with equal justification assume the opposite, namely, that the emptier the philosophical concept, the less effect it will have in this very respect. Put positively, such concepts as the "will to power" and "capital" and "oppression" are so effective precisely because they are not immanent, but rather require a representational reactivation; they seduce us, as it were, by making us accomplices in imagining what they suggest. That they make us complicit in corporeal acts is in-

voked in *A Thousand Plateaus* but undermined in *What Is Philosophy?*, where "force of sensation" is dissociated from the philosophical concept. It therefore does not come as a surprise when Deleuze's interpreters are confused as to the role of representation in the concept. Philip Goodchild, for example, insists that "one no longer asks what it means," but forgets this important claim a few paragraphs later when he illustrates the analysis of the term "deterritorialization": "This concept first makes us think of workers who were forced to leave their lands in the industrial revolution, so as to provide the labour which capital requires. Labour is no longer guaranteed by a relation to the land," and so we must find a different place and reterritorialize the "town and the factory." A little narrative follows, full of imaginative representations and the "force of sensation," telling us what the concept means after all. And to demonstrate that I am not mischievously bending the evidence, let me quote Goodchild's return of the repressed: "Deterritorialization means an encounter with a different formation which changes one's nature so that one no longer has the same bonds with one's previous proper domain."[27] Far from making a mistake here, Goodchild is merely forced by his very attention to the detail of the Deleuzian text to demonstrate the impossible consequences of the notion of immanence. This is underlined in his additional comment that "the concept remains inexact"; nor is it possible to arrive by way of a "higher degree of abstraction" at the elusive level of absolute deterritorialization.[28] Furthermore, the impossibility of demonstrating the asignificatory purity of the concept is compounded by a larger problem: the metaphysical implications of Deleuze's relativist semiotics. In a world where "every sign refers to another sign, and only to another sign, ad infinitum," we have nothing but the "limitlessness of significance," a "network of signs" that is "infinitely circular": "a hint of the eternal return."[29] However, there is something else apart from signs as nothing but "signs of signs," namely, what these authors call the *amorphous atmospheric continuum*.[30]

In terms of a larger picture, an ontology and its inferable conditions, a metaphysics, we need to know how this "amorphous atmospheric continuum" relates to the infinite network of signs. According to Deleuze and Guattari, the significatory network *"projects its shadow onto an amorphous atmospheric continuum . . . that for the moment plays the role of the 'signified,' but it continually glides beneath the signifier, for which it serves only as a medium or wall."*[31] This is important because it suggests that no

matter what this continuum is like, and we can of course know it only via signification, our significations function independently of it. Yet the other crucial question is whether that amorphous atmospheric continuum also throws its shadow on the network of signs.

If it does not, then any set of regimes of signs will do, resulting in a rampant relativism—and no answer to the simple question of how it is that in so many respects, especially those having to do with the basic conditions of the body, cultures produce very similar texts. This massive coincidence should not occur in any radically relativistic metaphysics. Rather, we should be able to observe major contradictions in the significations concerning death, the need to eat and drink certain things and not others, the inability to survive a fall from certain heights, and so on. Yet the culture whose order-words make us jump out of twentieth-story windows with the assurance that this will be to our benefit simply disappears. Why? Have its signs violated something that perhaps does after all throw its shadow on our significatory practices? Deleuze does not duck the question altogether, but he evades the kind of answer I have indicated, one which is based neither on a naked empiricism nor on a metaphysical realism. There is a post-Kantian path that is much closer to the Deleuzian project, that of an intersemiotic semantics, which allows for the restoration of the missing body.

Deleuze and Guattari proposed their redefinition of concept and meaning in the face of two powerful orthodoxies: (1) definitional semantics, with its idealized sense or *eidos* in the phenomenological tradition (the eidetic Husserl) and its formal semantics in the Frege/Carnap tradition; and (2) empiricist (and naturalist) semantics. Both have fundamental flaws. Definitional semantics assumes that natural languages behave in principle like their formal cousins, so we understand language terms because we share their semantic definitions. This is to be rejected for two reasons: first, in natural languages social-meaning practice comes first, then dictionaries get written; second, the descriptions in dictionaries are not really definitions in any strict sense but merely strings of signifiers of varying length, depending on the size of the dictionary. In other words, meaning descriptions are a priori in formal systems and a posteriori in natural language. They are chalk and cheese. The empiricist tradition of the theory of meaning, on the other hand, is grounded on the tenet that meaning is the result of our linking syntax and world as naturalistically given. This disallows the

constructivist insight that the world, as we can know it, is always already to a great extent the result of our significations, including linguistic ones. Hence what we have here is a massive case of begging the question.

The alternative I have offered elsewhere and which I believe to be relevant to the Deleuzian project is an intersemiotic and heterosemiotic semantics.[32] In this scheme, there is no meaning in language, much less in the dictionary. Meaning is the event of linking diverse sign practices, such as activating linguistic expressions by means of tactile, olfactory, gustatory, haptic, aural, and visual readings. Concepts, in turn, are regarded as the social recipes for aligning specific mixes of heterosemiotic elements under prescribed circumstances. This intersemiotic event can be highly schematic as a result of abstract concepts or richly representational at the more concrete level. Yet no natural-language term, no matter how abstract, is exempt from traces of corporeality in this scenario.

If Deleuze were right in saying that language does not function as a link between perception and words but only as one between words, then we could speak the signifiers of a language we did not know and still produce sense. However, while we might do so for speakers of that language, we certainly would not to ourselves. Why? The reason lies in the fact that we would not have been instructed on which nonverbal significations should be activated when we uttered those foreign sounds. When we perform such linkages under social rules, we replay the social world at different levels of schematization, yet we do so without ever reaching the eidetic stage of empty immanence. Not even syncategorematic terms of natural language such as "either/or" or "and," unlike their formal, fully dereferentialized and demodalized cousins, retain traces of corporeality—a position not altogether alien to the Deleuzian picture.

"Recognition," according to Deleuze, "may be defined by the harmonious exercise of all the faculties upon a supposed same object: the same object may be seen, touched, remembered, imagined or conceived."[33] What role does the concept play in this process? I am suggesting that we can take this intersemiotic insight and use it to redress the eidetic imbalance in Deleuze's notions of concept and sense. Deleuze and Guattari are right to emphasize that in signifying we are not so much "representing or referring" as "*intervening*" by way of "a speech act."[34] But before we can do so we must have grasped what our expressions mean and how they refer to the social. What we need is not the abandonment of reference but its

redefinition in intersemiotic terms. Without representational corporeality there is no meaning, and without reference no application to social life. Yet reference should be regarded not as a relation between a sentence that has a meaning and a specific item in the physicalistically given world but as a specific relation between at least two distinct systems of signs, between the signifier "that particular democratic practice" and our typical representational schematizations which identify the item for us. "United Nations armored vehicles in Bosnia" are available to us as typical televisual representations rather than by way of definition.

Deleuze tells us that a concept is syneidetic, that is, the result of synthesizing the eidos of each concept it subsumes and replaces; concepts are not synesthetic. However, as I have suggested, unless they are formal, concepts always bear the traces of their synesthetic genesis. Even so abstract a term as Being (as the condition of beings) bears traces of the human perspective of looking for an economizing sign in which to gather up a multitude of specifics. Emptier still, Derrida's *différance*, which gestures toward the mere condition without which the relations of differentiation are not thinkable, could be said to retain a tinge of the sensible: the human effort of gathering under one sign a multitude of acts of separating. In this respect, the concept, even at the most abstract philosophical level, continues a process in which language formation was probably the most decisively economizing step.

To declare what the syneidetic core or center of a concept is would require a linguistic substitution for the concept, which would in turn need a further syneidetic declaration, and so forth. The very notion of concepts as syneidetic, the very idea of eidos, already betrays a linguistic bias: the economizing faculty of language at its most radical. The only way out of the infinite regress of thinking in terms of linguistic substitutions is to take the exit to nonlinguistic signs. Instead of climbing higher on the pyramid of linguistic subsumption toward the eidos, we need to sidestep, in Deleuzian fashion, the linguistic whenever we must make sense of a concept. Although this procedure does not grant us an ultimate exit from significatory circularity, it nevertheless releases us into the much larger circle of general semiosis that is the horizon of our world.

Ironically, the transcendental condition without which even the high flyers of philosophical concepts are not thinkable turns out to be the body, the beginning and end of all human signs. And indeed, there are many in-

stances where Deleuze embraces the immediacy of the body. He and Guattari know that we cannot simply "escape the ignoble but [must] play the part of the animal (to growl, burrow, snigger, distort ourselves): thought itself is sometimes closer to an animal that dies than to a living, even democratic, human being."[35] Why not sharpen this insight? In spite of endless possibilities of abstraction, human thought is always sensual and hence synesthetic. Consequently, all natural-language expressions are also always more or less synesthetic, on a sliding scale from minimal abstraction to its high-level variants. This seems to make sense in the light of Deleuze's own observation that "the perception of death as a state of affairs and as a quality, or the concept 'mortal' as a predicate of signification, remain extrinsic (deprived of sense) as long as they do not encompass the event of dying as that which is actualized in the one and expressed in the other."[36] We are dealing here with the presence of "sub-sense (*sous-sens*) or *Untersinn*."[37] As Deleuze notes earlier in the same book, "Everything is body and corporeal."[38] And so, one might add, is meaning in natural language.

The reason why Frege banned *Vorstellung* from sense was that its subjectivity would contaminate his formal notion of sense as pure thought. However, since the so-called definitions of natural language are not formal, on the one hand, and *Vorstellungen* are controlled by the semiotic community just as much as meaning descriptions are, on the other, Frege's reason for banishing mental representations loses its force. Mentalism and subjectivity can no longer be used to denigrate the part that *Vorstellungen* play in the construction of meaning.[39] And if we can rewrite the Deleuze/Guattari project such that it forgoes its inherited, eidetic preoccupation and grants *Vorstellung* the central role in meaning, then the very corporeality they so treasure, the body, can be placed at the heart of their theory.

Notes

1 Immanuel Kant, *Critique of Pure Reason*, trans. Norman Kemp Smith (New York, 1965 [1781]), A727–30; quotation from A728. Cf. Gilles Deleuze, *Kant's Critical Philosophy: The Doctrine of the Faculties*, trans. Hugh Tomlinson and Barbara Habberjam (Minneapolis, 1984 [1963]).

2 Gilles Deleuze and Félix Guattari, *A Thousand Plateaus: Capitalism and Schizophrenia*, trans. Brian Massumi (Minneapolis, 1987 [1980]), 76.

3 Ibid., 75–76, 76.

4 Ibid., 79. On the question of power and Nietzsche's influence in this respect, see Michael Hardt, *Gilles Deleuze: An Apprenticeship in Philosophy* (Minneapolis, 1993), 34–37.

5 Deleuze and Guattari, *A Thousand Plateaus*, 79, 85.

6 Ibid., 141, 148.

7 Ibid., 83.

8 Ibid., 114.

9 Philip Goodchild, *Deleuze and Guattari: An Introduction to the Politics of Desire* (London, 1996), 217.

Deleuze and Guattari give us eight principles that pertain to signifying regimes: (1) infinite signifiance, which produces the deterritorialized sign; (2) the eternal return of the sign; (3) the sign's decentering movement from significatory circle to circle; (4) "interpretosis," or the endless production of signifieds and signifiers; (5) the "despotic signifier" as limit on significatory deterritorialization; (6) the "Face" as corporeal substance of the signifier, which reterritorializes the sign; (7) the scapegoat as the negative value of the system's direction; (8) the principle of deception underlying the sign's mobility, circularity, and interpretosis, its public appearance as "facialized center," and its scapegoat function (*A Thousand Plateaus*, 117).

10 See Deleuze and Guattari, *A Thousand Plateaus*, 117–19; see also Ronald Bogue, *Deleuze and Guattari* (London and New York, 1989), 139.

11 Deleuze and Guattari, *A Thousand Plateaus*, 81, 86.

12 See Horst Ruthrof, *Semantics and the Body: Meaning from Frege to the Postmodern* (Toronto, 1997), chap. 3.

13 Deleuze and Guattari, *A Thousand Plateaus*, 86.

14 Gilles Deleuze and Félix Guattari, *What Is Philosophy?*, trans. Hugh Tomlinson and Graham Burchell (New York, 1994 [1991]), 15, 18, 19, 20.

15 Ibid., 21.

16 Ibid., 33.

17 Brian Massumi, *A User's Guide to Capitalism and Schizophrenia: Deviations from Deleuze and Guattari* (Cambridge, MA, and London, 1992), 6.

18 Deleuze and Guattari, *What Is Philosophy?*, 35, 36.

19 Ibid., 208.

20 Gilles Deleuze, *The Logic of Sense*, trans. Mark Lester, with Charles Stivale; ed. Constantin V. Boundas (New York, 1990 [1969]), 20, 21, 22.

21 Ibid., 22, 21.

22 Ibid., 22.

23 "Sense is neutral. . . . It can be only indirectly inferred" (ibid., 123).

24 Bogue, *Deleuze and Guattari*, 70, 71.

25 Deleuze and Guattari, *What Is Philosophy?*, 199, 24, 198–99.

26 Ibid., 216.

27 Philip Goodchild, *Gilles Deleuze and the Question of Philosophy* (London, 1996), 79.

28 Ibid., 80.

29 Deleuze and Guattari, *A Thousand Plateaus*, 112, 113.

30 Ibid., 112.

31 Ibid.; my emphasis.

32 See Horst Ruthrof, "Meaning: An Intersemiotic Perspective," *Semiotica* 104 (1995): 23–

43; announced by way of the "intersemiotic corroboration" thesis in my *Pandora and Occam: On the Limits of Language and Literature* (Bloomington, 1992), 114ff.

33 Gilles Deleuze, *Difference and Repetition*, trans. Paul Patton (New York, 1994 [1968]), 133.

34 Deleuze and Guattari, *A Thousand Plateaus*, 86.

35 Deleuze and Guattari, *What Is Philosophy?*, 108.

36 Deleuze, *Logic of Sense*, 145.

37 Ibid., 136.

38 Ibid.

39 See Horst Ruthrof, "Frege's Error," *Philosophy Today* 37 (1993): 306–17.

Deleuze and the Three Powers of Literature and Philosophy: To Demystify, to Experiment, to Create André Pierre Colombat

The "economy" of literature *sometimes* seems to me more powerful than that of other types of discourse: such as, for example, historical or philosophical discourse. *Sometimes:* it depends on singularities and contexts. Literature would be potentially more potent. —Jacques Derrida, "This Strange Institution Called Literature"

Here's food for thought, had Ahab time to think; but Ahab never thinks; he only feels, feels, feels; *that's* tingling enough for mortal man! to think's audacity. God only has that right and privilege. Thinking is, or ought to be, a coolness and a calmness; and our poor hearts throb, and our poor brains beat too much for that. —Herman Melville, *Moby-Dick*

 Two mountain chains traverse the republic roughly from north to south, forming between them a number of valleys and plateaus.[1] The first sentence of *Under the Volcano* could be used as a metaphor to introduce Gilles Deleuze's thought in general and the relationship of his work to literature in particular. Deleuze's analyses of numerous works by philosophers, scientists, writers, and artists always lead to the distinction between heterogeneous and parallel series, with two or

more "mountain chains" traversing all his critiques from beginning to end. If the main task of the philosopher is to characterize precisely these series and to establish how they communicate with each other, for Deleuze they invariably originate in the Spinozist parallelism between "substance thinking" and "substance extended" as well as in Bergson's matter/memory parallelism. Every one of Deleuze's books entails comparable parallelisms, which were ultimately and explicitly systematized in *The Logic of Sense*.[2]

By analogy to the pair of mountain chains in *Under the Volcano*, Deleuze's philosophy relative to literature can be characterized as a complex relationship between two heterogeneous series, with Deleuze's own pair of "mountain chains" correspondingly expressing the unity of the same forces of Life, of the same unformed, "preindividual" magma pushing through the same fault. Deleuze's entire oeuvre largely revolves around the question of the link between the Multiple and the One that it produces "beside its parts." Here again, Spinoza serves as his main inspiration.

The most important event, in Deleuze's philosophy as in Lowry's novel, is what happens *in between* the parallel series, or two mountain chains, along the faultlines. Life and forms of life, including thought, literature, and philosophy, proliferate in between the shaped matter and a deadly fault; it is also in a perpetual in-between movement, or *perpetuum mobile*, that philosophy, literature, and all other forms of thought's expression are interconnected. In between their two mountain ranges, always threatened by a line of death, Lowry's characters evolve and try to invent their own ways of surviving. In a similar manner, Deleuze's concepts and his "conceptual personae" constantly try, in Rimbaud's words, to "reinvent life itself."[3] This movement, with its comings and goings, its experiments, its successes and failures, also takes place between the boundaries created by philosophical and literary works. Deleuze's resistance to privileging the philosophical expression of thought over the artistic, the scientific, or that of any other domain is clear from his Spinozist acknowledgment of parallelism issuing from a common source.[4]

The rest of Lowry's first paragraph allows us to bring another aspect of Deleuze's philosophical work to bear on literature:

> Overlooking one of these valleys, which is dominated by two volcanoes, lies, six thousand feet above sea level, the town of Quauhnahuac. It is situated well south of the Tropic of Cancer, to be exact

on the nineteenth parallel, in about the same latitude as the Revilla-gigedo Islands to the west in the Pacific, or, very much further west, the southernmost tip of Hawaii—and as the port Tzucox to the east on the Atlantic seaboard of Yucatan near the border of British Honduras, or, very much further east, the town of Juggernaut, in India, on the Bay of Bengal.[5]

Here, the two series of mountains and valleys described in the opening sentence are stretched across a flat map. These horizontal, geographic dimensions also establish territorial, political, and historical relationships, making it clear that the story that is about to unfold is connected to the entire planet. This story has to do with the relations among a great variety of lines of force, of fluxes, of both shaped and unformed territories and other entities situated on the same plane of immanence. My reading of this paragraph is, of course, greatly influenced by Deleuze and Guattari's *Thousand Plateaus*, but it is also informed by Deleuze's reading of Spinoza:

> In short, if we are Spinozists, we will define something neither by its shape, nor by its organs or its functions, neither as a substance nor as a subject. To borrow medieval terms, or geographical ones, we will define it by *longitude* and *latitude*. A body can be anything; it can be an animal, an acoustic body, a soul, or an idea; it can be a linguistic corpus, a social body, a collectivity. We call longitude of any given body the ensemble of relations of speed and slowness, of rest and movement, between particles that constitute it from this point of view, that is, between *unformed elements*. We call latitude the ensemble of affects that occupy a body at each moment, that is, the intensive states of an *anonymous force* (force to exist, capacity to be affected). Thus we establish the cartography of a body. The ensemble of longitudes and latitudes constitutes Nature, the plane of immanence or of consistency, always variable and never ceasing to be altered, constituted, reconstituted, by individuals and collectivities.[6]

This passage clearly defines the primordial role played by geography relative to history in Deleuze's work. Its correspondence to the first paragraph of *Under the Volcano* suggests that telling or creating stories is a force-mapping art, a cartography of active becomings open to new and unforeseeable connections.

≡≡≡≡≡

The Lowry/Deleuze parallel raises the question of what common forces enable thought to develop or express itself in the parallel but heterogeneous series of literature and philosophy. There are three main powers that, according to my reading of Deleuze, seem to be common to both. Articulated as infinitives, or Deleuzian "events," these are "to demystify," "to experiment," and "to create." In many ways, these forces seem to be parallels or developments of Nietzsche's famous "three metamorphoses of the spirit" described in Zarathustra's first speech on "how the spirit changes into a camel, the camel into a lion, and, finally, the lion into a child."[7] These metamorphoses of the spirit reappear as the three most active forces in Deleuze's work, illustrating his interest, and perhaps Nietzsche's as well, in literary writing.[8]

To demystify is one of the primary goals of thought and philosophy, according to Deleuze. He systematizes this power of thought in concluding *Difference and Repetition* through a general critique of classical representation and its four pillars, themselves based on the submission of the powers of differentiation to static repetition.[9] This well-known attack on Platonism and its consequences for modern thought is paralleled by Deleuze's treatment of literary writers and texts elsewhere. His readings of Proust, Sacher-Masoch, and Lewis Carroll all begin with characterizations of heterogeneous series of signs, languages, postures, images, and so on. Deleuze then goes on to use these heterogeneous series and the way they communicate with each other to characterize a given work.

What is demystified here is the belief in an organic or totalizing unity that would explain a writer's work and, ultimately, the world itself. (In this respect, these analyses are directly linked to *Anti-Oedipus*.[10]) In doing philosophy or when reading a literary work, Deleuze's first step is to characterize and classify heterogeneous series in order to think of the multiple in and of itself—its movement, its becoming multiple—without ever reducing it to an organic unity. The concept of representation is always the main target of the power of demystification in thought, in literature, and in philosophy.

For Deleuze, "the first philosopher [i.e., Lucretius] holds forth on nature instead of on gods." Then, "the myth is always the expression of a false in-

finite and of the confusion of the soul."[11] This raises a crucial problem as a considerable portion of literary production in general, and many texts that Deleuze admires in particular, are largely based on myths. Far from simply ignoring the importance of such widespread mythical texts and fables, however, Deleuze always made clear his strong interest in medieval literature and its myths. Indeed, along with Guattari, he created a concept that shed new light on them. Myth, as defined by dictionaries, is a narration such as a fable, often of popular origin, in which various beings incarnate the forces of nature or aspects of the human condition in symbolic form. In Deleuze and Guattari's view, such fables, myths, and mythical beings remain crucial to later literary texts but never as founding principles. Myths and fables in which a state or power is symbolically founded, for example, constitute precisely the kind of centripetal, territorializing representation that Deleuze and Guattari criticized. It was such a centrifugal reading of myths, characters, or even animals in literature that led them to devise the concept of the *Anomal* (from the Greek *omalia*, meaning "alike" or "similar," plus the privative prefix "an"). The Anomal is the extraordinary or unique (*anomalous*) individual who is at once inseparable from the pack, from his or her gang, and the Outsider, hence also in constant contact with the Outside of the pack, of the multiplicity.[12] Not really an individual, the Anomal defines a fringe or borderline at the limits of a multiplicity such as a pack, a gang, or a constellation of forces.[13]

In this respect, almost every centripetal founding myth or mythical figure could be analyzed, deconstructed, demystified, and maybe deterritorialized as such an anomalous figure, shifted from the symbolic center of a representation to its naturalized perimeter, where it denies, confronts, or captures the forces of the Outside. For example, a *renversement* of this kind occurs in Deleuze's *Francis Bacon* with respect to the influence of religious sentiment in classical painting: "One cannot say that religious sentiment was holding up figuration in classical painting: on the contrary, it was making possible a liberation of the Figures, the sudden appearance of the Figures outside of any representation."[14] In modern painting, Bacon's Figures provide us with exemplary Anomals. The Baconian Figure asserts the will to power of its own multiplicity.

As a creator of such unique or extraordinary entities, the writer, like the philosopher or the painter, becomes a sorcerer:

Sorcerers have always had an anomalous position, at the edge of the fields or the woods. They haunt the edges. They are at the border of the village, or *in between* two villages. The important thing is their affinity with the alliance, with the pact, which gives them a status opposite to that of filiation. The relationship with the anomalous is one of alliance. The sorcerer is in a relationship of alliance with the demon as the power of the anomalous.[15]

At the limits of this process of demystification, one becomes receptive to the signs or concepts created by the writer or artist, who, in turn, as a "sorcerer" becomes sensitive to the forces of the Outside. For this reason, a reading must be demystified as much as possible from preconceived representations, or at least their validity must be questioned. At that point, the second "event" that characterizes Deleuze's thought and his reading of literary texts occurs: the power "to experiment." Such experimenting consists, first of all, in following a lead, a direction, a becoming, in thought so as to evaluate its active and reactive powers.

This opening up to signs and expressions, then to thought, is depicted by Deleuze as the power to be affected. The absolute necessity of opening one's faculties to a work was explained by Deleuze during the very first session (22 October 1985) of his seminar on Michel Foucault:

You [students] must trust the author you are studying. Proceed by feeling your way. One must ruminate, gathering and regathering the notions. You must silence the voices of objection within you. You must let him [the author] speak for himself, analyze the frequency of [his] words, the style of his own obsessions. His thought invents its own coordinates and develops along its own axes.[16]

The power of demystification should allow us to silence within ourselves the "voices of objection." Then the power of experimentation could enable us to become more sensitive to an artist's signs or a philosopher's concepts by connecting our receptivity to the way in which a given work affects us. Similarly, to paraphrase a well-known Deleuzian comparison, a cabinet-maker has to become sensitive to the signs of wood in order to know how to work with them. In this respect, Deleuze's thought is always striking for its extraordinary ability to capture, characterize, and organize what makes

a work original or uniquely powerful—originality and forcefulness always being the focus of Deleuze's analyses of literary, artistic, and philosophical works. The centrifugal power of experimentation and its becomings allows Deleuze to assess how a given writer, artist, or philosopher progressively creates his or her own style.

This opening up of thought is then complemented by a confrontation and consequent coupling (*accouplement*) of forces that tests the power of the becomings thus developed. The challenge is to create new forms of expression by becoming sensitive, by capturing and coupling forces from the Outside within a certain form of expression, or what Bacon called a Figure. The "accouplement," or mating, of human Figures in some of Bacon's paintings provides us with a clear example of Deleuzian experimentation, in which a confrontation between the intensive forces of two specific figures occurs and thereby produces a new Guattarian "diagram," a new constellation of forces. Then, using the powers of demystification and experimentation, the philosopher will be able to attempt his own creation. (In practice, however, these three powers operate simultaneously.)

To experiment is to reenact the Nietzschean throw of the dice, for experimentation affirms chance—the multiple itself and all its becomings. "The player temporarily abandons himself to life and temporarily fixes his gaze upon it; the artist places himself provisionally in his work and provisionally above it."[17] It is only from this absolute affirmation of chance that the absolute necessity of the unique work produced will also be affirmed. The unity of the work will come about after the fact, that is, only as an affirmation of the multiple and not as a principle of creation. It is in precisely these words that, in *Proust and Signs*, Deleuze qualifies the creation of "style" as "non-style," the style of those about whom we say that they have no style. It is never a principle of unity but a unity produced as an effect. "It is never a matter of viewpoint, but constituted by the coexistence in the same sentence of an infinite series of viewpoints according to which the object is dislocated, sets up a resonance or is amplified."[18]

If the power of experimentation "throws the dice," the unique number produced in the present affirms the rules, "being affirmed of becomings as such." In this movement, the "game" of the Nietzschean child or artist becomes a "dance," and experimentation becomes creation: "The number that maintains the fire and which is affirmed of multiplicity when multi-

plicity is affirmed, it is the dancing star or rather the constellation born of the dicethrow. *The formula of the game is: give birth to a dancing star with the chaos that one has in oneself.*"[19]

To create, in Deleuze's view, also involves a certain kind of Blancholdian "rapport/non-rapport," a "relationship/non-relationship," that an individual may develop in between the heterogeneous series that characterize his or her work. Deleuze derives this creative power largely from his reading of Bergson, whose study of the parallelism of matter and mind, for example, led to his formulations of *élan vital* and time as duration. Similarly, Deleuze's theory, in the end, arrives at the ability of becomings to enable the creation of new, dynamic shapes for life or conceptual thinking. Becomings, continuous variations of the vital force, ultimately create new life forms.[20]

For this reason, Deleuze's concepts are of a new kind. Like any living shape or Spinozist "body," they are in constant motion and metamorphosis. They represent temporary shapes to be affected, captured, or connected to other series of thought and, ultimately, to be completely transformed so as to open the way to new creations in many different fields of thought. Here again, to create means to explain, that is, to unfold the pleats of thought and connect them to other dynamic series in nature, to develop fully the becomings opened up by new connections with the powers of the Outside—of a *natura naturans*. These connections largely correspond to what Guattari called the diagrammatic. More recently, Alain Badiou has defined this process of creation as "*a truth*" or "the real process of a fidelity to an event."[21]

However, it is clear that the power of creation is inseparable from a line of death, from a constant death threat. To create is to take the risk of a violent and possibly very destructive confrontation with the purely intensive forces of life itself.[22] When confronted with the purely intensive world of the Outside, one can take refuge from the threat of self-destruction in the shape of a concept and the structure of a method. These become folds from which forces can be captured and singularities connected to each other in order to open new paths for thought. As Deleuze and Guattari put it, "Maybe art begins with the animal, at least with the animal that carves out a territory and makes a house (the two are correlated and sometimes even the same in what we call a habitat)."[23] Art, thought, and life itself need to take shape in order to proliferate. But these shapes have nothing to do with Aristotelian forms; they are Bergsonian

nebula, Deleuzian problem-constellations, Guattarian diagrams, Badiou's "situations," Spinozist bodies, Bacon's (or Cézanne's) Figures, Deleuzian Anomals, or Outsiders, in literary texts. They are open shapes in constant motion, caught up in continuous variation and metamorphosis.

The distinctiveness of Deleuze's thought can also be traced to his absolute rejection of the powers of the negative—that strange sacralization of death which dominates modern and postmodern thought. Deleuze's theory of the event, his redefinition of the concept, and his open system of thought protect his work from nihilism. They enable him to combine the affirmative forces of Nietzscheanism with the active powers of Spinozist thought so as to strive for Rimbaud's reinvention of life itself. Death here is not characterized in a negative manner. To use a neo-Kantian and constructivist distinction, death is not to be considered the passive negation of life, but rather to be endorsed as the active negation of actual forms of life. To this extent, destiny and death appear to be expressions of life itself, conceived as a dynamic and differentiating power. In this respect, Deleuze's thought intersects with many aspects of constructivism. Jon Elster, a constructivist thinker, reminds us that, according to Kant, a distinction must be made between passive and active negations. So, for instance, if a proposition states that "A believes P," its passive negation would be "No (A believes P)," while its active negation would be "A believes non-P." The negative reigns over the former, but in the latter the negation appears only as the shadow of another necessary affirmation.[24] In a Deleuzian context, the first, "passive" negation constructs a relation between being and nothingness, with the difference characterized as a nonrepetition. The second, "active" negation renders thinking as a battlefield of forces continually affecting each other. The "active" negation would mark only the point where two different or even opposite powers of affirmation come in contact with one another. The inability to distinguish between these two forms of negation is quite common and characterizes what Elster calls "the primitive mentality." All of Deleuze's work revolves around active negation and denounces the myths and illusions of representations based primarily on passive negation. On this point, both Elster's constructivism and Deleuze's philosophy promote an active and paradoxical thought.[25]

Similarly, in *Francis Bacon*, Deleuze distinguishes between two kinds of gray in painting. On the one hand, there is the gray obtained by mixing white and black, which is based on the light value of a color, as opposed to

its tonality. This gray is characterized by light values on a continuum from absolute absence to absolute presence and, conversely, from pure light to pure darkness. It is based on an optical code and a passive negation, in other words—pure light versus no light, with all the degrees in between. On the other hand, there is the gray obtained by mixing, say, green and red, which is based on the tonality of color, its warmth or coldness. It is based on an active negation, a shadow of the assertion and confrontation of two colors, so is not optical but "haptical" and creates a new kind of language in painting that Deleuze calls "analogical language."[26] (Of course, as Deleuze notes, it is certainly possible to treat black and white as colors; one need only cite many paintings by Manet or Franz Hals, for example.)

The conception of an active negation also has implications for the three common powers of literature and philosophy. As in Bergson's work, dualisms in Deleuze's thought are based not on a negative term but on a "*corps à corps*," a kind of wrestling between forces. Deleuzian dualisms are always exceeded by a third term—an excess, or creative power of the paradox, that emerges in between them. For literature, "to demystify" and "to experiment" could characterize such a pair, with "to create" a third power that is always interposed in their relation, but difficult and dangerous to reach and to explore. These three powers develop in a plane of consistency that they produce as a unifying field for thought and for any living shape that Lucretius would call nature, but that we can call, after Rimbaud and Deleuze and Guattari, life itself. Deleuze always insisted on redefining unity as a whole produced next to its parts, a perspective that is consistent with the three powers of literature and philosophy, the unity of which is always to be produced.

In order to be more precise, what still needs to be characterized is how, in both literature and philosophy, these three powers concur or develop together, simultaneously, in the same creative thought but in two different series. The plane of consistency that connects philosophy to life itself is partly characterized through the Deleuzian concept of style and its continuous variation, which corresponds to "modulation" in Bacon's paintings.

Ultimately, for Deleuze, a great writer or a great philosopher is someone who can create his or her own style. To put it in Nietzschean terms, the "laugh" of demystification and the "game" of experimentation open up on the "dance" of creation—the creation of a "dancing star":

In relation to Zarathustra, the laugh, the game, and the dance are affirmative powers of transmutation: the dance transmutes the heavy into the light, the laugh transmutes suffering into joy, the game of dicethrowing transmutes the low into the high. But in relation to Dionysus, the dance, the laugh, and the game are affirmative powers of reflection and development. Dance affirms the becoming and the being of becoming; laughter [*éclats de rire*] affirms the multiple and the "one" of the multiple; the game affirms chance and the necessity of chance.[27]

As in *Proust and Signs*, style is the ultimate force, the metamorphosis of all signs and all concepts.[28] It appears as a Nietzschean "affirmative power of transmutation," as the movement of becoming and of creation itself.

The style of a work, understood as a Deleuzian "non-style," is what largely gives it its power to affect us, to make us think even in a prephilosophical manner. As Deleuze, after Plato and Proust, often reminded his readers, more important than what we think is what forces us to think. In this respect, the power of a concept, of a thought, and especially of a literary work can likewise be gauged by its ability to force us to think. The Deleuzian concept of style then enables us to better understand how a philosophical or a literary text does or does not affect us or, ultimately, force us to think.

In order to understand how style can be the source of the power common to literature and philosophy alike, we must first recall how literature and philosophy differ in their relationship to the affect and the percept. This is clearly explained by Deleuze and Guattari in the chapter of *What Is Philosophy?* entitled "Percept, Affect, and Concept." For them, the goal of a work of art, particularly that of a literary work, is to create *"a bloc of sensations composed of percepts and affects."*[29] This bloc of sensations made up of percepts and affects, that is, of perceptions and affections, is *freed of the individuals who actually felt them.* Beyond perception and affection or sentiment, the percept and the affect create what in *A Thousand Plateaus* is called, after Duns Scotus, a *hecceity*, a bloc of sensations that is nonhuman or prehuman yet inseparable from the human experience. It is by reaching the level of a hecceity that art reveals to us the becoming-universe, -animal, -vegetal, the becoming-zero, or imperceptible, of Man that unites him with life itself. This is why a work of art, as a bloc of sensations, has

to stand on its own. It has to become independent of any perception, affection, or sentiment that is linked to the person who felt it.

Thus was Bacon, in his famous *Study after Velázquez's Portrait of Pope Innocent X*, able to paint the scream without the horror, according to Deleuze. In other words, the work of art produces a bloc of sensations that we perceive and that affects us beyond the concepts of man, memory, or anecdote. Like Bacon's painting, it addresses our nervous systems directly. It creates a being of the sensation that exists in itself and reveals to us a state of becoming-nonhuman. In sum, for Deleuze and Guattari, art is what allows us to "see Life within the living." Art shows, invents, and creates affects, but style is the only power that enables the artist to reach the percept and the affect beyond or below the perception and the affection. In Bacon's paintings it is a style characterized by isolation, deformation, and dissipation.[30]

In literature, for Deleuze, style is characterized, first, by a series of processes that each writer has to invent in order to trigger the metamorphosis between words and pure blocs of sensations. Style allows the artist to reach beyond and within language and signs to the level of Spinozist expression and expressivity. "In every case one needs style—the syntax of a writer, the modes and rhythms of a musician, the strokes and the colors of a painter—to elevate lived perceptions to the percept, lived affections to the affect."[31] Style allows the writer to free his or her work from pure narration and the anecdote, from the person and then from the individual.[32] It is clear that with style, something else is at stake, something other than mere representation or simple narration. As Deleuze and Guattari say in *What Is Philosophy?*: "The writer uses words, but by creating a syntax allows them to become sensation that makes everyday language stutter, or tremble, or scream, or even sing: it is the style, the 'tone,' the language of sensations, or the foreign language within language, that calls for a new people to come."[33] Deleuze's work repeatedly addresses the characterization of such stylistic qualities as Baconian isolation, deformation, and dissipation. Style enables the metamorphosis of language into blocs of sensations by means of three main powers: to vibrate, to couple, and to rupture, or, as Deleuze and Guattari put it: to make language vibrate, to couple it, to break it open (*faire vibrer, accoupler, fendre*).

One important point remains to be considered: the function of style in philosophy as it links its own powers to those of literature and its creation of blocs of sensations. Style is what enables becomings to develop as it

establishes oblique or cross communications between parallel series that do not communicate in a static representation. It creates aesthetic figures, blocs of sensations, hecceities. However, becomings function quite differently in literature and in philosophy. As Deleuze and Guattari note in two key passages of *What Is Philosophy?*: "Aesthetic figures (and the style that creates them) have nothing to do with rhetoric. They are sensations: percepts and affects, landscapes and faces, visions and becomings. But didn't we define the philosophical concept precisely by its becoming, and even in the same terms? *However, aesthetic figures are not identical to conceptual personae.*" They then go on to explain the difference between becomings in literature and becomings in philosophy: "Sensory becoming is the act through which something or someone never ceases to become-other (while continuing to be what it is), sunflower or Ahab, whereas conceptual becoming is the act through which the common event itself eludes what is. The latter is heterogeneity grasped in an absolute form; the former is alterity engaged in a matter of expression."[34] Thus becomings in literature, via style, have to do with heterogeneity, with becoming other, as a matter of expression rather than absolute form. Such matters of expression as blocs of sensations—percepts and affects—constitute a writer's style, which is then capable of transversality, of establishing cross connections between different series. Eventually, these blocs of sensations and their becomings may produce a hecceity or an event in thought, but only because "there are sensations of concepts and concepts of sensations."[35]

In this respect, literature, as a mode of thought, is neither inferior nor superior to other modes such as philosophy or the sciences. However, the specific matter of expression of literature is composed of aesthetic figures defined by blocs of sensations and their becomings. It does not create concepts or "heterogeneity grasped in an absolute form" but sensations of concepts, with events and hecceities that are expressive, not absolute, which could be interpreted as a new or developed version of Spinoza's parallelism between matter and mind that was so crucial to Deleuze.

Philosophy, on the other hand, deals with and produces heterogeneity within an absolute form, the form of the concept. In writing about literature, the philosopher need not deal with "sensations of concepts," as this can be left to the literary critic; the philosopher deals instead with the concepts of sensations that can be derived from a writer's work. When Deleuze wrote his two-volume *Cinema* and his essays on Bacon and Beckett, his

goal as a philosopher was always to specify those events in thought, those concepts and their absolute forms that are necessary to the creation of a field of expression. An event in literature is inseparable from an event in thought, but the two are qualitatively different, parallel yet heterogeneous, like two Spinozist modes of expression. While the literary critic concentrates on aesthetic figures and sensations of concepts, the philosopher tries to characterize the concepts of sensations and conceptual forms that are created or modified by the same event in thought. For example, in *What Is Philosophy?* Deleuze and Guattari use this very distinction between philosophy and literature to conceptualize the flesh, the house, and the cosmos within a more general analysis of art. But even though they distinguish philosophy from literature, Deleuze and Guattari also insist on the parallelism between them as modes of thought. While philosophy creates or must try to create concepts, literature creates blocs of sensation and a foreign language within language itself, its becoming-intensive. Literature develops the becoming-other of language itself, the "becoming-sensation" of language, well beyond any concept of communication.[36] Literature opens up on "visions and auditions" of images and sounds never seen or heard before—new percepts and affects, new blocs of sensations. These constellations constitute what may be called ideas or dynamic, elementary shapes of thought. Such ideas are prephilosophical but essential to philosophy, which, in a parallel enterprise, creates its own concepts.

Here again, it is clear that Deleuze's conception of the powers of both literature and philosophy owes much to a naturalism inherited from Lucretius. As he wrote in an appendix to *The Logic of Sense*:

> Never had anyone [before Lucretius] pushed the enterprise of "demystification" so far. The myth is always the expression of the false infinite and the confusion of the soul. One of the deepest characteristics of Naturalism is to denounce everything that is sadness, everything that causes sadness, everything that needs sadness to exercise its power. From Lucretius to Nietzsche, the same goal was pursued and reached. Naturalism makes of thought an affirmation, it makes of sensibility an affirmation. It attacks the prestige of the negative; it takes away the power of the negative; it denies the spirit of the negative the right to speak in the name of philosophy. . . . Lucretius established for a long time to come the implications of Naturalism: the positivity of

Nature, Naturalism as a philosophy of affirmation, pluralism linked to multiple affirmation, sensualism linked to the joy of variety, and the practical critique of all mystifications.[37]

This passage, written in 1969, clearly indicates that philosophy and literature belong to the same naturalistic thought by virtue of their critical power to demystify and characterize nature, or life itself. In a similar manner, Spinoza once fought against the myths created by theologians in order to define his own thought. However, for Deleuze, the event is what makes life and thought possible in the end, the event as the movement of differentiation itself, which develops and creates its expressions in the two parallel and heterogeneous series of philosophy and literature. Ultimately, style is what expresses the power of the event in both literature and philosophy.

The very title of Deleuze's *Critique et clinique* articulates this new parallelism, the relationship between the two series of philosophy and literature in thought—the former aligned with critical thought and the creation of concepts, the latter with clinical observations, the deciphering of signs and symptoms, as in the symptomatology outlined in Deleuze's *Présentation de Sacher-Masoch*. *Critique et clinique*, however, is devoted entirely to the study of literature, but in a series of philosophical essays. Its title refers to two of the main powers of both literature and philosophy that enabled Deleuze to develop his own thought, his own becomings as a philosopher. In terms of critique, literature denounces the myths of language and representation. It demystifies thinking. In terms of the clinical, literature becomes sensitive to the highly localized signs and situations that it characterizes, articulates, and combines in order both to identify or diagnose a disease and to enable life to flourish. Literature experiments with signs and makes the writer the physician of civilization and the creator of new, possible, and dynamic forms of life. Here again, better than any literary criticism, Badiou's work develops the very rich implications of Deleuze's clinical thought on politics and advances a new kind of ethics that fights the repeated, bloody failures of the ethics of charity and human rights.[38]

However, the most important part of the title of Deleuze's last book might well be the third term in the middle, the *et* caught between *Critique* and *clinique*. This "and" indicates a zone in between, an outside where "critique" and "clinic" meet and create an actual literary work. This "and" both links and separates the critical and the clinical through the charac-

teristic becomings of the power of creation. "To create," as an infinitive, a pure event, develops itself outside of language. It is made of the sounds and visions of the Outside that language makes possible, but doesn't limit. Deleuze, like Rimbaud, believed every writer to be a voyant, a seer, a sorcerer, who eventually tells us what he or she has seen or heard in his or her encounter with the Outside.

The writer creates new regimes of visibility and new regimes of enunciation. The three powers of literature are listed in the preface to *Critique et clinique* as "une décomposition ou une déstruction de la langue maternelle, mais aussi l'invention d'une nouvelle langue dans la langue, par création de syntaxe" (a decomposition or a destruction of [one's] mother tongue, but also the invention of a new language within language, through the creation of syntax). These powers finally push language itself to

> une limite, à un dehors ou un envers consistant en Visions et Auditions qui ne sont plus d'aucune langue. Ces visions ne sont pas des fantasmes, mais de véritables Idées que l'écrivain voit et entend dans les interstices du langage, dans les écarts de langage. . . . L'écrivain comme voyant et entendant, but de la littérature: c'est le passage de la vie dans le langage qui constitue les Idées.
>
>
>
> a limit, toward an outside or a reverse side consisting of Visions and Auditions that do not belong to any language. These visions are not fantasms, but true Ideas that the writer sees and hears in the interstices of language, in the gaps of language. . . . The writer becomes a seer and hearer; that is the goal of literature: the passage of life in language that constitutes Ideas.[39]

Notes

1 Malcolm Lowry, *Under the Volcano* (London, 1967 [1947]).

There is, of course, a good deal of irony and provocation in my use of the prior quotation in my first epigraph, from an interview with Derrida in *Acts of Literature*, ed. Derek Attridge (New York, 1992), 43. Derrida and Deleuze diverge radically, but in this statement Derrida seems to come very close to Deleuze's Spinozist views on literature. However, for Derrida, literature always remains trapped in language, history, and its own contexts, while for Deleuze, literature provides unique opportunities—openings or becomings—to bypass the traps of language, linguistics, and history. It is geographical for Deleuze, not historical, and goes far beyond any word game or "communica-

tion" toward intensive, expressive, and nonlinguistic "independent blocs of sensation." While Derrida's work plays a fundamental role in the demystification of our linguistic representations of reality, Deleuze has gone further by analyzing and developing the "potentially more potent" Spinozist *power (potentia)* of literature. (At least this is what my essay will begin to demonstrate.) In this same interview, Derrida states, "No doubt I hesitated between philosophy and literature, giving up neither, perhaps seeking obscurely a place from which the history of this frontier could be thought or even displaced in writing itself and not only by historical or theoretical reflection" (34). Deleuze, contrariwise, always insisted that his work was philosophical and nothing else. Derrida's interest in philosophy and literature has been, from the outset, conditioned by his views on language and the "linguistic turn," whereas Deleuze's approach always focused on the relations among the forces that are at work in and beyond language itself. For Derrida, the "conditions of possibility" of a representation are to be found in its reflexive criticism of language and in its historical context. This is precisely why he considers literature so "potent," the "force" of the modernist or the nontraditional text's "event" depending "on the fact that a thinking about their own possibility (both general and singular) is put to work in them in a *singular* work" (42). In the end, "deconstruction calls for a highly 'historian's' attitude (*Of Grammatology*, for example, is a history book through and through), even if we should also be suspicious of the metaphysical concept of history. It is everywhere" (54). Deleuze's thought, on the other hand, calls for a "a highly geographer's attitude" that seems much more likely to allow us to develop the potentiality of literary texts in particular and of art in general.

2 The main problem, once their differences have been established, is to characterize how these series communicate. This is largely accomplished by means of Félix Guattari's concept of "transversality" in connection with the Deleuzian concept of style. See Gilles Deleuze, *The Logic of Sense*, trans. Mark Lester, with Charles Stivale; ed. Constantin V. Boundas (New York, 1990 [1969]).

3 On Deleuze's reading of Rimbaud's work, see my article "Le Voyant et les 'enragés': Rimbaud, Deleuze et Mai 1968," *French Review* 63 (1990): 838–48.

4 It is very important to Deleuze (and Guattari) to delimit the specificity of each of these domains in order to be able to develop its most creative power; indeed, this is the main purpose of *What Is Philosophy?*. If the parallel I draw between Lowry's and Deleuze's works rests on a metaphor, it is only in the Deleuzian sense of metaphor as "essentially a metamorphosis." Such a metamorphosis establishes differences in nature, connections between forces, and the creation of becomings; see Gilles Deleuze, *Proust and Signs*, trans. Richard Howard (New York, 1972 [1964]), 61; see also Gilles Deleuze and Félix Guattari, *What is Philosophy?*, trans. Hugh Tomlinson and Graham Burchell (New York, 1994 [1991]).

5 Lowry, *Under the Volcano*, 3.

6 Gilles Deleuze, *Spinoza: Practical Philosophy*, trans. Robert Hurley (San Francisco, 1988 [1981]), 127–28; translation modified.

7 Friedrich Nietzsche, *Ainsi parlait Zarathoustra*, trans. Marthe Robert (Paris, 1958 [1883]), 25; my translation.

8 In many respects, my analysis here can be read in parallel with Ronald Bogue's "Gilles Deleuze: The Aesthetics of Force," in *Deleuze: A Critical Reader*, ed. Paul Patton (London, 1996), 257–69. Bogue's article revolves around the Nietzschean/Deleuzian idea that the problem common to all the arts is that of "harnessing forces." Here, I am endeavoring to show how this harnessing of forces also becomes an expressive Spinozist power capable of creating affects and new blocs of sensation. On the differences between Nietzsche's thought and Spinoza's, as well as the influence of both on Deleuze's philosophy, see Pierre Zaoui, "La 'Grande identité' Nietzsche–Spinoza," *Philosophie* 47 (1995): 64–84.

9 Gilles Deleuze, *Difference and Repetition*, trans. Paul Patton (New York, 1994 [1968]), 262–304.

10 Gilles Deleuze and Félix Guattari, *Anti-Oedipus: Capitalism and Schizophrenia*, trans. Robert Hurley, Mark Seem, and Helen R. Lane (Minneapolis, 1983 [1972]).

11 Deleuze, *Logic of Sense*, 278.

12 For Deleuze, Melville's Bartleby and Moby-Dick constitute two perfect examples of mythical figures that must be considered Anomals; see Gilles Deleuze and Félix Guattari, *A Thousand Plateaus: Capitalism and Schizophrenia*, trans. Brian Massumi (Minneapolis, 1987 [1980]), chap. 10.

13 Ibid., 244–45.

14 Gilles Deleuze, *Francis Bacon: Logique de la sensation* (Paris, 1981), 14; my translation.

15 Deleuze and Guattari, *A Thousand Plateaus*, 246; translation modified.

16 Transcribed and translated from my lecture notes.

17 Gilles Deleuze, *Nietzsche and Philosophy*, trans. Hugh Tomlinson (New York, 1983 [1962]), 24.

18 Deleuze, *Proust and Signs*, 148.

19 Deleuze, *Nietzsche and Philosophy*, 29–30; my emphasis.

20 This power to create has many links with Spinoza's *conatus* and concept of expression, but also with Nietzsche's *will to power*, at least as analyzed in Pierre Klossowski, *Nietzsche et le cercle vicieux* (Paris, 1978 [1969]). The Blancholdian notion of "rapport/non-rapport" also finds new expression in Deleuze's reading of the Leibnizian harmony between monads; see Gilles Deleuze, *The Fold*, trans. Tom Conley (Minneapolis, 1993 [1988]); and "La Pensée mise en plis," *Libération*, 22 September 1988.

21 Alain Badiou, *L'Ethique: Essai sur la conscience du mal* (Paris, 1993), 39.

22 As Marie Buydens has stressed, the concept and the method are no longer the static enemies of a dynamic thought process, that is, one which tries to follow the dynamic movements of thought; see her *Sahara: L'Esthétique de Gilles Deleuze* (Paris, 1990), pt. 2, esp. 123–24.

23 Deleuze and Guattari, *What Is Philosophy?*, 183.

24 See Jon Elster, "Négation active et négation active: Essai de sociologie ivanienne," in *L'Invention de la réalité: Comment savons-nous ce que nous croyons savoir? Contributions au constructivisme*, ed. Paul Watzlawick (Paris, 1988); originally published as *Die Erfundene Wirklichkeit: Wir wissen wir, was wir zu wissen glauben? Beiträge zum Konstruktivismus* (Munich, 1985 [1981]).

25 In 1988, Deleuze declared in an interview that, with *Anti-Oedipus*, he and Guattari had

been "looking for an immanent conception, an immanent use of the synthesis of the unconscious, a productivism or a constructivism of the unconscious"; Raymond Bellour and François Ewald, "Signes et événements," *Magazine littéraire* 257 (1988): 16–25; quotation from 21. Deleuzian thought shares with constructivism a systematic critique of the concept of representation itself, largely based on a critique of negation, good sense, and common sense. Constructivism also claims that reality is not to be discovered but built, constructed, invented, while Deleuzian analysis is similarly concerned with the movements and orientations of thinking that are needed to make ideas, thoughts, and concepts possible at all.

26 See Deleuze, *Francis Bacon*, 83–85.

27 Deleuze, *Nietzsche and Philosophy*, 193–94; translation modified.

28 See Deleuze, *Proust and Signs*, 47–48.

29 Deleuze and Guattari, *What Is Philosophy?*, 164; translation modified.

30 See Deleuze, *Francis Bacon*, 42.

31 Deleuze and Guattari, *What Is Philosophy?*, 170; translation modified.

32 On the movement of art toward the impersonal and the preindividual, see Deleuze, *Logic of Sense*, Fifteenth Series (100–108) and Thirty-Fourth Series (239–49).

33 Deleuze and Guattari, *What Is Philosophy?*, 176; translation modified.

34 Ibid., 177; translation modified, my emphasis.

35 Ibid.

36 For an alternative to this concept of communication, and to that of Habermas, see Badiou's concept of the "encounter" (*L'Ethique*, 46–47). Here again, Badiou's work develops and often enriches many of Deleuze and Guattari's ideas.

37 Deleuze, *Logic of Sense*, 279; translation modified.

38 See Badiou, *L'Ethique*, 12–17.

39 Gilles Deleuze, *Critique et clinique* (Paris, 1993), 16; my translation.

Overdetermined Oedipus: Mommy, Daddy, and Me
as Desiring-Machine Jerry Aline Flieger

There is only desire and the social, and nothing else.
—Gilles Deleuze and Félix Guattari, *Anti-Oedipus*

For all its pathfinding brilliance, *Anti-Oedipus*, the first volume of *Capitalism and Schizophrenia*, is perhaps the most unfortunately titled work in the ether of high theory.[1] In spite of their antipsychoanalytic posturing, Deleuze and Guattari are, in my view, neither anti-Freudian nor even "anti-Oedipal," in the most interesting and nuanced sense of that term. Still, many newcomers to the daunting body of work by Deleuze (with and without Guattari) begin with *Anti-Oedipus*, the title most familiar to nonspecialists; and, because of the caricatural treatment of "institutionalized" psychoanalysis there, many readers who value Freud and take psychoanalysis seriously as an interpretative strategy read no further in Deleuze's work. As an unrepentant postmodernist, premillennialist, Freudian anti-anti-Oedipalist, I want to appeal to my fellow Freudians, nonspecialists in Deleuze's work, to read further in his remarkable oeuvre. To that end, I take on some of the (perhaps deliberately overdrawn) tendentious characterizations

of Freud/Oedipus in *Anti-Oedipus* here, using Deleuze and Guattari's own theoretical apparatus to counter some of their more flagrant positions. I also respond in kind, for the sake of spirited debate and fun, to the anti-Oedipalists' flippant and parodic tone (as when they repeatedly refer to the complicated Oedipal configuration as "daddy–mommy–me") to refute some of their willfully provocative critiques of Freudian theory.

Let me be clear: I am not about to speak as an apologist for that most reductive version of Oedipus—the only one Deleuze and Guattari attack—as a "complex" whereby all problems are traced to a desire for Mommy and a revolt against Daddy. But if *Anti-Oedipus* is to be taken seriously (*au pied de la lettre*, at its word, and not as ironic), this nearly obsessive underreading of Oedipus, patently narrow and ungenerous, may even be disingenuous, for surely these brilliant pathfinders see more in Freud than an invocation of "daddy–mommy–me." Or do Deleuze and Guattari perhaps, like enemy Oedipus, pay the price of lucent insight with a certain blindness?

I want to raise another possibility: Reading the stunning second volume of *Capitalism and Schizophrenia, A Thousand Plateaus*, which owes a profound and explicit debt to the most radical and interesting Freud, one wonders whether the first volume suffers from shortsightedness or malice, as seems to be the case, or serves as a preliminary strategy of sorts, a setup. Deleuze and Guattari may have been drawing up an itinerary for the big O (Other, Oedipus, the faceless One) as empty placeholder—framing underdetermined Oedipus as Hollow Man—effectively setting up the empty Tin Man as Straw Man, a kind of Cowardly Lion/Paper Tiger who will only reveal what he is made of by undertaking a circuitous journey to a millennial Oz of sorts, the "holey space" of *A Thousand Plateaus*.[2]

In any case, whether Deleuze and Guattari are on the level in their reduction of Oedipus to "the holy family" trinity, they pull no punches in squaring off against their adversary in *Anti-Oedipus*, and at least some of that belligerence persists in *A Thousand Plateaus*: "In truth, Freud sees nothing and understands nothing. He has no idea what a libidinal assemblage is, with all the machineries it brings into play, all the multiple loves." (For instance, the anti-Oedipalists charge Freud with tunnel vision in the case of the Wolf-Man, where "[Freud] glances at his dog and answers, 'It's daddy.'")[3] Just like Oedipus. Sees nothing and understands nothing, while playing the know-it-all. Doesn't know his own dad from a dog, or a beggar at the crossroads. Slays him with his rod and still comes up with the short end of the stick.

There is such animus in this frontal attack on psychoanalysis that it smacks of classic Freudian denial, the *Verneinung*, in which the patient protests too much. In fact, I think the virulence of this *disavowal* indicates that Deleuze and Guattari are more Oedipalist than they aver and that this may be argued with the help of their own theoretical machine. The very title of volume 1 of *Capitalism and Schizophrenia* is a case in point. In the syntactic terms that Deleuze and Guattari themselves formulate, their "anti"-Oedipal diatribe would qualify as an "exclusive disjunction": a binary, oppositional, either/or antagonism which draws a line in the sand. As they assert in *Anti-Oedipus*, two positions, and only two positions, figure in their theoretical scheme: "there are only resistances, and then machines desiring-machines." In this system, Oedipus is clearly a resistance, a limit, a constraint imposed on the infinite combinations produced by desire. And in *Anti-Oedipus* at least, the villain is not only guilty of resistance to the free flow of combinatory desire; as the henchman of psychoanalysis, he seems to be guilty of everything from the crimes of capitalism to the promotion of global psychosis, including perversion. Indeed, referring to "the intrinsically perverted nature of psychoanalysis," the anti-Oedipalists assert that "perversion in general is the artificial reterritorialization of the flows of desire."[4] Like a morals squad, the antiperverts seem determined to set the record straight, as it were; with all the subtlety of a heat-seeking missile, they aim to explode the myth of Oedipus and thereby, as they say, "to discover beneath the familial reduction the nature of the social investments of the unconscious . . . so as to discover the abstract figures, the schizzes-flows that it harbors and conceals."[5]

This virulent critique is all the more disquieting because it is compelling; *Capitalism and Schizophrenia* fashions a strikingly original geology of morals, a Brave New World of millennial theory complete with nomads, rhizomes, totemic emblems, faceless heads, and living rocks. But in upgrading theory for the New Age, must psychoanalysis be jettisoned like a burned-out rocket stage? Does Freud come with an expiration date, circa 2000? As a pro-Oedipal bimillennial, I suggest that it is time to suit Oedipus up for the third millennium, trading his toga for a space suit, wiring him like a state-of-the-art Internaut—a "probe-head," in Deleuze's sense of the term—so that he may effect a "deterritorializing line of flight" across strata, across a thousand plateaus, propelling us into the New Age. On the eve of the millennium, it is perhaps time to put Oedipus back on-line, as

a proto-cyborgian emblem of the very desiring-machine to which he is opposed by his critics.

Let me muster the radical insights of the Freudian apostates themselves, then, to support the following critique of their position. First, the crux of the Freudian Oedipal paradigm is not the patriarchal "familial romance" of "daddy–mommy–me," as suggested in *Anti-Oedipus*, but rather the configuration of connections, disruptions, and refractions of desire that constitutes the human organism and produces social interaction. Oedipus is a desiring-machine, not a Greek matinee idol. Second, the "BwO" ("body without organs") foregrounded in *Anti-Oedipus*—a system of interacting force fields (like a weather map) rather than of discrete subjects or partial objects in conflict—is already implicit in Freud's very early work, such as *Three Essays on the Theory of Sexuality* (1905), as the polymorphous perversity of the always already sexualized infant. Third, by imputing the spectacular failures of late-capitalist society to "Oedipal" neurosis and repression, Deleuze and Guattari conflate the symptom with its cause. In recapitulating only one key insight of *Civilization and Its Discontents* (1930), they have missed the crucial point that connections and disconnections of desiring circuits are socially productive—in their sense of the word— regardless of whether these circuits are ethical, politically progressive, or personally liberating. "Oedipus," even narrowly construed, does not engender capitalist repression; he enacts it. Fourth, even while attacking Freud's notion of Oedipal repression, Deleuze and Guattari adopt the repression hypothesis wholesale (the same notion brilliantly debunked in Foucault's writing on sexuality); they thus misconstrue Freud's most radical, most profoundly social and historic discovery: sexuality as a discursive production of the human psyche and its somatic coordinates, that is, of the desiring-machine housed in a casing composed of real energy fields and molecules (a body). It is possible to think of the libido as a kind of propulsion, say Deleuze and Guattari, the fuel of the desiring-machine, described not as a free "flow" but as a series of intermittent functions, of fits and starts: "Everything functions at the same time, but amid hiatuses and ruptures, breakdowns and failures, stalling and short circuits, distances and fragmentations." The essential thing, in other words, is not the smooth functioning of the machine but its production, which leaves something residual: "To withdraw a part from the whole, to detach, to 'have something left over,' is to produce, and to carry out real operations of desire in the

material world."⁶ Thus the unconscious does not think or believe, and it is certainly not continuous or linear; instead, it produces — meshworks, rhizomes, a labyrinth. This is a striking formulation, but it is not inconsistent with the Oedipal assemblage.

Many of these notions are adumbrated by Deleuze's impressive *Difference and Repetition*, in which difference is shown to be a decentering that inhabits all repetition, confounding the very notion of identity.⁷ In this thoroughly psychoanalytic treatise on figure and ground, he concludes that Oedipus is undecidable and argues for the illusory nature of any originary model. What the critique of identity in *Difference and Repetition* demonstrates is that even at that early, avowedly Freudian stage, Deleuze has begun to cast Oedipus on the side of identity, stasis, sedimentation. For Deleuze in 1968 — when lines were being drawn in France — Oedipus already has his place in the socius, and there is no question which side of the "either/or" separating repression from desire he's on.

But this Oedipus can only be received as astonishing by anyone with even a passing knowledge of Freud or Lacan (whose whole theory is based on shifting loci), let alone of Sophocles. Not even in Greek tragedy is Oedipus the agent of law and unitary self-presence. He is, after all, the man who never knows who or where he is, can't tell his father from a homeless man, and actually marries his mother by mistake even after the Oracle has alerted him to the danger. He doesn't even know that there's no place like home. The Oedipus narrative is indeed a machine — *la machine infernale* of Jean Cocteau's version, whose characters have significance only when "plugged into" each other's histories and desires. Mother/wife is significant only as a conjunction, and a disjunction. Indeed, Jocasta is a force field, a strange attractor, drawing her son/husband — *fort* and *da* — into an erratic and errant circuit. For Oedipus begins life as an exile, and ends up as one. The figure/ground story is actually a parable of "first time" as repetition: Oedipus loses his virginity in the same place it was conceived, showing that repetition, as Deleuze himself argues, is a function of displacement and disguise. But in *Anti-Oedipus*, Deleuze and Guattari seem to have disavowed their own compelling insights on displacement and regressed to a straightforward either/or attack mode, exemplifying their own category of "exclusive disjunction."

Let's assume that we're acting as the advocate for Freud and his spokesman, who are conflated to such a degree that I'm tempted to refer to my

"defendant" as Freudipus. What exactly are the charges leveled by the anti-Oedipalists? You name it, he's done it.

—He's a crass commercialist, a shady inside trader, for "psychoanalysis does not invent Oedipus";[8] it markets it.

—He's a Lacanian, caught up in the holy trinity of "lack, law, and signifier."[9]

—He's unkind to animals (especially those with talking heads, big paws, and a penchant for riddles); Deleuze and Guattari howl (in *A Thousand Plateaus*) that Oedipus kills our wildness, our "becoming-animal."

—He's a despotic killjoy, the agent of ideological hegemony, far too powerful to be tolerated; it is at the strongest point that he must be attacked, for "our society is the stronghold of Oedipus"—he is "everywhere."[10] In other words, he signifies blockage of the free, decoded flows of intensities and energies, which is an unpardonable offense. (When it comes to the search for schizoid thrills, get on with the orgy or be labeled a pervert.)

—He's a good-for-nothing, a ne'er-do-well: "Oedipus is completely useless," Deleuze and Guattari state flatly, "except for tying off the unconscious on both sides."[11] (Threadipus Rex?)

—He's a capitalist, and into semiotics to boot, for the crimes of the signifier include commodity fetishism: "For example, in the capitalist code and its trinitary expression, money as detachable chain is converted into capital as detached object. . . . The same is true of the Oedipal code: the libido as energy of selection and detachment is converted into the phallus as detached object."[12] In other words, Oedipalization converts all the break flows and discontinuities into the same major currency, flattening difference.

But in the next section, Oedipus is accused of the opposite crime—not the deterritorialization of energy flows but the reterritorialization of desire—in the name of Family Values. Now he's a linear positivist; let the signifier float as it will, there's just too much tendentious meaning in Oedipus, a conspirator with the international mafia of hermeneuts and therapists: Psychoanalysts are bent on producing man abstractly, that is to say ideologically, for culture: "How does one prevent the unit chosen, even if a specific institution, from constituting a perverted society of tolerance, a

mutual-aid society that hides the real problems? . . . How will the structure break its relationship with neuroticizing, perverting, psychoticizing castration?" Freudipus is a cultural imperialist: We are all little colonies, and "Oedipus is always colonization." He drives us crazy (not good, schizoid crazy, just nuts): "Everything in the system is insane: this is because the capitalist machine thrives on decoded and deterritorialized flows; . . . while causing them to pass into an axiomatic apparatus that combines them, and at the points of combination produces pseudo codes and artificial reterritorializations."[13] Oedipus is at it again.

So is Oedipus cause or effect? Does he oversignify/overcode, or is his meaning overrated? Does Oedipus become colonized under capitalism, the product of religion or nation, or is he the colonizing agent? Oedipus gets blamed for everything by the Deleuzian/Guattarian neo-Oracle. Here, distilled from *Anti-Oedipus*, are the Top 10 Schizoanalytic Reasons to Hate Freudipus, as the lackey of lack:

1. Oedipus is the repressive agent of the capitalist state apparatus.
2. Oedipus reterritorializes decoded flows and represses the poor schizo, who would prefer "mental illness" to madness.
3. He functions at the wrong level. Like Gulliver with the Lilliputians, he's too big to be molecular; Oedipus is molar and totalitarian/paranoid, not rhizomatic and schizoid.
4. His language is overcoded and Saussurian, not decoded and Hjelmslevian.[14]
5. Oedipus airs his dirty linen in public. His family story, everywhere in the air, becomes so diffuse as to mean nothing. In other words, Oedipalists are solipsistic, confusing their petty, private family squabbles with the human condition. Oedipus is definitely a bad son.
6. On the other hand, he's a nepotist. His family story, everywhere in the air, is so concrete and figural as to mean everything. Oedipalists are too gregarious, projecting their petty family romance onto all social constructs. Oedipus does have quite a family tree, and the "antis" hate arborescence. Nor is he very rhizomatic in their account— a man of few roots—and the few family connections he does have, he definitely abuses.
7. Oedipus is a structuralist, even a Lacanian, a real type-A personality, driven by law. (The anti-Freudians are scarcely generous to

Lacan; even as they grudgingly acknowledge that he "saved psycho-analysis from . . . frenzied oedipalization,"[15] they complain about the reductiveness of a system that classifies everything as Imaginary or Symbolic. Characteristically, they ignore the third and most deeply problematic register in Lacan's scheme—the Real.)

8. Oedipus makes debt infinite, and this is the era of the balanced budget.

9. When he gets over his complex, Oedipus commands language, but he is then less a king than a "subject," that is, subjected. What's more, he refers to himself in the singular, as "I," avoiding the royal "We" that is the privilege of monarchs and schizophrenics.

10. He's a dreamer, unable to get real and get a life. The error of psychoanalysis is to understand the body without organs as regression, projection, fantasies, imago. (Personally, I think psychoanalysis is to be congratulated for understanding the BwO at all.)

In summing up their case, Deleuze and Guattari fault Freud above all for talking about castration—about what's missing, or might be lost if Oedipus doesn't behave. Lack cannot be a category of the unconscious, they argue, because "desire does not lack anything";[16] it produces.

And they have a point. There is no "no" in the unconscious, as Freud tells us, only plenitude. Either . . . or . . . or. In other words, although his opponents don't admit it, they follow Freud in asserting that the unconscious is characterized by motility of cathexis and absence of contradiction: it is not the site of either/or—the binary logic of exclusion—but rather functions with what Deleuze and Guattari call *inclusive disjunctions*, where inconsistent terms may coexist thanks to the extra "or" that, making (God forbid) a triangle, makes it nonetheless a paradox, an emblem of both connection and alterity:

> It becomes nevertheless apparent that schizophrenia teaches us a singular extra-Oedipal lesson, and reveals to us an unknown force of the disjunctive synthesis, an immanent use that would no longer be exclusive or restrictive, but fully affirmative, nonrestrictive, inclusive. A disjunction that remains disjunctive, and that still affirms the disjoined terms, that affirms them throughout their entire distance, *without restricting one by the other or excluding the other from the one*, is perhaps the greatest paradox. . . . "Either . . . or . . . or," instead of "either/or."[17]

Disjunctive inclusion: I think this is a more productive syntactic model for reading Oedipus than the either/or, stratified "anti" stance in which Oedipus himself is considered a stratum, a hardening of the fluidity of human desire. But Deleuze and Guattari are right: the unconscious doesn't lack anything. There is no "no" in the unconscious, no *either* (mother) *or* (wife), as Oedipus learns the hard way.

How does the defendant plead? *Guilty*, of course. Freudipus invented the guilty conscience. What is the sentence? The plaintiffs have a suggestion: "A true politics of psychiatry . . . would consist . . . in . . . undoing all the reterritorializations that transform madness into mental illness."[18] Rehabilitating the culprit means convincing him that schizophrenics aren't crazy and teaching him that desiring-production is one and the same thing as social production. The problem is that Freud might well agree. It matters how you read Freud — and which Freud. Deleuze and Guattari themselves convincingly frame two alternative theoretical visions, whereby the same territory (the sea, for example) may be experienced as smooth or striated. Smooth is fluid, molecular, destratified; striated is territorialized. Well, Oedipus is at once smooth and striated, something like Deleuze and Guattari's holey space. Subject O is but a placeholder, occupying a site that every nomad occupies in turn, just passing through. The family threesome is but one of the desiring-assemblages/machines configured by the Oedipal/Freudian diagram, globally construed. In fact, Freudian theory, particularly as read by Lacan, Laplanche, Pontalis, and company, describes a trajectory — *how* the unconscious functions, not *what* its content is. To use the high-tech lingo of *A Thousand Plateaus*, the Oedipal parable might be said to describe a self-organizing process at a moment of bifurcation when the self "crystallizes" in response to both catalysts and "attractors." In other words, Deleuze and Guattari conflate message and path; Oedipus is a diagram or machinic phylum, not a self-help manual.

In any case, Deleuze and Guattari seem to be less than jurisprudent in handing down an indictment that puts Oedipus in triple jeopardy. They seem to pronounce him guilty, on the one hand, *either* because he's too influential and significant *or*, on the other hand, because he's meaningless and insignificant, *or*, on a third hand, because meaning doesn't matter, only function does. "Inclusive disjunction" can come in handy in court. But it is hard to accuse Freud's antagonists of a self-defeating lack of logic since they repeatedly affirm inclusive disjunction as their preferred brand

of cognition—labeled *schizoid*, reflecting the fluidity of "either . . . or . . . or," freeing up the psyche from the constraints of grammar-as-syllogism.

The paradox of the inclusive disjunction is indeed instructive and productive, but is it schizoid and non-Freudian/Oedipal, as Deleuze and Guattari would have it? After all, Freud explains the "logic" of the unconscious in strikingly similar terms, saying that one of its characteristics is the ability to hold two or more logically exclusive notions at once without any sense of contradiction. In fact, this logic is the centerpiece of a work on machinic, automatic desire in which Freud foregrounds triangulation and the social—*Jokes and Their Relation to the Unconscious*. This is a much better paradigm for social machination than the Sophoclean parable, although they describe the same trajectory. Here, Freud tells one of his favorite Jewish anecdotes, putting forth the celebrated "kettle argument," the epitome of logical nonsense:

> A. borrowed a copper kettle from B., and after he had returned it was sued by B. because the kettle now had a big hole in it which made it unusable. His defense was, "First, I never borrowed a kettle from B. at all; secondly, the kettle had a hole in it already when I got it from him; and thirdly, I gave him back the kettle undamaged." Each one of these defenses is valid in itself, but taken together they exclude one another. A. was treating in isolation what had to be connected as a whole. . . . We might also say A. put an "and" where only an "either, or" would suffice.[19]

Surprise, surprise—from the mouth of the Oedipal enemy himself comes a perfect example of putatively schizoid, anti-Oedipal reasoning: inclusive disjunction. Deleuze and Guattari, like the kettle borrower, tinker with smooth logic and forge a holey argument, then claim to own what they've borrowed from Freud. The anti-Oedipalists, overstating their case—Oedipus has handed us a fine kettle of fish—betray the radicality of Freud's discovery, then protest too much, with leaky reasoning and overspill—kettle logic. Still, I will overrule my own objection, since I want to join in the fun and use precisely the same inclusive-disjunction defense for Freud/Oedipus. To the plaintiffs I say: (1) You never lent us loyalists the true Freudian kettle of psychoanalysis; (2) when you lent us the Oedipal cauldron (in your version), it was already riddled with holes (thanks to your potshots); and (3) here, we're returning the vessel undamaged (handed

over by Lacan), bright and shiny, an example of what you call smooth, non-striated space. Or, better yet, holey space, forged by itinerant metallurgists, those smiths and tinkers honored in *A Thousand Plateaus*. The defacialized millennial Oedipus is a nomadic spaceman, forging and tinkering with a new image: a high-tech Tin Man, a metallic cyborg, an (empty) Oedipal kettleful.

Let me elaborate briefly on these inclusive disjunctions. The plaintiffs never lent my clients the theory they say has been vandalized, since they never owned it: the family romance and rule of law is not the radical essence of Freud as reread by Lacan, as even Deleuze himself acknowledges (in *Difference and Repetition*, where Oedipus is acquitted on the grounds of reasonable doubt, for he is pronounced undecidable). Now, desire is indeed a mechanical matter, an assemblage of one node hooked onto another, *pace* Deleuze and Guattari: Think, for instance, of the nursing infant, protagonist of Freud's seminal *Three Essays*, hooked to the mother's "flow" and plugged into (or "laid onto," in the *Anlehnung*) her field of intensity. The mother of *Three Essays* is by no means the contested Oedipal Mother, or even the pre-Oedipal Madonna; she is an agent of production, a dairy factory overlaid with hallucinatory desire. Moreover, the formulation of desiring-machine versus Oedipal blockage or stratification does not begin to account for the complexities of this Freudian notion of *Anlehnung*, or of polymorphous perversity (also central to *Three Essays*). But it is an excellent example of the infant body as a body without organs, or rather a body of nothing *but* organs, one big erogenous zone entertaining multiple intensities and flows.

True, the socializing process "organizes" this pure field into genital sexuality, but the point of *Three Essays* is that "perversion"—not "normalcy"—is primary and endemic to the human species. Moreover, sexuality is mimetic and contagious, always "plugged in" to multiple desiring minds/bodies. As Lacan puts it, our desire is the desire of the Other. In this formulation (expressed by Lacan as the excess of demand over need), all desire, even old-fashioned desire for Mommy, is refracted, alienated, and circulatory— a boomerang or a missile with a homing device. Yet in spite of this overwhelming evidence that psychoanalysis is more than "daddy–mommy–me," Deleuze and Guattari persist in accusing Freud of abandoning desire, which constitutes a felony: "The Freudian blackmail is this: either you recognize the Oedipal character of infantile sexuality, or you abandon all

positions of sexuality."[20] This additional charge of blackmail is not only overstated but incomprehensible, for *Three Essays* focuses on distinctly non-Oedipal avatars of desire, or "perversions." Freud's radical point is that desire is automatically perverse, deflected from its object (the breast) to a substitute, which Lacan would later formulate as an excess (of demand over need): every baby cries, even when all its needs are met. This is polymorphous perversion, but perversion, as Freud reads it, is above all deferral of and deflection from goal, one of the principal expressions of destratified, deterritorialized flows that Deleuze and Guattari invoke. They call psychoanalysis an ideology of lack, but it is really a mapping of excess, of perversion as the very condition of sexuality. In fact, citing perversion as the opposite of neurosis, Freud says we must imagine the pervert a happy man. So Deleuze and Guattari certainly never lent us a truly Freudian kettle, but tried to pass off a fake (the figure of daddy–mommy–me) as the real article.

Second defense: the Oedipal kettle was riddled with holes when you gave it to us. It is hard to believe that Deleuze, psychoanalytic savant, is not being disingenuous when he accuses Oedipus of not being a political animal, of being insufficiently cathected to the social field. The plaintiffs presume to blast the "hypothesis dear to Freud: the libido does not invest the social field as such except on condition that it be desexualized."[21] Is *this* what Freud says? Tell that to the Frankfurt school, who discuss the erotic appeal of fascism; or to the Freud who analyzes the herd dynamics of army and church as a kind of infatuation in *Group Psychology and the Analysis of the Ego* (1921); or to Fredric Jameson, when he theorizes the political unconscious as cathexis. What about the libidinal scenarios of identification with a charismatic leader in *Group Psychology* or the passionate social cannibalism in *Totem and Taboo* (1912), where the kids identify so strongly with Dad that they eat him? And what about the orgiastic murder of Moses by his "children," under the influence of pagan desire, schizzes and flows, the golden calf?[22] Unless one restricts sexuality to genital contact, one must be blind indeed to see in Freudian theory a passionless, nonlibidinal social field. Moreover, the anti-Oedipalists' either/or exclusive disjunction simply overlooks the radicality of the most intriguing Freudian insights, such as the death instinct, the narcissistic constitution of the ego or the splitting of the ego in "Mourning and Melancholia" (1917), and the nonlinear economics of masochism. Not a parent in sight. The Deleuzian critique of Oedipus is applicable only to the most rigidly construed Freudian ortho-

doxy, while French Freud has been dissing the APA for some time, show-ing that processes of "organizing" and "mastery" are driven as much by thanatopic and sadomasochistic impulses as by any punitive notion of law or any normative notion of cure. Freud's *Three Essays* recasts sex as sexu-ality, that is, as an irrevocably social effect, not an "instinct." The process of subjectification is a social production, as Deleuze and Guattari assert, but one that is driven by amplification, not repression, of desire. The Deleuzian kettle is already a pretty leaky vessel when it is given to us in *Anti-Oedipus*.

Third defense: the kettle had no hole when you got it back; or, maybe this is a false debate—can we settle out of court? I think we can agree with Deleuze and Guattari that psychoanalysis should not be in the business of discovering such-and-such a code, even that psychoanalysis must undo the codes so as to attain the quantitative and qualitative libidinal flows that tra-verse dreams, fantasies, and pathological formations. In other words, okay, some of Freudian theory is vatic and dogmatic. Undoing the dogma is a fine agenda, a good itinerary and one that Jameson follows in *The Politi-cal Unconscious*, as do French Freudians like Lyotard and Laplanche, and French feminists like Irigaray and Montrelay, in their own Freudian cri-tique of Freud. I suggest we take Oedipus along as navigator, for at the center of the Oedipal paradigm is pure desire, cathecting, disconnecting. As we give the plugged-in electric kettle back to our opponents, we say: Kettlepus is good as new, see? A certain Oedipus actually fits your own theory of smooth, nomadic space—or rather, because he's hollow, he's an example of holey space. Deleuze and Guattari are right to ask of the un-conscious not "What does it mean?" but "How does it work?" They just need to put the same question to the Oedipal machinic diagram.

Let me raise a new question now, recasting "daddy's mommy and me" as "desiring-machine and multiplicity": Does the family romance qualify as one instance, one stratum, of an inclusive disjunction, a larger mechanism shot through with "lines of flight"—the abstract machine as sliding signi-fier or overdetermined meaning that will not stop at one point and will always produce a remainder? The Oedipal configuration is not just a family tree but also a rhizome, a tentacular tuber sending out shoots and cross-ing lines (Octopus Oedipus), for Deleuze and Guattari finally make the crucial point that "the unconscious poses no problem of meaning, solely

problems of use."²³ However, this insight is also received or even "lifted" from Freud, like the kettle logic Deleuze and Guattari deploy.

In any case, we could consider Freud's *Jokes* an alternative scenario to the Oedipal one, in which Freud is elaborating a functionalist conception of intersubjectivity as "abstract machine." What this reading suggests is that Deleuze and Guattari get it backward: rather than projecting Oedipus onto everything, a radical Freud sketches Oedipus as a parable or even as a machinic blueprint, merely one instance of a more inclusive narrative or operation in the "anthropomorphic" strata. Freud's work tells the story of the origin of joking itself, and, not surprisingly, it is a triangulation tale, a classic boy-meets-girl narrative.²⁴

BOY MEETS GIRL. "The one who makes the joke" encounters a desirable "object," gets ideas, and makes them known in "wooing talk." BOY LOSES GIRL. But the wooer's design is confounded by the entry of a second male — a potential rival and decidedly importunate third party. Alas, the implicit rivalry between the "boys" interrupts the natural course of events. JOKE CONQUERS ALL. But never fear, boy does get girl, by "exposing her in the ob-scene joke" and enjoying the spectacle of her embarrassment, effecting an imaginary exposure or put-down which is clearly both voyeuristic and exhibitionist: the hapless woman is now exposed before a listener who has been "bribed by the effortless satisfaction of his own libido." Joker and listener, poles one and three (boys will be boys) share a laugh at the expense of pole two in the locker-room joys of male bonding.²⁵ But the laughing listener does not escape unscathed. Freud points out the aggressive nature of this capturing of the listener's attention (hit by a surprise punch line), and he insists on the pleasure the joker takes in misleading his hearer. This dupe damps down his annoyance by "resolving to tell the joke himself later on" (to the next victim in the joking chain).²⁶ Thus the joking triangle is always a quadrilateral of sorts, a social chain in which the imaginary capture of both the joke's object (pole two) and its listener (pole three) is perpetuated by a changing cast of players. The joking pleasure produced turns out to be as double-edged as its punch line, for the joke is a circuit in which no one's identity remains uncontaminated by exposure to the Other's desire.

One could hardly ask for a clearer picture of desiring-machines at work ("to withdraw a part from the whole, to detach, to 'have something left over,' is to produce, and to carry out real operations of desire in the ma-terial world"). Like the desiring-machine, joke production works, subject

to fits and starts: "One machine interrupts the current of the other or sees its own current interrupted,"[27] just as the wooer is interrupted by the entry of the rival.

Although this "diagram" seems to be content-specific, it is actually functionalist, showing not what joking means but how it works. It should remind us of another shady story of love, aggressivity, and renunciation. In the classic Oedipal myth, of course, boy does indeed get girl, by simply eliminating the paternal rival. Freud's own retelling of the myth, however—the postulation of outcome in the Oedipal phase of human development—reinstates the happy ending of the joke paradigm: the subject identifies with the former rival, renounces the impossible love, and chooses a substitute object to ensure the long-circuiting of his desire, a productive remainder that sends him on his way in search of another hookup.

Finally, in another crucial text on social constructs and triangulation, "Creative Writers and Daydreaming," Father Freud insists on the role of veiling (*Ankleidung*) in the creative process: the writer softens his or her own daydreams—themselves already "veiled" versions of the same sort of erotic impulses that motivate the joking process—by "changes and disguises."[28] In other words, in order to satisfy a wish, the writer must display an "object" to a voyeur (the reader), but only after a costuming, a dressing-up which eroticizes the dressing-down, as in the joke. The joking triangle may be overdetermined, as in the diagram below.[29]

2

desired female–butt of joke
Jocasta–Mother
writer's "daydream" object–character

I
desiring subject–joker
Oedipus–child 3
writer–dreamer joke listener–intruder–accomplice
 Laius–Father
 reader

This diagram shows how the Oedipal scenario is really only an instance of a larger, "automatic" process. Far from simply blocking desire, it recycles it, hooking up one desiring-machine with others who read, who laugh, and who compulsively repeat the circuit that defines their own "drives," hard

and soft. The joke *must* be told to someone else, for payback and production of pleasure. The joke is consistent with the Oedipal drama not because everything reminds the joker of Mother and Father, but because, in the desiring chain, everything hooks up to other planes, other desiring-linkages, other planes of consistency. The Oedipal diagram is a rhizome.

At the end of the joking process, the "triumphant" listener takes flight into holey space in search of a new connection. So, the Oedipal scenario sends the odd man out in a nomadic line of deterritorialized flight toward the Other, to unsettle a new territory, with "something left over": the desiring animus left by the impact of the punch line, the encounter with Oedipus as Other. And what is the joke scene? It is the "space" of the unconscious, neither smooth nor striated but *either* smooth *or* striated *or* holey: like outer space itself, a big O filled with heavy black holes which riddle a vacuum where much of the matter, and all of the "gravity," is . . . missing.

═══

So let's take Internaut Oedipus into the next millennium. The ludic field of the joke is not unlike cyberspace. What is a labyrinthine message path but a voyage in space, a peregrination, traced in the header—a signifying chain in which the subject is a subject for another signifier, the address a message for another address? It is a "path" that is also a "string"—not "tying off the unconscious on both sides," as Deleuze and Guattari charge, but taking us hither and yon (*fort* and *da*)—passing linked bits of desire from terminal to terminal, subject to subject. In this formula, cyberspace is a virtual playground of desire as excess. For do we in fact *need* all this information, on demand? The act of chatting is more significant than the chat. More important than what millennial Oedipae ask is how and where they ask it, by what circumlocution: cyberspace voyages entail zigzagging paths, an effect of our situation relative to the other's imaginary "identity" (a kind of psychic URL, where the other may be "located" but not found).

To quote Deleuze and Guattari's love ode to the probe-head, a faceless avatar of the Lacanian Other: "You are longitude and latitude, a set of speeds and slownesses between unformed particles, a set of nonsubjectified affects." "Wonder of a nonhuman life."[30] Just so, Oedipus, vagrant space voyager, monstrous and human, a desiring-machine: in the Information Age, desire and the social are still the only players, just changing

sites. The cyber-version of their interaction manifests Oedipal prohibition as screen and detour, the labyrinth of hypertext links, the conditions of e(ccentric)-communication (thou shalt not go directly from point A to point B without navigating the Web). For being on-line does not assuage or even reflect desire; it engenders it. Cyberspace is filled with Oedipal questions: Who are my Others? What is human? Who is out there? Can you come out (or in) to my chat group and play? The Other (big O) might just be Oedipus, asking us to come on-line.[31]

With the movement of Oedipus from Greek hero to cyborg, from tragedian to joker, we have traversed points of convergence among what Deleuze and Guattari call the three "strata" of energy and matter—the anthropomorphic, the organic, and the inorganic.[32] For all three strata are enmeshed in the figure of the (whistling) kettle, where energy transforms matter, a desiring-machine that produces and vents desire, as it "lets off steam." The Tin Man is a living kettle who leaks real tears, rusting in the process (and whistling too: "If I Only Had a Heart"). A template of Deleuze and Guattari's robotic probe-head, Kettlepus is human, an organism, and metallic all at once—a body without organs on a line of flight over the rainbow in search of a good cardiologist.

═══════

Let me conclude with what Deleuze and Guattari call "the wonder of a nonhuman life," which I call Nonorganic Oedipus, following Manuel DeLanda's imaginative essays "Nonorganic Life" and "Immanence and Transcendence in the Genesis of Form."[33] In these essays and elsewhere,[34] DeLanda expounds upon the difference between tree and rhizome, applying the distinction between hierarchies and meshworks. Hierarchies, he says, are formed by coagulation and deceleration in the flows of biomass, genes, memes, and norms as a result of hardening and sedimentation, or stratification; meshworks, however, are characterized by fluidity, resulting from the erosion and proliferation of nodes, segments, and assemblages. Hierarchies such as trees settle and consolidate vertically, while meshworks—rhizomes such as crystals or the Internet—spread and branch out. Furthermore, there are "abstract machines" behind the structure-generating processes that yield, as historical products, particular meshworks and hierarchies. DeLanda also provides a helpful exegesis of the notion of abstract machines as engineering diagrams, such as a blind

probe-head or searching device, defining "the edge" of a process or the parameters governing the emergence of assemblages.

Similarly, in their conclusion to *A Thousand Plateaus*, Deleuze and Guattari tell us that abstract machines constitute becomings, that is, they make something open onto something else,[35] hence their granting of a special status to metallurgy, which studies changes of state—fluidity and hardening—and to metalwork, the craft of nomads. Matter–energy is deterritorialized by nomadic metalworking, in which tool, ornament, and weapon manifest intersecting forms and functions.

So, is Freud/Oedipus a cutting edge—an abstract machine or diagram— or a blockage, a resistance to energy flows? Is he, like a kettle maker, a metalworker, or an itinerant tinker, ambulant and deterritorialized matter– energy? Or does he "settle" in and down, having successfully resolved his complex? Does he create meshworks or stratifications? Does he postulate an eternal unconscious with one immutable family romance or describe a functioning assemblage, cutting across boundaries, intruding into new territories, unsettling any home to which he returns, the catalyst intruding into consciousness, the return of the foreclosed, provoking cataclysm?

DeLanda claims that such self-organizing systems of matter reach points of bifurcation, where a catalyzing agent changes the course of events. Energy oscillations (like the *fort–da*) seek the right viscosity, transforming stasis or chaos into a stable pattern of oscillatory movement, such as that of weather or chemical clocks.[36] In these terms, I think Oedipus and triangulation, or intersubjectivity—compelling human subjects to repeat and to live—could be considered that which gives human life its proper viscosity, its stable oscillation. The point of bifurcation, or cross catalysis, would occur with an encounter between subjects—yielding intersubjectivity in both Lacan's and Althusser's sense of interpellation—a meeting at a crossroads between a wanderer and an anonymous old man, say, who quarrel and change the course of events.

In other words, Oedipus, globally construed, marks the convergence of force fields, desire as movement, as oscillation—or, at the very least, the oscillation between states of relative stability, a balance in movement, a resilience, a stable oscillation—movement governed by attractors. Resiliency is life on the edge, suspended between stasis and chaos. It is existence poised on the rim of a basin of attraction or a resting point, home or death or "stability" as matter–energy locked into the field of an attractor. In fact,

in *Beyond the Pleasure Principle* (1920), Freud furnishes an excellent example of such a state of resiliency, the effects of drives in competition that lead to movement, *fort* and *da*, a certain compromise between the urge to complete a discharge of energy (pleasure) and the need to recharge the organism or to maintain a specific level of energy. Oedipus necessitates a detour, an extended path to a deferred end, avoiding the short circuit in yet another machinic assemblage that describes a long circuit (like joking, like writing). *But the force field created by the oscillation is not just a metaphor*; it is a description of how desire (energy) behaves when it encounters certain catalytic conditions, what Deleuze and Guattari, and DeLanda, call a bifurcation. The *fort–da* compulsive repetition is a periodic or cyclic attractor, where energy is cathected, alternately, to processes of life and of death. Although Freudipus can be read as a family narrative, then, it may also be read as a machinic diagram describing a functionalist material assemblage. As Deleuze and Guattari themselves note, one never stops, and never has done with, dying—or, I would add, with living. For what Freud calls the successful resolution of the Oedipus complex is finding a balance on the rim of the basin of the attractor, between chaos and stratification. That's why Deleuze and Guattari are wrong to think of the Oedipal circuit as a family battle with winners and losers, lawmakers and lawbreakers; there are only circuit nodes connecting two elements, and circuit breakers separating them. There can never be intersubjectivity with fewer than three parties precisely because the third is the catalyst, something like the extra "or" in the "either . . . or . . . or" inclusive disjunction.

This corroborates what Deleuze said in his pre-anti-Oedipal days about Oedipus being strictly undecidable—not a behavior but the parameters of an assemblage. So Oedipus is protean, looking and acting differently in different social configurations: each set of determinate conditions causes the abstract machine to produce a completely different viscosity—Oedipus the king, paranoid and despot; Oedipus the stranger, upstart and revolutionary; even Oedipus the happy man, pervert or joker. However, he always experiences a bifurcation at the crossroads thanks to the encounter with the third, the catalyst who comes along to be hit by the punch line. Commenting on this analogy between the catalyst and the joking third, DeLanda notes that "it makes clear the significance of the number 3 in science (a minimum of three actors to get the intersubjective dynamic going sounds like a critical mass threshold, which after being crossed causes the

emergence of new assemblages)." Intersubjective threesomes (or more-somes) would act as "tipping points," catalysts for bifurcation. Oedipus has all the trappings of an assemblage: tangled shapes, strange attractors (the Sphinx), figures of destiny (the Oracle), bifurcations as choices between destinies (the crossroads), and the pull of more than one attractor (Thebes or Corinth? Shades of the strawbrained Scarecrow at the crossroads giving befuddled directions to Oz).

Indeed, I think Deleuze and Guattari form a triangular assemblage with Freud from which a theory emerges, transformed. We bimillennials should be anti-anti-Oedipals, since Oedipus himself is already anti-Oedipal: an errant, fragmented remainder of the ineluctable machinations of blind desire, without specific content. He follows a trajectory, an oracular "code" or program, not in response to a specific desire for his mother, whom he does not even know, or a specific animus toward his father, a complete stranger. He does not kill the Symbolic father or marry the Symbolic mother; he operates in the automatism of the Real. Neither good nor bad per se, Oedipus is an abstract machine, effectuating connections or delaying them. As Deleuze and Guattari assert, the unconscious poses a problem of use: "The question posed by desire is not 'What does it mean?' but rather '*How does it work?*'"[37] (Sure, it's a kettle, but does it hold water?)

So Deleuze had it right in *Difference and Repetition*. Oedipus is undecidable; society is a milieu for the circulation of "unowned" objects, holey or intact, thefts or gifts. Deleuze and Guattari put it this way: "There is no Oedipal triangle: Oedipus is always open in an open social field,"[38] one whose effects will be determined by the conditions we shape and that shape us. But even if they disavow the ménage à trois, Deleuze and Guattari concede that "one never deterritorializes alone": blind Oedipus takes along Antigone, who is three (mutually exclusive) companions in one— *either* mentor *or* sister *or* daughter. Blinded, this probe-head has black holes for eyes—holey spaces: holes in his head; a quixotic knight-errant with holey armor, missing links in his "chain mail"; Oedipus and Antigone as Don Quixote and Sancho Panza—warriors not at war but a war machine in Deleuze's sense—on a holey quest. This need for companions in flight is also familiar to the Tin Man, who joins an intersubjective assembly for the journey to the Emerald City, the big-O capital of Oz. The Internaut, voyaging through holey space (*Star Trek* meets the *Odyssey*)—riddled with riddles, with black holes and pitfalls—navigating between voracious mon-

sters and ruthless living rocks, is part of an assemblage subject to a force field. (The Wizard is indeed a strange attractor, a *distractor* on the long journey over the rainbow, even though "there's no place like home.") The rainbow is smooth and striated space, an ark/arc ending at a leaky cauldron filled with fool's gold, the punch line being that we have gone to the ends of the earth but never left home. Like Oedipus. For although Earth's smooth global space is striated with inscribed coordinates to govern progress, it always brings the wanderer full circle.

Deleuze and Guattari call this itinerant disjunction nomadic movement or flight; Freud calls it displacement, the motility of desire, the return of the repressed. But we can all agree with the lyrical enigma that is the last word on space in *A Thousand Plateaus*, which assures us that the most satisfying closures have loopholes, that the road of golden bricks has potholes; one need only solve the riddle of the Sphinx, or unveil the Wizard, or "get" the punch line to be riven by the discovery. Deleuze and Guattari warn us, in closing their round on the smooth and the striated, of what Oedipus and his avatars have always been up against: "Never believe that a smooth space will suffice to save us."[39]

Notes

1 Gilles Deleuze and Félix Guattari, *Anti-Oedipus: Capitalism and Schizophrenia*, trans. Robert Hurley, Mark Seem, and Helen R. Lane (Minneapolis, 1983 [1972]).

2 Gilles Deleuze and Félix Guattari, *A Thousand Plateaus: Capitalism and Schizophrenia*, trans. Brian Massumi (Minneapolis, 1987 [1980]).

3 Ibid., 37, 38.

4 Deleuze and Guattari, *Anti-Oedipus*, 314.

5 Ibid., 271.

6 Ibid., 42, 41.

7 Gilles Deleuze, *Difference and Repetition*, trans. Paul Patton (New York, 1994 [1968]).

8 Deleuze and Guattari, *Anti-Oedipus*, 365.

9 Ibid., 111: "The three errors concerning desire are called lack, law, and signifier."

10 Ibid., 175.

11 Ibid., 81.

12 Ibid., 73.

13 Ibid., 320, 170, 374.

14 Ibid., 242–43.

15 Ibid., 217.

16 Ibid., 26.

17 Ibid., 76.

18 Ibid., 321.

19 Sigmund Freud, *Jokes and Their Relation to the Unconscious* (1905), Vol. 8 of *The Standard Edition of the Complete Psychological Works of Sigmund Freud*, trans. James Strachey (New York, 1961 [1955]), 62.

20 Deleuze and Guattari, *Anti-Oedipus*, 100.

21 Ibid., 352.

22 Sigmund Freud, *Moses and Monotheism* (1939), Vol. 23 of Strachey, trans., *Standard Edition*.

23 See Deleuze and Guattari, *Anti-Oedipus*, 109.

24 For an elaboration of the joking paradigm to which I refer here, see chapter 4 of my book on the jokework: Jerry Aline Flieger, *The Purloined Punch Line: Freud's Comic Theory and the Postmodern Text* (Baltimore, 1990), 89–122.

25 See Freud, *Jokes and . . . the Unconscious*, 98–100.

26 Ibid., 139.

27 Deleuze and Guattari, *Anti-Oedipus*, 41, 6.

28 Sigmund Freud, "Creative Writers and Daydreaming" (1908), Vol. 9 of Strachey, trans., *Standard Edition*, 153.

29 See Flieger, *Purloined Punch Line*, 94.

30 Deleuze and Guattari, *A Thousand Plateaus*, 262, 191.

31 For further discussion, see Jerry Aline Flieger, "Is Oedipus On-line?" (paper delivered at Cyberconf5, Madrid, 1996), in *Pre-Texts: Studies in Writing and Culture*, ed. John Higgins (London: Carfax, in press).

32 See Deleuze and Guattari, *A Thousand Plateaus*, 44–74.

33 Manuel DeLanda, "Nonorganic Life," in *Incorporations*, ed. Jonathan Crary and Sanford Kwinter (New York, 1992), 128–67; and "Immanence and Transcendence in the Genesis of Form," which appears in this issue of *SAQ*.

34 Manuel DeLanda, *A Thousand Years of Nonlinear History* (New York: Zone Books, forthcoming).

35 Deleuze and Guattari, *A Thousand Plateaus*, 510–14.

36 See DeLanda, *Thousand Years of Nonlinear History*, 154–57.

37 Deleuze and Guattari, *Anti-Oedipus*, 109.

38 Ibid., 96.

39 Deleuze and Guattari, *A Thousand Plateaus*, 500.

Deleuze's Philosophy of the Concrete Jean-Clet Martin

If Gilles Deleuze's philosophy makes no concessions to abstraction, that certainly does not mean it must be accessible to everyone. The concept takes place in silence, in that twilight moment [*entre chien et loup*] when we are no longer sure what it was we were supposed to understand, when communication is blocked and reflection comes up against its own stupidity [*bêtise*]—a moment when we don't really know what to think, a moment of difficulty for thought.

It is in this sense that Deleuze often said the concept needs an idiot in order to be realized. It has to encounter the difficulties that idiots experience as the fascinating singularity of a thing or an event. To have difficulty, or rather to be in difficulty, is the position of philosophy mired up to its neck in the detail of the concrete.

For Deleuze, the concrete is the condition of possibility for philosophy and thus for the concepts philosophy is led to create. And if the concrete arouses the idiot in us, it is because its multiplicity overwhelms us, at every step, before our amazed eyes. The concrete is a multiplicity of concretions. It is compact and thick, a condensation that, like its Latin root *concretio*, expresses

an assemblage. The concrete is thick, thickened by anything capable of growth as an ensemble: an aggregation of forces or, as in Spinoza, a composition that increases the power of that agglomerate. The concrete is anything that comprises itself, anything that, in this composition of forces, will grow in ensemble [*va croître ensemble*], not without increasing in dimension.

Such a composition, such an assemblage of concrete forces, is called a *concrescence*. In botany, for example, concrescence refers to the grafting of two plants that have sprouted together, side by side. Sometimes even two plants of different kinds will become a concrescence, with a branch of one grafting to a branch of the other. But then something remarkable happens: These two engage in a common becoming, a marriage against nature that produces seedless fruit the idiot cannot plant and whose ripening he cannot understand.

We are talking about a composition, a botanical concretion, a rhizome of forces, a thicket of singularities that, acting like plants, do not so much filiate as pullulate. Confronted by the rhizomes of the concrete, we cannot help but lose the power of linear thinking or deductive reasoning: neither the mandarin orange nor the mule can reproduce in accordance with seminal reason.

≡≡≡

Stupidity, or idiocy—the inability to grasp the rationale of certain concretions—is thus a passion for the concrete without which there would be no concepts. The concept can no more be obtained through reflection than a mandarin can. One can't deduce a concept: there is no filiation, no father! Philosophy is not the labor by which a concept is birthed, for it is not subject to genesis. It is obtained by *grafting* rather than by filiation, through the encounter, the crossing, of different species. And, as with the concrescence of two branches, you never know what kind of fruit you'll get! You can't reason your way to an a priori deduction of fruit. A mule has neither ancestors nor descendants. It is an event for an idiot, an event without any *ratio*, without any reason that could be considered originary or any anteriority from which a genealogy could be derived.

Faced with such a configuration [*agencement*],[1] reflection and logic have nothing left to say. This is why the idiot, whom Deleuze describes as a *conceptual persona*,[2] is lost at first; he becomes absorbed in the assemblages of the concrete without knowing how to find those concretions that ac-

cord with his ability to persist in his own being, not knowing a priori with what he should join forces [*avec quoi entrer en concert*] in order to extricate himself. Idiocy in this sense is a kind of groping, an experimentation with often dangerous concrescences. Standing before a flower bed, absorbed by each pistil, by a myriad of petals, the idiot can't immediately formulate a concept by which to fashion a bouquet.

He is too caught up in detail. The multiplicity of the concrete disintegrates, swarms, fragments into a cloud of pollen impossible to configure in any vital way. It suddenly escapes our control over the persistence of being. Sometimes the idiot stammers excitedly, lost in the flux of *concreta* he cannot reassemble. At other times, he manages to channel [*agencer*] his stammering into a kind of *concetto*, even a *concerto*, examples of which abound in literature and music, and that philosophy, for its part, elaborates in the form of the concept.

Neither the concetto nor the concerto, much less the concept, is given ready-made in the face of the swarming singularity of the concrete. And everyday nouns cannot save us from the multiplicity that batters us from all sides, for such nouns cannot be used to form concepts. It is a commonplace that the metaphor, in bearing meaning from one domain to another, can take on the heterogeneity of the multiple. As a matter of fact, Derrida denounces any such synthesis in his analysis of *la mythologie blanche*, while Ricoeur, in *La métaphore vive* (*The Rule of Metaphor*), makes resemblance and metaphoric conveyance the engine of the concept.[3] But the concept has nothing to do with that kind of conveyance.

———————

To the categorial error of metaphors — which consists in obliterating boundaries between genres through a transfer or conveyance of sense capable of arousing new resemblances and thereby new meanings — Deleuze, it seems to me, continually opposes particular regimes of signs, configurations that he calls *diagrams*.[4] These diagrams have nothing to do with the metaphoric gap, with the categorial transgression that simply introduces a deviation relative to a preestablished logical order.[5] The concrescence of a diagram is not something with which to mediate a categorial reconstitution through a conveyance that would respect resemblance and be indistinguishable from what Hegel called *conceptual movement*. The matrix of this movement for Hegel, as we recall, was that of plant filiation, in which

the fruit ultimately aims to take over from the flower: "The bud disappears in the bursting-forth of the blossom, and one might say that the former is refuted by the latter; similarly, when the fruit appears, the blossom is shown up in its turn as a false manifestation of the plant, and the fruit now emerges as the truth of it instead." [6]

If the gap reconstitutes in its wake what it has timidly undone—and all the more effectively—if the transgression of categories by a metaphor that moves between them is an altogether dialectical overstepping, concrescence, inversely, seems to me essentially a becoming. It is, as Alain Badiou would say, the site of that eventful [*événementielle*] discordance which, in a singular transversal, spans a whole multiplicity of heterogeneous dimensions. In this sense, if the gap designates the possibility of metaphoric productivity, the concrescence is more the index of a heterogenesis that Deleuze formulates in terms of conceptual creations.

The metaphor conveys an underlying meaning from one domain to another. For example, the proposition *le soir de la vie* (the evening of life) moves us from twilight, a physical phenomenon, to old age, a biological one. Here we have an analogy, a resemblance that motivates the conveyance of sense. It is in this shift [*trajet*] that Derrida and Ricoeur, in their very different ways, see the dynamism of the concept. Thus in Plato we start with the visible sun and arrive at the Idea of the good. The sun serves as a metaphor by which to define thought as light, the natural light of the mind. For Deleuze, the concept does not work this way. Let's go back to our example, *the evening of life*. There is certainly a resemblance between evening and old age, but there is no concrescence. Metaphors cannot yield concrescences.

The mandarin is a concrescence. It doesn't resemble an orange. It is a grafting of trees of different species. The same is true of a mule, which raises the question of whether such *hybridizations* can be embodied in language. And this is precisely the question that Deleuze poses apropos of the concept: something that occurs *au milieu*, between two series—as with the grafting of two branches.

Deleuze has plenty of examples with which to explicate this grafting: the methods [*procédés*] of Louis Wolfson or Jean-Pierre Brisset and the formulations of Melville or Malcolm Lowry are true *dispositifs*, in Foucault's sense of the term. In *The Archaeology of Knowledge* Foucault constructs his concept of the *archive* on the model of the portmanteau words he discovered with his book on Raymond Roussel and which Deleuze systematizes

within the series that are splayed out like a fan across the pages of *The Logic of Sense*. The most striking example is ultimately the French typewriter keyboard: A-Z-E-R-T.[7]

This statement [*énoncé*] makes no sense. It is neither a proposition nor a metaphor. It is above all incomprehensible—and yet it is not pure nonsense. It is simply a figure of speech that is difficult to think. It has to do with the juxtaposition of the first letters of a typewriter keyboard. AZERT is the statement of a confluence, a statement made *au milieu*, a graft between two heterogeneous series. The first series has to do with the frequency of the letters of the alphabet in the French language: *A*, *Z*, and *E* don't occur with the same frequency in German, for example. The second series has to do with the fingers, with their span and respective length. AZERT is the concrescence of the French alphabet together with the span, or gaps between the fingers, of the hand.

In no other language will the keyboard be the same, the frequency of the letters requiring a new distribution of the keys in accordance with what's feasible for the hand. With the metaphor *the evening of life* we had a conveyance of sense from the physical to the biological. AZERT, on the contrary, is a graft between hand and language [*la main et la langue*]. And there is no resemblance between a hand and a language: this is a matter of two dimensions that can't be articulated by a metaphor, which, according to Aristotle, can only be yielded by analogous categories. To effect a concrescence between hand and language requires something else—what Foucault calls an *énoncé* and Deleuze an *agencement*. We need to create a concretion! AZERT, as an example, is a bit bizarre and utterly trivial. But it has the merit of showing us the existence of a logic that is not one of signification, of the phrase or the proposition.

Now, it is just this type of *semiotic* that governs the constitution of cultural formations and geohistorical mentalities. I am thinking, for example, of the name of St. Marcoul, which, between the eleventh and twelfth centuries, served as the archive or scion [*greffon*] from which the Capetian dynasty constituted itself, as I have shown elsewhere.[8] St. Marcoul's hagiography has made his name the concretion of an illness, a royal contagion, an animal, a placename, and a curse—an ensemble of forces with which the Capetian dynasty has an almost vegetal relationship. As with AZERT, multiple meanings and heterogeneous dimensions intersect in "St. Marcoul." It is the name of an archive in which religious politics, literature, and

geography clashed—a confrontation that drew the established power into the process whereby relics were scattered and the feudal system dissolved.

The issue in this case can't be the margin, which, as we know, always marks the limit of a text; the history I am speaking of is tied to an order of events that is not at all marginal, not at all *obscure* or *out-of-the-way*, one that would thereby be accessible only to the scrupulous interpretations of talmudic exegesis, eminently respectable but a hermeneutics that would be useless to us here. For too long the text has imposed itself as a "substantification" of history, exporting narratology to the heart of the history of the arts and sciences, images and signs, gestures and practices whose archives and regimes of actuality [*régimes d'actualité*] are in fact dependent—as *The Archaeology of Knowledge* has forced us to recognize—on neither the play of the phrase nor the structure of the proposition, but rather on a complex of strata that would be difficult to show here in all its palimpsestic superpositions.[9] The text is the tomb of any history that fails to acknowledge the alloying of forces of resistance in which a strategy of struggle intersects with living lines of friendship—the true machinery [*ressorts*] of an actuality or an archive through which pass bundles of singularities that may be pictorial or musical, architectural or artisanal, even religious or thaumaturgic, and whose peaks take the name of a particular epoch.

≡≡≡

The exception of French philosophy, removed, as Eric Alliez has so accurately noted, from the phenomenologic/analytic division of the world, is timely [*fait actualité*] in that it doesn't subscribe to Wittgensteinian language games where we are expected to "stifle what can't be said" and consequently to ignore those regimes of signs that no longer depend on the text. Such descriptive regimes [*régimes signalétiques*], in escaping the jurisdiction of language, must nevertheless not allow themselves to fall back on the seduction of the "unspeakable" [*non-dit*] conceived of as a primordial world.[10] A concept is no more dependent on propositional syntax than is a tympanum or a stained glass window, an image or a song. But this is not to imply the inverse—the dark depths of the "unseen," the "unknown," that only prayer can lift up through an internal donation which eludes the analytic constitution of the transcendental ego. The French exception, its "except" [*except*] or excess, neither yielding to the injunctions of any *pre-predicative* [*antéprédicatif*], entrenched in the oblivion of its origin,

nor letting itself be carried away by analytic charms that offer everything up to the multiple resources of the play of language, subscribes instead to a pragmatics in which, as Maurice Blanchot has said, "to speak is not to see." In other words, what we shouldn't stifle is the very thing that can't be spoken, recited in the logical form of the text, a "seeing" whose visibility is accessible only to hybrid, asignifying discursive formations.

This kind of concretion is what Deleuze means by "concept": a movement of the concrete, the signs of which are no longer consolidated by phrases or propositions but according to new *assemblages* that are proper to philosophy. We owe Deleuze thanks for having taught us the practice of a concept that need not be dialectical. The oeuvre he has given us to think is probably the finest philosophical creation since Hegel. Accordingly, Deleuze is the knight of thought, a knight who moves neither in a straight line nor diagonally but, as on a chessboard, by jumps, leaving a gap in his wake that then drives him on to another series. And it is this jump that we call *becoming*: becoming mule or mandarin, on the back of a nomadic concept.

—Translated by Alex Martin

Notes

1 *Trans. note*: Some translators of Deleuze render *agencement* as "assemblage," but the frequent use of *assemblage* here requires another synonym, hence my opting for "configuration" instead.

2 See Gilles Deleuze and Félix Guattari, *Qu'est-ce que la philosophie?* (Paris, 1991), 60–62; *What Is Philosophy?*, trans. Hugh Tomlinson and Graham Burchell (New York, 1994), 61–64.

3 Jacques Derrida, *Marges de la philosophie* (Paris, 1972); *Margins of Philosophy*, trans. Alan Bass (Chicago, 1982); and Paul Ricoeur, *La métaphore vive* (Paris, 1975); *The Rule of Metaphor*, trans. Robert Czerny, with Kathleen McLaughlin and John Costello (Toronto, 1977).

4 See, especially, Gilles Deleuze and Félix Guattari, *Mille plateaux*, Vol. 2 of *Capitalisme et schizophrénie* (Paris, 1980), 17–21; *A Thousand Plateaus: Capitalism and Schizophrenia*, trans. Brian Massumi (Minneapolis, 1987), 10–13. Here, the diagram is exemplified by the marriage of the wasp and the orchid, the cat and the baboon.

5 On the function of resemblance in the metaphoric process, see Ricoeur, *La métaphore vive*, chap. 6.

6 G. W. F. Hegel, *Phenomenology of Spirit*, trans. A. V. Miller (Oxford, 1977 [1807]), 2.

7 Gilles Deleuze, *Foucault* (Paris, 1986), 85; trans. Seán Hand (Minneapolis, 1988), 78–79. *Trans. note*: On keyboards used in English-speaking countries, the letters that correspond to A-Z-E-R-T are Q-W-E-R-T.

8 The rivalry of king and saint, which was a constant of the Romanesque period, took one form in the legend of St. Marcoul, whose power blighted the Carolingian royalty as a curse symbolized by Marcoul's becoming-wolf. On this legend of king, wolf, and saint, see my study of the Romanesque archive, *Ossuaires: Une anatomie du Moyen Age roman* (Paris, 1995), esp. *Planche* 6.

9 On one stratigraphic history, see all of Michel Serres's work, which has been inscribed under a fixed program since *Hermès, ou la communication*, Vol. 1 of *Hermès* (Paris, 1968), esp. 84–88.

10 This rut of phenomenology, whose branches lead both to a logical positivism of the undecidable and to negative theological aesthetics, seems to me the major attainment of Eric Alliez's critical account of an originary donation; see his "L'Appel de l'hors d'être," in *De l'impossibilité de la phénoménologie* (Paris, 1995), 60–80.

From Multiplicities to Folds: On Style and
Form in Deleuze Tom Conley

What Gilles Deleuze has to say about Baroque space and habitus in *Le pli* is conveyed as much by his reflections on Leibniz and the fine arts as on style and architecture per se.[1] *Le pli* is arguably the most "difficult" of this philosopher's writings. Touching on city planning, art history, musicology, calculus, chaos theory, and the history of physics, it ventures through an astounding sum of disciplines. Most readers would avow that certain chapters and pages must be taken on faith, whereas others open a fruitful and extensive dialogue on issues specific to given domains. Alain Badiou remarks that, as the "major concept of Deleuze's terminal work," the fold constitutes a discernible and highly material figure that embraces both the span of Deleuze's philosophy (from the pre-Socratics and early moderns to Bergson) and the scope of his reflections on art, music, and literature (from El Greco to Boulez).[2] What the fold conveys for Badiou is the Deleuzian paradox of unicity (the end of ontology—the basis of his philosophy) relative to multiplicity or singularity. *Le pli* is, to be sure, a dazzling summation of all the motifs of the earlier writings, but at the same time it appeals

to the history and theory of art less on account of its conclusions than because of its rivalry with its sources, that is, the demand that its own style be read as the content of those conclusions.

An assertion of this temper should not surprise political and aesthetic historians of the Baroque, for it places *Le pli* squarely in the tradition of aesthetic politics that includes Elie Faure, Henri Focillon, and André Malraux.[3] One of the poets in this tradition was Victor Hugo, who declared that the physical mass and infinite energy of his poetry were constitutive of its politics and ethics. What *Le pli* makes especially obvious is that Deleuze belongs to a tradition that similarly invests plastic and verbal expression with political efficacity. A style of composition conveys a tactic and a way of dealing with the world, hence a habitus, understood in a general fashion, that determines both being and action. Authors in this mold, in which are also cast the writings of Deleuze, seek to create "styles of thinking" consequential enough to supersede their content. However utopian they may seem, they compel us to believe that to aestheticize is to politicize.

In 1955, when Nikolaus Pevsner argued tautologically for the "Englishness of English art,"[4] it was clear that he was leaving in the margins a virtual project about the Frenchness of French art. It would be safe to say that today Pevsner and his adepts would be inculpated for a silly identitarian analysis, for perpetuating myths of nationhood that displace the ideology of one age into the objects of another, for unalloyed belletrism, and for monadic isolation in pure aesthetics; all the same, when the author of *The Englishness of English Art* argued for a "style" of crafting space and language, he did so both heuristically and productively. His claims are as specific to and extensive for the British Isles since the Middle Ages as Deleuze's are in terms of the Baroque in Europe since the Council of Trent.

Would Deleuze's writings figure in a certain Frenchness of French aesthetics? To answer that question, we might recall Paul Valéry's assertion after reading *La légende des siècles* (when Bergson had completed the majority of his philosophical writings) that Hugo was, beyond any shadow of a doubt, a *créateur par la forme*. Valéry was calling attention to the fact that centuries of French poetry had informed Hugo's energetic style and that, by implication, his penchant to unfold an infinite verbal volume had inspired Mallarmé conversely to "infold" the same material. Form, Valéry asserted, generated the essence of Hugo's politics—especially in the verse written during the poet's exile on the island of Jersey. Would it be erro-

neous, then, to declare that Deleuze—hardly an adept of the national literature on which he was weaned—captures, by dint of the energetic process that Valéry locates in the formal virtue of Hugo's creation, a "Frenchness" in the manner of his aesthetic writings?[5] The question is well worth pursuing, for if some of the compositional tactics that inform Deleuze's reflections on space and habitus are of a broader historical and aesthetic scope, they can surely be charted along comparative lines. Deploying categories that have defined the Baroque since the beginning of the twentieth century, Deleuze inserts his reflections into an art-historical tradition that includes French and German forebears. The dialogue he establishes with the likes of Wölfflin and Wörringer could be extended, however, to the issue concerning how a form of content [*forme de contenu*], a concept borrowed from Louis Hjelmslev and Michel Foucault, rewrites the aesthetic tradition in a specifically poetic way. Its treatment of the classical historians in light of Bergson and formal invention makes the style of a book such as *Le Pli* the very evidence of its relation to the Baroque in general.

In terms of the form and shape of his oeuvre relative to other creative aesthetics, Deleuze's attention to aesthetics as a mode of politics and of habitus is especially visible in four works: *Mille plateaux* (with Félix Guattari), *Cinéma 1: L'Image-Mouvement*, *Cinéma 2: L'Image-Temps*, and *Foucault*. Published between 1980 and 1986, these works display an increasing attention to the physical aspect of the mental spaces they create and explore. Having mapped out in his earlier writings the principal concepts of what one philosopher has called a philosophy of events,[6] Deleuze came to place a greater stress on form and style as what mobilizes a politics. This shift of emphasis aligned him more explicitly with those artists, poets and cineasts to whom his allegiance earlier in his career had been evident, if not so declared.

In the works of his last decade, Deleuze effectively *becomes* Melville, Leibniz, Bacon, Beckett, Godard, Michaux, Hantaï, or Antonioni. In a very logical but also compelling and moving way, the strident politics, rightly aimed by Deleuze and Guattari in the two volumes of *Capitalisme et schizophrénie* against the deleterious effects of global capital, got absorbed into Deleuze's relationship of identification and shared space with those cineasts, poets, musicians, and painters. My concern here, however, is not with tracing political lines from *Capitalisme et schizophrénie* to the aesthetics of Deleuze's subsequent polymorphous writings, but with identifying

some political effects of formal choices in his philosophy of multiplicity and the fold.

≡≡≡≡

Jean-Louis Leutrat stated an axiom of the first order when he affirmed that a reader who wants to know anything about Deleuze must read *every-thing* he has written, individually or with collaborators, in order to follow the adventure of its formulation, its habitus, its overall style of thinking.[7] The point seems especially valid when we discover how an unfolding or multiplicative effect inaugurates *Mille plateaux*. It adheres to an emblem structure where inscriptive images are set below the chapter headings, in dialogue with rebus-titles (superscriptions) and riddles (subscriptions deceptively assuming the shape of an argument or a disquisition in the space below). The book acquires the appearance of a creation in the line of Alciati's *Emblematum liber* or, perhaps, a piece of storyboarded philosophy that opens up visual and discursive "lines of flight" within and through its typography. It asks the reader to look at paratactic patterns of images and texts as one might study different areas of an abstract painting.

One of those patterns emerges in the second "plateau." The chapter number and title (in boldface), "2. 1914—Un seul ou plusieurs loups?" (A single or several wolves?), is suspended over an image of a snowscape pocked with a vaguely vertical line of black dots and captioned (in italics) "Champ de traces ou ligne de loup" (Field of tracks or wolf's line). The wolf tracks emanate from a point just above the word *ligne* in the caption, which divides the image from the chapter text beginning at the bottom of the page. They can be followed upward into a mottled area of the land-scape where small black blotches convey a shifting ground, a melting snow cover, or, more abstractly, a diffusing visual/verbal *ligne*. A riddle is sug-gested by the ostensible connection between the date, 1914, that follows the serial number 2 in the title and the "incipit":

> Ce jour-là l'Homme aux loups descendit du divan, particulièrement fatigué. Il savait que Freud avait un génie, de frôler la vérité et de passer à côté, puis de combler le vide avec des associations. Il savait que Freud ne connaissait rien aux loups, aux anus non plus d'ailleurs. Freud comprenait seulement ce que c'était qu'un chien, et la queue d'un chien.

Reproduced by permission of University of Minnesota Press.

. . . .

On that day the Man of the wolves was particularly tired when he got off the divan. He knew Freud had a genius for rubbing truth and passing by, then of filling the void with associations. He knew that Freud hadn't the vaguest notion about wolves, or about anuses either. All Freud could know was what was a dog, and a dog's dick.[8]

Here, all of a sudden, the chapter number and title are visually and discursively assimilated to a date that, lacking both a day and a month, is nonetheless rendered with a Proustian precision of recall usually reserved for the traumatic experience of a primal scene: "On that day. . . ." On that day the man-of-the-wolves was fed up. He had had enough of the normalizing effects that came with the realization that his head was being shrunk

to ordinary size. In a word, he knew he was getting *lobo*-tomized. Freud was wolfing his brains. If the vibrant vernacular of *Mille plateaux* can be approximated in English, we might say that he knew Freud articulated space like a bitch, rubbing places where he gamboled about with a scent of truth. Because he himself had become a pack of wolves, the wolf-man knew that Freud could not smell the delight of an asshole, since, obsessed as he was, the analyst wanted to sniff a pussy.

The paragraph that follows refers to Freud's famous anecdote in "The Unconscious" about the patient who "behaved in other respects exactly as though he were suffering from an obsessional neurosis; he took hours to wash and dress, and so on. It was noticeable, however, that he was able to give the meaning of his inhibitions without any resistance. In putting on his stockings, for instance, he was disturbed by the idea that he must pull apart the stitches in the knitting, i.e. the holes, and to him every hole was a symbol of the genital aperture."[9] The implication here is that the man-of-the-wolves knew his analyst was opening holes in the meshes of his associations and that those same holes were being filled with the phallic farce of explanation. All of a sudden the wolf tracks in the emblematic image of the second plateau begin to look like tears in the warp and the woof of the Freudian fabric. The tracks of *one* wolf become many, while the very *event* of the emblem becomes the multiplication of "one" wolf trail into a swarm of tracks.

And no less so in the text: When the man-of-the-wolves thinks to himself, "Et mon cul, c'est pas un loup?" (What? Isn't my asshole a wolf?),[10] he is affirming that his obsession swarms everywhere, but especially, it may be added, in this very text by Deleuze and Guattari. When the wolf-man gets up off the couch, "particulièrement fatigué," the *tournure* that substitutes *particulièrement* for the more habitual *surtout, un peu,* or *assez* (*il serait descendu,* we can surmise, *surtout, tant soit peu, un peu,* or *assez fatigué,* but not really "particulièrement fatigué") makes "particulièrement" jump off the page. It is a rebus that extends the unique area of a scopophilic obsession—a sole and singular hole—into a *cul* at the vanishing point on the orthographic horizon of the word (par-ti-*cul*-ière-ment). It is also an adverb that formally multiplies by being inflected as a force of pulverization, thus exemplifying Freud's tendency to repress the "molecular" [*moléculaire*] properties of perception by means of "molar" [*molaire*] terms or fixed ideas, hardened areas that freeze the convections of what he so brilliantly

discovered. "A peine a-t-il découvert le plus grand art de l'inconscient, cet art des multiplicités moléculaires, que Freud n'a de cesse de revenir aux unités molaires, et retrouver . . . *le* père, *le* pénis, . . . *la* castration" (No sooner does he discover the great art of the unconscious, this art of molecular multiplicities, than is Freud incessantly returning to molar unities, and retrieving . . . capital-F father, capital-P penis, . . . capital-C castration).[11] When he is "particularly" tired, the man-of-the-wolves begins to molecularize his sensibility in ways that collapse the differences between words and things, such that swarms of anuses proliferate in the very molecularization he experiences during a state of analytical exhaustion.[12]

By means of the redundancy of the composition with which this chapter begins, we too become people-of-the-wolves, making as much or as little of the infinite number of possible trajectories at the bifurcation of the wolf line into as many particularities as we wish. At the same time, the text becomes a graphic shimmer that inspires healthy obscenity: just as particular care is taken to nest the sign of the anus in the verbal gist of the text, so too are its contiguous figures embedded. A homophobic dog, "Freud comprenait seulement ce que c'était qu'un chien, et la queue d'un chien," meaning that all Freud could understand was what he *com-prenait*, what he took to be the *feminine* origin of the world, the unique sign of the unknown.

Readers familiar with the rest of the chapter know that Deleuze and Guattari mobilize the very multiplication of fragments of words, images, and things in a Vertovian montage of allusions, names, and signifiers that causes the text itself to swarm. Reference is made to Louis *Wolf*son, the author of *Le schizo et les langues,*[13] and to Virginia *Woolf,* whose initial V becomes the double U—the W recalling the wolves' ears that multiply in the patient's dream. So too does "M. de Charlus," with his love for a "pack" of ephebes, the quixotic homosexual's name recalling one wolf (Char-loo) and beckoning another (Saint-Loup) from Proust's fiction, such that in the *Recherche* it might qualify as a *lobo*-nym: "Meute de taches de rousseur sur un visage [i.e., the symptom of lupus erythematosus], meute de jeunes garçons parlant dans la voix d'une femme, nichée de jeunes filles dans celle de M. de Charlus, horde de loups dans la gorge de quelqu'un, multiplicité d'anus dans l'anus [e.g., the *c-u-l* in Charlus]" (a horde of red spots on a face, a horde of young boys speaking in the voice of a woman, a nest of girls in that of M. de Charlus, a horde of wolves in someone's throat, a multiplicity of anuses in the anus).[14]

Through the sign of the wolf and its translation into various languages (*loup, lobo*, things lupine) and graphic images (from V into W)—in accordance with Freud's practice of composing *Bilderschriften*—and through associations that range between the ones and the others (such as their allusion to Kafka's famous coleoptera in *The Metamorphosis*, which is at once a cockroach and a *beetle*), Deleuze and Guattari visually advance (i.e., verbally and lexically) an expanded practice of language as the intercommunication of force and sensation felt in a continuous process of psychogenesis. Their own discourse functions coextensively in both a legible and a visible register. Herein is a dialogical condition in which feelings and sensations multiply in and about words as they might for someone in the field of the emissive effects of a film or a painting. The verbal play deterritorializes most readers' expectations, disseminating the obsessions of *Mille plateaux* all over its signifying surface.

It also beckons us to the "feeling" of the arguments, which are shaped like composite works of art. "C'est un fourmillement, un lupullement" (it's a swarming, a lupullation). Nested in *fourmillement* is the cipher (1,000) of the *mille* plateaus, just as the neologism *lupullation* yields the wolf as the creature that pullulates. Both *wolf* and *loup* are proper names, or what these authors call "l'appréhension instantanée d'une multiplicité" (the instantaneous apprehension of a multiplicity), adding that "le nom propre est le sujet d'un pur infinitif compris comme tel dans un champ d'intensité" (the proper name is the subject of a pure infinitive as such in a field of intensity).[15]

The proper name both locates and sets in motion the very site it denotes. When Deleuze and Guattari advocate a pluralization of singularities by rendering Freud's "Wolf-Man" as "l'Homme aux loups," their hero sustains the anti-Lacanian bias of the work, returning to a more immediately practical and pragmatic, but also prescient, theory of communication. They seek a discernible process of communication that extends from humans to inorganic matter, as in Gregory Bateson's theory of feedback loops— "l'Homme aux loups" as *l'Homme aux loops*, the man whose identity is a web of associations and thus not limited to a single idiolect or unified regime of thought. Loops, like the figure of one man as a pack of wolves, multiply the lines of creative association indiscriminately through the visual and lexical registers. The cinematic and emblematic design of *Mille*

plateaux mobilizes this process with a ruseful simplicity and by appeal to a conjunction of picture and writing that has a rich aesthetic history.[16]

═════

The polemical style of *Mille plateaux*, like that of *L'Anti-Oedipe*, owes much to the divided structure of its writing. Its *caméra-stylo* prose constantly splinters into different "tracks" that recombine, bend, and bifurcate, looping back, unwinding, and knotting together. Deleuze's more strictly philosophical works have a relatively controlled quality, but are nonetheless informed by the same creative disposition. Reduction or extrapolation of their content from this process is almost impossible, while the art of a book like *Le pli* comes from a design based on this process and can be grasped simultaneously from several perspectives. The implied shape of *Le pli* suggests a point of view that originates in multiplicity and is read through Leibniz's philosophy of space. An operative concept that bifurcates and loops ahead and back through images and language, point of view becomes an active and mobile element in the very architecture of *Le pli*, that is, in the textual space it creates from the disposition and strategic placement of its arguments. Also vital to this textual architecture is the book's emblematic design.[17]

Le pli's argument is spelled out on the *explicit* or colophon-like verso of its cover:

> The fold has always existed in the arts; the character of the Baroque is one of carrying the fold to infinitude. If Leibniz's philosophy is Baroque par excellence, it is because everything folds, unfolds, refolds. His most famous thesis is that of the soul as a "monad" without either a door or a window, that draws all of its clear perceptions from a dark background: the thesis can be understood only by analogy to a Baroque chapel, in black marble, in which light penetrates only through openings imperceptible to the observer within; thus is the soul full of obscure folds.
>
> In order to discover a modern neo-Baroque it suffices to follow the history of the infinite fold in all of the arts: "folding following fold," with Mallarmé's poetry and Proust's novel, but also the work of Michaux, Boulez's music, Hantaï's painting. And this neo-Leibnizianism has endlessly inspired philosophy. (My translation)

Printed on the outer wall of *Le pli*, conceived as a book–monad, the site
and inscription of this summary blurb encapsulates the principles laid out
at the beginning of the third chapter, in which American abstract expres-
sionism is described as having revolutionized classical definitions of vol-
ume and surface. Deleuze begins with Leibniz's *Monadologie*. Monads lack
the perspectival model or frame furnished by the classical painting as a
"window on the world." Citing Leo Steinberg, he shows that a monad, like
a Rauschenberg painting, is a surface that abandons its role as a window
giving onto the world for one as "an opaque table of information" on which
lines and ciphers are written. Lines, numbers, and ever-changing charac-
ters are drawn in the boxes of a grid. "Folds replace holes." The window–
landscape system is replaced by "the dyad of the city-information table,"
implying that the monad would be a curvilinear surface or, rather, "a room
or an apartment, completely covered with lines of variable inflection." [18]

Here and elsewhere *Le pli* begins to acquire its own traits of a strange
tabular grid, a three-dimensional or neo-abstract picture of words that
might indeed resemble a Baroque cityscape viewed from an anamorphotic
perspective. The "objective" form of the book qualifies it to be identified
with such figures as the dark, closed room, the house with two storeys,
the flatbed painting, the mathematical table, the informational grid, and
the series of musical notations. *Le pli* is all those things at once, while also
outlining the pertinent traits of the Baroque within a closed textual space.
Its order of argumentation is *staggered*, with its chapters following the re-
cession of chapels in such darkly illuminated Romanesque monuments
as Sainte-Foy de Conques, for example, but without any narthex or facade
that would effectively orient the reader toward a privileged site such as
a choir or an ambulatory. The chapters are punctuated by thirteen hand-
drawn schemas and a grid that shows how "sufficient reason" cannot be
contained in its twenty-four pigeonholes. [19] There are also numerous alge-
braic and proportional equations, as well as two still lifes that illustrate the
tradition overall. [20]

The relationship between the illustrations and the arguments and orga-
nization of *Le pli* is neither so emblematic nor so aggressively serialized as
it is in *Mille plateaux*, but a latent dialogue between images and text is evi-
dent nonetheless. Here, invisible foldings take place, as if the arguments
for multiplicity developed in *Le pli* had been encoded in *Mille plateaux*,
with the fold then becoming what bifurcates or loops all morphogenetic

activity into lines of actualization and realization.[21] If *Le pli* could designate a monadic chamber in which the abstraction of its concepts is produced, it would be everywhere (going by what happens in the vocables of the second chapter of *Mille plateaux*), but it would also be a ubiquitously secret space that allowed the motivating force of point of view to be made manifest everywhere and nowhere. In this book Deleuze crafts, from Leibniz and from William and Henry James, what is probably one of the most effective definitions of perspective. Correcting the reductive tendency to associate point of view with relativism, he declares perspective to be "not a variation of truth according to the subject, but the condition in which the truth of a variation appears to the subject."[22]

This definition forces the reader to look at *Le pli* in just such a way. Three sites provide a telling clue as to how the veracity of Deleuze's own variation appears to a subject. First, in his discussion of Baroque harmonics, the emblem from *Mille plateaux* returns in the guise of an agent of allegorical multiplication. In a limited sense, the Renaissance emblem (whose principle has been used here to explicate the second chapter of *Mille plateaux*) sought to impose moral truths through the mechanism of a motto, a text, and an image; yet the relation of difference established between the visual and lexical registers effectively exceeded the emblem's objective of control, subverting its moral or edifying aims.[23] In Baroque emblems allegory is built on a principle of excess. Images break through their frames to "form a continuous fresco," hence to become *events* that multiply by virtue of a design based on anamorphotic renderings of conic sections. The latter are used to symbolize painting and to codify the point of view or signature of the emblem-bearer (at the apex or origin of the conic section). The whole of the world is projected from the base. In this context point of view cannot be anything other than the realization of the way in which a variation is being apprehended and of how that variation, as multiplicity itself, could be grasped otherwise than the way in which it is presently being discerned. In this difficult passage on the emblem (which seems to derive from the very process of *Mille plateaux*), Deleuze shows how the book can be dispossessed of its author by figuring within a tradition that inaugurates a precapitalist system of ownership and circulation of signs and titles.[24] At that point and others, *Le pli* begins to molecularize.

At a second site, the celebrated allegory of the Baroque house, Deleuze shows how the inner world of pure thought and abstraction recedes so far

from public space as to become an elevated chapel, a windowless room decorated with folded draperies that are as much figments of the mind as pendant festoons of fabric. The space he is designating here is clearly opposed to the Cartesian *poêle*, the heated room in the darker climes of Northern Europe where French philosophy has its official origins. The Leibnizian inner sanctum, or *fuscum subnigrum*, is a response to the recti-linear and Euclidean extension that maps out the unilateral itinerary of the formula *je pense, donc je suis*. Much more in the dark, the Leibnizian thinker vibrates with harmonies that come from a world *dehors*, literally from *outer space*, that space we can no longer fathom with our senses. The Leibnizian variation on the Cartesian formula might be expressed as *je vibre, donc je sens*,[25] in response to the world as seen and felt from the outside in. Yet what the diagram of the Baroque house[26] inscribes are folds of sensation wafting their way upward into the closed room, such that its occupant can produce worlds of abstraction on the basis of molecularization or particu-larization, the distillation of sensory raw materials emanating from the public domain. The architecture becomes quasi-ideal for the apprehension of point of view, for within the fold-festooned apartment as nowhere else can the subject discover worlds in constant molecularization. Here "the truth of a variation" becomes processual.

The ground plan of *Le pli*, evident in its opening pages on the Baroque house, is indeed a facade. Beginning with the perspective of a horizon-tal passage leading *through* the volume, on the one hand, establishes an effectively "flatbed" ground plan. Thus a bent perspective is attained, such that the book's initial question—"What is Baroque?"—is deferred until the third chapter. The passages on costume and harmonics, so resonant in the final pages, on the other hand, would be more historically convincing if they were to follow the discussion of spatial folds. The ruses of deferred conclusions and reiterated figurations show forth more in the overall "tabu-lar" style of *Le pli*'s discursive arrangement as its chapters begin to fold over and about themselves.

For this reason the principle of multiplication, which includes the dis-cernment of point of view and its dispersion, seems to be centered in the third site—the very event of *Le pli*—the chapter entitled "What Is an Event?," located in what might conceivably be the inner chamber of the volume according to its own monadic "architecture." This chapter consti-tutes the world as seen from within, from a highly abstract space designed

to open onto the entirety of the cosmos from within its own folds. Deleuze begins by noting that in *The Concept of Nature* Alfred North Whitehead rehearses Leibniz's theory of the event in order to explain its manifestation in the domain of scientific philosophy. Traditionally equated with the adventitious, or that which befalls an individual and indelibly marks his or her relation with the world, an event need not be associated with the force of gravity, such as when "un homme est écrasé" (a man is crushed). Rather, it can be felt as duration: "la grande pyramide est un événement, et sa durée pendant 1 heure, 30 minutes, 5 minutes" ("the Great Pyramid is an event, and its duration a period of one hour, thirty minutes, five minutes").[27] From the feeling of duration arises a consciousness of the surrounding chaos in which it takes place, but this chaos cannot be separated from a "webbing" or gauzelike filter (such as the cheesecloth used to filter fruit juices for homemade jellies), a *crible* through which something minimally different, a "one," will issue—in this case, from the chaotic darkness of the Baroque apartment.

Then, all of a sudden, point of view reappears in the discussion: "D'un point de vue psychique, le chaos serait un universel étourdissement, l'ensemble de toutes les perceptions possibles comme autant d'infinitésimales ou infiniments petits" ("from a psychic point of view, chaos would be a universal giddiness, the sum of all possible perceptions being infinitesimal or infinitely minute"). What results for Whitehead and Leibniz are three congruent constituents of the event: First, *extension* is felt by way of vibration, such as a wave of sound or light. Second, space and time "are not limits but abstract coordinates of all *series*, that are themselves in extension," whereas matter is classified in terms of "intensions, intensities, or degrees."[28] Third, the event is associated with *individuation*, the individual becoming a "concrescence" of elements caused by a "prehension" of being "prehended" by something or someone else. The individual does not gain self-consciousness through the realization that he or she is grasping the world as would no one else because of the unique time and place created by the prehension. Rather, prehension is multidirectional: the Great Pyramid prehends Napoleon's soldiers as they march south of Cairo during the Egyptian campaign, just as ambient spaces and objects prehend whoever inhabits them.

It follows that Deleuze associates psychogenesis and subjectivity—what became the Wolf-Man's apprehension of molecular multiplicities in Freud's

case history—with three subtraits. Subjectivity is "the manner" by which a perception is expressed *within* the subject, that is, how the subject actively prehends a datum, whether an emotion or consciousness in general. Second, prehensions follow each other in a becoming that "places the past in a present portending the future," which leads, third, to a feeling of self-enjoyment.[29] In developing this way, an event becomes a sort of prehension of prehension that reveals the molecular play of flux and permanence in all things. The only decisive difference between Leibniz and Whitehead, remarks Deleuze, is that the monadic closure essential to the former's sense of space gives way in the latter to a chaotic seriality, to divergences and multiplications, to a "florescence" of harmonic accords, and to "emancipations of dissonance" that turn closures into polytonal effects. Events are the prehensions of what, quoting Pierre Boulez, Deleuze calls a "polyphony of polyphonies."[30]

At this point in *Le pli*, after the chapter devoted to the event, the spatial model that initially described Leibniz's monad now includes a musical component. A greater degree of abstraction has thus been gained, enabling Deleuze to generalize the concepts of bifurcation (looping in the Batesonian sense), multiplication, simultaneity, succession, and permanence, all of which are *felt* in the act of prehension. This new florescence or "broadened chromatic scale" confers a limitless possibility upon the reader's experience of space and form, with the space of the monad becoming an event in the very *dilation* of the kind that the reader encounters in the shift of emphasis from a closed to an open space. The darkened confines of the monad–apartment described at the beginning are infused with—but also traversed by—harmonic waves that multiply, swarm, and endlessly produce more and more affect, inspiring more prehensions of prehension.

Harmonics traverse infinite numbers of monads as both sound waves and continuous beams of light would. They pluralize (or nomadize) monadic space by making containment of a feeling of the latter, a sense of "self-enjoyment," the very essence of an event. As a form of molecularization or a consciousness of the atomic flux of permanence, the event is now tantamount to what is described elsewhere as multiplication—of swarming, of movement along infinite lines in perpetual bifurcation. The event is effectively the process by which the multiplication of affective loopings

is characterized in the verbal style of *Mille plateaux*; in *Le pli*, we witness the mental and physical space in which the event creates the place of its happening. Studied through the comparative architectures of the Baroque period and Leibniz's philosophy, the event is also inherent to the very form and spatial arrangement of *Le pli*'s discourse.

=======

As I proposed at the outset of this essay, Deleuze belongs to a tradition of aesthetics in European and French art-historical theory in which creative force is regarded as something to be endowed with political virtue. Situating him among a group of writers and theorists who, in Valéry's words, are energetic *créateurs par la forme*, this aesthetics is associated in many of Deleuze's writings with Bergson and *élan vital*, but it also encompasses much of what has been written about the Baroque tradition throughout the twentieth century. Close readings of Deleuze's post-1980 works in which greater stress is placed on art, music, or literature show that the utopian politics of his philosophy informs his aesthetics as well.[31] The emblematic style of *Mille plateaux* mobilizes its arguments for multiplicity and singularity, while the monadic and nomadic architecture of *Le pli* similarly constitutes much of its exposition of Baroque habitus and style.

The relation of multiplicity and singularity that Deleuze extracted from the *Monadologie* became a pertinent concept in the overall architecture of his later writings. In *Le pli* and elsewhere the multiple and the singular are applied as standard measures of consciousness and immanence, of our feeling of and knowledge about where we are in the *Tout*, the world at large. If the fold between singularity and multiplicity, or "the each and the every," accords with the injunction to "act locally and think globally," then Deleuze's aesthetics can conceivably ground an eco-political philosophy. Insofar as we are witnessing an accelerated eradication of social and biological diversity in the world, what he says about immanence, harmonics, continuous folding, and the proliferation of events can suggest ways of thinking about and coping with some of the effects of geocide.[32] How to mobilize the ecological component of Deleuze's political aesthetics is a topic whose treatment must extend beyond the frame of this essay. In the best of all possible worlds it will follow, or unfold in the direction of a more specific agenda with a tactic and a set of practical operations, as a sequel.

Notes

1 Gilles Deleuze, *Le pli: Leibniz et le baroque* (Paris, 1988); *The Fold: Leibniz and the Baroque*, trans. Tom Conley (Minneapolis, 1993).

2 Alain Badiou, *Deleuze: La clameur de l'être* (Paris, 1997), 26; my translation.

3 In "A Plea for Leibniz" (my Foreword to *The Fold*), I argued that Deleuze's work on the Baroque bears strong affinities with what theorists and historians of Gothic art make of serial creation, three-dimensional treatments of planar forms, and pullulation. Moreover, the categories that Focillon used to describe irrealism and illusion in the *flamboyant* share much with Deleuze's work on morphogenesis and unfolding, while Deleuze's figure of the infinite line recalls Wilhelm Wörringer's "Gothic will to form, . . . which, as the style peculiar to primitive man, is spread over the whole earth," in *Form in Gothic*, trans. Herbert Read (New York, 1967 [1912]), 38.

4 Nikolaus Pevsner, *The Englishness of English Art* (Harmondsworth, 1978 [1955]).

5 See Gilles Deleuze and Claire Parnet, *Dialogues*, trans. Hugh Tomlinson and Barbara Habberjam (New York, 1987 [1977]), where Deleuze makes clear his attraction to the open spaces of American literature; and Gilles Deleuze, *Critique et clinique* (Paris, 1993), in which his chapters on Walt Whitman ("Whitman," 75–80) and Melville's "Bartleby the Scrivener" ("Bartleby, ou la formule," 89–114) adduce the attraction, while a book on Proust and essays on Jarry and Zola serve to complicate Deleuze's allegiances. Nevertheless, it seems strange that in those philosophical writings strongly based on the early modern tradition only passing reference, at best, is made to Montaigne, a writer whose affinities with Descartes, Spinoza, and Leibniz are complex and indeed Baroque.

6 See François Zourabichvili, *Deleuze: Une philosophie de l'événement* (Paris, 1994), who describes an event as inflected by the "constance du virtuel, extériorité des relations, identité finale du dehors, du sens et du temps" (constancy of the virtual, exteriority of relations, final identity of the outside, of meaning, and of time [127]). Cf. Gilles Deleuze and Félix Guattari, *Qu'est-ce que la philosophie?* (Paris, 1991), which seems to situate the growing concern for aesthetics at the same time that it plays the role of a "poetics" to reclassify the work of the past twenty years.

7 Jean-Louis Leutrat, "La pyramide" (paper presented at the First Conference on Deleuze and Cinema, Weimar, Germany, 3–5 October 1995).

8 Gilles Deleuze and Félix Guattari, *Mille plateaux*, Vol. 2 of *Capitalisme et schizophrénie* (Paris, 1980), 38–39; my translations here and throughout.

9 Sigmund Freud, "The Unconscious" (1915), in *Papers on Metapsychology*, Vol. 14 of *The Standard Edition of the Complete Psychological Works of Sigmund Freud*, trans. James Strachey (London, 1957), 200.

10 Deleuze and Guattari, *Mille plateaux*, 44.

11 Ibid., 39–40.

12 The issue of exhaustion and creation, only implicit here, is developed at length in Gilles Deleuze, "L'épuisé," appended to *Quad* by Samuel Beckett (Paris, 1992). In chapter 3 of *Mille plateaux* (78), however, the man-of-the-wolves is said to understand "a language of images and spaces," the "third language," Deleuze and Guattari's term for an idiom mixing lexical and sensuous forms that are not a function of meaning.

13 In fact, Deleuze explained the process in his 1970 Preface to *Le schizo et les langues*; see "Louis Wolfson, ou le procédé," in *Critique et clinique*, 18–33.

14 Deleuze and Guattari, *Mille plateaux*, 49. The next sentence, "Chacun passe par tant de corps en chacun" (everyone goes through so many bodies in each other), is also related to the maddening multiplicity when Kafka's "Jackals and Arabs" is invoked to illustrate the pack effect, with the jackals contained as multiplicity in *chacal*'s echo of *chacun* (50).

15 Ibid., 45, 51. Here we begin to see why, at the outset of Deleuze's *Cinéma 1: L'Image-Mouvement* (Paris, 1983), he seems to be making a regressive analytical move in the name of auteur theory (8), which had been entirely dismantled by Althusserian adepts of ideological formation and Foucaldian devotees who saw more deeply invested discursive formations in the name of the author. Deleuze arches back to post-Bazinian politics because auteur theory (at least as François Truffaut had cast it in homage to Jean Giraudoux) is based on the axiom that "il n'y a pas d'oeuvres, il n'y a que des auteurs" (there are no works, only authors). Deleuze forces us to recognize that auteur theory does not center aesthetic consciousness in the person of the director, but in the "swarm" of stylistic and thematic associations that percolate through the names and forms operating in a given body of work "signed" by an auteur.

16 I am referring, of course, to the emblematic tradition. The classic study is Robert Klein, "La théorie de l'expression figurée dans les traités italiens sur les *imprese*, 1555–1612," in *La forme et l'intelligible* (Paris, 1970), 125–50. See also Daniel Russell, *Emblematic Structures in Renaissance French Culture* (Toronto, 1995), esp. chap. 7 (159–88), for a handsome overview. Karen Pinkus, in *Picturing Silence: Emblem, Language, Counter-Reformation Materiality* (Ann Arbor, 1996), addresses the politics of the genre by way of Walter Benjamin and thus, like Deleuze (in *Le pli*, 170–71; *The Fold*, 125), takes up the ideology of emblematic form.

17 "Textual space," "textual architecture," and similar locutions risk being taken in a figurative sense, but Deleuze, it seems, has a fairly medieval vision of the plastic qualities of graphic form and speech. The way that space is conceived through his writing is consistent with Paul Zumthor's spatial typology in *La mesure du monde* (Paris, 1993): textual (printed), discursive (descriptive), and poetic (dialogical) space (363).

18 Deleuze, *Le pli*, 38; *The Fold*, 27.

19 *Le pli*, 77; *The Fold*, 57.

20 *Le pli*, 167; these are not reproduced in *The Fold*.

21 See the figure in ibid., 140; and *The Fold*, 105.

22 *Le pli*, 27; *The Fold*, 20.

23 Gisèle Mathieu-Castellani notes that in his or her dreams of glory the Renaissance emblematist wanted to transform the visible into a legible world. That project, however, was really engaged in a more problematic—indeed impossible—translation that raised doubts about the emblem as an esperanto. Since the image is suffused with words and words become images, the emblem can be read in ways counter to its design; see her "Anatomie de l'emblème," *Littérature*, No. 78 (May 1990): 3–21.

24 See Deleuze, *Le pli*, 170–72.

25 Astronomers have noted two effects that make Leibnizian space more plausible today than it might have been in the late seventeenth century. First, a layer of atmospheric

pollution has covered the planet, rendering study of outer space with the naked eye increasingly difficult. Second, the earth has become so illuminated at night that total darkness cannot easily be found outside of an artificial enclosure. Outer space is thus abstracted from the inside of a darkened chamber, or, as Deleuze puts it on the last page of *The Fold*, a "sealed car speeding down the dark highway."

26 See *Le pli*, 7; *The Fold*, 5.
27 *Le pli*, 103; *The Fold*, 76.
28 *Le pli*, 104, 105; *The Fold*, 77.
29 *Le pli*, 106; *The Fold*, 78.
30 *Le pli*, 112; *The Fold*, 82.
31 See Deleuze and Guattari, *Qu'est-ce que la philosophie?*, where the immanence of the utopian dimension is taken up in chaps. 4 and 5, esp. 104–13.
32 See Zumthor (*La mesure du monde*, 410), who decries our own lack, in contrast to medieval subjects, of either a philosophy or a theology of space: "We have nothing, or rather we are overwhelmed by dispersed and cumbrous forms of knowledge. We speak of objects situated in space but, ever since Newton, we can speak of the latter only in abstract ways, as if of a void." Deleuze offers a pioneering philosophy of space that can meet the medieval measure espoused by Zumthor.

Notes on Contributors

RONALD BOGUE is Professor of Comparative Literature at the University of Georgia. He is the author of *Deleuze and Guattari* (1989), as well as coeditor (with Mihai I. Spariosu) of *The Play of the Self* (1994) and (with Marcel Cornis-Pope) of *Violence and Mediation in Contemporary Culture* (1996).

IAN BUCHANAN is Assistant Professor in the Department of English and European Languages at the University of Tasmania. He is the author of *Deleuzism* (Edinburgh and Duke, forthcoming) and *De Certeau and Cultural Studies* (Sage, forthcoming).

ANDRÉ PIERRE COLOMBAT, Associate Professor of French at Loyola College in Maryland, is the author of *Deleuze et la littérature* (1990) and *The Holocaust in French Film* (1993). He is currently writing a book on bilingual literature.

TOM CONLEY teaches early modern and cinema studies at Harvard University and is the author of *The Self-Made Map: Cartographic Writing in Early*

Modern France (1996). He has translated *The Fold* (1993) by Gilles Deleuze and *Culture in the Plural* (forthcoming) and *The Capture of Speech* (1997) by Michel de Certeau.

MANUEL DELANDA teaches a seminar at Columbia University on "Theories of Self-Organization and Urban History" and lectures around the world on the philosophy of science and technology. The author of *War in the Age of Intelligent Machines* (1991) and *A Thousand Years of Nonlinear History* (1998), he also contributed an article to the 1993 *SAQ* special issue *Flame Wars*, edited by Mark Dery.

TESSA DWYER is a graduate student in Art History and Cinema Studies at the University of Melbourne. Her article "Literary Exoticism and the Postcolonial Wardrobe: Travel-Writing in Pierre Loti, Marc Hélys, and Isabelle Eberhardt" appeared in *Antithesis* (1995), and she coedited *1st Floor* (1996), a volume of catalog essays from the Melbourne gallery of the same name.

JERRY ALINE FLIEGER, Professor of French, Comparative Literature, and Women's Studies at Rutgers University, is the author of *The Purloined Punch Line: Freud's Comic Theory and the Postmodern Text* (1990), *Colette and the Fantom Subject of Autobiography* (1992), and a forthcoming book, *The Listening Eye: Hypervisibility, Paranoia, and the Millenial Text*.

EUGENE W. HOLLAND, Associate Professor of French and Comparative Studies at The Ohio State University, is the author of *Baudelaire and Schizoanalysis: The Sociopoetics of Modernism* (1993) and *Introduction to Schizoanalysis* (Routledge, forthcoming). He is currently writing a book on Marxism and French poststructuralism.

FREDRIC JAMESON is Director of the Literature Program at Duke University and General Editor of the *South Atlantic Quarterly*. His most recent book is *Brecht and Method* (1998).

JEAN-CLET MARTIN, Professor of Philosophy, Lycée d'Altkirch, is the author of *Variations: La philosophie de Gilles Deleuze* (1993), forthcoming in translation from Humanities Press, *Ossuaires: Une anatomie de Moyen Age roman* (1995), *L'image virtuelle* (1996), and the forthcoming *Van Gogh: L'oeil du monde*.

JOHN MULLARKEY, Lecturer in Philosophy at the University of Sunderland, has published essays on *Metaphilosophy, Philosophy Today,* and *Process Studies. Bergson and Philosophy: The Rule of Dichotomy* is forthcoming from Edinburgh University Press.

D. N. RODOWICK, Professor of English and Visual/Cultural Studies at the University of Rochester, is the author of *The Difficulty of Difference: Psychoanalysis, Sexual Difference and Film Theory* (1991), *The Crisis of Political Modernism: Criticism and Ideology in Contemporary Film Theory* (1994), and *Gilles Deleuze's Time Machine* (1997).

HORST RUTHROF is Professor of English and Comparative Literature at Murdoch University. The author of *The Reader's Construction of Narrative* (1991), *Pandora and Occam: On the Limits of Language and Literature* (1992), and *Semantics and the Body: Meaning from Frege to the Postmodern* (1997), he is currently completing a book on language and "the corporeal turn" to be published by Cassell.

CHARLES J. STIVALE is Professor of French and Chair of the Department of Romance Languages and Literatures at Wayne State University. His books include *The Art of Rupture: Narrative Desire and Duplicity in the Tales of Guy de Maupassant* (1994) and *The "Two-Fold Thought" of Gilles Deleuze and Félix Guattari: Intersections and Animations* (1998). He has also edited special issues of *SubStance* (1984, 1991) on Deleuze and Guattari and of *Works and Days* (1995) on "CyberSpaces."